THE ART BOOK

Phaidon Press Limited
Regent's Wharf
All Saints Street
London N1 9PA

Phaidon Press Inc.
180 Varick Street
New York, NY 10014

First published 1994
© 1994 Phaidon Press Limited

ISBN 0 7148 4487 X

A CIP catalogue record for
this book is available from the
British Library.

Printed in China

Note

abbreviations:

c=circa
b=born **d**=died
h=height **w**=width **l**=length
diam=diameter

The publishers have made every
effort to include dimensions
wherever possible. As some
frescos illustrated are part of large
cycles, covering entire rooms, the
correct measurements have been
impossible to acquire and are
therefore omitted.

THE ART BOOK presents a whole new way of looking at art. Easy to use, informative and fun, it's an A to Z guide of 500 great painters and sculptors from medieval to modern times. It debunks art-historical classifications by throwing together brilliant examples of all periods, schools, visions and techniques. Only here could Michelangelo be considered with Millais, Picasso with Piero della Francesca and Rodchenko with Rodin. Each artist is represented by a full-page colour plate of a typical work, accompanied by explanatory and illuminating information on each image and its creator. The entries are comprehensively cross-referenced and glossaries of artistic movements and technical terms are included, together with an international directory of galleries and museums to visit. By breaking with traditional classifications, THE ART BOOK presents a fresh and original approach to art: an unparalleled visual sourcebook and a celebration of our rich and multi-faceted culture.

Agasse Jacques-Laurent The Nubian Giraffe

A giraffe leans its long, slender neck to reach the bowl held by its Arab keepers. Two Egyptian cows can be seen in the background. With the development of communication links, traders of the early nineteenth century were able to travel further and further afield and return with increasingly exotic gifts. Giraffes, lions and leopards were given to wealthy landowners and Agasse, being renowned for his acute attention to detail, was often commissioned to paint them. King George IV paid Agasse £200 for 'a picture of the Giraffe and Keepers'. The gentleman depicted wearing a top hat is Edward Cross, a well-known importer of foreign birds and animals for the royal menagerie. Born in Switzerland, Agasse lived in England from 1800 where he achieved considerable success painting sporting scenes and exotic animals. He also painted a number of portraits of noblemen on horseback.

☛ Audubon, Landseer, Longhi, Stubbs

4

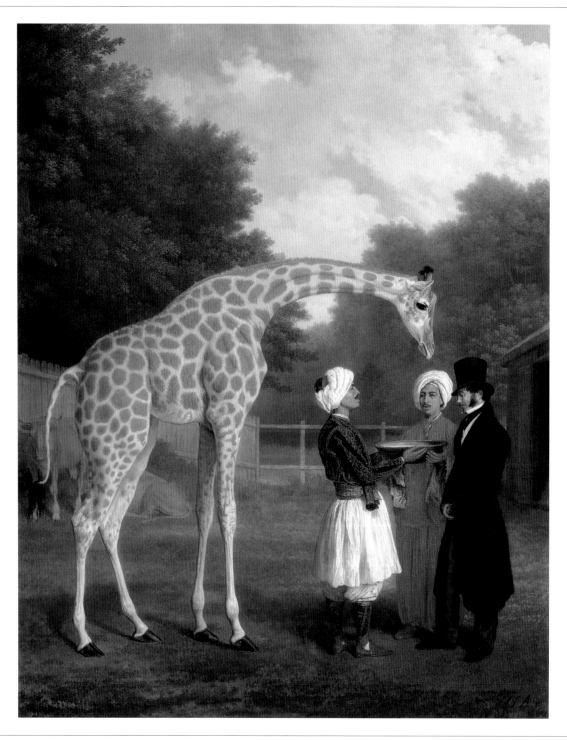

Jacques-Laurent Agasse. b Geneva, 1767. d London, 1848. **The Nubian Giraffe**. 1827. Oil on canvas. h127 × w101.5 cm. h50⅛ × w40 in. The Royal Collection, Windsor Castle, Windsor

Albers Josef

Homage to the Square

Four squares of yellow nest together. Despite a rigid format, they float freely, creating an optical illusion of another dimension. Each area has been painted in a single colour. The paint has been applied with a knife, directly from the tube. Albers' most famous series of paintings, of which this is one, shows squares created from pure colour.

The optical illusion created in this picture means it is related to the Op Art movement. Yet the way the paint has been applied and the use of colour link it with the Post-Painterly Abstraction movement. Between 1920 and 1923 Albers studied at the famous Bauhaus school. He joined the staff in 1923. A Dutchman by birth, Albers moved to

the USA in 1933, where he taught many established artists at the Black Mountain College and Yale University. His influential book *The Interaction of Color* was published in 1963. In this he explores the perception of colour, which was a dominant theme throughout his life.

☛ Andre, Van Doesburg, Kelly, Klee, Reinhardt, Vasarely

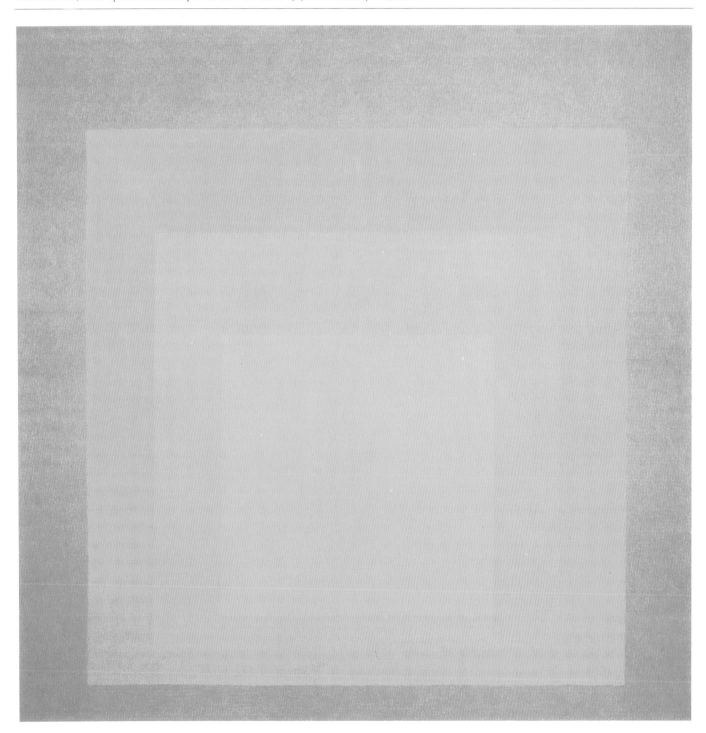

Josef Albers. b Bottrup, 1888. d New Haven, CT, 1976. **Homage to the Square**. 1964. Oil on panel. **h**76.2 × **w**76.2 cm. **h**30 × **w**30 in. Tate Gallery, London

Algardi Alessandro

Bust of Cardinal Paolo Emilio Zacchia

The cardinal's fine robes, lace cuffs and distinctive moustache and beard tell the viewer immediately that this is a distinguished individual. The marble portrait has a spark of life that shows Algardi's close observation of the cardinal's features. As was customary at the time, Algardi originally sculpted this bust in terracotta. This would have been used as a study before making a final version in the more expensive medium of marble. Although an artist of the Baroque period, Algardi's style is more reserved than the flamboyant approach of his contemporary Gianlorenzo Bernini. This may be because he trained in Bologna under the painter Lodovico Carracci (the cousin of Annibale) before embarking on a career in Rome. One of the century's foremost Italian sculptors, Algardi was commissioned to make many important works while in Rome, including the tomb of Leo XI in St Peter's and a bronze statue of Innocent X.

☛ Bacon, Bernini, Carracci, Houdon, Manzù

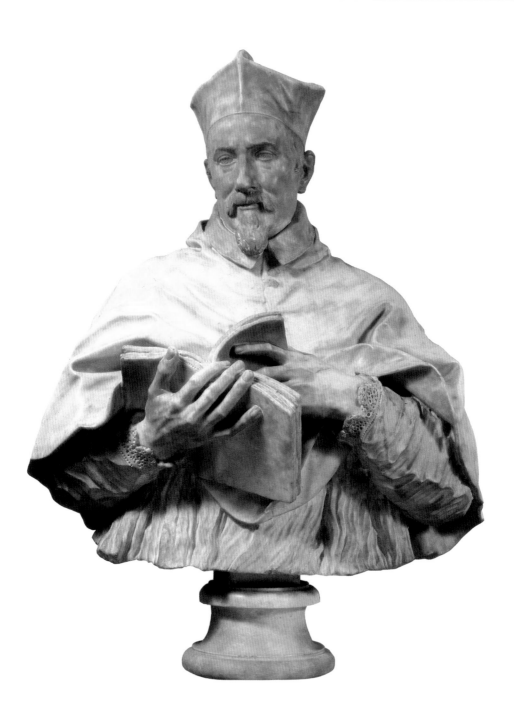

Alessandro Algardi. b Bologna, 1595. **d** Rome, 1654. **Bust of Cardinal Paolo Emilio Zacchia.** c1625/30. Marble. **h**121 cm. **h**47⅔ in. Museo Nazionale del Bargello, Florence

Allston Washington

Landscape with a Lake

A path with a figure by a lake leads the viewer into a stark landscape that has a haunting sense of emptiness. The plants in the foreground, the trees and gnarled trunks are all carefully rendered in great detail. Allston was the greatest of North America's Romantic painters. His landscapes glorify the natural wonders of the New World.

As a young man he studied in London (where he was a pupil of his compatriot Benjamin West) and Rome. His early landscape paintings were directly inspired by the French artist Claude, who was much admired in England at the time. However, he soon developed a more sublime, melodramatic conception of the landscape in the manner of J M W Turner and John Martin. Allston's portraits and canvases on scriptural themes won him great acclaim, while the poetry he wrote was somewhat less enthusiastically received.

☞ Bierstadt, Claude, Cozens, Hodler, Martin, West, Turner

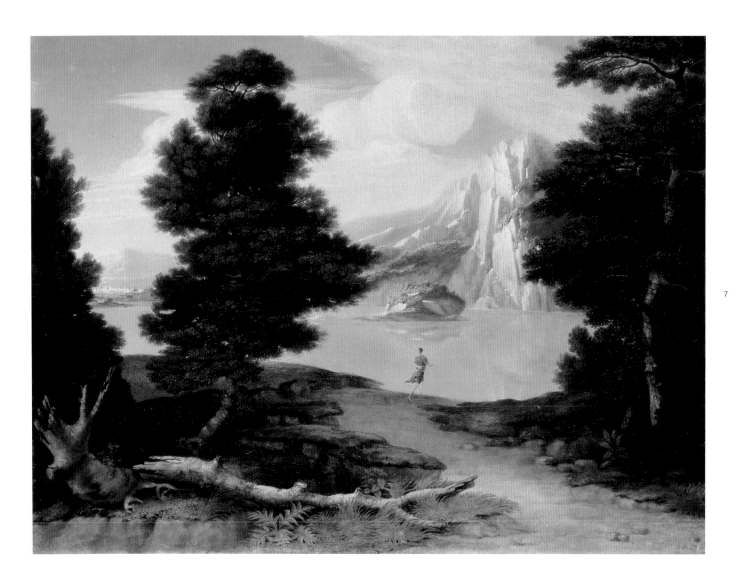

Washington Allston. b Charleston, SC, 1779. d Cambridge, MA, 1843. Landscape with a Lake. 1804. Oil on canvas. h96.5 × w130.2 cm. h38 × w51¼ in. Museum of Fine Arts, Boston, MA

Alma-Tadema Sir Lawrence A Coign of Vantage

Three Roman women watch the return of galleys from a corner, or 'coign'. This charming work conveys a sense both of height and of warm sunlight. The fabric of the women's clothes, the marble ledge and the bronze beast are all rendered in great detail. In the handling of the women and the sea far below, the artist shows his great skill with complicated perspective. A Dutch painter who moved to England in 1870, Alma-Tadema had a successful career and was lavished with personal and professional honours in his lifetime. His Neo-Classical portrayals of ancient Roman, Greek and Egyptian life were highly popular with Victorian society. They also showed the artist's knowledge of archaeology and social history. On several occasions Alma-Tadema was commissioned for theatre designs, in particular Sir Henry Irving's 1901 production of *Coriolanus* at the Lyceum Theatre in London.

☞ Carpaccio, Leighton, Poussin, Waterhouse

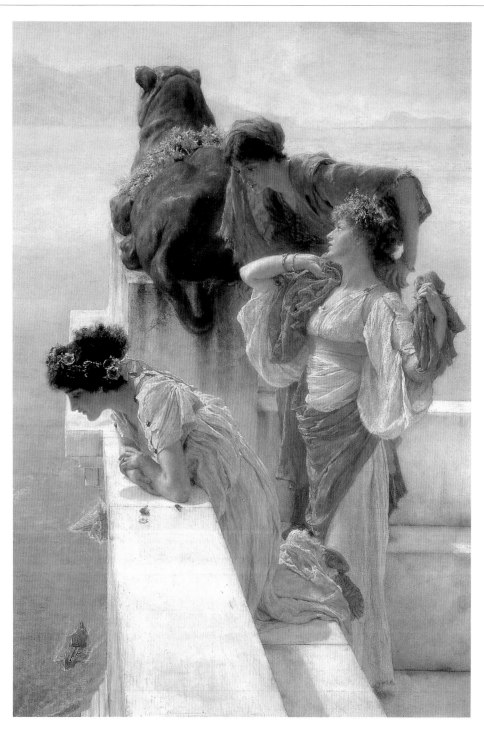

8

Sir Lawrence Alma-Tadema. b Drontyp, 1836. d Wiesbaden, 1912. **A Coign of Vantage**. 1895. Oil on canvas. **h**64.2 × **w**45 cm. **h**25¼ × **w**17¾ in. Private collection

Altdorfer Albrecht

Battle of Alexander at Issus

A sweeping Alpine landscape dominates a battle scene. The grand view emphasizes the importance of the battle that has just occurred, without focusing on it directly. Altdorfer was one of the first artists to focus on the landscape, making it the most important element in the picture. A large panel dangles high above Alexander the Great in his horse-drawn chariot to the centre-left of the composition. It tells the viewer that Alexander has gained a victory over Darius. The battle itself is shown in vivid detail, of which Altdorfer was a master. He was a prominent citizen and popular architect in his home town of Regensburg. Altdorfer is known to have taken a tour of the Danube and the Austrian Alps in 1511, and the scenery he encountered there no doubt confirmed his inclination towards the landscape. He produced a large number of drawings and engravings, many of them depicting pure landscape, without a story.

☛ Dossi, Dürer, Leonardo, Patenier, Uccello

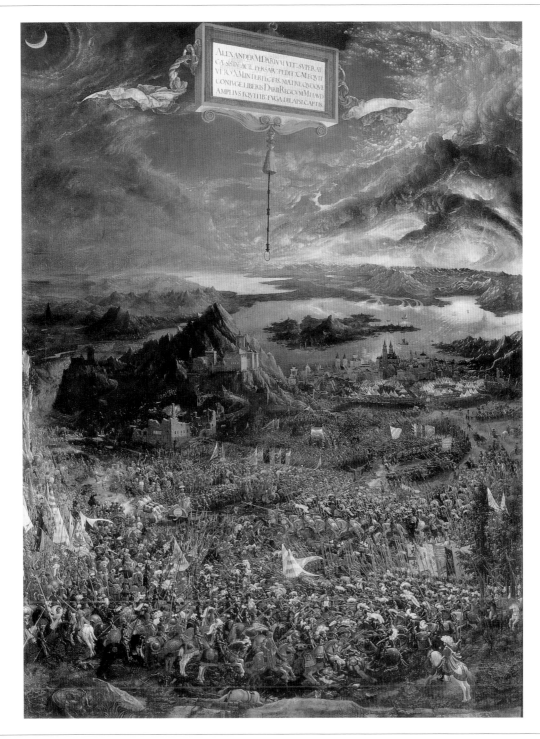

Albrecht Altdorfer. b Regensburg, c1480. d Regensburg, 1538. Battle of Alexander at Issus. 1529. Oil on panel. h132.7 × w120 cm. h52¼ × w47¼ in. Alte Pinakothek, Munich

Amigoni Jacopo

Juno Receives the Head of Argus

Juno, the wife of Zeus, asked the hundred-eyed giant Argus to watch over Io, whom she rightly suspected of being her husband's lover. Argus was murdered at Zeus' command by Mercury. Juno set the giant's eyes into the tail of her peacock in his memory. The picture here shows Juno receiving the head of Argus. The soft,

sensual style, light colours and graceful lines of the painting are typically Rococo. Amigoni was a fashionable and successful painter of portraits and of historical scenes. Like many Rococo artists, he worked all over Europe, particularly in England. It was probably he who, upon returning to Venice after a highly profitable trip to

London, persuaded Canaletto to travel to England in 1746. In England he painted decorations for Covent Garden and Moor Park. Thereafter he lived comfortably by painting elegant portraits of the royal family and of nobility.

☛ Boucher, Fragonard, Gentileschi, Luini, Tiepolo

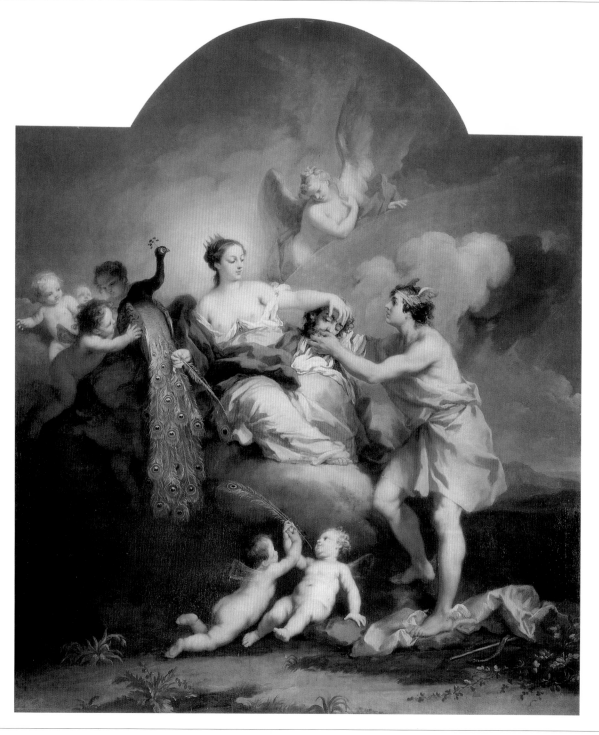

10

Jacopo Amigoni. b Venice, c1685. **d** Madrid, 1752. **Juno Receives the Head of Argus**. c1730. Oil on canvas. **h**396.2 × **w**304.8 cm. **h**156 × **w**120 in. Moor Park, Rickmansworth

Andre Carl

Zinc Magnesium Plain

Thirty-six industrially produced square plates of pure magnesium and zinc have been alternately placed flat on the floor. Contrary to the traditional concept of sculpture, these separate parts are not bound together in any way; each can be picked up and interchanged with another. Nor are they built up to create a vertical structure; they

simply sit on the ground. They do not stand upright in space like traditional sculpture; they are not crying out to be seen, but merge with the floor to be trodden on and walked over. Originally influenced by the work of Frank Stella and Constantin Brancusi, from 1960 to 1964 Andre worked on the Pennsylvania Railway which involved

using standardized, interchangeable units. From the mid-1960s he assembled groups of bricks, styrofoam planks and cement blocks, extending them horizontally on the floor. The configurations of these identical shapes are determined by simple mathematical principles.

☛ Albers, Brancusi, Judd, LeWitt, Long, Serra, Stella

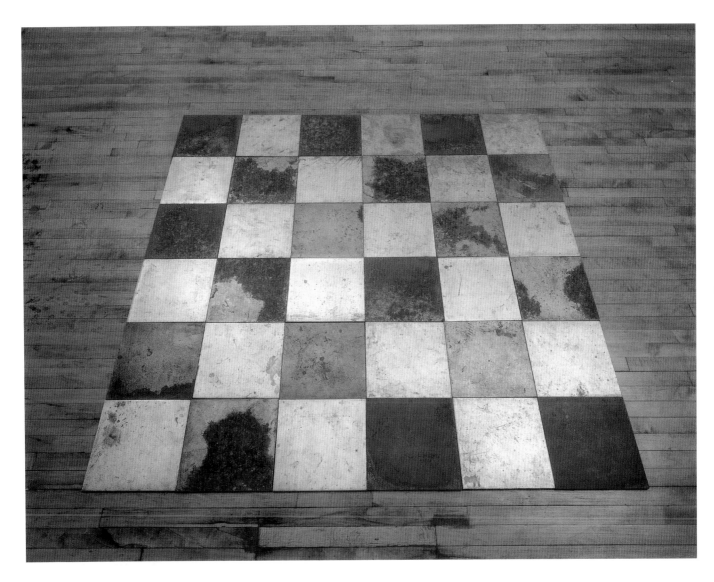

Carl Andre. b Quincy, MA, 1935. **Zinc Magnesium Plain**. 1969. Zinc and magnesium. **h**182.9 × **w**182.9 cm. **h**72 × **w**72 in. Baltimore Museum of Art, Baltimore, MD

Andrea del Sarto Assumption of the Virgin

Heaven and earth divide this picture into two parts. Above, the Virgin Mary ascends into heaven, helped by a group of angels. Below, the Apostles marvel at the event, as St Thomas peers into Mary's grave to check that her body is no longer there. Saints Nicholas and Margaret, patrons of the donor and of the town for which the altarpiece was made, kneel in front of the scene. The painting is typical of the High Renaissance in its rigid composition. Florentine artists were generally superb draughtsmen, and Andrea del Sarto was no exception. To create an altarpiece like this, he would probably have made many studies of each figure. Known in his time as 'the perfect painter', Andrea del Sarto studied under Piero di Cosimo and produced many important frescos. He has been described as a cold, unimaginative painter, but few sixteenth-century artists achieved his harmonious use of colour or his technical skill.

☛ Fra Bartolommeo, Murillo, Perugino, Piero di Cosimo, Pontormo

12

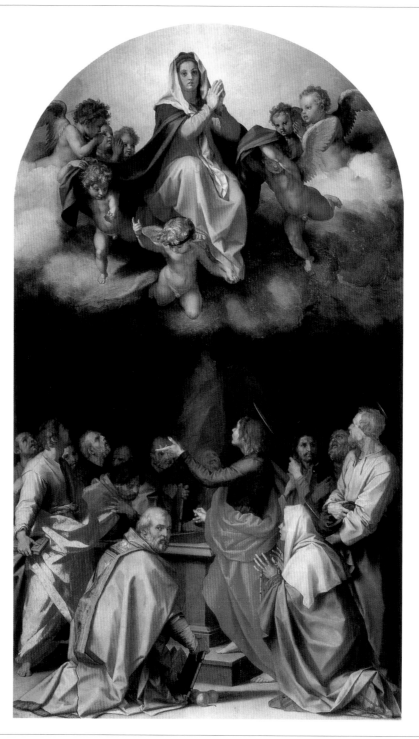

Andrea del Sarto. **b** Florence, 1486. **d** Florence, 1530. **Assumption of the Virgin**. c1526. Oil on panel. **h**379 × **w**222 cm. **h**149 × **w**87½ in. Palazzo Pitti, Florence

Fra Angelico The Annunciation

The Archangel Gabriel tells the Virgin Mary that she is to give birth to the Son of God. Calmness, order and simplicity are the outstanding features of this painting. Mary kneels and bows her head as she humbly accepts Gabriel's message. The fresco is painted on a cell wall in the monastery of San Marco where Angelico was a friar. (He became a Dominican monk in 1407.) On the left, St Peter the Martyr prays as he watches the scene; he is included in the picture to encourage the viewer to contemplate the Annunciation as he is doing. Fra Angelico's powerful and simplified forms and his sensitive treatment of light and colour are indicative of the recent developments in Florentine art. A celebrated religious painter in his lifetime, he earned the nickname Angelico ('Angelic') from his visionary, harmonious paintings on many Christian themes. He worked on projects throughout Italy, and died while painting a private chapel at the Vatican.

☞ Martini, Piero della Francesca, Tintoretto

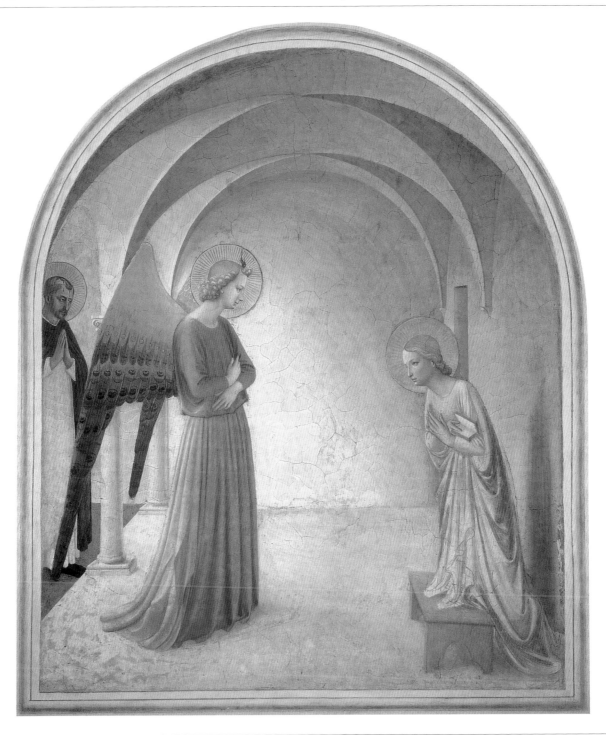

Fra Angelico (Guido di Pietro). b Vicchio di Mugello, c1387. **d** Rome, 1455. **The Annunciation**. c1441–3. Fresco. **h**187 × **w**157 cm. **h**73⅔ × **w**61⅛ in. Museo di San Marco, Florence

Anguissola Sofonisba Self-portrait

The artist has portrayed herself as an honest and devout woman: she looks at us with a frank gaze as she fingers the cross around her neck. Anguissola was a leading portraitist in Genoa and Palermo – an extraordinary feat for a woman in the sixteenth century. Of noble birth, Anguissola began a three-year apprenticeship when she was quite young. The Duke of Alba in Spain drew her to the attention of the Spanish Court, and she went on to become Court painter and lady-in-waiting to the Spanish Queen. A letter from the Queen of Spain said of Anguissola that she was 'an excellent painter of portraits, above all the painters of this time'. Anguissola painted numerous self-portraits and portraits of her family. All of these have a special tenderness, as well as a direct approach. Towards the end of her life the young Anthony van Dyck became her friend, and painted her likeness as an old woman.

☞ Van Dyck, Ramsay, Sittow, Verrocchio, Vigée-Lebrun

Sofonisba Anguissola. **b** Cremona, c1532. **d** Palermo, 1625. **Self-portrait**. c1600. Oil on canvas. **h**22 × **w**17 cm. **h**8⅔ × **w**6⅔ in. Private collection

Antonello da Messina Saint Jerome in his Study

Stealing a look through the open window of St Jerome's study, the viewer sees the saint absorbed in his reading. Only the lion on the right pauses in his tracks to acknowledge the outside world. It is possible that Antonello was influenced by aspects of Netherlandish painting; details such as the objects on the shelves, the tiled floor, the birds perched on the windowsill and the quality of the light are reminiscent of the intense realism of paintings by Robert Campin and Jan van Eyck. There is no proof that Antonello ever left Italy, but he seems to have been familiar with the techniques of the Netherlandish masters. Several authorities believe he was taught oil painting techniques by the master Van Eyck himself, and then brought the 'secret' method to Italy. More likely, Antonello was influenced by Flemish artists in Milan. In 1475–6 he was in Venice, where his innovative technique greatly influenced Giovanni Bellini and other contemporaries.

☛ Giovanni Bellini, Campin, Van Eyck, Patenier, Reni

Antonello da Messina. Active 1456. **d** Messina, 1479. **Saint Jerome in his Study**. c1475–6. Oil on panel. **h**46 × **w**36.5 cm. **h**18 × **w**14¼ in. National Gallery, London

Appel Karel

Phantom with Mask

The central figure fixes his eyes and teeth on the viewer with a demonic expression. The paint is applied with characteristic force in thick, sweeping strokes, creating a harsh and brutal image – but there is also humour, and a childlike quality. Appel finds the very act of applying paint a liberating, almost sensual experience. He delights in combining raw energy, expressed through slashes of wild colour, with savage, challenging subjects. The painting is a representative example of the work of the Cobra movement, which was formed in 1948 by a group of artists from Copenhagen, Brussels and Amsterdam. Cobra rejected the abstraction of post-war European painting, considering it lifeless and too passive. Instead, it turned to children's paintings and mythological tales for its inspiration. Appel now lives in New York, where he continues to paint exuberant, representative images in dazzlingly lurid colours.

☛ Baselitz, Dubuffet, De Kooning, Pollock

16

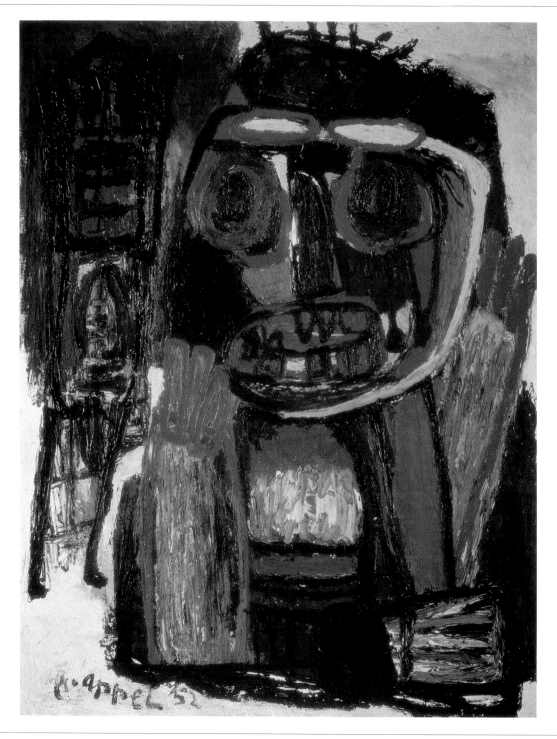

Karel Appel. b Amsterdam, 1921. **Phantom with Mask**. 1952. Oil on canvas. **h**116 × **w**89 cm. **h**45¾ × **w**35 in. Private collection

Archipenko Alexander Walking

At first glance this sculpture seems to be abstract. Looking closer, it is possible to see a walking woman, who has been made out of bronze with a green surface. Archipenko created the figure by using gaps and by hollowing out sections. Her head, for example, is made from the space created by the bronze around it. This is possibly the first work in the history of Western sculpture to introduce such concepts of construction, representing a radical departure from the Classical tradition. Archipenko was associated with the Cubist movement, which challenged and redefined the traditional approach to portraying the human form. His use of holes and spaces to create a new way of looking at the human figure paralleled the Cubists' method of fragmenting the subject and portraying a number of views of the same object simultaneously. Archipenko subsequently developed his sculptural techniques still further by mixing together different materials.

☛ Braque, Gaudier-Brzeska, Giacometti, Lipchitz, Picasso

Alexander Archipenko. b Kiev, 1887. **d** New York, NY, 1964. **Walking**. 1912. Bronze. **h**67.3 cm. **h**26½ in. Private collection

Arcimboldo Giuseppe · Summer

Up close, this painting looks like a greengrocer's dream. Moving away from the picture, a human head emerges. It has been made entirely of the fruits and vegetables of summer – pears, peaches, cherries and plums can all be found. While he often used fruits and vegetables to create his portraits, Arcimboldo was also known to use pots, pans and even workmen's tools to create his weird images. His most important works were painted in Prague, where he was employed by a series of Hapsburg emperors. Arcimboldo had other courtly duties besides painting, such as designing decorations for festivities, purchasing works of art for the Emperor's collection and, strangely enough, designing and constructing waterworks. Arcimboldo's paintings were looked upon as slightly silly, although they were imitated often enough. It was not until the Surrealists recognized a fellow artist who loved visual puns that he became popular.

☞ Dalí, De Heem, Koons, Magritte

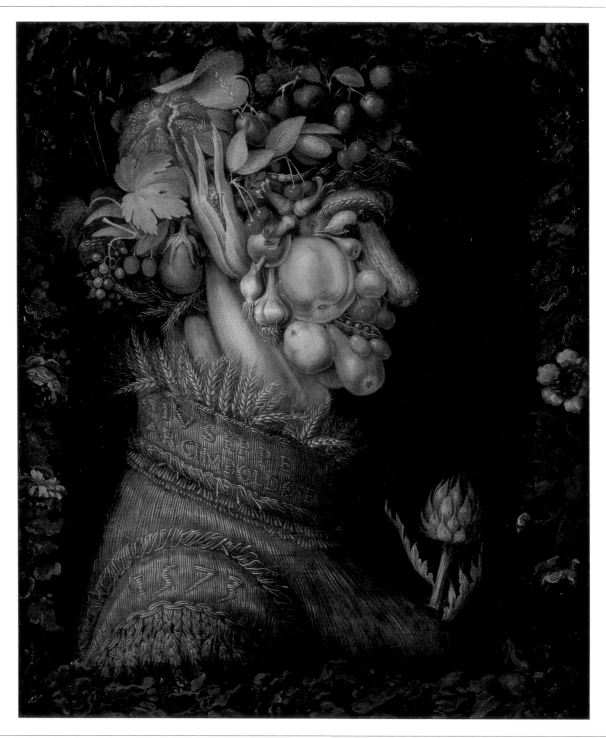

Giuseppe Arcimboldo. b Milan, 1527. **d** Milan, 1593. **Summer**. 1573. Oil on canvas. **h**76 × **w**63.5 cm. **h**30 × **w**25 in. Musée du Louvre, Paris

Arp Jean

Leaves and Navels, I

Small circular forms punctuate the stillness of this work, the shadows of their shapes in relief distinguishing them from the white painted wood background. They are arranged in a harmonious pattern with no logical order, evoking the fluttering of leaves in the wind or the natural randomness of drops of rain falling on glass. Arp's work is characterized by its use of sensuous sculptural shapes recalling organic forms, which are highly poetic and suggestive in their delicacy. He was intimately involved with several of the major art movements of the first half of the twentieth century, particularly the Dada movement. The Zurich Dadaists were formed in 1916 and Arp participated in many of their riotous and infamous 'happenings' at the Cabaret Voltaire. In his quest for a spontaneous, elementary art he wrote poetry, created collages, made wood reliefs (such as the one shown here) and experimented with automatic writing.

☛ Cornell, Hepworth, Mondrian, Schwitters

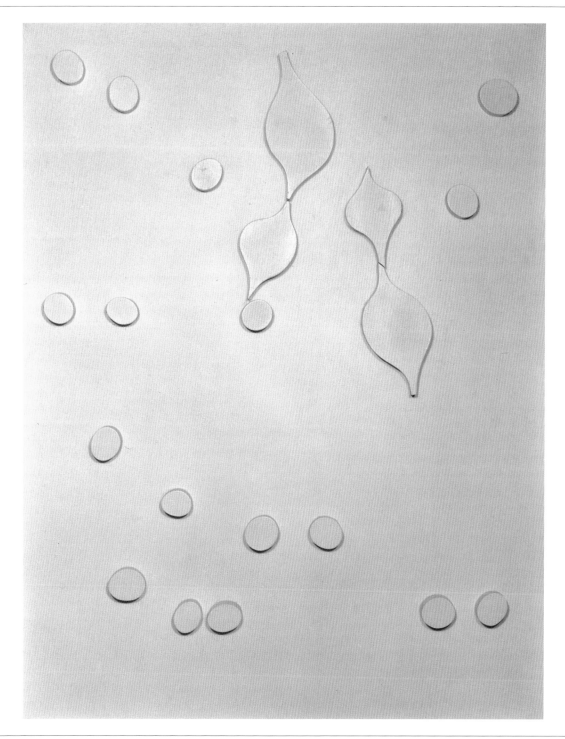

Jean Arp. b Strasbourg, 1886. **d** Basel, 1966. **Leaves and Navels, I**. 1930. Painted wood. **h**101 × **w**81 cm. **h**39¾ × **w**31¾ in. Museum of Modern Art, New York, NY

Audubon John James Roseate Spoonbill

From its odd, spoon-shaped bill to each fantastic pink feather, this bird has been depicted with immense care. Audubon's desire to classify the birds he observed in North America, coupled with careful scientific research, resulted in the splendidly illustrated book *The Birds of America* which included 435 plates. Audubon trained to be a painter alongside the famous French Neo-Classicist Jacques-Louis David. He coupled his skills as a painter with a passion for ornithology to create a practical use for his training. Even though the book on birds concentrated on North America, Audubon had to travel to Britain to find funding for his work. Ultimately it was published in America and Britain, and remains both a beautiful work of art and an important scientific document. He spent the last seven years of his life compiling a companion volume, *The Quadrupeds of America*, which also combines exquisite illustrative skills with naturalistic knowledge.

☛ Agasse, Catlin, J-L David, Stubbs

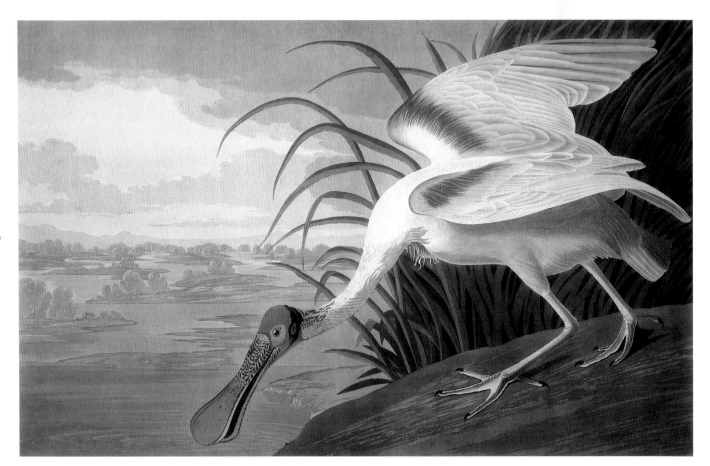

John James Audubon. **b** Les Cayes, Haiti, 1785. **d** New York, NY, 1851. **Roseate Spoonbill**. 1835–8. Engraving on paper. **h**64.7 × **w**95.2 cm. **h**25½ × **w**37½ in. From *The Birds of America*, 1835–8, Vol. 4

Auerbach Frank

J Y M Seated in the Studio VI

The surface of this picture, which is a portrait of one of the artist's regular sitters, looks like wet newspapers compressed into ridges and gullies. Auerbach is well known for his technique. Brushfuls of paint are dragged in violent swirls across the picture surface, creating arms and eyes, legs and cheeks. These are not restful, comfortable works to look at; instead they invite the viewer into a world of squashy movement, as thick and sensuous as peanut butter. Auerbach is a member of the School of London, but uses paint in a different way to the others in this loose grouping of artists. He adds thick layers and then scrapes them back, creating the subject through his manipulation of the paint and the surface. Auerbach is known to work with great discipline, regularly from morning till night, every day. His studio has remained unchanged since 1954, when he inherited it from his friend Leon Kossoff.

☛ Bacon, Kitaj, De Kooning, Kossoff, Sutherland

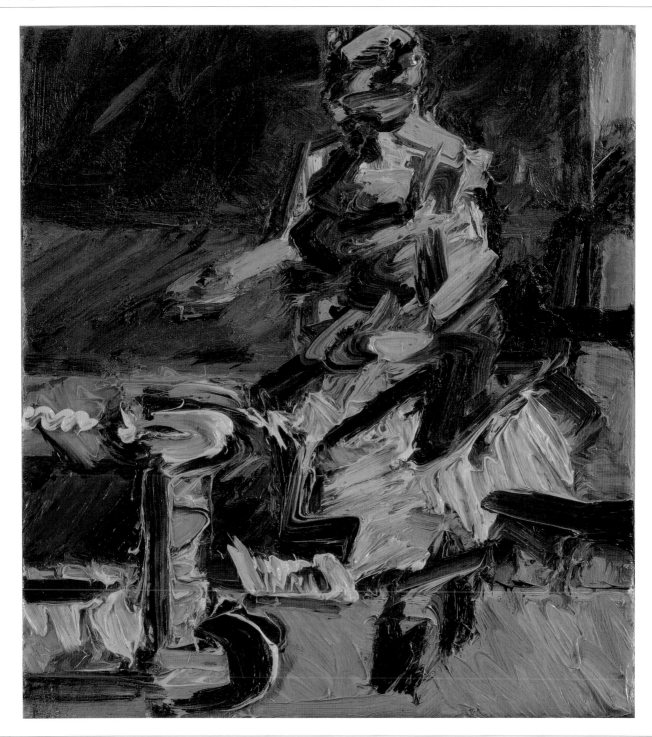

Frank Auerbach. b Berlin, 1931. **J Y M Seated in the Studio VI**. 1988. Oil on canvas. **h**55.9 × **w**50.8 cm. **h**22 × **w**20 in. Private collection

Avercamp Hendrick A Scene on the Ice Near a Town

An entire town full of people seems to be enjoying itself on a frozen lake. The picture wonderfully evokes the chilly skies of a northern winter. The attention to detail in many of the figures, such as the woman with her red sash at the lower left, brings the scene to life, giving it a joyful feeling. (It is said that Avercamp was deaf, hence his acute visual sense and the almost anecdotal quality of his minutely detailed paintings.) Seventeenth-century Holland witnessed a rise in the middle classes and a decline in church patronage because of Protestant reform. This led to painters specializing in small-scale easel paintings for the new market of private collectors. Avercamp was well known for his wintery scenes, which are similar in style to those of Jan Bruegel, and his careful observation of lighting effects made his paintings highly prized. He was also one of the originators of realist landscape painting in seventeenth-century Holland.

☛ J Bruegel, Cuyp, Van Goyen, Lowry, Raeburn, Ruisdael

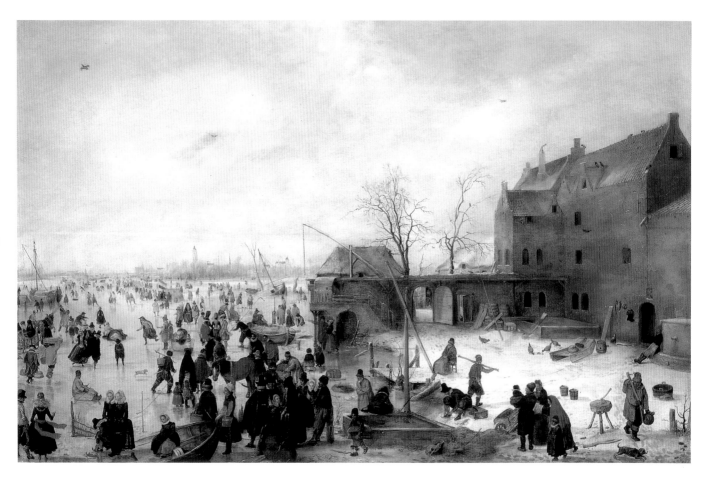

Hendrick Avercamp. **b** Amsterdam, 1585. **d** Amsterdam, 1634. **A Scene on the Ice Near a Town**. c1615. Oil on panel. **h**58 × **w**90 cm. **h**22¾ × **w**35½ in. National Gallery, London

Bacon Francis

Study after Velázquez's Portrait of Pope Innocent X

This terrifying image, based on Diego Velázquez's famous portrait, depicts the tortured expression of a blood-spattered Pope, imprisoned in a tubular construction resembling an unpadded throne. The background, painted in dramatic vertical strokes, cruelly blurs out the screaming figure as he sits helplessly with clenched fists. While Bacon's sources and subject matter were often based on real or traditional images – Old Master paintings, newspaper photographs, film stills or X-rays, for instance – his treatment of them is shockingly perverse. As in this painting, he highlighted the distasteful, and sometimes the disgusting, depths of the human psyche with nightmarish intensity. Although his early works have been likened to those of the artist Graham Sutherland, Bacon progressed to develop his own particular idiom, remaining best known for his often horrific distortions of the human form.

☞ Bosch, Manzù, Soutine, Sutherland, Velázquez

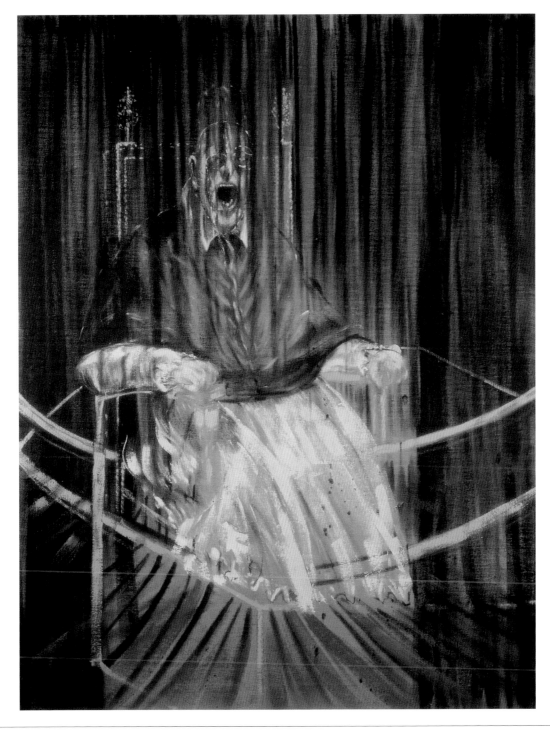

Francis Bacon. b Dublin, 1909. **d** Madrid, 1992. **Study after Velázquez's Portrait of Pope Innocent X**. 1953. Oil on canvas. **h**153 × **w**118 cm. **h**60¼ × **w**46½ in. Des Moines Art Center, Des Moines, IA

Baldung Hans

The Three Ages of Man and Death

These four figures are an allegory of the three ages of man. Death is portrayed as a skeleton holding an hourglass. Around him are a sleeping baby (infancy), a youthful maiden (youth) and a haggard old woman (old age). Baldung was a productive draughtsman, and the realism of the bodies in this picture shows that he studied the nude figure closely. Like his teacher Albrecht Dürer, Baldung was both a painter and a printmaker. He created many fanciful engravings, and also designed stained glass and illustrated books. Like Hieronymus Bosch, Baldung was one of a group of artists that expressed the terror and suffering of their times through the use of fantasy.

One of Baldung's most important commissions was for the panels over the altar at Freiburg Cathedral, which he made in 1516. He died in Strasbourg, a wealthy and influential member of the community.

☛ Bosch, Cranach, Dürer, Ribera

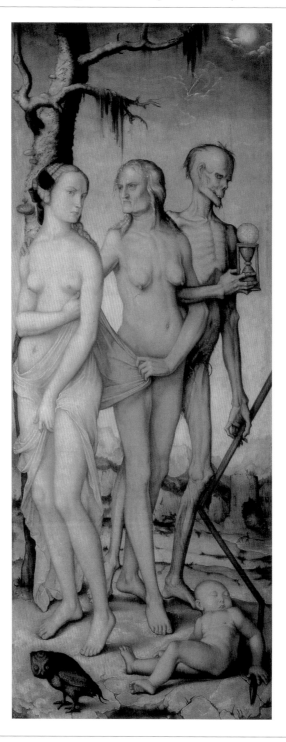

24

Hans Baldung. b Schwäbisch-Gmünd, c1484. **d** Strasbourg, 1545. **The Three Ages of Man and Death**. 1539. Oil on panel. **h**151 × **w**61 cm. **h**59½ × **w**24 in. Museo del Prado, Madrid

Balla Giacomo

Flight of the Swallows

A flock of swallows swirl and dive outside the artist's window. Balla has recreated their speed and movement by placing them in precise sequence, one after another. He appears to have included the rigidity of the shutters to contrast their motionlessness with the birds' continuous movement. Balla painted a series of swallow paintings during a visit to Düsseldorf from 1912 to 1913. The picture is a good example of the work of the Italian Futurists, who were primarily concerned with depicting motion as a symbol for the dynamism of the modern world. Balla publicly declared his affiliation to the Futurist movement in March 1910. With Gino Severini, Umberto Boccioni and Carlo Carrà he developed the notion of depicting movement by presenting the same form over and over again, like the stills from a video tape. From 1931 Balla moved away from this style of painting, and developed a more figurative approach.

☞ Boccioni, Braque, Carrà, Catlin, Feininger, Gris, Severini

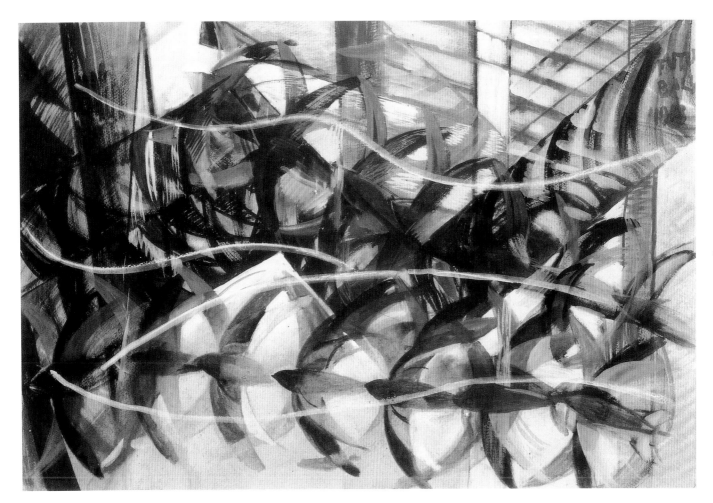

Giacomo Balla. b Turin, 1871. **d** Rome, 1958. **Flight of the Swallows**. 1913. Tempera on paper. **h**50.8 × **w**76.2 cm. **h**20 × **w**30 in. Museum of Modern Art, New York, NY

Balthus

Girl and Cat

A simple scene presents itself: an adolescent girl sits in a stark and gloomy interior, a contented cat at her feet. Yet the image is somehow disturbing, perhaps because of its erotic overtones: are we looking at an innocent girl, or a sexually sophisticated young woman? In fact, what Balthus has captured is the disturbing quality of adolescence, when the innocence of childhood, portrayed by the cat, is pushed aside by the new, sexual feelings of adulthood. This is emphasized by the fact that the only light in the picture is directed at the girl's thighs. Although Balthus received no formal art training, he studied the Old Masters extensively and was encouraged by such artists as Pierre Bonnard and André Derain. He is known particularly for erotically charged paintings such as this, featuring young girls sleeping, daydreaming or reading within a darkened interior.

☛ Bonnard, Derain, Foujita, Rego, Schiele, Sherman

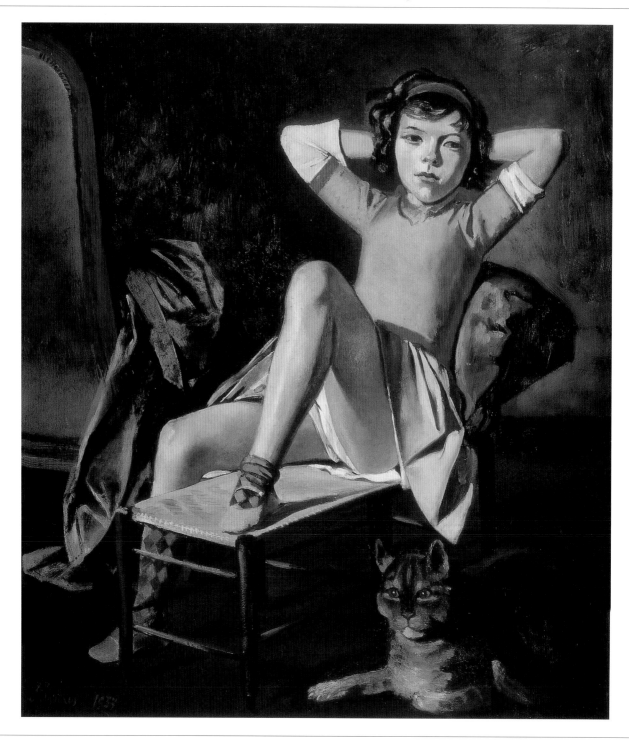

26

Balthus (Balthazar Klossowski de Rola). b Paris, 1912. d La Rossinière, 2001. **Girl and Cat**. 1937. Oil on panel. **h**88 × **w**78 cm. **h**34½ × **w**30¾ in. Private collection

Fra Bartolommeo Resurrected Christ with Saints

The billowing drapery, the raised arm of Christ, the pointing arms and turned heads contribute to the overwhelming sense of movement in this painting. The powerful figure of Christ dominates the composition, inspiring worship and contemplation in the viewer. Fra Bartolommeo studied painting in Florence. Here he was profoundly influenced by the preaching of the charismatic and controversial Dominican priest Savonarola – so much so that he entered the Dominican Order when Savonarola was burnt at the stake in 1498. At this point he took the name Fra Bartolommeo – before this he was known as Fra Baccio della Porta – and allegedly destroyed all his paintings and drawings of the nude figure, considering them sinful. A friend of Michelangelo and Raphael, Fra Bartolommeo studied the works of Leonardo da Vinci and created brilliantly vivid paintings on religious subjects.

☛ Carracci, Leonardo, Michelangelo, Raphael

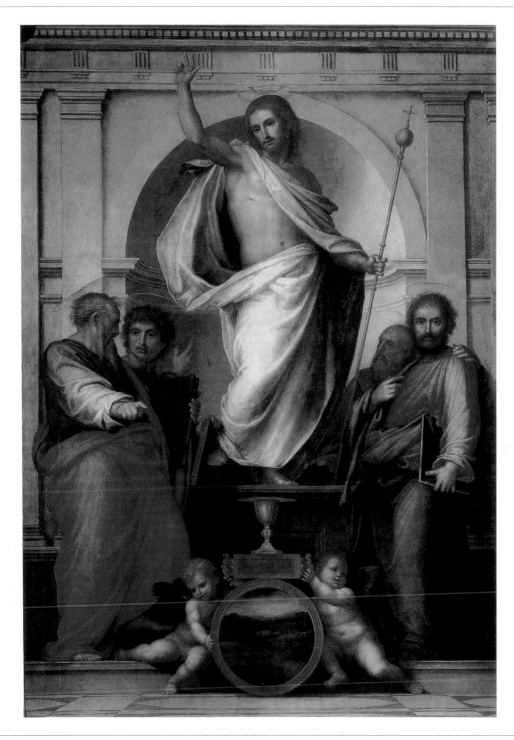

Fra Bartolommeo (Baccio della Porta). b Florence, c1474. **d** Florence, c1517. **Resurrected Christ with Saints**. 1516. Oil on canvas. **h**284 × **w**204 cm. **h**111¾ × **w**80¼ in. Palazzo Pitti, Florence

Baselitz Georg More Blondes

Harsh finger and brush strokes have been used to depict this upside-down female nude, imprisoned by a heavy black border. The strong impact of the thick black paint was achieved by the artist actually walking on the canvas. Baselitz has portrayed the woman crudely, without compassion or subtlety. Muted in colour, her image is stark and simple, with no distracting detail. This avant-garde artist likes to paint theatrical sets with a shouting or gesticulating figure which is repeated from canvas to canvas. He paints violent and distinctive images with topsy-turvy figures and colourful and liberated brushwork. He also makes sculpture by fiercely cutting away at a massive chunk of wood leaving a hacked figure, which he often daubs with red pigment. Baselitz's work is aggressive and expressive to the extent that one of his paintings was seized by the public prosecutor who claimed that it might 'arouse sexual desire among certain kinds of viewers'.

☞ Van Gogh, Fautrier, Kiefer, De Kooning, Polke

28

Georg Baselitz. b Sachsen, 1938. **More Blondes**. 1992. Oil on canvas. **h**162 × **w**130 cm. **h**63¾ × **w**51⅛ in. Anthony d'Offay Gallery, London

Basquiat Jean-Michel Untitled

Crudely drawn figures, handwritten phrases and scientific formulae are jumbled together on a multi-coloured background, forming a visual cacophony of colour and shapes. The primitive and childlike images reflect Basquiat's links with graffiti art. The painting seems to be a distillation of the New York underworld of the artist's roots, evoking its multi-ethnic, hip-hop culture and reflecting the fast-moving, chaotic reality of the city's street life through a series of disconnected images and written fragments. Basquiat was part of a loosely associated group of so-called graffiti artists, some of whom worked in New York's subways, and indeed he started his own short-lived career by daubing graffiti on public walls. His international reputation was rapidly established and rose with meteoric speed – fuelled by the art boom of the 1980s – until his death from a drugs overdose at the age of 26.

☛ Dubuffet, Gaudier-Brzeska, Rauschenberg, Twombly

Jean-Michel Basquiat. **b** New York, NY, 1960. **d** New York, NY, 1986. **Untitled**. 1984. Acrylic, silkscreen and oilstick on canvas. **h**223.5 × **w**195.6 cm. **h**88 × **w**77 in. Estate of Jean-Michel Basquiat

Bassano Jacopo

The Animals Entering the Ark

Two by two, Noah and his family usher a crowd of animals onto the Ark before the break of dawn. The boat is not an important part of the picture, as the artist shows only its side and door. Instead, he has focused on the parade of wonderful beasts. They almost spring off the canvas, so real and alive do they seem. To create this wonderful menagerie, Bassano must have studied all kinds of animals – dogs, cats and even turkeys. A prolific draughtsman, Bassano often used bright chalks to help him in designing his colourful paintings. His early works appear somewhat provincial, but over the years his style evolved into a sophisticated synthesis of the colouring of Venetian masters such as Tintoretto and Veronese, coupled with the vibrant figures of central Italian masters such as Francesco Salviati. All four of Bassano's sons followed in their father's footsteps, although only one of them, Francesco, achieved distinction as a painter.

☛ Hicks, Salviati, Savery, Tintoretto, Veronese

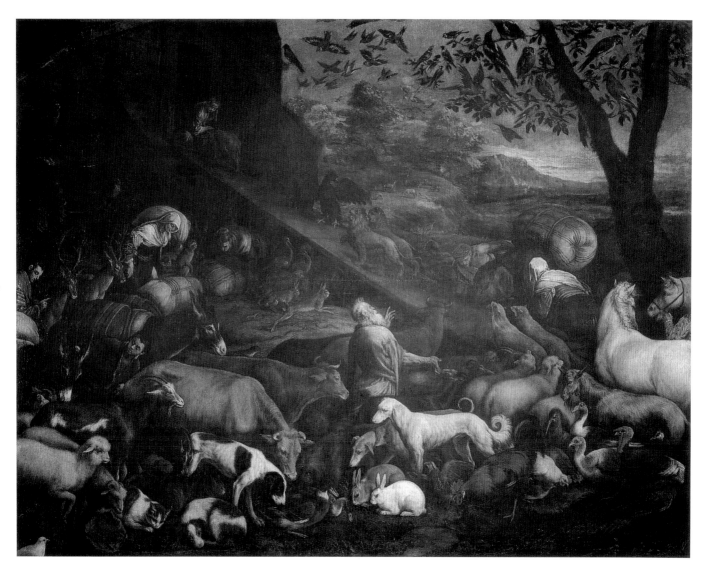

Jacopo Bassano (Jacopo da Ponte). **b** Dal Ponte, c1510. **d** Bassano, 1592. **The Animals Entering the Ark**. c1590. Oil on canvas. **h**207 × **w**265 cm. **h**81½ × **w**104⅜ in. Museo del Prado, Madrid

Batoni Pompeo

Thomas William Coke

A sumptuous silk suit, trimmed with lace and bows and topped by a fur cape, makes up the exquisite outfit worn by the man in this portrait. The statue of Venus, the colonnade and the broken pediment give the viewer clues that the setting is Rome. Thomas Coke was the quintessential eighteenth-century wealthy gentleman, who completed his education by going on the traditional Grand Tour of the European continent. Batoni himself was one of the most wealthy and successful painters of the eighteenth-century Roman school of painting, and many of his commissions were from eminent foreigners. He was best known for his smooth portraits of popes, monarchs and the British upper classes. The latter considered his portraits a 'must' to bring home as a souvenir from the Grand Tour. Batoni was curator of the Pope's collection of art, and his house became a centre of artistic, intellectual and social debate.

☛ Dobson, Hilliard, Kneller, Moroni

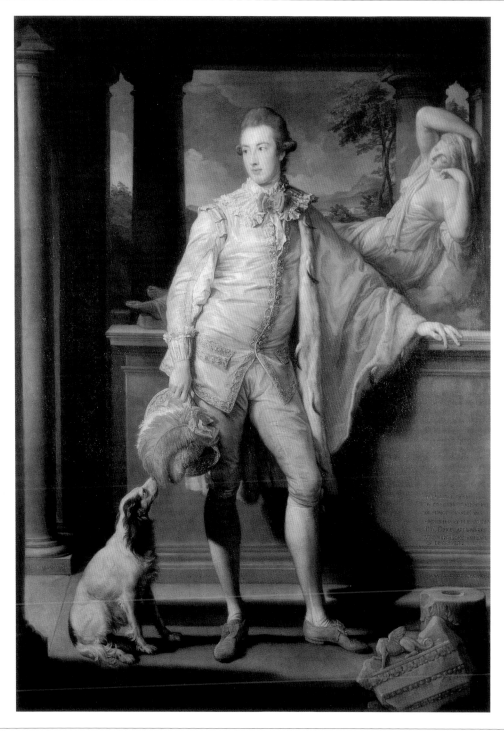

Pompeo Batoni. **b** Lucca, 1708. **d** Rome, 1787. **Thomas William Coke**. 1774. Oil on canvas. **h**245.8 × **w**170.3 cm. **h**96¾ × **w**67 in. Holkham Hall, Norfolk

Baumeister Willi Mortaruru with Red Overhead

Large egg-shaped blots of colour appear on the surface of this picture. Their relationship to each other – both formalistically and colouristically – is unclear, creating a disjointed feeling of tension and uneasiness. The small appendages are connected to the parent blocks with delicate, fragile lines that make them seem like

mathematically induced organic growths. Baumeister's early works were influenced by Fernand Léger and others, but he went on to develop a personal form of expression that has been termed 'abstract Surrealism'. He was much concerned with the philosophy of art, believing that freely imagined forms could provide images relating

to the deeper, primitive roots of humanity – ideas which he set out in his 1947 book *Das Unbekannte in der Kunst* ('The Unknown in Art'). His paintings are not entirely subjectless, but are intended as representations of 'other' realities.

☛ Arp, Dalí, Heron, Léger, Matisse, Miró

32

Willi Baumeister. b Stuttgart, 1889. **d** Stuttgart, 1955. **Mortaruru with Red Overhead**. 1953. Oil on board. **h**100 × **w**81 cm. **h**39¼ × **w**31⅞ in. Private collection

Bazille Frédéric

The Artist's Studio on the rue de la Condamine

Inside his studio, Bazille is showing one of his pictures to fellow artists Claude Monet and Édouard Manet (with the hat). To the left is Pierre Auguste Renoir (seated), deep in conversation with the writer Émile Zola (standing on stairs). It is a fascinating glimpse into the world of the artist at that time, his friends and everyday surroundings.

The picture itself also shows Bazille's bold modelling of figures, and the broad handling of colours that became his hallmark. Although he died four years before the first Impressionist exhibition, Bazille is closely linked with the movement, as he executed a radically new kind of painting that recorded his observations of everyday life.

The number of paintings that he produced is small as he was killed in battle in the war with Prussia at the age of only 29. His death occurred shortly after this painting was rejected by the French academy, known as Le Salon.

☛ Manet, Monet, Renoir, Sisley, Teniers

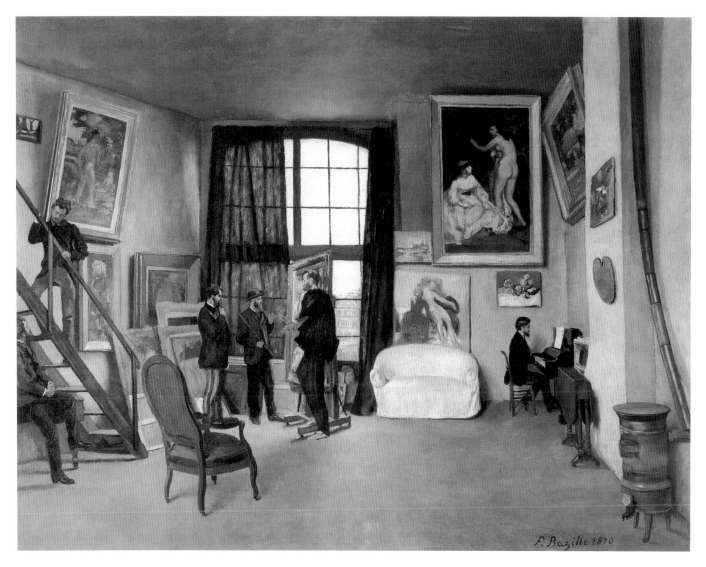

Frédéric Bazille. b Montpellier, 1841. **d** Beaune-la-Roland, 1870. **The Artist's Studio on the rue de la Condamine**. 1870. Oil on canvas. **h**97 × **w**112 cm. **h**38⅛ × **w**44⅛ in. Musée d'Orsay, Paris

Beauneveu André Saint Philip

St Philip sits on an elaborate Gothic throne. The artist has paid particular attention to his bearded face, and to the folds of his robe where it has spread out on the ground. The throne itself recedes into the background in an attempt at realistic perspective, but the saint seems to be floating awkwardly in his seat, not solidly fixed to anything or held by gravity. The picture comes from a page in a psalter or Book of Psalms that was made for Jean, Duc de Berry. The duke was a great patron of the arts, who prided himself on his large collection of manuscripts. This included the wonderful book of hours, the *Très Riches Heures du Duc de Berry*, by the Limbourg brothers. Psalters were made very small so that they could be carried about easily. At the time that Beauneveu was working on this manuscript, the illustration of religious works was experiencing a revival in Renaissance France.

☞ Antonello, Van Eyck, Fouquet, Limbourg

André Beauneveu. Active in Valenciennes, 1361. **d** Valenciennes, c1402. **Saint Philip**. c1380/5. Illumination on vellum. **h**12.7 × **w**10 cm. **h**5 × **w**4 in. Bibliothèque Nationale, Paris

Beccafumi Domenico Tanaquil, Wife of Lucomo

The contemporary appearance of the sitter's gown and hairstyle belie the fact that she is an Ancient Roman; she is pointing to a tablet which identifies her as Tanaquil, who persuaded her husband to move to Rome where he reigned as King Tarquinius Priscius from 616 to 578 BC. During the Renaissance, Tanaquil was greatly admired for her fortitude and perseverance and was thus seen as a notable historical figure. The soft colours and elongated forms show Tanaquil in an elegant and sensitive style. These elements were to become hallmarks of Mannerism. An imaginative artist and draughtsman, Beccafumi is famous for decorating the churches of Siena with many paintings and frescos. He was able to combine the ideas formalized in the work illustrated here with the bright and decorative colours typical of Sienese painting. He is particularly famous for designing an elaborate marble pavement inside Siena Cathedral, decorated with scenes from the Old and New Testaments.

☛ Cranach, Goya, Parmigianino, Pontormo, Rosso Fiorentino

Domenico Beccafumi. b Valdibiena, c1486. d Siena, 1551. **Tanaquil, Wife of Lucomo**. c1520. Oil on panel. **h**92 × **w**53 cm. **h**36¼ × **w**21 in. National Gallery, London

Beckmann Max Departure

Horror and brutality are juxtaposed in stark contrast with serenity and peace in this triptych. The left and right panels depict nightmare scenes of torture and degradation, in which men and women are subjected to terrible pain, while the centre panel portrays spiritual figures in the blue of an apparently infinite sea. The work is considered to be the most powerful in a series of nine triptychs Beckmann painted. It mirrors the political turbulence of Germany during the early 1930s, when the rise of Nazism and the consequent constricting atmosphere put the future of art into question. Although the painting evokes with powerful force the artist's own feelings, and could therefore be considered as an example of Expressionism, Beckmann did not ally himself to any particular movement. In 1938 political persecution drove him to Amsterdam. He spent the last three years of his life in the USA, where he helped to spread the influence of contemporary German art.

☞ Bosch, Ensor, Heckel, Kokoschka, Orozco, Siqueiros

Max Beckmann. **b** Leipzig, 1884. **d** New York, NY, 1950. **Departure**. 1932–5. Oil on canvas. **h**215.5 × **w**314 cm. **h**84⅞ × **w**123⅝ in. Museum of Modern Art, New York, NY

Bellini Gentile

The Miracle of the True Cross near the San Lorenzo Bridge

Renaissance Venetians took great pride in their city and it was common for works of art to be commissioned to depict special events. The 'miracle' shown here is used as an excuse for the artist to show off everyday life in Venice, and his skill as well. The gondoliers, monks, society ladies and gentlemen, palaces and canal are all part of the beautiful city in which Gentile lived and worked. The scene is full of delightful details: ladies' jewellery and the bricks in the chimneys are painted with equal skill and concern. In addition, Gentile has infused the scene with a soft light that picks out the figures in the crowd and illuminates the buildings. Gentile came from an important dynasty of Venetian painters, which included his father Jacopo and his younger brother Giovanni. In 1479 he travelled to Constantinople where he worked in the Court of Mohammed II and painted his portrait.

☛ Giovanni Bellini, Bellotto, Canaletto, Guardi, Hiroshige

Gentile Bellini. b Venice, c1429. **d** Venice, 1507. **The Miracle of the True Cross near the San Lorenzo Bridge**. 1500. Oil on canvas. **h**323 × **w**430 cm. **h**127¼ × **w**169¼ in. Galleria dell'Accademia, Venice

Bellini Giovanni

Young Woman at her Toilet

With its idealized face and distant landscape, this painting recalls some of Bellini's paintings of the Virgin Mary. The aim of this work, however, was certainly not to create an object of religious devotion; this nude presents us with a secular ideal of feminine beauty. Giovanni was the most famous member of the Bellini dynasty and did much to popularize the new technique of oil painting. In fact, he takes much of the credit for transforming Venice into an important centre of the Renaissance. The major influence on his early years was his brother-in-law Andrea Mantegna. However, Bellini's pictures tend to be romantic and imaginative, where Mantegna's are sharp and precise. Bellini led an active workshop, with Titian and Giorgione among his pupils. As was common at the time the master would sign the workshop paintings as his own. Today Bellini's own paintings are considered to be superior, but at the time, any workshop paintings would have been valued as the master's work.

☞ Gentile Bellini, Giorgione, Ingres, Mantegna, Titian

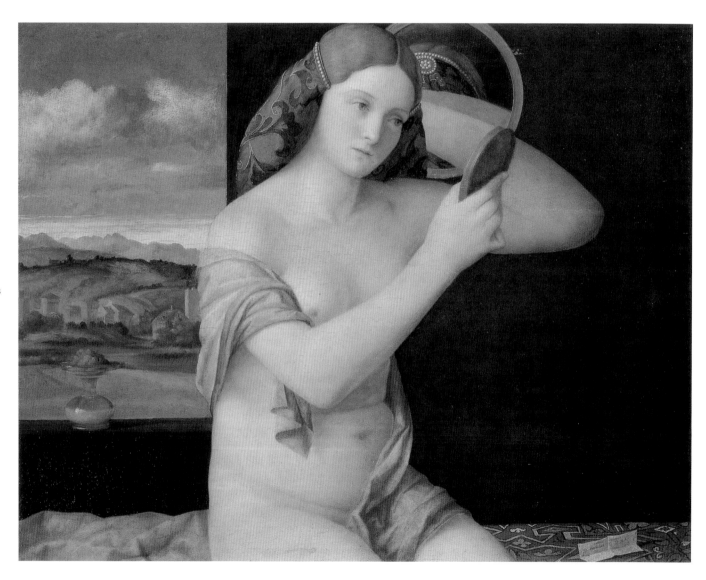

Giovanni Bellini. b Venice, c1434. **d** Venice, 1516. **Young Woman at her Toilet**. 1515. Oil on panel. **h**62 × **w**79 cm. **h**24¼ × **w**31 in. Kunsthistorisches Museum, Vienna

Bellmer Hans

The Spinning Top

A whirling skeletal female form spins on a top which she is holding in her bony hand. This peculiar image symbolizes woman turning the hearts and heads of men, as she spins in defiance of gravity. Relating to an unrealized project for a sculpture, conceived in 1936–9, it is certainly one of Bellmer's most haunting images. The painting was reworked over several years, and only signed when Bellmer had found a buyer in 1956. Polish-born, Bellmer became an active Surrealist when he moved to Paris in 1938. This painting reflects many of the movement's preoccupations – its distorted, phantasmagoric imagery appears to have emerged directly from the artist's subconscious fantasies.

Bellmer's central theme was that of the female body, often treated in an obsessively erotic manner. He is known particularly for his disturbingly fetishistic 'Dolls', a series of articulated female mannequins, and for his drawings and lithographs, executed with superb technical precision.

☛ Brauner, Dalí, Delvaux, Ernst, Matta, Tanguy

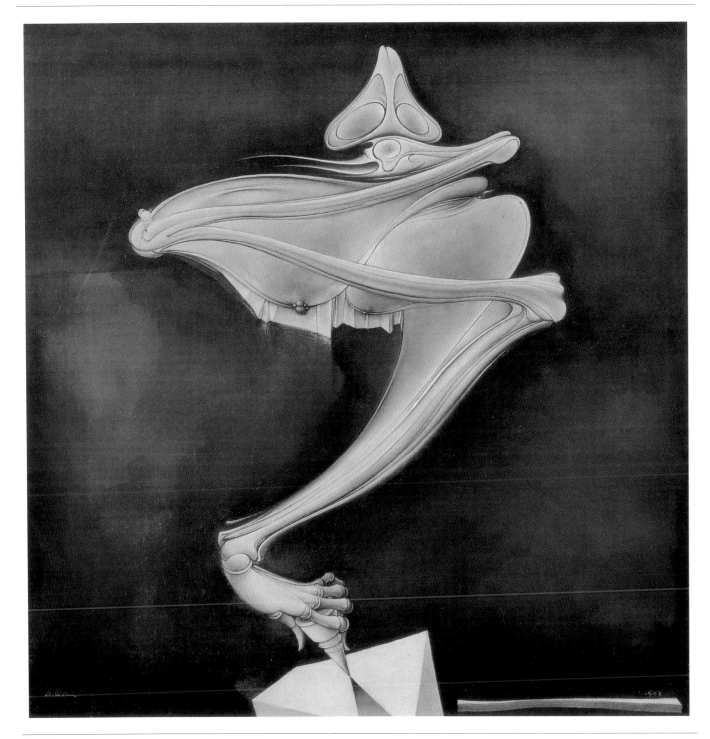

Hans Bellmer. b Katowice, 1902. d Paris, 1975. **The Spinning Top**. c1937–56. Oil on canvas. **h**65 × **w**65 cm. **h**25⅝ × **w**25⅝ in. Tate Gallery, London

Bellotto Bernardo

View of the Ponte delle Navi, Verona

With splendid visual accuracy the artist has evoked the crusty plaster and brickwork of buildings, and the bright play of sunlight on the city skyline. Bellotto was the nephew and pupil of Canaletto, and for a time worked with the master as an assistant in Venice. Bellotto's style is very much like his uncle's – in fact he sometimes signed himself Canaletto, which caused much confusion. However, Bellotto's works are cooler and crisper, and he was more interested in clouds, shadows and foliage. Bellotto's paintings also include more figure groups than Canaletto's – as can be seen in this picture, with its strolling couples, running children, and so on. In 1746 Bellotto left Venice and visited other Italian cities. He then travelled to Munich, Dresden and, finally, Warsaw. Bellotto's views of the Polish capital were considered of such accuracy that they were used in its reconstruction after the Second World War.

☛ Gentile Bellini, Bonington, Canaletto, Guardi, Pannini

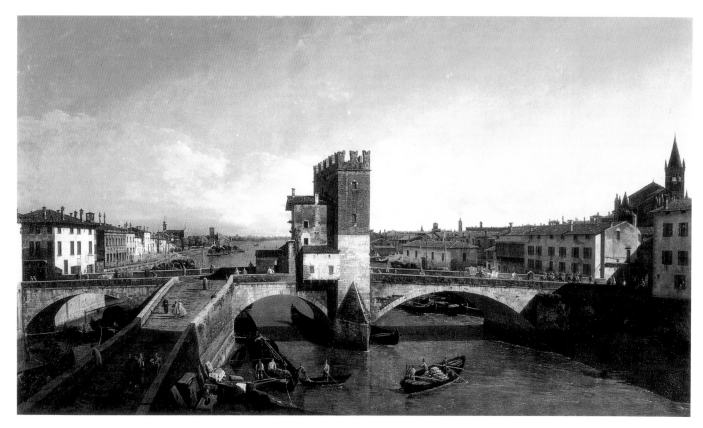

Bernardo Bellotto. b Venice, 1721. **d** Warsaw, 1780. **View of the Ponte delle Navi, Verona**. c1745. Oil on canvas. **h**132 × **w**233.7 cm. **h**51 × **w**92 in. Private collection. On loan to the National Gallery of Scotland, Edinburgh

Bellows George Forty-two Kids

On the right of the pier a child is frozen in a half-completed dive. The children have been caught as if in a photograph, at the split-second of action. The artist has used rapid brushstrokes to simplify the bodies in order to give the impression of a fleeting moment. Bellows turned his back on the formality of the artists who came before him, with their posed portraits and idyllic landscapes. Instead, he aimed to capture real life as he saw it. He was influenced and inspired by a group known as The Eight, who believed that art should reflect reality, particularly the gritty reality of the city. Bellows often painted subjects that evoked the vitality of city life such as crowded neighbourhood streets. He painted portraits as well as landscapes, and later in life experimented with different subjects and techniques. Bellows personified the American spirit of enthusiasm and eagerness both in his painting and in his life.

☛ Eakins, Hopper, Vuillard, Wyeth

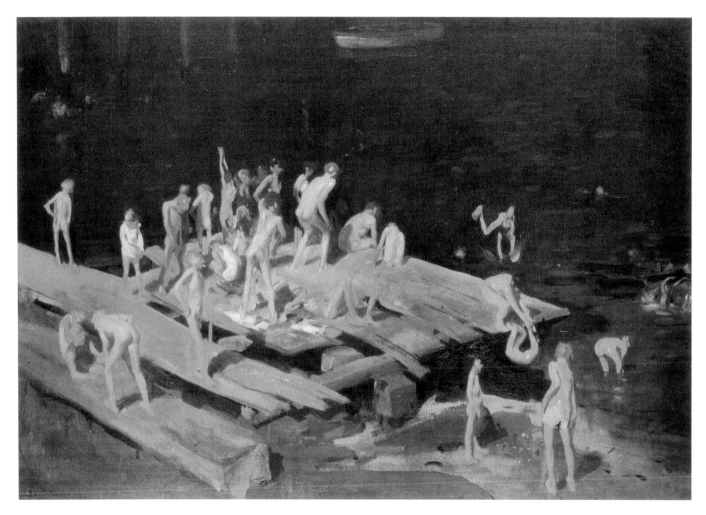

George Bellows. b Columbus, OH, 1882. **d** New York, NY, 1925. **Forty-two Kids**. 1907. Oil on canvas. **h**107.6 × **w**153 cm. **h**42⅜ × **w**60¼ in. Corcoran Gallery of Art, Washington, DC

Bernini Gianlorenzo The Ecstasy of Saint Theresa

In a vision, St Theresa of Avila sees an angel thrusting a golden spear into her heart. Swooning in physical and spiritual abandon – symbolic of her love of God – she expresses the intensity of her mystical experience for all to see. This marble group is a perfect example of the Baroque spirit – full of drama, emotion and movement.

Bernini was an outstanding artist of the Italian Baroque. The virtuosity and delicacy of finish of his statues is reminiscent both of Michelangelo and of Antique statuary, although it also combines the styles of his contemporaries Caravaggio, Annibale Carracci and Guido Reni. An accomplished architect as well as a sculptor,

Bernini virtually monopolized papal commissions during Rome's 'golden age'; no other single artist has left such an indelible imprint as he has on the city. The layout of Rome's St Peter's Square is one of his grandest architectural achievements.

☛ Caravaggio, Carracci, Michelangelo, Pietro da Cortona, Reni

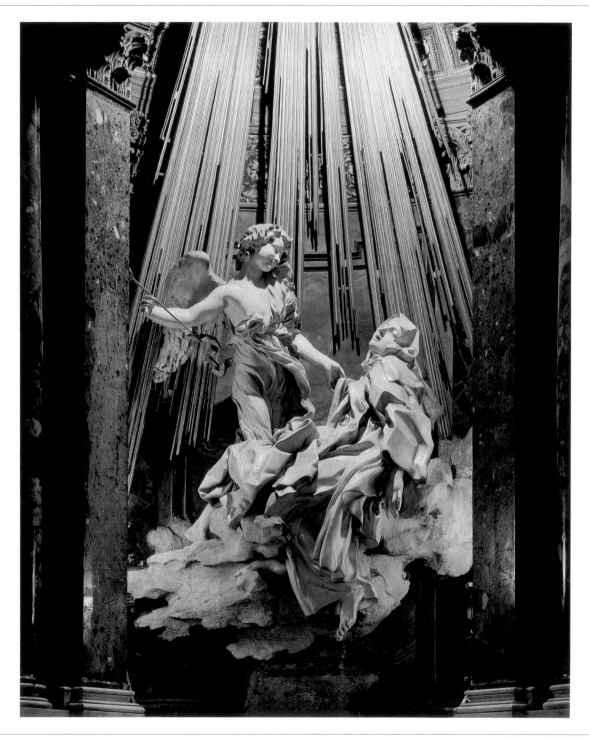

Gianlorenzo Bernini. b Naples, 1598. **d** Rome, 1680. **The Ecstasy of Saint Theresa**. 1646–52. Marble. **h**350 cm. **h**138 in. Santa Maria della Vittoria, Rome

Beuys Josef

Felt Suit

This stitched felt suit expresses the idea of human physical warmth. It symbolizes and evokes a sense of safety and shelter because felt is an insulating and life-protecting fabric. Beuys was at one stage connected with Fluxus, a movement dedicated to organizing anarchistic events and 'happenings', and this suit was copied from one he wore at an anti-Vietnam event. Beuys considered art as a medium for social and political change. He also saw it as having a spiritual dimension, and believed that commonplace materials (felt and animal fat were among his favourites) could be invested with an intense healing power. He saw the role of the artist as parallel to that of the shaman, channelling energy from objects and giving them new powers and new meaning. Beuys achieved cult status in his native Germany, and many of his works, including this suit, were produced in large editions.

☛ Broodthaers, Duchamp, Oldenburg, Schwitters

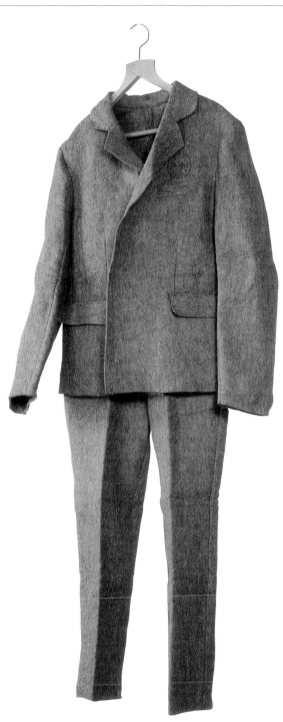

43

Josef Beuys. b Krefeld, 1921. **d** Düsseldorf, 1986. **Felt Suit**. 1970. Stitched felt. **h**170 × **w**100 cm. **h**67 × **w**39⅜ in. Private collection

Bierstadt Albert

The Rocky Mountains

During the early nineteenth century the passion of the American nation was stirred by the peaceful forests and wide open spaces of its own lands. This occurred at a time when America was becoming rapidly industrialized. The threat of the railroad and of the Machine Age was a real one, and in response, the nation desired to protect its places of natural beauty. Bierstadt was a master at creating romanticized visions of the American wilderness. His canvases were usually huge and painted in great detail. They showed nature at her most remote and unassailable, from the distant splendour of the Rocky Mountains to the magnificence of the Yosemite Valley. Bierstadt was born in Germany but moved to the USA as a child. His work represented a nation's last gasp of romanticism before the railroad ate into the countryside. The need to believe in the existence of a New World, at least in spirit if not in reality, remained strong for a long time.

☛ Church, Cole, Cozens, Daubigny, Hobbema, T Rousseau

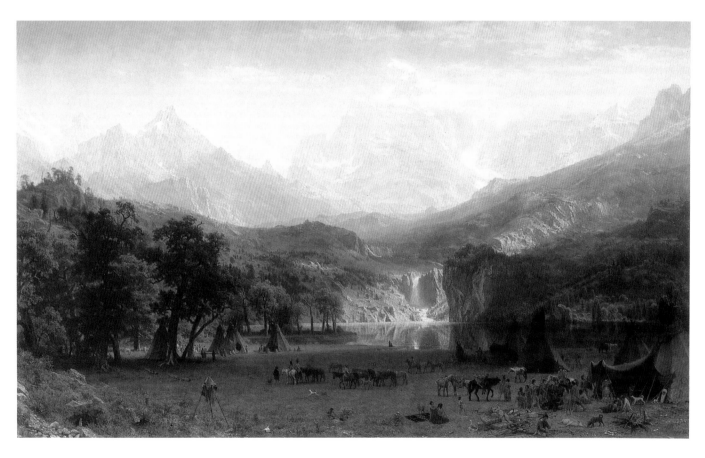

Albert Bierstadt. **b** Solingen, 1830. **d** New York, NY, 1902. **The Rocky Mountains**. 1863. Oil on canvas. **h**180 × **w**306 cm. **h**73¼ × **w**120¾ in. Metropolitan Museum of Art, New York, NY

Bingham George Caleb Fur Traders Descending the Missouri

In a misty peacefulness, two trappers and their cat glide down the Missouri. A warm light, shimmering across the still river, creates a dreamy sense of timelessness. The two figures will soon be out of sight. In many of his early pictures Bingham used carefully balanced horizontals and diagonals, with figures placed at right-angles to create a solid structure. The artist, one of the most important of the early North American Frontier Painters, painted the landscapes and settlers of the American West. At a time when the camera was not widely used, it was left to artists to show the world what this new and strange land was like. Gradually, Bingham moved off the river, onto the land, and into politics (he was elected to the Missouri legislature in 1848). However, he is best remembered as a popular chronicler of a bygone American way of life, and a painter of great skill and sophistication.

☛ Allston, Bierstadt, Cole, Friedrich

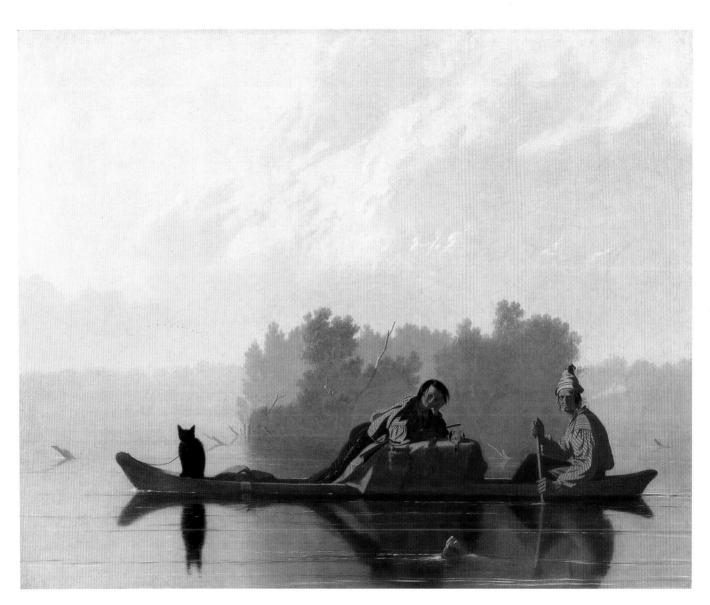

George Caleb Bingham. b Augusta County, VA, 1811. d Kansas City, MS, 1879. **Fur Traders Descending the Missouri**. 1845. Oil on canvas. **h**74 × **w**92 cm. **h**29 × **w**36½ in. Metropolitan Museum of Art, New York, NY

Blake Peter

On the Balcony

The figures sitting on a park bench are surrounded by and display four paintings executed by Blake's fellow students, together with various expendable commercial items including cigarette packs, magazines and food packaging. The painting's simple arrangement pays little attention to perspective, as the represented objects are the most important ingredients of the composition. At the time it was considered Blake's most important work in its direct visual impact, and it now also conveys a sense of the escalating culture of the 1950s by confronting the viewer with an unordered riot of popular imagery. It is this depiction of commercial memorabilia that helped pave the way for the British Pop Art movement. During the 1970s Blake moved towards a more naturalistic style and in 1975 he became a founder member of the Brotherhood of Ruralists, whose ideal was to work together in the countryside, as artists had in the nineteenth century.

☛ Hamilton, Hockney, Jones, Rauschenberg, Schwitters

Peter Blake. b Dartford, 1932. **On the Balcony**. 1955–7. Oil on canvas. **h**121.3 × **w**90.8 cm. **h**47¾ × **w**35¾ in. Tate Gallery, London

Blake William

Pity

An apparently lifeless woman lies on the ground. Above her two female figures rush by on horses, the wind lifting their hair. One of the women looks down, and is holding a tiny child. The work illustrates a passage from Shakespeare in which Macbeth contemplates the results of the murder of Duncan: 'Pity, like a newborn babe, striding the blast of heaven's cherubin, hors'd…'. Blake's precisely delineated forms, rejecting traditional composition and ideas of perspective, evoke an enigmatic otherworldliness. His style reflects his uniquely personal, mystical vision, in which imagination and reality become one. Originally a book engraver by trade, Blake's genius expressed itself through his poetry as well as his striking symbolic paintings. He believed that the spiritual was more important than the material world, and that the true artist is a prophet because he or she is given divine insight.

☛ Etty, Martin, Moreau, Redon, Turner

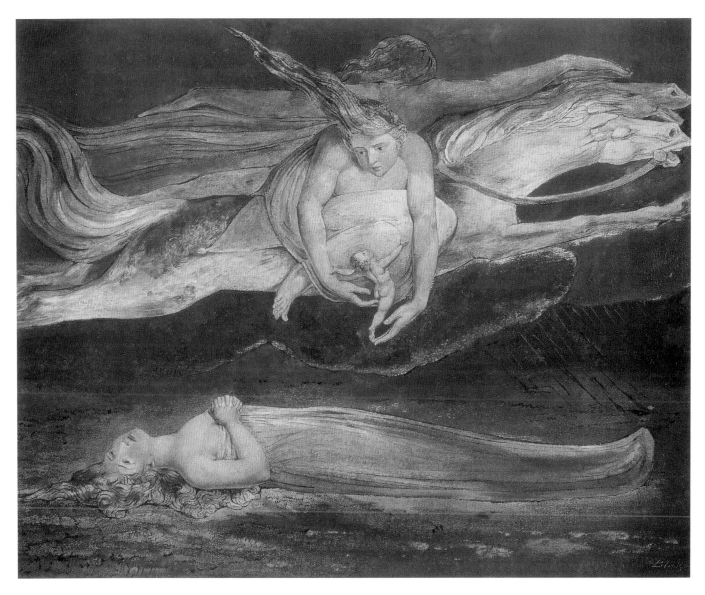

William Blake. b London, 1757. d London, 1827. **Pity**. c1795. Watercolour heightened with ink on paper. **h**42 × **w**54 cm. **h**16¾ × **w**21¼ in. Tate Gallery, London

Boccioni Umberto Head + Light + Surroundings

Swirling, fragmented forms sweep across the surface of this picture. In a pattern of reds and blues, a head appears; it is a world seen through a moving kaleidoscope. As the picture shows, Boccioni was intrigued with movement through time and space. In fact, he co-founded the Italian Futurist movement in 1910 and signed the Futurist Manifesto.

Rejecting the past, the Futurists looked to science and technology for their inspiration, focusing on the idea of motion through space. Unlike many artists of the time the Futurists felt the Machine Age to be a positive influence on art, and Boccioni urged his fellow painters to seize hold of modern life with all its dynamism, vitality and speed. In this

work he wanted to present simultaneously a whole complex of impressions and associated sensations. Boccioni was a sculptor as well as a painter. He volunteered for the First World War in 1915; tragically, and ironically, he was killed as a consequence of falling from a speeding horse.
☛ Balla, Carrà, Feininger, Klee, Léger

Umberto Boccioni. **b** Reggio di Calabria, 1882. **d** Sorte, 1916. **Head + Light + Surroundings**. 1912. Oil on canvas. **h**60 × **w**60 cm. **h**23½ × **w**23½ in. Paolo Baldacci Gallery, New York, NY

Böcklin Arnold

Centaurs' Combat

A suggestion of horror, rather than its explicit reality, is portrayed in this painting. Set in an otherworldly landscape, the animated, heroic figures of the centaurs dominate the canvas with their dramatic choreography. Much of the tension of this painting derives from the contorted poses and haunted expressions of the centaurs, loosely painted in rich tones, which convey a sense of heightened drama and emotion. Böcklin spent much of his career in Italy. This inspired him to take up Classical and mythological themes which he interpreted in a poetically Romantic manner, influenced by Eugène Delacroix and Théodore Géricault. The artist's dream-like settings, menacing tones and haunting emotional undercurrents brought him popularity in his day, and later inspired the work of the German Expressionists and the French Symbolists. His allegorical paintings were particularly admired for their strong impact and their challenging demands on the emotions.

☛ Delacroix, Géricault, Giulio Romano, Schmidt-Rottluff

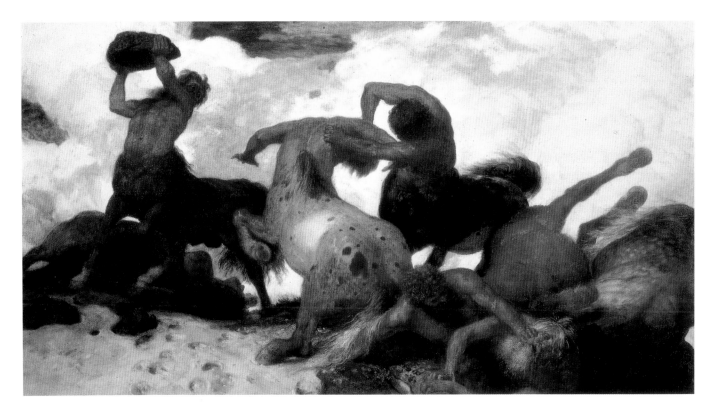

Arnold Böcklin. b Basel, 1827. **d** Fiesole, 1901. **Centaurs' Combat**. 1873. Oil on canvas. **h**105 × **w**195 cm. **h**41¼ × **w**76¾ in. Kunstmuseum, Basel

Boltanski Christian Reserve of Dead Swiss

This large-scale installation consists of two walls of metal biscuit boxes and a series of black-and-white photographs taken from obituaries in a local newspaper, poorly illuminated by clamp-on electric lamps. Powerful sensations of life and death are evoked by this shrine to the memory of the dead, with its almost religious atmosphere of perpetual stillness and peace. In previous works, Boltanski had used photographs of Jewish children. Here, by using images of the Swiss – a race associated with neutrality rather than a specific and terrible fate – Boltanski lays greater emphasis on the universality of mortality. His unique style, medium and subject matter focusing on themes of death have made Boltanski one of the most acclaimed artists of our time. His other works include glass display cabinets containing memories of childhood, 'Shadow' sculptures made of scrap materials which are illuminated by candles, and rooms filled with clothes which he also calls 'Reserves'.

☛ Andre, Kiefer, Poussin, Teniers

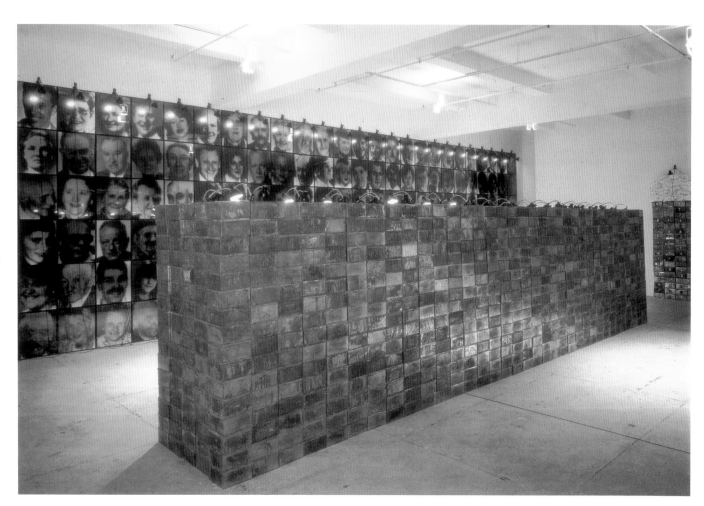

50

Christian Boltanski. **b** Paris, 1944. **Reserve of Dead Swiss**. 1990. Photographs, metal tins and electric lamps. **h**203 cm. **h**80 in. Marian Goodman Gallery, New York, NY

Bomberg David

The Mud Bath

At first, this might seem to be a completely abstract picture. In fact, it shows a vapour bath, used by the Jewish community of Whitechapel in London. Blue and white figures jostle and leap around the bath's red rectangle shape, throwing themselves around the central dark pillar. The son of a Polish immigrant, Bomberg used angular and semi-abstract forms to express the vitality and dynamism of the twentieth century and the excitement of the Machine Age. He was a founder member of the London Group, an exhibiting society formed in 1913. Although Bomberg kept his distance from the Cubists, Futurists and Vorticists, which were all active at the time, he did identify with some of their theories. In the 1920s he moved away from geometric forms and turned to a more representational style, often using vibrant colours and expressive brushstrokes.

☛ Bellows, Boccioni, Braque, Lewis, Nash, Picasso

51

David Bomberg. **b** Birmingham, 1890. **d** London, 1957. **The Mud Bath**. 1914. Oil on canvas. **h**152.5 × **w**224 cm. **h**60 × **w**88¼ in. Tate Gallery, London

Bonington Richard Parkes Rouen from the Quais

The steeple of the great Rouen Cathedral and the tall masts of the boats create strong verticals in this picture. Watercolour is a lively, immediate medium, which has allowed the artist to capture the activity of the busy quays. Bonington's watercolour style is characterized by a small range of colours applied to highly textured paper. This work was painted while he studied under the artist Baron Gros at the École des Beaux-Arts in Paris. He was close friends with the Romantic painter Eugène Delacroix, who wrote of him, 'no one in the modern school, perhaps no earlier artist, possessed the lightness of execution which makes his works, in a certain sense, diamonds, by which the eye is enticed and charmed'. Bonington spent most of his life in France and, in addition to city views, he also painted landscapes and historical scenes. Shortly before his death Bonington began to paint in oil; he is best remembered, however, for his skill as a watercolourist.

☛ Gentile Bellini, Bellotto, Cozens, Delacroix, Gros

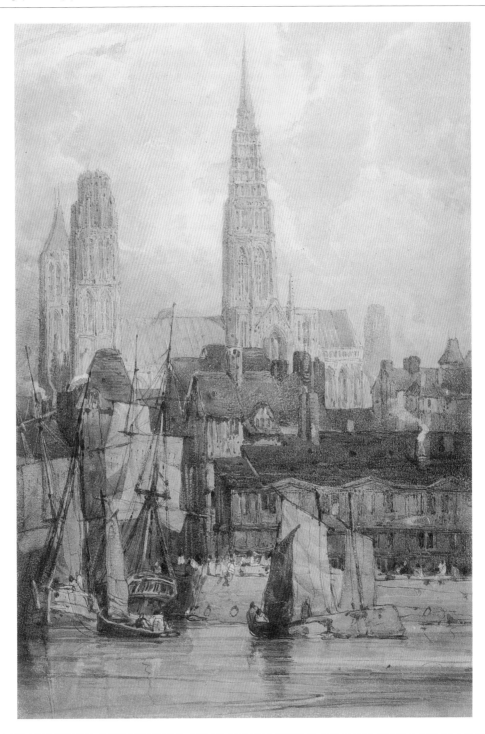

Richard Parkes Bonington. b Arnold, 1802. **d** London, 1828. **Rouen from the Quais**. 1821. Watercolour on paper. **h**40.5 × **w**27.5 cm. **h**15⅞ × **w**10¾ in. British Museum, London

Bonnard Pierre

The Open Window

The interior and open window, the sleeping girl and the kitten are barely visible in a rich riot of colour. The viewer is encouraged to enter the room and join the scene, looking out of the window at the trees beyond. Bonnard successfully conveys the atmosphere of heat and tranquillity of the South of France by using warm and bright tones of colour. Known particularly for his intimate domestic interiors, Bonnard was a member of the group known as Les Nabis whose aim was to simplify the outline and colour of their paintings. The Nabis rejected the idea of engaging the viewer purely through subject matter. Instead, they aimed at expressing feeling through form, often using broad areas of flat colour. As well as a painter Bonnard was a master of lithography, using shapes, colour and line to great effect. He was one of the few foreign artists to be elected to the Royal Academy in London.

☛ Caillebotte, Denis, Hassam, Matisse, Vallotton, Vuillard

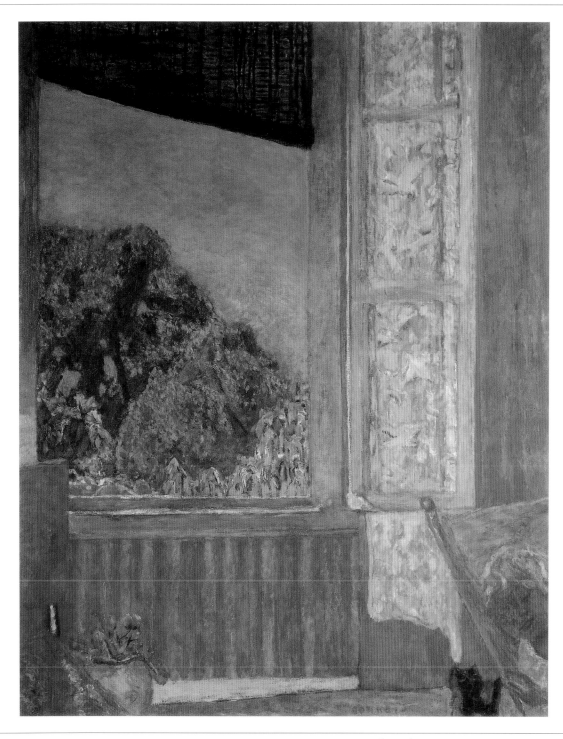

Pierre Bonnard. **b** Fontenay-aux-Roses, 1867. **d** Le Cannet, 1947. **The Open Window**. c1921. Oil on canvas. **h**118 × **w**96 cm. **h**46½ × **w**37¾ in. Phillips Collection, Washington, DC

Bordone Paris

Presentation of the Ring to the Doge of Venice

A fisherman who had been rescued by St Mark is giving the saint's ring to the Doge of Venice. The artist has depicted the figures in contemporary dress, even though the incident is said to have happened hundreds of years earlier. Portraits of prominent Venetians, including the Doge of the time, were used as models. Elaborate columns, arcades and apses dominate the work, which is a good example of Renaissance Venetian art. Bordone was a leading portraitist as well as a painter of landscapes and anecdotal and mythological scenes. He originally studied under Titian, and in fact rivalled his master in popularity. The painting shown is very much in the style of Titian. Bordone was invited to France by François I, who was a great admirer of Italian Renaissance artists. While in France, Bordone painted several portraits of the prominent political figures of the day.

☛ Gentile Bellini, Clouet, Guardi, Sassetta, Titian

Paris Bordone. **b** Treviso, 1500. **d** Venice, 1571. **Presentation of the Ring to the Doge of Venice**. 1534. Oil on canvas. **h**370 × **w**300 cm. **h**145²⁄₃ × **w**118 in. Galleria dell'Accademia, Venice

Bosch Hieronymus The Tribulations of St Anthony

The pious hermit St Anthony is subjected to all the temptations and tortures that Bosch's ghoulish imagination can muster. Evil lurks around every corner – a seductive temptress hides in a cleft tree, a monster bursts forth from a huge, over-ripe fruit, and the scene is rife with menacing, supernatural-looking creatures. The raging inferno in the background hints at the fate that awaits all those who succumb to evil. Bosch's style is unique, and unparalleled in the Netherlandish tradition of painting. His work is not at all similar to other artists of the time, such as Jan van Eyck or Rogier van der Weyden. Most of the subjects of Bosch's paintings revolve around scenes from the life of Christ, or a saint confronted by evil and temptation, or allegories or proverbs about the folly of human beings. Bosch's work seems strangely modern: four hundred years later, his influence emerged in the Expressionist movement, and still later in Surrealism.

☞ Beckmann, Dalí, Elsheimer, Van Eyck, Van der Weyden

Hieronymus Bosch. b 's-Hertogenbosch, c1450. **d** 's-Hertogenbosch, 1516. **The Tribulations of St Anthony**. c1505. Oil on panel. **h**131.5 × **w**172 cm. **h**58 × **w**67 in. Museu Nacional de Arte Antiga, Lisbon

Botero Fernando

Our Lady of Cajica

The universal image of the Madonna is portrayed here as an inflated, rotund figure in Botero's unique style. He has created a sense of the Madonna's monumental hugeness by contrasting her with tiny figures that peep out of the clouds behind – a device frequently employed by the artist. In addition, the snake at the bottom of the picture has been made unnaturally long, in order to emphasize her largeness. Botero was born in Colombia and the religious subject of this painting is largely a response to his upbringing. In most Catholic Latin American countries the Madonna is worshipped as the most important religious figure. Botero's works are characterized by their simplicity of form and exquisite application of paint. He has been living in Paris since 1971, where he continues to paint and sculpt. His recent work includes a series of monumental sculptures of the female nude, which were displayed down the length of the Champs-Élysées.

☛ Bouts, Fouquet, Lochner, Spencer

56

Fernando Botero. b Medellín, 1932. **Our Lady of Cajica**. 1972. Oil on canvas. **h**234.4 × **w**181.8 cm. **h**95¾ × **w**71⅝ in. Private collection

Botticelli Sandro

Spring

The diaphanous gowns of the Three Graces, the elegant hands of Venus and the flowered dress worn by Flora combine to make this one of the most beautiful paintings of the Italian Renaissance. The painting reflects the fine draughtsmanship that was fundamental to Florentine art at that time, and Botticelli's graceful line creates a sensitive, almost feminine atmosphere. Botticelli began his training under Fra Filippo Lippi and went on to move in the intellectual circles that flourished during the Florentine 'golden age'. Many of his paintings involve philosophical and allegorical meanings; *Spring* in particular has sparked much debate as to its symbolic significance. Later in life he came under the influence of a charismatic priest called Savanorala, and painted fewer paintings with mythological themes. Botticelli died in obscurity. He was rediscovered in the nineteenth century by the Pre-Raphaelites, who particularly admired the Renaissance artist's delicate linework.

☛ Filippo Lippi, Millais, Pontormo, Rubens

Sandro Botticelli. b Florence, 1445. d Florence, 1510. **Spring**. c1470/80. Tempera on panel. **h**175.5 × **w**278.5 cm. **h**69¼ × **w**109½ in. Galleria degli Uffizi, Florence

Boucher François

Odalisque

A young girl lies naked on a bed with lavish draperies all around her. Blatantly provocative, she flirts with the viewer as she looks out from her boudoir. Boucher's paintings epitomize the frivolous excesses of the mid-eighteenth century, making him one of the truest exponents of the Rococo style. In his youth he was closely connected to Antoine Watteau, whose pictures he engraved, and in the 1740s obtained the patronage of Madame de Pompadour. Through her influence he became chief painter to Louis XV. Boucher was one of the most sought-after decorators in Paris, and his charmingly coquettish pictures of naked nymphs and goddesses, usually in mythological and allegorical scenes, pandered to the taste of the Parisian upper classes whose elegant houses he decorated. Epitomizing the artifice of the Rococo age, he allegedly said of nature that it was 'too green and badly lit'.

☛ Fragonard, Ingres, Moore, Watteau, Wesselmann

58

François Boucher. **b** Paris, 1703. **d** Paris, 1770. **Odalisque**. c1745. Oil on canvas. **h**53 × **w**64 cm. **h**20¾ × **w**25¼ in. Musée du Louvre, Paris

Boudin Eugène

The Beach at Trouville

A crowd of formally dressed Parisians is seen basking in the sun at the fashionable seaside resort of Trouville on the Normandy coast. Boudin came to be known as 'the painter of beaches' and frequently travelled to this particular beach throughout his career. An exceptionally gifted observer and recorder of nature, he was able to capture the characteristic gestures of people. Using a subtle and free brushwork, speckled with flecks of pure colour, he could make the surface of his paintings sparkle, evoking a glowing sky or a glittering sea. As in seventeenth-century Dutch landscape painting, the sky in Boudin's paintings plays an important role. It often takes up two-thirds of the picture, forcing the viewer's eyes to focus on the tiny figures below. Boudin was a major source of inspiration for the Impressionists, particularly Claude Monet, who painted this very beach some years later.

☞ Avercamp, Van Goyen, Krøyer, Monet

Eugène Boudin. b Honfleur, 1824. d Deauville, 1898. **The Beach at Trouville**. 1864. Oil on canvas. **h**26 × **w**48 cm. **h**10¼ × **w**18⅞ in. Musée d'Orsay, Paris

Bourdelle Antoine Herakles

Power, strength and tightly coiled energy seem about to burst forth from the impressive form of Herakles. The sculptor has used muscular shapes and bold, expressive features to create a sense of vitality. The tension is clearly shown in the bowstring, which is being pulled back by a huge, powerful hand. Further tension is created by the archer's leg which, with its bulging tendons, strains against a boulder. Bourdelle was a pupil of Auguste Rodin. Rather than following his master's loose style, however, Bourdelle studied Gothic and Ancient Greek sculpture. Inspired by the images of Antiquity, Bourdelle aimed to create a similar feeling of density and volume.

This was very different from the popular sculpture of the time, which was usually concerned with graceful forms. Taut and heroic, this sculpture epitomizes Bourdelle's quest for the monumental in his art.

☛ Böcklin, Giambologna, Giulio Romano, Rodin, Rosso Fiorentino

60

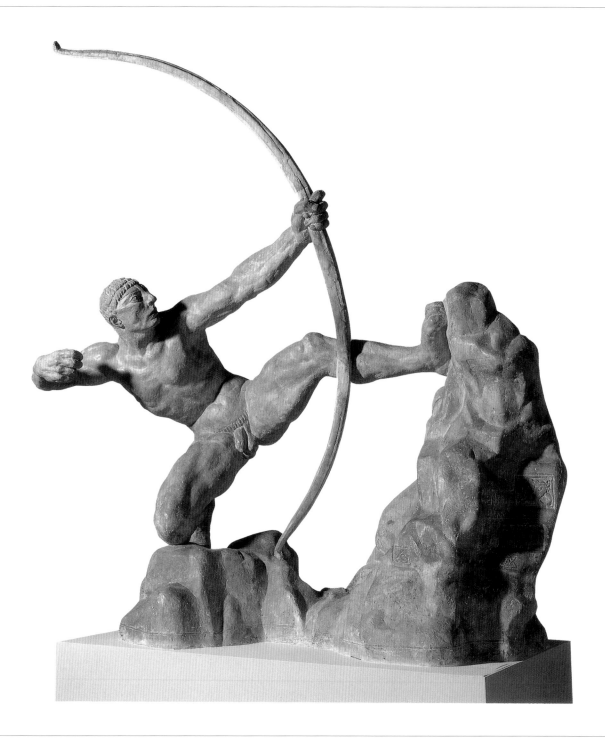

Antoine Bourdelle. **b** Montauban, 1861. **d** Vesinet, 1929. **Herakles**. 1908. Plaster. **h**248 cm. **h**97²⁄₃ in. Musée Bourdelle, Paris

Bourgeois Louise

Here I Am, Here I Stay

Encased within a glass casket, a pair of truncated human feet are firmly placed on a roughly hewn block of marble. Perhaps alluding to the triumphant order man has created out of the disordered chaos of nature, the elemental qualities of the material – marble, glass, metal – evoke the timeless world articulated by human endeavour. Great attention has been paid to the sensual surfaces, ranging from the roughness of the stone hewn from the earth to the smoothness of the man-made glass. Bourgeois' work is frequently suggestive of the human form, often in a remote, abstracted context. The dynamic tensions of opposing materials and finishes raise provocative responses to the physical presence within the natural environment. Bourgeois moved to New York from Paris in 1938 where she had worked with the Surrealists. Initially a painter and engraver, she turned to sculpture in the late 1940s.

☛ Brancusi, Canova, Dalí, Noguchi, Rodin

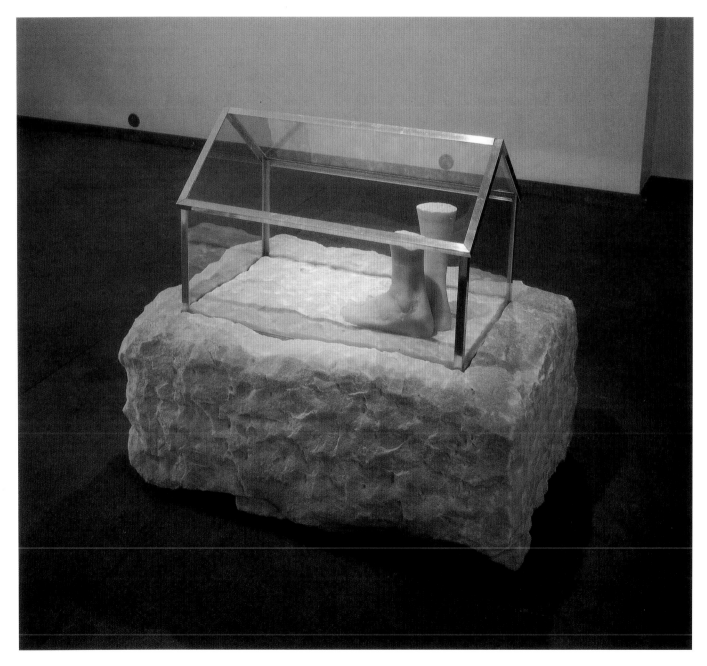

Louise Bourgeois. b Paris, 1911. **Here I Am, Here I Stay**. 1990. Marble, glass and metal. **h**88.9 × **w**102.8 cm. **h**35 × **w**40½ in. Galerie Karsten Greve, Cologne

Bouts Dieric

Virgin and Child

This image of the Virgin and Child is painted with neither austerity nor pomp. The Virgin is seen tenderly cradling the Christ Child as any mother would her new-born baby. The result is a picture that is both spiritual and human. Small, half-length images of the Virgin and Child were popular in Netherlandish art. They were treated as objects of private devotion, and were kept at home. Such works were often made of two panels, the second being a portrait of the owner looking over at the Virgin, as if in prayer. The sleepy cast to the eyes of the figures in this picture is a quirky characteristic of Bouts' way of painting faces. Bouts was undoubtedly influenced by Rogier van der Weyden's angular, sharply defined and sculptural approach to painting, although some of his works hint at an understanding of a more sophisticated form of perspective.

☛ Campin, Van Eyck, Fouquet, Schongauer, Van der Weyden

Dieric Bouts. Active in Louvain, 1457. **d** Louvain, 1475. **Virgin and Child**. c1460–5. Oil and tempera on panel. **h**27.9 × **w**24.1 cm. **h**11 × **w**9½ in. Private collection

Boyd Arthur

The Australian Scapegoat

The swirling, radiant colours of the sky converge at the bright sun. In the foreground, a scraggy black beast, a hint of a tear falling from its sad eye, looks longingly at a dead, upturned ray as if he were the cause of its demise. A man in an unnatural pose holds the goat; perhaps he is a farmer, perhaps a fisherman. The shallows of the sea in which they appear to stand reflect the red of the sky, clashing violently with the yellow coat of the man who, like the goat, sticks out his tongue at the sun. The fiery, passionate colours and visionary nature of this picture give it an expressionistic quality. In fact, many of his paintings are concerned with the emotions of sexual passion, guilt and betrayal. Born in Australia, Boyd belonged to a family of artists – his father was a sculptor and potter, his mother a painter. He moved to England in 1959 where he gained a high reputation as an artist both there and in his native land.

☛ Burra, Heckel, Kitaj, Nolan, Schmidt-Rottluff

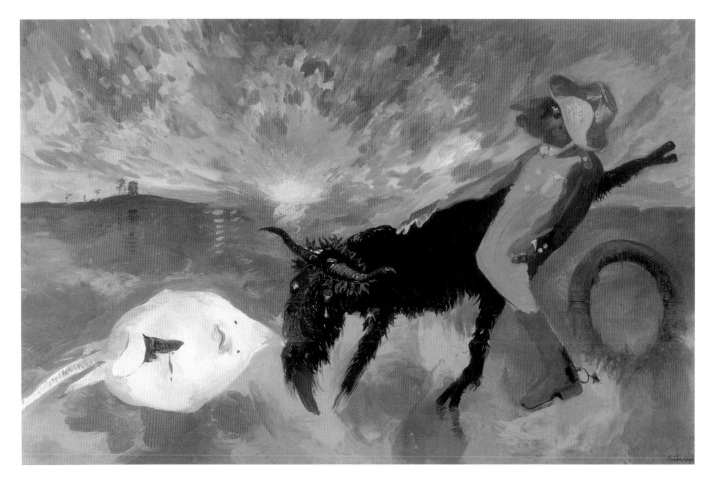

Arthur Boyd. **b** Murrumbeena, 1920. **d** Melbourne, 1999. **The Australian Scapegoat**. 1987. Oil on canvas. **h**259 × **w**442 cm. **h**102 × **w**174 in. Collection of the artist

Brancusi Constantin The Kiss

Tightly entwined, two lovers embrace in a passionate kiss. The elemental power of this work is expressed by the bulk of the stone from which the forms are only sketchily emerging, as if roused from a timeless slumber. Brancusi reduced his sculptures to their most basic, most abstract, lending them a primordial vitality. Eschewing all surface decoration, nothing but pure form remains. Brancusi had an immense effect on twentieth-century sculpture and abstract art in general. The simple grandeur of his works evokes a sense of freedom and strength. In 1904 he walked from Romania (the country of his birth) to Paris, a feat which gained him widespread admiration. His celebrity was further fuelled by the law case he brought against US Customs, who wanted to charge duty on an imported bronze sculpture which they considered as nothing more than raw material, thus liable for tax.

☛ Bourgeois, Gaudier-Brzeska, Moore, Noguchi, Rodin

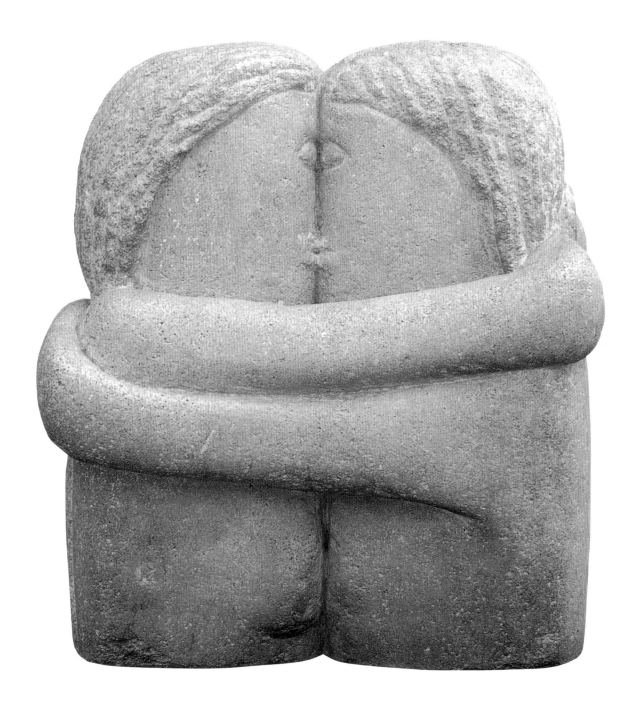

64

Constantin Brancusi. b Hobitza, 1876. **d** Paris, 1956. **The Kiss**. 1907. Stone. **h**28 cm. **h**11 in. Muzeul de Arta, Craiova

Braque Georges

Clarinet and Bottle of Rum on a Mantelpiece

Letters and lines, triangles and rectangles, are scattered across the canvas in apparently random order, in what seems to be an abstract composition. In fact, the picture has been very carefully thought out. It is a painting of a fireplace with a mantelpiece, on which are set a clarinet and a bottle of rum. A page of sheet music is pinned to the wall. Rather than recreating the illusion of real space on the flat canvas with the use of perspective, light and shade, Braque has suggested three-dimensionality and depth by displaying all sides of the objects at once. Painted in muted tones of brown and grey these flat shapes combine to create a Cubist image. This revolutionary way of reproducing the world was invented by Braque and Pablo Picasso in the first decade of this century. They were the first artists to change radically the perception of art for five hundred years. With Cubism, art no longer needed to be merely an imitation of the world around us.

☛ Archipenko, Gris, Morandi, Nicholson, Picasso

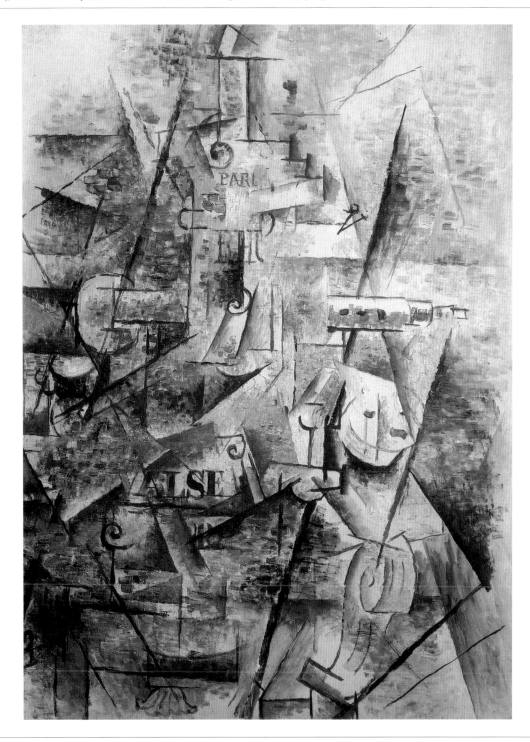

Georges Braque. b Argenteuil-sur-Seine, 1882. **d** Paris, 1963. **Clarinet and Bottle of Rum on a Mantelpiece.** 1911. Oil on canvas. **h**81 × **w**60 cm. **h**31⅞ × **w**23⅝ in. Tate Gallery, London

Brauner Victor Fascination

Muted browns and ochre tones decorate a spartan room with a table – part furniture, part wolf – at which a featureless naked lady sits nonchalantly as if calmly waiting for a meal to be served. Her hair curves up and forms a bird with a swan-like neck which viciously confronts the wolf's head growing out of the table. His tail and genitals are at the other end. Brauner produced a series of paintings such as this inhabited by strange hybrids of women, animals and objects. These absurd, hallucinatory fantasies spring from the enigmatic world of Surrealist art, in which the visual imagination is freed from the constraints of reason and logic. The Surrealists' vision aimed to harness the unconscious to produce revelatory, stimulating images. Born in Romania, Brauner worked mainly in France. In 1931 he painted his *Self-portrait with Extracted Eye*; the work proved to be prophetic, as the artist lost his left eye in a bar brawl in 1938.

☛ Bellmer, Dalí, Ernst, Magritte, Matta, Tanguy

66

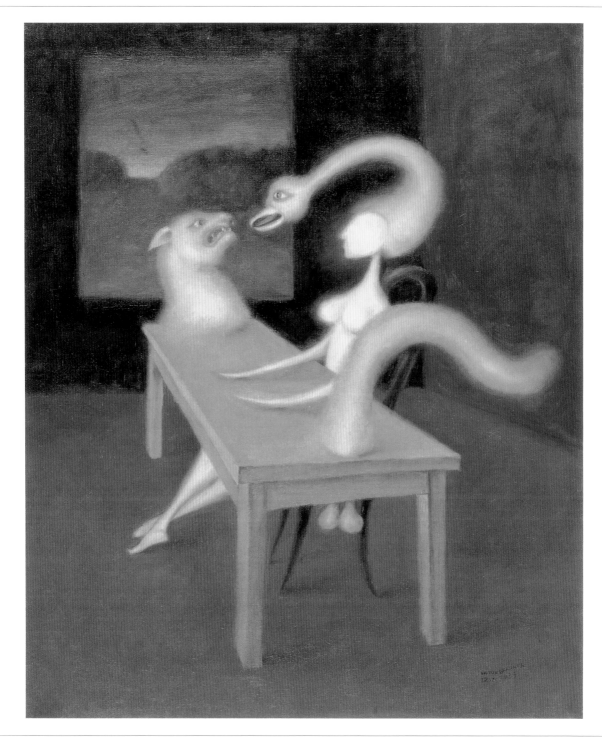

Victor Brauner. b Piatra Neamtz, 1903. **d** Paris, 1966. **Fascination**. 1939. Oil on canvas. **h**65 × **w**54 cm. **h**25½ × **w**21¼ in. Private collection

Bronzino Agnolo An Allegory of Venus and Cupid

Venus turns to kiss Cupid, who fondles her breast. A bearded Father Time pulls a curtain over the scene. Jealousy clutches her head in her hands, and a masked figure looks on the scene from above. A girl who is part furry beast and part reptile holds a honeycomb in one hand and the stinging end of her tail in the other. The

painting is obviously some kind of allegory, but what is it about? No one is certain. The cool light that bathes this bizarre scene and the smooth handling of the paint are typical of the artist's style. Bronzino's work is a wonderful example of Mannerism, in the way he distorts natural poses, exaggerates expressions and emphasizes

movement. A successful portrait painter in his day, Bronzino often placed his models in oddly rigid poses. His sitters' somewhat cold, detached expressions compel the viewer to look closely for a glimmer of emotion.

☛ Michelangelo, Parmigianino, Pontormo, Vouet

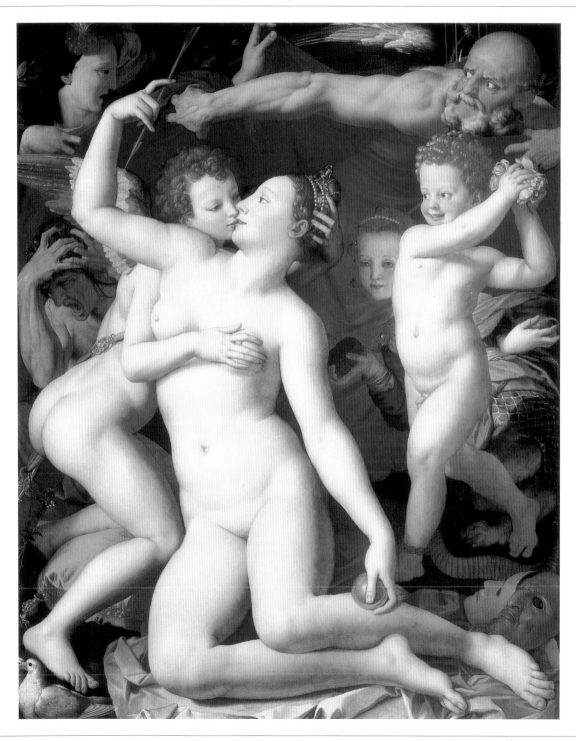

Agnolo Bronzino. b Florence, 1503. **d** Florence, 1572. **An Allegory of Venus and Cupid**. c1550. Oil on panel. **h**146 × **w**116 cm. **h**57½ × **w**45¾ in. National Gallery, London

Broodthaers Marcel Casserole and Closed Mussels

A tall pile of mussel shells is held together with green-tinted resin, evoking the sea. The shells seem to be surging upwards in an explosion of vitality. The image uses a pun on the words *la moule* ('the mussel') and *le moule* ('the mould'). The work is intended as a metaphor for the artist's home country of Belgium, where mussels

are a national dish; it is also a satire on the Belgian bourgeoisie. It is probably Broodthaers' most famous image. The artist's sculpture can be categorized as Conceptual Art, in that the ideas behind his works are more important than the works themselves. Broodthaers was also greatly influenced by his compatriot, the

Surrealist painter René Magritte. Like Magritte he often delights in incongruous juxtapositions and the creation of visual paradoxes through the combination of words, everyday objects and printed material.

☛ Beuys, Duchamp, Magritte, Oldenburg, Rauschenberg

Marcel Broodthaers. b Brussels, 1924. d Cologne, 1976. **Casserole and Closed Mussels**. 1964–5. Mussel shells, polyester resin and iron casserole. **h**30.5 cm. **h**12 in. Tate Gallery, London

Brown Ford Madox

Work

It is impossible not to get the artist's message in this action-packed picture crammed with detail. What is perhaps less obvious is that the painting is also meant to celebrate the relationship between art and work. It was therefore painted in a style to mimic the great Italian masters of the early Renaissance. The idea of combining art and work later became the central theme of the Arts and Crafts movement. Brown settled in England in 1845 after training at Antwerp, Paris and Rome. He became associated with the Pre-Raphaelite Brotherhood, but never joined them. Although he shared their desire to return to the simple vision of the early Renaissance painters, Brown was more interested in social issues than in purely artistic matters. In 1844 and 1845 he entered a competition to paint frescos for the Houses of Parliament, which he lost. Instead, he won a commission to paint frescos for Manchester Town Hall.

☞ Burne-Jones, Hunt, Léger, Filippo Lippi, Millais, Rossetti

69

Ford Madox Brown. **b** Calais, 1821. **d** London, 1893. **Work**. 1852–65. Oil on canvas. **h**134.6 × **w**196 cm. **h**53 × **w**77⅛ in. Manchester City Art Gallery, Manchester

Bruegel Jan

The Garden of Eden

Exotic and everyday animals mingle in this Garden of Eden, richly and meticulously endowed with a profusion of lush plants and flowers. Bruegel's main concern in this picture was the creation of a mystical, imaginary landscape, and the figures of Adam and Eve have been reduced to insignificance in order to emphasize their

setting. The limited selection of flora and fauna may seem comical to the modern eye, but Bruegel has successfully imbued this sylvan glade with a dream-like quality. His breadth of feeling and sensitivity to natural surroundings helped to develop the great tradition of seventeenth-century Dutch landscape painting. His highly finished

manner of painting flowers, landscapes and Garden of Eden subjects earned him the nickname 'Velvet' Bruegel. Jan came from the great Bruegel dynasty of Flemish painters; his father was Pieter Bruegel the Elder.

☞ Bassano, P Bruegel, Hobbema, Patenier, Ruisdael, Savery

Jan Bruegel. b Antwerp, 1568. **d** Antwerp, 1625. **The Garden of Eden**. c1620. Oil on panel. **h**53 × **w**84 cm. **h**20¾ × **w**33 in. Victoria and Albert Museum, London

Bruegel Pieter

Peasant Wedding Feast

The viewer is invited into an animated feast to celebrate the wedding of two peasants. The painting is rich in detail – the figure filling the jug of wine at the left, the pies being brought to table on a door, and the bagpipe player hungrily staring at the food. All show Bruegel's ability to capture the peasants' earthiness. The drunken, bumbling characters who animate Bruegel's lively scenes are the very opposite of the Italian ideal of refined perfection. Yet it is Bruegel's work, based on real-life observation, that is the more real and human. Legend has it that Bruegel would put on disguises in order to take part in the peasants' rollicking gatherings; this led to his being given the nickname 'Peasant Bruegel'. His technique, however, was far from crude; his carefully applied thin layers of paint express a wonderful sense of the richness and variety of colour. Pieter Bruegel headed a family of painters which flourished in the sixteenth and seventeenth centuries.

☛ Bosch, J Bruegel, G David, Ostade

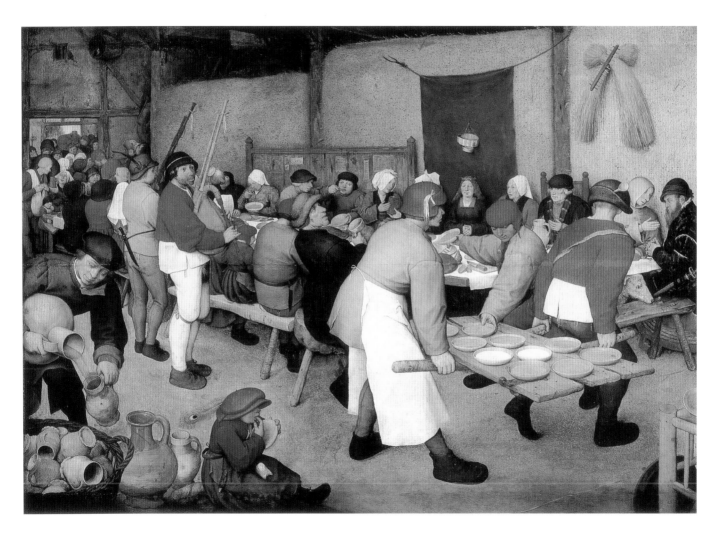

Pieter Bruegel. **b** Brögel, c1525. **d** Brussels, 1569. **Peasant Wedding Feast**. c1566/7. Oil on panel. **h**114.3 × **w**162.6 cm. **h**45 × **w**64 in. Kunsthistorisches Museum, Vienna

Buren Daniel

Two Levels

What is seen here is only a small part of a spectacular, colossal sculptural installation which was created especially for the Cour d'Honneur of the Palais-Royal in Paris. Each column is constructed of black and white strips of marble and is placed in a rigid, uniform sequence in the central square. The work's impact is entirely governed by the surroundings, as Buren creates his own interpretation of an existing architectural space (the traditional columns are visible in the background). A leading light in French Conceptual Art, Buren acknowledges that meaning is determined by context. He demonstrates this by reproducing his trademark – vertical stripes – in a variety of settings. Although neither his idea nor his form of expression have changed over the years, he did at one time apply his paint to different materials, including flags, sails, stone steps and walls.

☞ Andre, Christo, Judd, Long

Daniel Buren. **b** Boulogne-Billancourt, 1938. **Two Levels**. 1985–6. Black and white marble. **surface area** 67 × 50 m. 220 x 164 ft. Palais-Royal, Paris

Burne-Jones Sir Edward King Cophetua and the Beggar Maid

A lost age of chivalry and romance is rediscovered in this elegant painting. It tells the story of a king who searched far and wide for the perfect woman, and finally found her disguised as a simple beggar. She is the brightest object in the picture, and appears to glow with heavenliness. Burne-Jones was deeply affected by artists of the early Italian Renaissance, such as Sandro Botticelli and Andrea Mantegna, and was also inspired by his association with Dante Gabriel Rossetti. Although he was not one of the original members of the Pre-Raphaelite Brotherhood, his work reflects many of the ideas associated with those painters. Burne-Jones' rich colours, poetic subject matter and meticulous attention to detail give his paintings a mystical, spiritual quality. At the time, William Morris' Arts and Crafts movement had swept the country, and its influence can be seen here in the leaves, fabrics and designs on the staircase.

☞ Botticelli, Brown, Mantegna, Millais, Rossetti

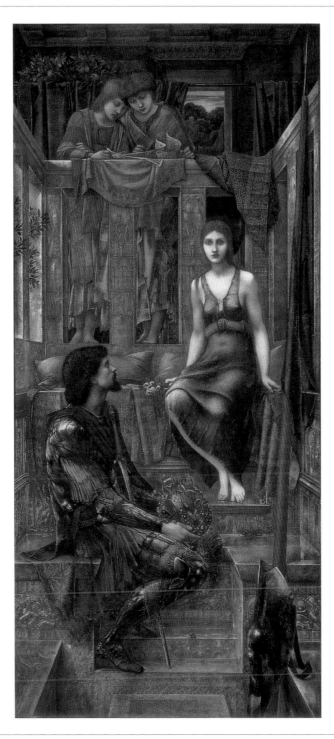

Sir Edward Burne-Jones. b Birmingham, 1833. d London, 1898. **King Cophetua and the Beggar Maid**. 1862. Oil on canvas. h76.2 × w63.5 cm. h30 × w25 in. Tate Gallery, London

Burra Edward

Cornish Landscape with Figures and Tin Mine

The artist has captured the spirit of the formidable and depressed figures in this haunting Cornish landscape, with its ruined tin-mine workings in the background. It is known that the man in the striped coat (who is painted twice) was seen by Burra in a pub, and the two tattooed figures are direct copies from a book. The strange, ghostly head, just visible in the top left-hand corner, may reflect Burra's interest in Surrealism. Although he knew a number of the Surrealists while living in France, he never really allied himself with them or any other movement. Burra's work during the 1930s became satirical, recalling that of George Grosz. Towards the end of his life his work developed into his own peculiar style. Most of his famous works are watercolours of women, or of people enjoying themselves. These were done in Burra's sharp, slightly exaggerated style, which changed little throughout his life.

☞ Boyd, Dalí, Grosz, Kitaj, Tanguy

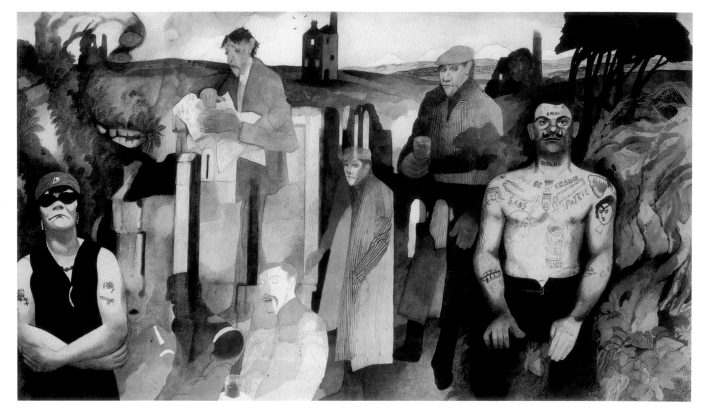

74

Edward Burra. b London, 1905. d Playden, 1976. **Cornish Landscape with Figures and Tin Mine**. 1975. Watercolour on paper. **h**78.1 × **w**135.9 cm. **h**30¾ × **w**53½ in. Private collection

Burri Alberto

Sacco

Materials that have been ravaged by time and discarded as waste, lacerated and unravelled, have been stitched back together and painted. Burri's early experiences as a doctor, handling blood-stained bandages and sewing up wounds during the Second World War, provided the inspiration for this work. The coarseness of the material used, and the violence with which it has been torn, creates a powerful tension between beauty and decay. The picture reflects the philosophy of the Art Informel movement, a post-war school of abstract art that rejected conventional ideas of composition and turned to new materials for inspiration. Burri's works demonstrate his fascination with surface texture and different media. He has made a series of pictures using charred wood, iron plates and plastic sheets, burnt into gaping holes with a blowtorch, which are highly sought after by collectors.

☞ Dubuffet, Fautrier, Riopelle, Still, Tàpies

Alberto Burri. b Città di Castello, 1915. d Nice, 1995. **Sacco**. 1954. Burlap, linen, oil and gold paint on board. h33 × w38 cm. h13 × w15¼ in. Private collection

Caillebotte Gustave Young Man at his Window

The artist's younger brother René stands with his back to us, looking out from the window of the family home at 77 rue de Miromesnil, Paris. The huge stone balustrade creates a strong division between the inside of the house and the world beyond, as our eyes are drawn to the streets below following René's gaze. This device of drawing the viewer into the picture via the window-frame view makes it one of Caillebotte's most compelling images. Caillebotte specialized in views of Paris and its surroundings, and images of working-class life. An intimate and supportive friend of Claude Monet, Pierre Auguste Renoir and Alfred Sisley, Caillebotte not only organized exhibitions of the Impressionists' works but also bought many of the paintings they found difficult to sell. In his will Caillebotte left his collection, including 65 Impressionist paintings, to the state. The collection was refused, and only after three years of negotiations were 38 pictures finally accepted.

☛ Bonnard, Cassatt, Matisse, Monet, Renoir, Sisley, Vuillard

Gustave Caillebotte. **b** Paris, 1848. **d** Paris, 1894. **Young Man at his Window**. 1876. Oil on canvas. **h**116.2 × **w**80.9 cm. **h**45¾ × **w**31⅞ in. Private collection

Calder Alexander

Lobster Trap and Fish Tail

The delicate balancing and twisting of the metal shapes create an image of a lobster trap, while the stylized brightly coloured fish and nine black elements suspended below give us the impression that we are looking at a fish skeleton. The metal elements gracefully swing independently of each other in slow circles, set in motion by currents of air. Calder combines the humour of the marine images with the sense of beauty and grace of a construction which continually rises, falls and turns at varying speeds and in different directions. The element of motion in the work makes it a prime example of Kinetic Art, a term applied to works of art in which actual movement, or an impression of movement, plays an integral part. Calder was the inventor of the mobile, and made his first one in 1932. His mobiles have ranged in height from around 4 cm (1½ inches) to over 5 metres (12 feet); an example of the latter can be seen at J F K Airport in New York.

☛ Lissitzky, Miró, Tinguely, Vasarely

Alexander Calder. b Philadelphia, PA, 1898. **d** New York, NY, 1975. **Lobster Trap and Fish Tail**. 1939. Steel wire and painted sheet aluminium. **w**289.5 cm. **w**114 in. Museum of Modern Art, New York, NY

Campin Robert

The Virgin and Child before a Fire-screen

Despite her rich and elaborate fur-lined gown, the Virgin is shown in a homely setting. She looks as though she has just put down her book to nurse her child. Minutely observed details appear throughout the work; the townscape in the background is as clear and precise as the figures in the foreground, while the pages of the Virgin's book, the decoration along the hemline of her dress and the rushwork of the fire-screen have been painstakingly rendered. The artist's technical skill and inventiveness invite comparison with his contemporary, Jan van Eyck. Robert Campin's identity is shrouded in mystery. It is generally thought that he is the same person as the so-called Master of Flémalle, a name given to the painter of a group of pictures that were (wrongly) supposed to have come from Flémalle. It is thought that Rogier van der Weyden may have been one of Campin's pupils.

☛ Bouts, Van Eyck, Fouquet, Schongauer, Van der Weyden

Robert Campin. Active in Tournai, 1406. **d** Tournai, 1444. **The Virgin and Child before a Fire-screen**. c1425/30. Oil and tempera on panel. **h**63.5 × **w**49.5 cm. **h**25 × **w**19¼ in. National Gallery, London

Canaletto

The Bucintoro Preparing to Leave the Molo on Ascension Day

Seen from across the Basin of St Mark's, the Doge is about to embark on the magnificent state barge, the *Bucintoro*, to celebrate Venice's symbolic Wedding to the Sea, one of the great events of the Venetian calendar. On Ascension Day each year, the Doge would throw a ring into the Adriatic Sea. The event presented the artist with a grand opportunity to show all the pomp and splendour of his native city's festivals. As the leading Venetian landscape painter of his day, Canaletto's works were very popular, especially with the English nobility. Canaletto's acutely observed paintings of Venice's canals and palaces, with their shimmering wealth of detail, even today evoke a romantic view of this beautiful city. Canaletto visited England in 1746, and while there painted a group of landscapes, including views of Warwick Castle, Eton College and Whitehall.

☞ Bellotto, Gentile Bellini, Bonington, Guardi, Pannini

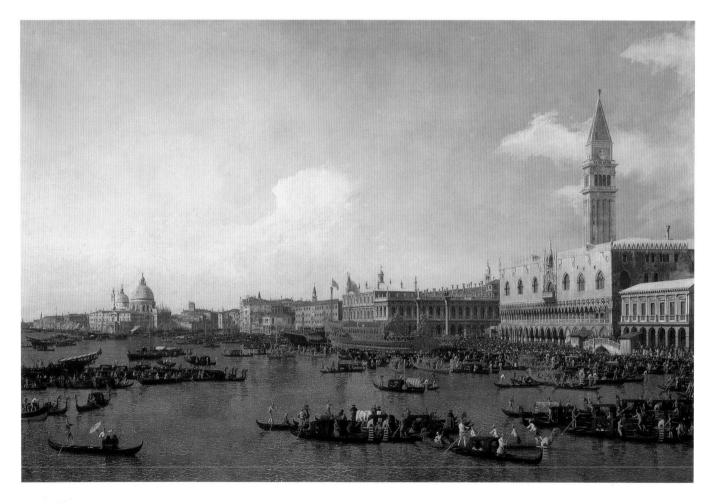

Canaletto (Antonio Canale). b Venice, 1697. d Venice, 1768. **The Bucintoro Preparing to Leave the Molo on Ascension Day**. c1740. Oil on canvas. **h**122 × **w**183 cm. **h**48 × **w**72 in. National Gallery, London

Canova Antonio

Cupid and Psyche

With wings not yet folded, Cupid lands to revive his dying lover Psyche with a tender embrace. The focus of the sculpture is created by their interlocking arms and gaze of love. Their smooth bodies and delicate limbs create a sense of young passion in all its innocent purity; the entire scene is one of effortless, spiralling grace.

Canova's sculpture is a fine example of the Neo-Classical ideal of perfection of form and finish. However, he also was able to express the ardour that pulsates beneath the lovers' thin marble skin. Canova had a distinguished career in his native Venice, where he was commissioned to create public monuments, tombs and statues. He also established a school for young artists. As an emissary of the Pope, he travelled throughout Europe, demanding the return of works of art that were looted during the Napoleonic wars.

☛ Bernini, J-L David, Etty, Powers, Prud'hon, Rodin

Antonio Canova. **b** Possagno, Treviso, 1757. **d** Venice, 1822. **Cupid and Psyche**. 1787/93. Marble. **h**155 cm. **h**61 in. Musée du Louvre, Paris

Caravaggio

Doubting Thomas

It is just after the Crucifixion. St Thomas is touching Christ's wounds to see if they are real. The heads of Christ and the three Apostles are the focus of the composition. The moment is intense, as the Apostles look on St Thomas who, with deeply furrowed brow, plunges his finger into Christ's side. The drama of this shockingly realistic detail is heightened by the harsh lighting and dark shadows (known as *chiaroscuro*); the background is non-existent. Caravaggio was renowned for his vivid realism and rejection of idealization, an approach that was revolutionary at the time. He often used coarse peasant types for his models of saints and Apostles, and is even said to have painted one of his Virgins from a drowned prostitute fished out of the River Tiber. Despite a somewhat dubious personal reputation (he was frequently in trouble with authority), Caravaggio almost singlehandedly brought about a revolution in art. Even today his paintings have the power and immediacy to astonish us.

☛ Bernini, Hals, Jordaens, Rembrandt, Terbrugghen

Michelangelo Merisi da Caravaggio. b Caravaggio, 1571. d Porto Ercole, 1610. **Doubting Thomas**. 1599. Oil on canvas. **h**107 × **w**146 cm. **h**42¼ × **w**57½ in. Stiftung Schlösser und Gärten Potsdam-Sanssouci, Potsdam

Caro Sir Anthony

Rape of the Sabines

Vast and powerful, this conglomeration of metal forms breathes with a life of its own. Part of – yet distinct from – the ground from which it grows, its dynamic planes fuse into one huge whole without form. Caro began making metal sculpture using pre-fabricated objects in 1960. He would lay out industrial objects in patterns that reflected the mood of their title – however remote or ambiguous. Caro wished to bring the spectator into the sculpture by getting rid of the base or pedestal. By laying his works on the ground, and making any supports part of the sculpture itself, he allowed the spectator to come right up close to – even onto – his sculpture. Unlike Henry Moore, under whom he worked as an assistant, Caro did not transform his materials into something else; his welded steelworks keep all their nuts and bolts. The sculpture shown here now stands outside the Metropolitan Life Building in Seattle, Washington.

☛ Andre, Deacon, Moore, Serra, Smith

Sir Anthony Caro. **b** London, 1924. **Rape of the Sabines**. 1985–6. Steel, rusted and varnished. **h**222 × **w**603 cm. **h**87½ × **w**237½ in. Metropolitan Life Building, Seattle, WA

Carpaccio Vittore Two Venetian Ladies on a Balcony

The pearl-covered gowns worn by these two ladies are typical of Venetian nobility in the fifteenth century. The two sit on a balcony, idly toying with the birds and animals around them. The point of the picture is not clear – it is neither a portrait nor a story. It has probably been cut from a larger panel, which would have put it in context and made it more understandable. Carpaccio has a straightforward style. His paintings are not as realistic as those of some of his Florentine counterparts, however, favouring picturesque story-telling over the balanced intellectualism that was gaining ground in that city. His bright colours have all the charm and vibrancy associated with Venetian Renaissance painting. He probably trained with Gentile Bellini and like him often used historical or religious subjects as an opportunity to depict everyday Venetian life.

☛ Alma-Tadema, Gentile Bellini, Canaletto, Giorgione

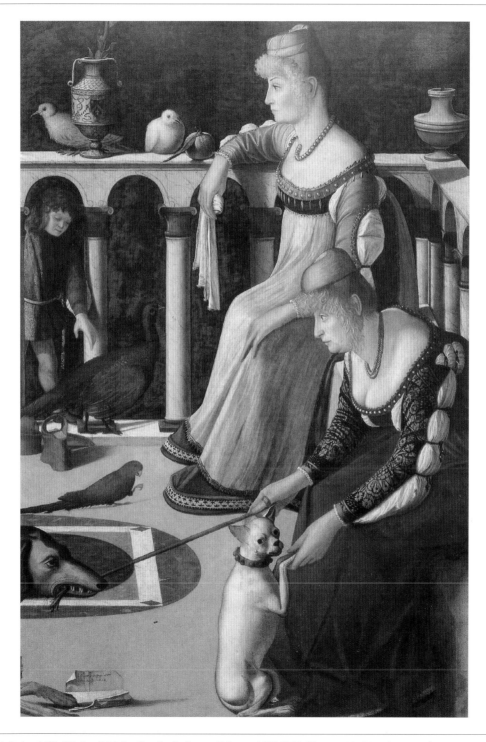



Vittore Carpaccio. Active in Venice, 1472. d Venice, 1526. **Two Venetian Ladies on a Balcony**. c1495/1500. Oil on panel. **h**164 × **w**94 cm. **h**64½ × **w**37 in. Museo Correr, Venice

Carrà Carlo

The Metaphysical Muse

In a low-ceilinged room, the main character is a plaster-cast of a female tennis player with a mannequin head. She stands next to a map of Trieste and Istria; in the background, a brightly coloured geometric cone stands behind a canvas painted with factories. The irrationally juxtaposed and dream-like images are curiously disturbing, and link this painting with the Pittura Metafisica ('metaphysical painting') school. Founded by Carrà and Giorgio de Chirico, Pittura Metafisica used disconnected and mysterious images to create a magical and often weird atmosphere. Carrà had met De Chirico in 1917, and swiftly adopted his imagery of mannequins set in claustrophobic spaces. His work had earlier passed through a Futurist phase; Carrà was one of the signatories to the 1910 Futurist manifesto. From 1924 he turned away from 'Metaphysical' painting towards a more heightened realism, inspired by the Italian masters of the early Renaissance.

☛ Balla, Boccioni, Brauner, De Chirico, Kahlo, Wadsworth

84

Carlo Carrà. b Quargnento, 1881. d Milan, 1966. **The Metaphysical Muse**. 1917. Oil on canvas. **h**89 × **w**65 cm. **h**35 × **w**25⅝ in. Pinacoteca di Brera, Milan

Carracci Annibale Christ Appearing to Saint Peter on the Appian Way

Christ is shown bearing the Cross as he appeared in a vision to St Peter. Upon being asked where he was going, Christ said to St Peter, 'I am going to Rome to be crucified again'. The artist shows great sensitivity to detail in this painting, particularly in the landscape. The harmonious composition and the beautiful figures recall the work of Raphael and Michelangelo, and represent the artist's desire to bring back the Classical spirit to seventeenth-century Rome. His style is characterized by a fusion of naturalism and Classicism. In a letter he spoke of his admiration for Correggio and Titian: 'I like this straight-forwardness and this purity that is not reality and yet is life-like and natural, not artificial or forced.' With his brother Agostino and cousin Lodovico, Annibale Carracci founded an important academy of fine arts in Bologna in 1595. The academy trained a number of artists, many of whom were to form the great school of seventeenth-century Baroque Bolognese painting.

☛ Correggio, Michelangelo, Raphael, Reni, Titian, Vouet

Annibale Carracci. b Bologna, 1560. **d** Rome, 1609. **Christ Appearing to Saint Peter on the Appian Way**. 1601–2. Oil on panel. **h**77.4 × **w**56.3 cm. **h**30½ × **w**22 in. National Gallery, London

Cassatt Mary

Woman Sewing

The woman here has been caught in a quiet moment as she does her sewing. It is not a portrait, but a study in the interplay of colour and light in an outdoor scene, which would have been painted from life. The artist's realistic approach stems from her studies at the Pennsylvania Academy under Thomas Eakins. Later, in Europe, Cassatt formed a close association with Edgar Degas, who had a great influence on her style. Cassatt exhibited with the Impressionists at their 1874 show and although an American, she is classified as part of the French Impressionist movement. Many of her paintings show mothers with children, painted with a feminine tenderness not found in other Impressionist work. Cassatt was very influenced by Japanese woodcuts, and excelled in making woodcut prints. She is widely credited with popularizing Impressionism in North America.

☛ Chase, Degas, Eakins, Hiroshige, Monet, Morisot

Mary Cassatt. **b** Pittsburgh, PA, 1844. **d** Mesnil-Beaufresne, 1926. **Woman Sewing**. c1880/2. Oil on canvas. **h**92 × **w**63 cm. **h**36¼ × **w**24⅞ in. Musée d'Orsay, Paris

Castagno Andrea del The Young David

Bold power and strength characterize this image of David with the head of Goliath. These were qualities that were highly valued by Florentines at the time; they identified with the young, spirited warrior who overcame the huge giant with a sling-shot. The image is painted on a leather shield, to be carried through the streets of Florence during festive processions. Artists in fifteenth-century Italy made such decorations regularly. However, because they were not made to last, most examples have not survived to the present day. Castagno is known for his strong, powerful figures. He painted a number of frescos, which in particular reflect his sculptural approach to painting. He did not pay much attention to either landscape or nature, choosing to focus on the human form. Castagno was at one time thought to have brutally murdered his teacher. We now know this story to be untrue, but it may reflect the artist's violent nature.

☛ Botticelli, Donatello, Ghiberti, Ghirlandaio, Signorelli

Andrea del Castagno. b Castagno, c1421. d Florence, 1457. **The Young David**. c1450/57. Tempera on leather mounted on panel. **h**115.6 × **w**76.9 cm. **h**45½ × **w**30¼ in. National Gallery of Art, Washington, DC

Catena Vincenzo

The Supper at Emmaus

The artist has used a straightforward composition to highlight a simple meal. The table, glassware and setting have all been kept to a minimum. All, that is, except the cloth that hangs behind Christ. The simplicity of the picture contrasts with the elaborate cloth, drawing the viewer's attention to the Saviour. The Cloth of Honour, as it is known, is a feature of other Venetian Renaissance paintings and can be found, for example, in many works by Giovanni Bellini, particularly in his paintings of the Virgin. As with many Venetian paintings of the time, colour and light are as important to this picture as its composition: the play between the blue and yellow of the servant's clothes and the yellow and purple of the man on the right shows the artist's inventive colour sense. Catena appears to have entered into some kind of partnership with Giorgione at one stage in his career. His works show the influence not only of Giorgione but of other Venetian artists such as Titian and Palma Vecchio.

☛ Giovanni Bellini, Champaigne, Giorgione, Palma Vecchio, Titian

Vincenzo Catena. **b** Venice, c1480. **d** Venice, 1531. **The Supper at Emmaus**. 1520/30. Oil on canvas. **h**130 × **w**241 cm. **h**51 × **w**94¾ in. Galleria degli Uffizi, Florence

Catlin George

Ambush for Flamingoes

Creating a pretty red-and-white pattern along a plain stretching out to the horizon, a flock of flamingoes attend to their nests. Overhead a group of birds fly in a looping formation across the sky. A hunter and his servant lurk behind a bush, waiting for the perfect moment to shoot. The hunter is meant as a reminder of how the beauty of nature can so swiftly be destroyed by man. Catlin has taken great care in presenting the flamingoes in different poses, so as to express variety and movement and to create rhythm in a painting that is otherwise fairly rigid. A lawyer by training, Catlin turned to portrait painting and spent many years studying and living among the Indians of North and South America. He painted many portraits of native American Indians, and was an early campaigner for the preservation of Indian tribes. In 1841 he published *Manners…of the North American Indians*, illustrated with some 300 of his engravings.

☛ Allston, Audubon, Bingham, Cole

George Catlin. **b** Wilkes-Barre, PA, 1796. **d** Jersey City, NJ, 1872. **Ambush for Flamingoes**. c1857. Oil on canvas. **h**48.3 × **w**67.3 cm. **h**19 × **w**26½ in. Carnegie Museum of Art, Pittsburgh, PA

Cellini Benvenuto — Salt Cellar

This beautiful salt cellar is made of two figures – Neptune and Ceres, who represent Water and Earth. Their intertwined legs symbolize the combination of these elements, which together produce salt. Cellini was a celebrated goldsmith, sculptor and engraver. He worked for emperors, kings, popes and princes; this particular object was made for King Francis I of France. The splendour and grace of Cellini's work is a perfect example of the Mannerist school. The aim of these artists was to appeal to the emotions through aesthetic effect. This led to the use of elongated figures and sharp colours, as can be seen in the work of late sixteenth-century artists. A great deal is known about Cellini's tempestuous life from his autobiography, which is full of racy anecdotes such as an account of his imprisonment for stealing the papal crown jewels. Unfortunately, most of Cellini's smaller works – medals, cups and daggers – were melted down. Many of his larger masterpieces, however, have survived.

☛ Clouet, Giambologna, Parmigianino, Rosso Fiorentino

90

Cézanne Paul Mont Sainte-Victoire

Purples, blues, yellows and reds create this mountain in the South of France. Rather than altering the tones of the colours as they changed with the light and shade, Cézanne changed the colours themselves. The mountain and surrounding landscape have been simplified into geometrical shapes and planes of colour. The result is a painting that may not faithfully reproduce the scene, but which evokes its tones and volumes through the interplay of light and shade. Cézanne said that he 'wanted to do Poussin again, from Nature'. He achieved this by combining direct studies of the landscape with a Classical sense of form. Mont Sainte-Victoire, near the artist's home town of Aix-en-Provence, was Cézanne's favourite subject. He returned to it again and again throughout his career, producing paintings that were increasingly radical in conception. His reduction of nature into simple geometric shapes, and his use of bold colours, point to the later work of the Cubists and the Fauves.

☛ Braque, Derain, Hodler, Picasso, Poussin, Vlaminck

Paul Cézanne. b Aix-en-Provence, 1839. d Aix-en-Provence, 1906. **Mont Sainte-Victoire**. 1885/95. Oil on canvas. **h**72.8 × **w**91.7 cm. **h**28⅝ × **w**38⅛ cm. Barnes Foundation, Merion, PA

Chagall Marc

Above the Town

Above a town made up of simple wooden houses and barns, two fantastical figures fly across the sky. The man's hand gently cups the woman's breast. They seem to be lovers, perhaps eloping. The quaint and naively ordered town, painted in blocks of colour, with its pretty wooden fencing and warmish tones, shows Chagall's interest in fairy-tales and fantasy. Chagall was born in Russia and much of his imagery is firmly rooted in the Jewish folklore of his early years. His style is both sophisticated and childlike, blending reality and dreams into colourful compositions. He was compelled to leave Russia because the state demanded a certain type of art, and came to divide his time between the USA and France. He was a very productive artist, painting and designing mosaics, stage sets and tapestries. His works can be found in many public buildings, including the Paris Opéra and the UN Headquarters in New York.

☛ Gontcharova, Hodgkin, Rodin, Soutine, Utamaro

Marc Chagall. b Vitebsk, 1887. d Saint Paul-de-Vence, 1985. **Above the Town**. 1915. Oil on canvas. **h**48.5 × **w**70.5 cm. **h**19¼ × **w**27¾ in. Private collection

Champaigne Philippe de The Last Supper

Christ announces to the Apostles that one of them will soon betray him. A mysterious air pervades the scene. The only light in the picture falls from the window, barely illuminating the back wall. This sets the figures in relief and heightens a feeling of drama and tension. While Christ consecrates the bread, the Apostles express their feelings without words. The rich colour of the draperies and the rhythmic folds of the tablecloth help the viewer's eye move across the picture. Champaigne did not paint dramatic scenes like his contemporary artists of the Italian Baroque, but the dignified, restrained emotions expressed in his work are rich and powerful. Of Flemish origin, Champaigne became a naturalized Frenchman, working as a portrait painter at the Court of King Louis XIII of France. One of his most well-known paintings is a full-length, austere study of Cardinal Richelieu.

☛ Catena, G David, Domenichino, Guercino

Philippe de Champaigne. b Brussels, 1602. **d** Paris, 1674. **The Last Supper**. c1652. Oil on canvas. **h**158 × **w**233 cm. **h**62⅕ × **w**91¾ in. Musée du Louvre, Paris

Chardin Jean-Baptiste-Siméon The Young Schoolmistress

The subject is simple: a young woman teaching a child to read. Painted with great honesty, in a simple and direct style, the artist conveys a strong emotional link between the two figures. There is little background detail, and the thickly layered but carefully planned brushstrokes create depth and solidity. It is a silent painting, similar in its timelessness to the work of Jan Vermeer. Only the key of the cabinet breaks the magical spell of serenity and repose. Chardin was a leading painter of genre and still-life scenes in eighteenth-century France. His simple, unsentimentalized compositions are rich in feeling; with their calm, balanced tonal range they embody an acute analysis and understanding of form. In this century, Chardin's work has regained popularity because of its almost abstract nature. He is widely considered to be the greatest still-life painter of his day.

☞ De Hooch, Lancret, La Tour, Metsu, Vermeer

94

Jean-Baptiste-Siméon Chardin. b Paris, 1699. d Paris, 1779. **The Young Schoolmistress**. c1736/7. Oil on canvas. **h**62 × **w**66 cm. **h**24¼ × **w**26⅛ in. National Gallery, London

Chase William Merritt A Friendly Visit

Two elegant women sit on a sofa exchanging chit-chat. Sunlight fills the room, lightening the tone of the artist's bright palette. This is not a formally posed scene, but one typical of everyday life. Like the Impressionists, Chase used loose brushwork and pastel colours to portray the world around him. The informality of his subjects and the vigour with which he painted them may be particularly North American characteristics, but they have been injected into an essentially European style. Chase worked in North America throughout his long and active career. He was particularly influenced by the painter James McNeill Whistler, and for a time adopted that artist's flat, decorative style. He even painted Whistler's portrait when he met him in London in 1885. Chase was particularly admired for his portraits, landscapes and the type of everyday scene shown here. He was also a highly influential teacher.

☞ Cassatt, Manet, Sargent, Tissot, Whistler

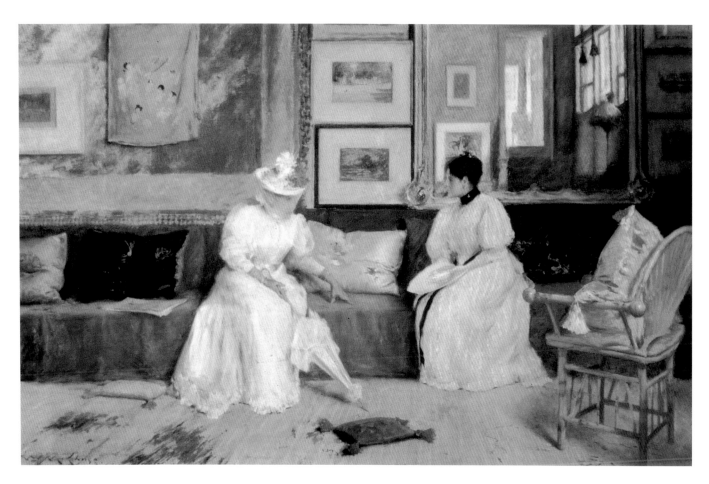

William Merritt Chase. **b** Williamsburg, IN, 1849. **d** New York, NY, 1916. **A Friendly Visit**. 1895. Oil on canvas. **h**76.8 × **w**122.5 cm. **h**30¼ × **w**48¼ in. National Gallery of Art, Washington, DC

De Chirico Giorgio The Uncertainty of the Poet

A pile of bananas and a Classical plaster-cast of a female torso appear in front of an arcade. The horizon is defined by a wall. Behind this, a train disappearing into the distance can just be seen. Such a collection of objects may appear arbitrary and nonsensical, but each has a symbolic meaning: the plaster-cast symbolizes a human presence;

the bananas represent exoticism; the train, a voyage. The outlines of all this strange imagery are drawn with vigour. However, it is the shadows, monumental and menacing as they sweep across the picture, that add power and mystery. De Chirico and Carlo Carrà founded a movement called Pittura Metafisica ('metaphysical painting') that was known

for its imaginative and mysterious imagery. De Chirico's enigmatic, dream-like paintings profoundly influenced the Surrealists of his day. From 1925, however, he adopted a more traditional style and his later paintings included portraits, horses on the seashore and still lifes.

☞ Carrà, Dalí, Delvaux, Magritte, Tanguy, Wadsworth

96

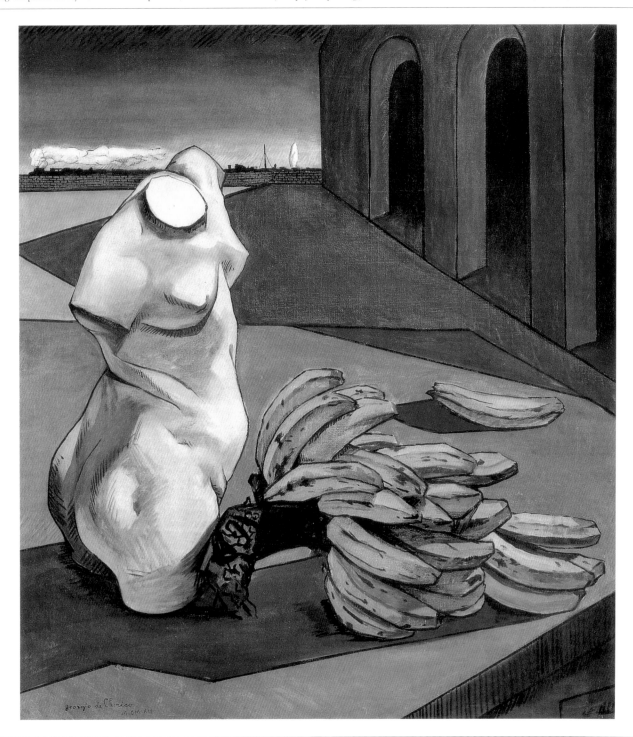

Giorgio de Chirico. b Volo, 1888. d Rome, 1978. **The Uncertainty of the Poet**. 1913. Oil on canvas. **h**106 × **w**94 cm. **h**41¾ × **w**34 in. Tate Gallery, London

Christo and Jeanne-Claude

The Pont Neuf Wrapped, Paris

The environmental sculptor Christo has become world-famous for wrapping things up. Shown here is the massive sculptural work he created by wrapping one of the great landmarks of Paris – the Pont Neuf – in woven nylon, secured by rope. The temporary transformation of the bridge into a work of art was an exciting new way of creating sculpture. By covering it in fabric, the artist drew people's attention to the sculptural details of the bridge, while also creating a majestic and mysterious object of beauty. It also served to emphasize the importance of preserving such historical monuments. Christo's work encourages us to look at objects in a new and different way. This notion of transforming familiar objects is typical of the New Realists, a movement founded in 1960. Born in Bulgaria, Christo moved to New York in 1964 and later became an American citizen. In 1976 he completed *Running Fence*, comprising 40 km (25 miles) of white fabric running over the Californian hills.

☞ Gentile Bellini, Buren, Hiroshige, Klein, Long

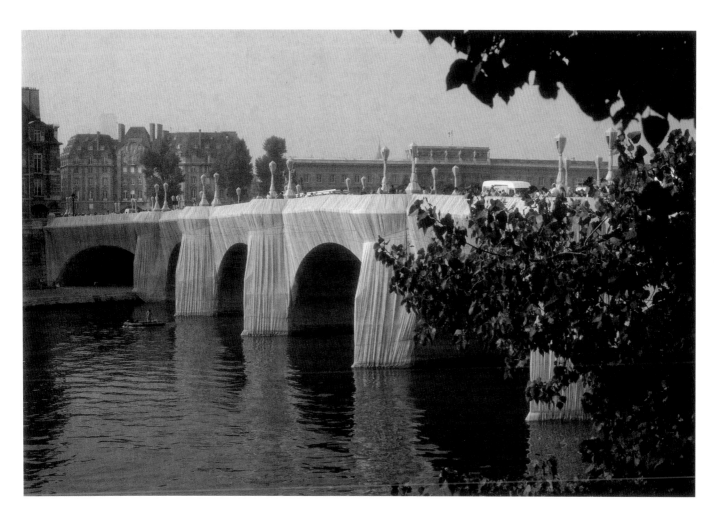

97

Christo and Jeanne-Claude. Christo Javacheff. **b** Gabrovo, 1935. Jeanne-Claude de Guillebon. **b** Casablanca, 1935. **The Pont Neuf Wrapped, Paris**. 1975–85. The Pont Neuf wrapped in woven nylon fabric and rope

Church Frederick

Twilight in the Wilderness

The sun sets over the distant horizon, leaving behind a blood-red and orange sky reflected in a wide river. Gnarled tree branches stand out against the background like skeletons. Church has revealed the power of nature in all its glory. The only pupil of Thomas Cole, Church chose to banish man from his compositions and concentrate on nature in its purest state. After exploring his native New England, he went in search of dramatic and panoramic landscapes further afield. Unusually, for the time, he did not choose to go to Europe. Instead he explored the American continent: the volcanoes of Mexico, the tropical jungles of South America, the snow-covered peaks of the Andes and the icebergs of Labrador. Church recorded uncharted marvels with amazing skill, changing the texture of his paints, for example, according to different natural forms. The epic grandeur and sublime drama evoked by his work epitomize the ideals of the Romantic movement.

☛ Cole, Friedrich, Grimshaw, Martin, Turner

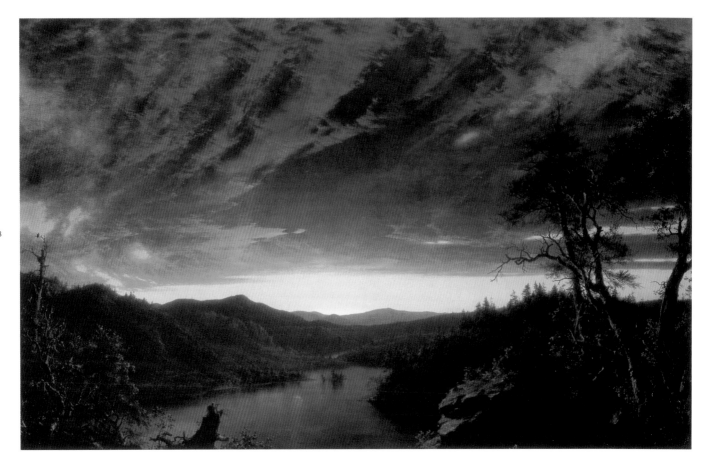

Frederick Church. b Hartford, CT, 1826. d New York, NY, 1900. **Twilight in the Wilderness**. 1860. Oil on canvas. **h**101.6 × **w**126.6 cm. **h**40 × **w**49⁷⁄₈ in. Cleveland Museum of Art, Cleveland, OH

Cimabue

The Santa Trinità Madonna

Originally gracing the high altar of the church of Santa Trinità in Florence, this image was intended to inspire contemplation and devotion. The Virgin and Child sit on an ornate throne flanked by graceful angels. Below, four bearded prophets look out from an arcade as they, too, contemplate the divine image. The picture's simplicity and abundance of gold leaf would have helped to make it more visible in the dark church. The fine gold lines in the Virgin's robe are reminiscent of the rigid Byzantine style, yet the artist's attempt to put the figures in some kind of three-dimensional space points towards developments that were to flower during the Renaissance over a century later. Cimabue's origins are obscure. He is also known for his magnificent figure of St John – part of a large mosaic in the apse of Pisa Cathedral. Legend has it that he taught Giotto, who in turn developed Cimabue's naturalistic approach to painting the human form.

☛ Campin, Duccio, Giotto, Lochner

Cimabue. Active in Florence, 1272. d Florence, 1302. **The Santa Trinità Madonna**. c1260/80. Tempera on panel. **h**385 × **w**223 cm. **h**151½ × **w**87¾ in. Galleria degli Uffizi, Florence.

Claesz Pieter

A Vanitas Still Life

A human skull dominates this odd array of objects. Bathed in warm tones, with a ray of sunlight sweeping across them, the objects are painted in shades of pale brown. The artist was renowned in the Netherlands for still lifes such as this. These were often painted in almost monochrome tones, lending a sense of mystical harmony to the objects he depicted. The theme of this work is the transience of earthly life: the skull represents death; the overturned glass symbolizes life flowing away; the watch reminds the viewer that time is forever moving on. Dutch seventeenth-century painters delighted in the depiction of everyday objects, often treated with great illusionistic skill. Such paintings were not overtly moralizing in tone, but would often be rich with symbolic meanings that would have been readily understood at the time. Today, these paintings are more commonly admired for their sheer virtuosity.

☛ Hals, De Heem, Kalf, Ruysch, Snyders

Pieter Claesz. **b** Burgsteinfurt, 1590. **d** Haarlem, 1661. **A Vanitas Still Life**. 1645. Oil on panel. **h**39 × **w**61 cm. **h**15⅓ × **w**24 in. Private collection

Claude Lorrain

Landscape with a Sacrifice to Apollo

This magnificent, spacious scene is an example of Classical landscape painting at its best. It is carefully constructed, using a balance of strong horizontals and verticals, while areas of light and shade help to move the viewer's eye across and into the scene. Claude has captured the solemn grandeur of the Roman countryside. The delicate atmosphere is developed from a careful colour-range of greens, blues and browns. The figures, representing a scene from Classical mythology where Psyche's father makes a sacrifice to invoke Apollo's help in finding a husband for his daughter, are almost incidental to the setting. Claude was a Frenchman, but spent his long creative life in and around Rome. His pastoral scenes and the poetry of his vision were a source of great inspiration to English eighteenth- and nineteenth-century landscape painters. Upon seeing the painting shown here, J M W Turner remarked that it seemed 'beyond the power of imitation'.

☛ Allston, Constable, Cozens, Poussin, Turner

Claude Lorrain (Claude Gellée). b Nancy, 1600. d Rome, 1682. **Landscape with a Sacrifice to Apollo**. 1662. Oil on canvas. **h**176 × **w**223 cm. **h**69 × **w**87¾ in. Anglesey Abbey, Lode

Clemente Francesco

Self-portrait: The First

The naked artist fixes his penetrating gaze on the viewer, who feels compelled to return his look. A host of different birds rest on the artist's shoulders. The first in Clemente's series of large, calligraphically rendered drawings of himself, this picture illustrates the artist's almost erotic drive towards self-exploration and self-exposure. The figure is treated in an expressive manner, while the birds symbolize the supremacy of subjectivity and imagination over reason. The work is an example of the Neo-Expressionist trend known as Transavanguardia, which focuses on expressive figurative work done on a large scale. Towards the end of the 1970s Clemente and other Italian Neo-Expressionists largely led the way in reviving figure painting. This revival may be seen partly as a reaction to non-figurative Abstract Expressionism, which had dominated the art scene for many years.

☛ Baselitz, Dürer, Kiefer, Kirchner, Pollock, Schiele, Schnabel

Francesco Clemente. b Naples, 1952. **Self-portrait: The First**. 1979. Gouache, watercolour and ink on paper mounted on canvas. **h**112 × **w**147 cm. **h**44⅛ × **w**57⅞ in. Private collection

Clouet François

Portrait of François I on Horseback

Sitting astride an ornately decorated horse and dressed in an equally splendid suit of armour, François I of France looks at us with a slightly bemused expression on his face. Clouet is renowned for his powers of observation and detailed technique. Here he has rendered the intricate patterns of the King's attire with dazzling precision,

especially the heads on his kneecap and elbow and the figures on his arms and chest. Clouet has not only paid homage to his master by depicting him in all his finery but has placed the horse and rider on the top of a hill with a landscape stretching behind him to imply that his King was ruler of an extensive kingdom. Clouet was a

prolific painter of royal portraits. He was Court painter to four Kings of France – François I, Henri II, François II and Charles IX – and achieved great fame for his ceremonial portraits and striking drawings.

☛ Van Dyck, Van Eyck, Géricault, Holbein, Lawrence

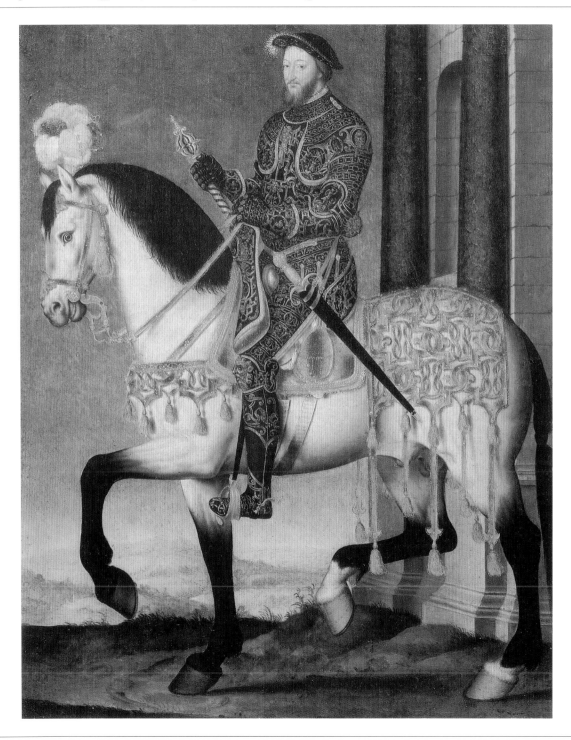

François Clouet. **b** Tours, c1522. **d** Paris, 1572. **Portrait of François I on Horseback**. c1540. Oil on panel. **h**27 × **w**22 cm. **h**10.6 × **w**8.7 in. Galleria degli Uffizi, Florence

Cole Thomas

Scene from Last of the Mohicans

Massive outcrops of rock overwhelm a circle of small figures in this craggy, mountaintop scene bathed in an autumnal glow of warm colours. The artist has taken great care to show every natural detail, evoking the awe-inspiring vastness of the American wilderness. The picture illustrates a scene from James Fenimore Cooper's *The Last of the*

Mohicans. Cole is considered the leading painter of the Hudson River School. This group of painters, who worked mainly around New England, were fond of river and mountain scenes untouched by man – particularly by Europeans. Cole aimed to bring religious and moral meaning to his paintings. He once wrote that 'the wilderness

is yet a fitting place to speak of God', and after converting to Anglicanism, his painting became increasingly religious in feeling. He visited England, France and Italy, but was not greatly influenced by what he saw there. His paintings had a strong Romantic quality, full of drama and grandeur.

☛ Allston, Bierstadt, Church, Cozens, Friedrich

104

Constable John The Lock

A man struggles to open a lock, as his companion tries to hold a barge still in a current of surging water. With its silvery highlights and rich colouring, this picture is a celebration of the freshness and beauty of nature. Perhaps more than any other landscape painter, Constable sought to express his love of the open countryside. Through an apparently spontaneous use of colour and rapid brushstrokes he was able to capture the fleeting mood of a scene. Behind these speckled, flecked bits of paint, however, lies a carefully composed structure. Constable enrolled at the Royal Academy in 1799 and for the first decade of his painting career he failed to sell any work in England. This was not the case in Paris, however, where his paintings were accepted with enthusiasm. Constable's landscapes had a strong influence on French landscape painting, and his swift gestures and use of light to create a particular mood were an inspiration to the Impressionists.

☛ Corot, Daubigny, Hobbema, T Rousseau, Ruisdael, Turner

John Constable. **b** East Bergholt, 1776. **d** London, 1837. **The Lock**. c1824. Oil on canvas. **h**142 × **w**120 cm. **h**56 × **w**47½ in. Fundación Colección Thyssen-Bornemisza, Madrid

Copley John Singleton The Death of Major Pierson

The limp body of Major Pierson is held by his generals as his life slowly ebbs away. His furious black servant fires back at the enemy. The painting portrays the English repelling a French invasion on Jersey in 1781. A truly dramatic scene, it is symmetrically composed, clearly lit and described in great detail. Copley colourfully chronicles the heroism of the young officer killed in the service of a country whose flags are patriotically waving overhead. Copley first established his reputation as a portrait painter, becoming known for his direct, precise style and ability to capture the essence of his sitters. In 1774 he left America and settled in England, embarking upon a career as a history painter. Copley was among the first to treat subjects from modern history – such as *The Death of Major Pierson* – in the grand manner usually reserved for Classical subjects.

☞ David, Delacroix, Uccello, West

John Singleton Copley. b Boston, MA, 1738. d London, 1815. **The Death of Major Pierson**. 1782–4. Oil on canvas. **h**252 × **w**366 cm. **h**99 × **w**144 in. Tate Gallery, London

Cornell Joseph Untitled

A frugal assortment of stamps, newspaper cuttings and other objects with no particular relevance to each other is placed in a wooden box. This container acts as a metaphor for the whole world, inhabited by these strange items. It is also a treasury of curiosities that is compelling to explore and evokes a mood of nostalgia. The fragments of once ornamental or beautiful objects come together in a magical and dream-like way. This is Cornell's genius, and why he has proved so popular over the years. The randomness of these 'assemblages', as they are known, reflects Cornell's interest in the irrationality of Surrealism. Nevertheless, a sense of order and precision pervades pieces such as this. Of his own work Cornell once said, 'Shadow boxes become poetic theatres or settings wherein are metamorphosed the elements of a childhood pastime.'

☛ Blake, Brauner, Rauschenberg, Schwitters

Joseph Cornell. b Nyack, NY, 1903. **d** Flushing, NY, 1972. **Untitled**. c1950. Mixed media in a wooden box. **h**38 × **w**27 cm. **h**15 × **w**10½ in. Private collection

Corot Jean-Baptiste-Camille Ville d'Avray

In this landscape of great delicacy, soft pastel tones and feathery trees evoke a dreamy, dewy, early-morning atmosphere. A pale, silvery sky is reflected in the lake, and the sun shining on the houses to the left recalls Corot's oil sketches of Italian buildings. Corot's father bought a country house in 1817 at Ville d'Avray near Paris, the site

of this painting. Throughout his long career he continued to paint the scenery in the area. Corot was one of the greatest landscape painters of the nineteenth century. His work spanned practically the entire century, and he was inspired by and inspired generations of painters. His grounding in the academic tradition, together with his

clear, fresh vision, have led him to be called the 'last of the Classical landscapists, and the first of the Impressionists'. Indeed, aspects of his later paintings can be seen in the work of Alfred Sisley and Claude Monet. Corot is thought to have painted around 3,000 canvases during his career.

☛ Boudin, Claude, Daubigny, Monet, Pissarro, Sisley

Jean-Baptiste-Camille Corot. **b** Paris, 1796. **d** Paris, 1875. **Ville d'Avray**. c1867/70. Oil on canvas. **h**49 × **w**65 cm. **h**19½ × **w**25½ in. National Gallery of Art, Washington, DC

Correggio

The Nativity

Christ illuminates this painting with a divine light, a light so bright that the woman at his feet has to shield her eyes from its glare. The asymmetrical composition of the scene is full of movement. The staff of the shepherd leads the viewer's eye into the composition, directing it up towards the angels, who in turn point down towards the child. This vibrant picture is typical of Correggio's late style. The movement and drama of the work look forward to the seventeenth-century Baroque style. Best known for his paintings executed in cupolas and the ceilings of churches, Correggio aimed to give the viewer the sensation of looking up into the glory of Heaven.

One of his greatest works is a fresco on the inside of the dome of the church of St John the Evangelist, Parma, which is a dizzying mass of swirling figures. Correggio worked for most of his life in Parma, where he was one of the city's outstanding painters.

☛ Carracci, Caravaggio, Elsheimer, Parmigianino

Correggio (Antonio Allegri). b Correggio, c1489. d Correggio, 1534. **The Nativity**. 1530. Oil on panel. **h**256 × **w**188 cm. **h**100¾ × **w**74 in. Staatliche Kunstsammlungen, Dresden

Del Cossa Francesco May

It is May. Apollo the sun god sits atop a chariot, presiding over courtiers, cherubs and gentlemen. The nudes below represent the astrological sign of Gemini. This pageant is one in a series of 12 frescos that cover the walls of the Sala dei Mesi ('room of the months') in the palace of the Duke Borso d'Este in Ferrara. Del Cossa was commissioned with other artists to depict the activities of the Court throughout the year by using astrological signs and deities. The fresco is painted in bright colours, in a slightly unrealistic style that is typical of Del Cossa and his fellow artists of that area. The principles of perspective, important to Florentine art of that time, do not seem to have been used. We know that Del Cossa, upset that he had been underpaid for his work on the fresco cycle, lodged a letter of complaint with the Duke. He subsequently left Ferrara and spent the rest of his days in Bologna.

☛ Limbourg, Mantegna, Piero della Francesca

110

Francesco del Cossa. b Ferrara, c1435. **d** Bologna, c1478. **May**. 1470s. Fresco. **h**319 × **w**320 cm. **h**125½ × **w**126 in. Palazzo Schifanoia, Ferrara

Courbet Gustave

Bonjour, Monsieur Courbet

In May 1854 Courbet arrived at Montpellier as the guest of Alfred Bruyas, an important patron and collector of the arts. Courbet has shown himself with a walking-stick and knapsack at the moment he was met on the road by his host, his servant and dog. Courbet's choice of subject, painted with stark realism and honesty, caused a great stir when the painting was exhibited at the Paris World Exhibition of 1855. Soon Courbet was heralded as the champion of a new, anti-intellectual type of art that was free from the shackles of academic history and religious painting. In turning away from literary subjects to the natural world around him, Courbet was an important influence on Édouard Manet and the Impressionists. When asked to include angels in a painting for a church, he is said to have replied, 'I have never seen angels. Show me an angel and I will paint one.'

☛ Daubigny, Manet, Millet, T Rousseau

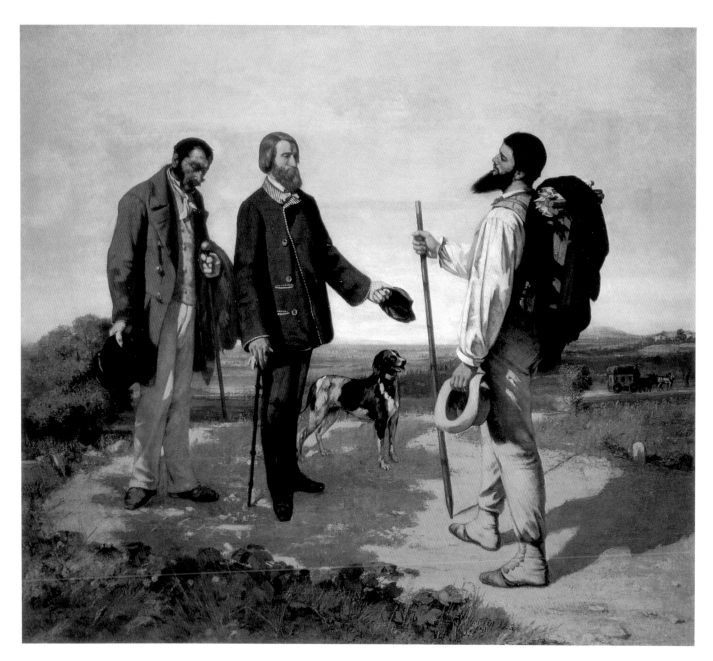

Gustave Courbet. b Ornans, 1819. d Tour de Peitz, 1877. **Bonjour, Monsieur Courbet**. 1854. Oil on canvas. **h**129 × **w**149 cm. **h**50¾ × **w**58¾ in. Musée Fabre, Montpellier

Cozens John Robert Between Chamonix and Martigny

A traveller on horseback and his companion cross a pass above the tree-line in the French Alps. Their diminutive size and inconsequence are stressed by the overhanging rock above them and the monumentality of the spiked, snowy summit of the Aiguille Verte. From 1776 to 1779 Cozens travelled through Switzerland to Italy via the Alps and was overawed by the all-powerful presence of these mountains. A melancholy and poetic painter, Cozens' restricted palette of subdued colours evokes the magnitude of space and the unassailability of nature. Cozens is considered one of the most talented English landscape painters of the eighteenth century. He had a marked influence on J M W Turner and John Constable; the latter claimed that he was the 'greatest genius that ever touched landscape'. Cozens painted landscapes in watercolour almost exclusively; he is known to have executed only two works in oil, one of which is now lost.

☛ Church, Constable, Friedrich, Martin, Turner

John Robert Cozens. b London, 1752. **d** London, 1797. **Between Chamonix and Martigny**. c1776/9. Watercolour on paper. **h**43.5 × **w**61.6 cm. **h**17⅛ × **w**24¼ in. Private collection.

Cragg Tony

Eroded Landscape

The artist has concocted an urban landscape out of a collection of containers of frosted glass. The group of objects has been arranged to evoke feelings of both familiarity and strangeness. The glass shelf could be found in any home. It too might be displaying objects that mean something to their owner, but not to the viewer. The two large vases at the bottom right and left support the structure and give the composition amazing symmetry and stability. The entire composition takes on the feel of a Greek temple, so stabilizing is their influence. Cragg has specialized in the arrangement of industrial objects. His works are an exploration of the space between reality and the imagination. His compositions frequently evoke the idea of consumer waste, yet they are often arranged with a delicate sense of poetry, and a sensitivity to the beauty of still life.

☛ Bourgeois, Caro, Deacon, Morandi, Smith

Tony Cragg. b Liverpool, 1949. **Eroded Landscape**. 1992. Glass. **h**43 × **w**132 cm. **h**16⅞ × **w**51⅞ in. Lisson Gallery, London

Cranach Lucas the Elder Venus

Venus wears only an elaborately jewelled hairnet and necklaces. She is coyly holding a diaphanous veil and looks out seductively at the viewer. Her body is idealized, perhaps because artists at this time rarely used live female models. Nude women were not often shown unless they appeared in a narrative scene or as mythical goddesses.

Cranach seems to have ignored the Classical spirit of the day, and for this reason his nudes sometimes seem almost primitive. The choice of a mythological rather than a religious subject for this picture may have been because the patron was Protestant. We know little about Cranach other than that his influence in Protestant Germany was

widespread. He seemed to appear suddenly, and produced his best work early in his long career, thereafter leading the easy life of a Court painter. He is called Lucas the Elder because he was the first in a dynasty of artists who carried on his traditions and style.

☞ Baldung, Dürer, Grünewald, Leighton

114

Lucas Cranach the Elder. **b** Kronach, 1472. **d** Weimar, 1553. **Venus**. 1532. Oil on panel. **h**37 × **w**25 cm. **h**14½ × **w**9⅞ in. Städelsches Kunstinstitut, Frankfurt

Cuyp Aelbert

Cattle with Horseman and Peasants

This peaceful country scene is bathed in the golden glow of evening. The warm light permeates every detail of the composition and creates a luminous effect, very different from the cool blues and greens of Cuyp's contemporaries such as Meindert Hobbema. The apparently random placement of the animals was in fact closely studied by the artist in order to show the play of light and shade on the cows, which almost appear to radiate the light of the sun. Cuyp is considered one of the most important seventeenth-century Dutch landscape painters and was influenced by Jacob van Ruisdael and Jan van Goyen in their close scrutiny of nature. He is particularly admired for his river and town views, which he painted mainly in and around his native Dordrecht. Cuyp's landscapes were first appreciated and bought by British collectors in the late eighteenth century. As a result he has since then had an incalculable effect on British art.

☛ Bierstadt, Claude, Daubigny, Van Goyen, Hobbema, Ruisdael

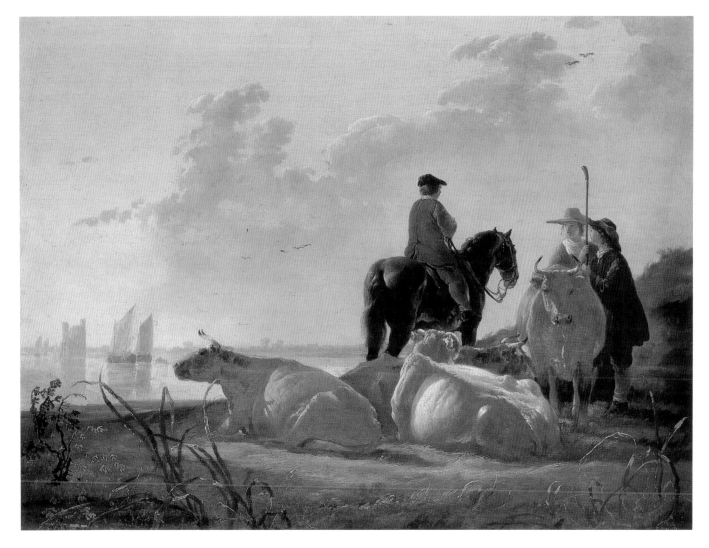

Aelbert Cuyp. b Dordrecht, 1620. d Dordrecht, 1691. **Cattle with Horseman and Peasants**. c1650. Oil on panel. **h**38.1 × **w**50.8 cm. **h**15 × **w**20 in. National Gallery, London

Dalí Salvador

Sleep

In this fantastic interpretation of sleep, only the head of the dreamer is seen, against a background of dream-like images. The delicate balancing of the figure indicates that, should a single crutch fail, the dreamer will awake; this demonstrates the fragility of the state of sleep. Dalí's meticulous attention to detail creates an atmosphere of enhanced hyper-reality. As a member of the Surrealist movement, he promoted the idea of absurdity and the role of the unconscious in his art. Dali also collaborated with the film-maker Luis Buñuel on films such as *Un Chien Andalou* and *L'Age d'Or*, which are still regarded as landmarks in the history of the cinema. Although he frequently provoked public outrage, Dalí's reputation and contribution to art are undeniable. Having worked in Paris and New York, Dali returned to his native Spain in 1955, settling there with his long-time companion, Gala, of whom he painted many weird and wonderful pictures.

☛ Bosch, Bellmer, Brauner, Delvaux, Kahlo, Magritte, Tanguy

Salvador Dalí. **b** Figueras, 1904. **d** Barcelona, 1989. **Sleep**. 1937. Oil on canvas. **h**50.8 × **w**78.2 cm. **h**20 × **w**30¾ in. Private collection

Daubigny Charles-François The Lock at Optevoz

In this quiet contemplation of nature, a shepherdess with her dog is attending to a herd of cows by a lock. It is painted with a smooth, creamy technique and predominantly cool tones. This dreamy landscape retains its freshness by Daubigny's close observation of nature; indeed, he executed a full-sized sketch of the scene on site. In this way, he was one of the earliest to paint outdoors (*en plein air*), a method that the Impressionists were later to adopt and to develop to its furthest extreme. Daubigny's ideals and manner of painting were that of the Barbizon School, who favoured simple, rustic scenes, painted with vigour and immediacy. However, in changing this scene into one of atmospheric nostalgia Daubigny shows the influence of Camille Corot, who was a great friend. It was Daubigny's vision that later helped to pass on Corot's genius to the Impressionists.

☛ Bingham, Boudin, Constable, Corot, Pissarro, T Rousseau

117

Charles-François Daubigny. b Paris, 1817. d Paris, 1878. **The Lock at Optevoz**. 1855. Oil on canvas. **h**92 × **w**162 cm. **h**36¼ × **w**63¾ in. Musée des Beaux-Arts, Rouen

Daumier Honoré The Print Collectors

Two elderly gentlemen are looking through a folder of prints in an art dealer's gallery. It is clear they are only pretending to be knowledgeable. The picture may have been the artist's own bitter comment on his inability to sell his works to the newly rich middle classes. Daumier was a supreme satirist, able to capture a person's character with a single stroke of his pen. He was well known and feared for his biting, sarcastic portrayals of leading figures of the day, as well as for his comments on political issues. Daumier had the rare gift of being able to express in pictures what would take hundreds of words. He was also a fine painter and sculptor. His cartoon lithographs, of which he produced around 4,000, were collected by artists such as Edgar Degas and may be compared with the work of Japanese calligraphers in their marvellously free handling.

☛ Degas, Hogarth, Hokusai, Toulouse-Lautrec, Utamaro

Honoré Daumier. **b** Marseille, 1808. **d** Valmondois, 1879. **The Print Collectors**. c1878. Ink and wash on paper. **h**35 × **w**32 cm. **h**13¾ × **w**12½ in. Victoria and Albert Museum, London

David Gérard

The Marriage Feast at Cana

This picture depicts an episode from the Bible, but all of its characters wear contemporary dress. The intricate details of their garments have been executed with minute precision. The donors who commissioned the painting have been included as guests at the feast, and can be seen kneeling at either side of the composition. It was usual in the Netherlands at this time to include the patrons in the painting, usually positioned as if kneeling in front of the altarpiece. David's rich colours and meticulous attention to detail are typical of northern painting of the fifteenth and early sixteenth centuries. He was one of the masters of the time, and his compositions were copied repeatedly. His domestic scenes from the life of Christ were very popular, and he excelled in painting landscapes. Although the city of Bruges was in decline, David's workshop continued to be successful, supplying paintings to other countries.

☞ Bouts, P Bruegel, Van Eyck, Van der Goes, Memling

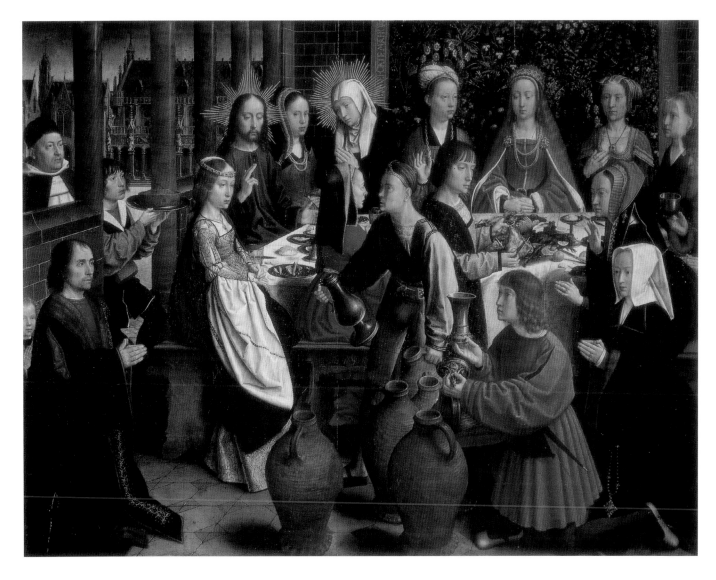

Gérard David. b Ouwater, c1450/60. **d** Bruges, 1523. **The Marriage Feast at Cana**. c1511. Oil on panel. **h**100 × **w**128 cm. **h**39¼ × **w**50½ in. Musée du Louvre, Paris

David Jacques-Louis

The Death of Marat

Jean-Paul Marat, one of the most passionate leaders of the French revolution, was a personal friend of David. He was stabbed to death in his bath, and this powerful image commemorates his murder. David has included only the most important elements to tell the story: the limp body, the bloody wound, the murder weapon and the letter which the murderer used to gain admission to the house. The bright lighting and contrasting plain, dark background highlight these details. David denounced the flowery Rococo style of the previous generation and led a return to Classical ideals. These were expressed with realism, a strong sense of composition and crisp handling of paint. David was also an active political revolutionary. He voted for the execution of Louis XVI and was an ardent supporter of Napoleon, whom he painted a number of times.

☞ Canova, Delacroix, Géricault, Ingres, Powers, Prud'hon

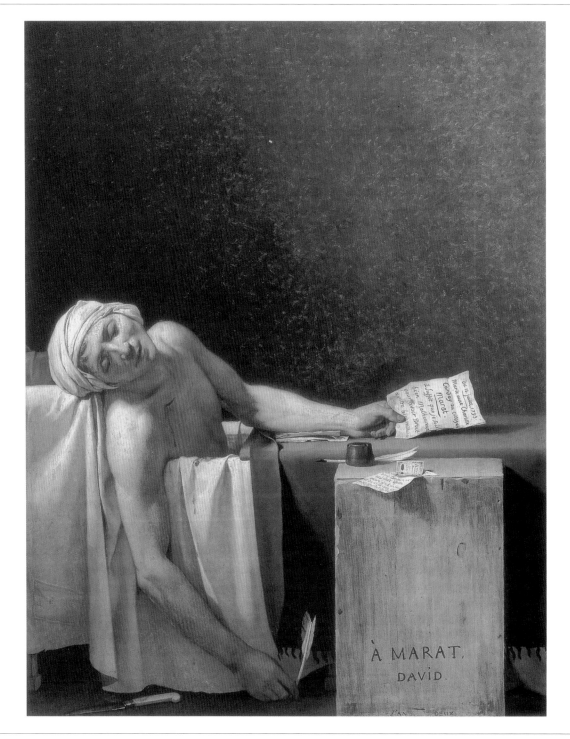

Jacques-Louis David. b Paris, 1748. d Brussels, 1825. **The Death of Marat**. 1793. Oil on canvas. **h**165 × **w**128.3 cm. **h**65 × **w**50½ in. Musées Royaux des Beaux-Arts de Belgique, Brussels

Davis Stuart

Egg Beater No. 4

Ambiguous colours and shapes stand together in this delightful interplay of form, line and depth. Individual elements have been crystallized into an abstract whole created from blocks of flat colour and precise shapes. These invite the eye to zip around the canvas, following the angular movements of the egg beater. Much of the artist's work shows the influence of Cubist fragmented shapes, although Davis has developed these through the humour, zest and zany sounds of jazz, which he was passionate about. Painted in 1927 and 1928, the 'Egg Beater Series' was based on the shapes of an egg beater, a fan and a pair of rubber gloves and demonstrated the first abstract compositions to be created by an American artist in ten years. Davis used contemporary American life as his subject matter, painting everything from petrol stations to landscapes.

☛ Braque, Feininger, Nicholson, Picasso

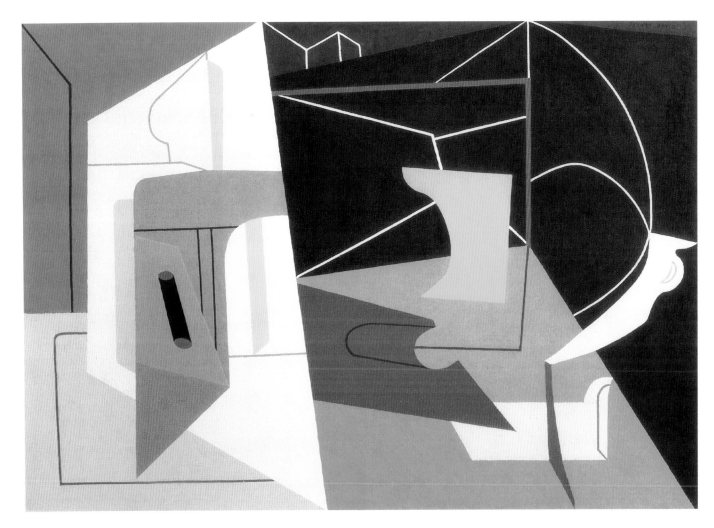

Stuart Davis. b Philadelphia, PA, 1894. **d** New York, NY, 1964. **Egg Beater No. 4**. 1928. Oil on canvas. **h**68 × **w**97 cm. **h**27 × **w**38¼ in. Phillips Collection, Washington, DC

Deacon Richard

Fish Out of Water

Although this sculpture wears its construction on its sleeve – glue seeps out between layers of bent hardboard, and hundreds of rivets keep the whole from springing apart – its bulging, rib-like structure makes it distinctly organic, like a skeleton blown dry by a desert wind. One of a generation of sculptors who emerged in Britain in the 1980s, Deacon shares with them an interest in the objects of everyday life. His works use the construction techniques of boat-building or aviation. Like drawings in space, they trace outlines that expose frameworks, echoing engineering structures, and form curvilinear skins that enclose volumes, evoking pots and vessels. The body is also a constant motif. Often room-sized in scale, these sculptures suggest a repertory of body parts – from ribcages to genitalia. Rather than representing anything specific, Deacon's forms suggest images, emotions and memories which are, of course, different for each viewer.

☞ Bourgeois, Calder, Cragg, Serra, Smith

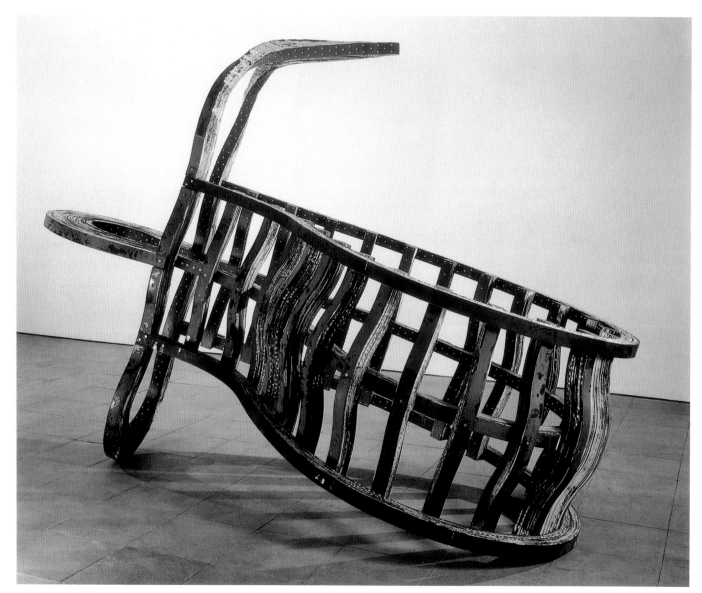

122

Richard Deacon. b Bangor, 1949. **Fish Out of Water**. 1986/7. Laminated hardboard. **w**350 cm. **w**137¾ in. Hirshhorn Museum and Sculpture Garden, Washington, DC

Degas Edgar

The Rehearsal

The artist is giving the viewer a secret glimpse into a rehearsal studio. We hide with him, in the shadows, watching the fluid movement of the slim, supple limbs and graceful bodies of the young ballet dancers. Degas has depicted the dancers from unusual angles and viewpoints. The composition appears totally random: the figure on the far right is cut off by the edge of the canvas, and truncated legs appear at the top of the stairs – had he waited only a few seconds more, it seems, another dancer would have walked into the picture. The painting is executed with vibrant, rapid strokes of pastel and some areas have merely been sketched in. The cool tones and lack of formality are refreshing. Degas' real interest was not in the ballerinas or ballets themselves; what fascinated him was the movement of abstract forms and shapes and the colours' graceful harmonies.

☛ Hiroshige, Laurencin, Toulouse-Lautrec, Utamaro, Whistler

Edgar Degas. b Paris, 1834. d Paris, 1917. **The Rehearsal**. 1873–4. Pastel on canvas. **h**59 × **w**83.8 cm. **h**23⅓ × **w**33 in. The Burrell Collection, Glasgow Museums and Art Galleries, Glasgow

Delacroix Eugène The Battle of Taillebourg

So real is this scene of the historic victory of Louis IX over Henry III of England that the battlecries can almost be heard. Despite its vast size, the painting is compactly composed. A whirling mass of figures brings our attention to the focal point at the centre, dominated by Louis on his white horse. Executed with great gusto and passion in warm tones, it shows the Romantic spirit of Delacroix, who managed to free himself from the stiff Classicism that dominated French early nineteenth-century art. He was much inspired by Peter Paul Rubens' colour and loose brushwork, as well as by the landscapes of John Constable and Richard Parkes Bonington. At the Paris World Exhibition of 1855 Delacroix showed 36 canvases in one room. His journals provide a vivid commentary on the social, intellectual and artistic world of Paris in the first half of the nineteenth century.

☛ Bonington, Constable, Copley, Géricault, Rubens, Uccello

124

Eugène Delacroix. b Charenton-St-Maurice, 1798. d Paris, 1863. **The Battle of Taillebourg**. 1835/7. Oil on canvas. **h**485 × **w**555 cm. **h**191 × **w**218½ in. Musée National et Domaine de Versailles, Versailles

Delaunay Robert Homage to Blériot

In this apparently abstract composition, swirling spirals and rotating discs of colour form a lyrical pattern across the surface of a sheet of paper. On closer inspection we can see the Eiffel Tower on the right and the wings and propeller of an aeroplane on the left. These combine with the floating forms in the sky to celebrate the first flight across the English Channel, undertaken by Louis Blériot in 1909. Artists often used paper to jot down ideas and work out compositions. This watercolour is a preliminary sketch for a large collage of the same title that hangs in the Kunstmuseum in Basel. Delaunay developed his use of colour to create purely abstract paintings whose shapes and forms originated from his imagination and bore no relation to the tangible world. This style of painting, which was closely related to music, was called Orphism, a term invented by the poet Guillaume Apollinaire.

☞ Klee, Kupka, Marc, Nash, Seurat, Signac

Robert Delaunay. b Paris, 1885. **d** Montpellier, 1941. **Homage to Blériot**. 1914. Watercolour on paper. **h**78 × **w**67 cm. **h**30¾ × **w**26⅓ in. Musée d'Art Moderne de la Ville de Paris, Paris

Delvaux Paul

Venus Asleep

In a moonlit town Venus lies asleep, watched over by a skeleton and a dressmaker's dummy. She lies with her legs open, dreaming of the seduction of Death. Perhaps it is the combination of youthful female beauty and death, of desire and horror, that makes this painting so disturbing. It was the hallmark of Surrealists like Delvaux to depict such strange, often beautiful, images that were inspired by dreams and the subconscious. Delvaux came late to Surrealism, after experimenting with Impressionism and then Expressionism. He was popular in fashionable art circles after the Second World War, when Surrealism was in its heyday. Delvaux visited Italy in 1939 and was deeply impressed by Roman architecture. He is known for his dream-like images of beautiful, often naked, young women, usually positioned in front of meticulously rendered buildings.

☛ De Chirico, Cranach, Dalí, Kahlo, Magritte, Tanguy

Paul Delvaux. b Antheit, 1897. **d** Knokke, 1994. **Venus Asleep**. 1944. Oil on canvas. **h**173 × **w**199 cm. **h**68 × **w**78⅜ in. Tate Gallery, London

Denis Maurice

Portrait of Yvonne Lerolle

Three images of the same slender figure dominate this painting. The folds of her dress, and tree trunks, combined with the straight walkways, emphasize the vertical lines of the composition. Denis was a member of the Nabis, a group of painters who associated themselves with Paul Gauguin's expressive use of colour and rhythm. At the age of 20 Denis made the following statement, which is often considered the key to contemporary painting: 'Remember that a picture – before being a war horse or a nude woman or some anecdote – is essentially a flat surface covered with colours assembled in a certain order.' This way of looking at art eventually led to abstraction. The painting shown here confirms the artist's belief that a picture's subject matter is not as important as its composition. Paradoxically, Denis later attempted to revive religious painting – which is very dependent on subject matter – and in 1939 he published a history of religious art.

☛ Bonnard, Gauguin, Maillol, Mucha, Vallotton, Vuillard

Maurice Denis. b Granville, 1870. d Paris, 1943. **Portrait of Yvonne Lerolle**. 1897. Oil on canvas. **h**166 × **w**78 cm. **h**65⅜ × **w**30¾ in. Musée Départemental du Prieuré, Saint-Germain-en-Laye

Derain André

The Pool of London

Bright colours dance and shimmer on a dock on the River Thames. The unmistakable silhouette of Tower Bridge is in the distance. The artist has transformed the scene into a rainbow of primary colours, which have been applied in bold blocks. His use of colour distorts the perspective and gives the painting's surface a pulsating, vibrating unity. The spontaneous brushwork shows Derain's understanding of the techniques of Impressionism. Derain has made colour the picture's subject; the setting has become nearly irrelevant. Along with a group of like-minded artists, Derain's inspiration came from a desire to work only with strong colours. This, plus the primitive power of the artists' style, caused a public outcry when they first exhibited. They were given the nickname 'Fauves', or wild beasts, as an expression of their 'wild' use of colour and unusual subject matter.

☛ Van Dongen, Van Gogh, Matisse, Signac, Vlaminck

André Derain. b Chaton, 1880. **d** Garches, 1954. **The Pool of London**. 1906. Oil on canvas. **h**66 × **w**99 cm. **h**26 × **w**39 in. Tate Gallery, London

Diebenkorn Richard Ocean Park No. 67

Geometric lines define different sections of colour, evoking the local tones and light of the sea, sky and tawny hills of Ocean Park, California. The artist has created an illusion of space by making his canvas appear like a window through which to view the space contained within it. The painting hovers between a purely abstract composition of lines and colour, and a representation of sea and sky. This may be because up until this and similar paintings of the same subject, Diebenkorn's work was largely representational. The painting is close in feeling to the work of the Abstract Expressionists, who were popular in the 1950s and whose use of expression, paint and colour would have had a great influence on Diebenkorn. There is also a tranquil, mystical quality to the picture, which is often found in Abstract Expressionist work – notably that of Mark Rothko, with whom Diebenkorn taught at the California School of Fine Arts in San Francisco from 1947 to 1950.

☛ Albers, Louis, Marin, Noland, Pollock, Rothko

Richard Diebenkorn. b Portland, OR, 1922. d New York, NY, 1994. **Ocean Park No. 67**. 1973. Oil on canvas. **h**254 × **w**205.5 cm. **h**100 × **w**81 in. Private collection

Dine Jim

My Name is Jim Dine 2

A deep red heart pulsates on a background of iridescent patchwork colours. This glitzy image glows with a strange appeal. It brightly captures the viewer's attention, despite looking like a lurid birthday card. Dine's roots lie in Abstract Expressionism, evident in his loose, free brushwork. He sometimes used real objects such as lawnmowers and toothbrushes, which he would attach to painted canvases. He often emphasized these objects with painted shadows, or would write the name of the object beside it to draw attention to its everyday existence. Dine has experimented with a host of different styles and media, but is best known as a prominent figure of American Pop Art, a movement characterized by its irreverent use of familiar and banal images. His 'Heart' series of paintings, executed from the early 1980s onwards, are said to represent the artist's personal expression and his belief in the ability of paint to convey feeling.

☛ Hamilton, Klee, Oldenburg, Rauschenberg, Warhol

130

Jim Dine. b Cincinnati, OH, 1935. **My Name is Jim Dine 2**. 1992. Oil and enamel on canvas. **h**91.4 × **w**127 cm. **h**36 × **w**50 in. Pace Gallery, New York, NY

Dix Otto

Portrait of the Journalist Sylvia von Harden

The eccentric, severe-looking journalist Sylvia von Harden is portrayed with the essential accoutrements of a café society woman – a gilt chair, a marble-topped café table, elegant Russian cigarettes and a glass of Spritzer, the most fashionable drink in Berlin at the time. A feeling of tension and suspense is created by the use of vibrant colours, while a sexual element is hinted at by the stocking slipping down the journalist's leg. Considered to be one of Dix's finest, this portrait encapsulates the decadent glamour of Germany's Weimar Republic. Its harsh, almost grotesque portrayal of its subject makes the painting an excellent example of New Objectivism (Neue Sachlichkeit). Dix's other renowned paintings form a protest against the horrors of war, and they often depict working people, cripples and whores. Because of his penetrating social criticism, Dix was suppressed by the Nazis. He began to paint again after the Second World War.

☛ Beckmann, Ensor, Freud, Grosz, Schad

Otto Dix. **b** Untermhausen, 1891. **d** Singen, 1969. **Portrait of the Journalist Sylvia von Harden**. 1926. Oil on panel. **h**120 × **w**88 cm. **h**47¼ × **w**34¾ in. Musée National d'Art Moderne, Paris

Dobson William

Endymion Porter

It is through the intricate lace collar and cuffs, pearl buttons and gold embroidery, all topped by a proud gaze, that the importance and flamboyance of this person are conveyed. In addition, the bust of Apollo and the rifle and dead hare show that this is a cultured man, known for his gentlemanly pursuits. Endymion Porter was Groom of the Bedchamber to Charles I and can be seen to represent all of the elegance of the English Court in the years before the Civil War. At his prime, Dobson was considered to be the most accomplished portrait painter in England. His contemporary Aubrey described him as 'the most excellent painter England hath yet bred'. His style was vigorous, with a strong English character. Dobson's ability to evoke sumptuous fabrics in paint is a hallmark of his style. Said to have been 'somewhat loose and irregular in his way of living', he was imprisoned for debt and died soon after his release.

☛ Batoni, Van Dyck, Hilliard, Kneller, Lely, Moroni

William Dobson. b London, 1610. d London, 1646. **Endymion Porter**. c1640/3. Oil on canvas. **h**150 × **w**127 cm. **h**59 × **w**50 in. Tate Gallery, London

Van Doesburg Theo Arithmetic Composition

A sense of movement and perspective is created in this picture by the sequence of black squares starkly painted against a white background. In fact, the artist has used a simple mathematical calculation – the sides of each square, and the distance between them, are half the size of the preceding square. Through the use of this simple square motif Van Doesburg was able to create a three-dimensional effect on a two-dimensional surface. The use of a mathematical formula perhaps reveals Van Doesburg's interest in architecture. The artist Piet Mondrian strongly influenced his work. In 1917 the two artists founded *De Stijl*, a magazine representing the work and ideas of that same group. De Stijl artists tended to use flat, primary colours which were arranged geometrically. Van Doesburg devoted much of his life to promoting De Stijl's ideas through his writing, lecturing, art and architecture.

☞ Albers, Lissitzky, Malevich, Moholy-Nagy, Mondrian

Theo van Doesburg. **b** Utrecht, 1883. **d** Davos, 1931. **Arithmetic Composition**. 1930. Oil on canvas. **h**101 × **w**101 cm. **h**40 × **w**40 in. Private collection

Domenichino

The Sacrifice of Isaac

Abraham has been instructed by God to sacrifice his son Isaac as a test of his faith. The naked youth bravely accepts his fate as his father wields his sword in blind obedience. An angel intervenes, indicating that Abraham should offer the ram instead of Isaac. This dramatic scene is played out in the foreground of the picture so as to enhance the sense of immediacy. Abraham, the most important figure, dominates in his rich blue and red robes. Domenichino trained at the Carracci Academy in Bologna. He became a popular artist who was often commissioned to decorate the many palaces, villas and chapels that surrounded Rome. Although he worked within the Baroque period, with its characteristic swirls and painterly effects, Domenichino remained firmly Classical in his style. For this he met with hostility in Naples and had to leave the city, his many works unfinished.

☛ Carracci, Poussin, Reni, Vouet

Domenichino (Domenico Zampieri). **b** Bologna, 1581. **d** Naples, 1641. **The Sacrifice of Isaac**. c1620/1. Oil on canvas. **h**147 × **w**140 cm. **h**57¾ × **w**55 in. Museo del Prado, Madrid

Donatello

David

This statue of David shows the young hero in a dreamy, contemplative mood after slaying Goliath, whose head lies at his feet. The flowing naturalism of David's pose, his shy demeanour, and the sensual surface texture of the bronze combine to bring the statue to life. This ability to instil human emotion in Classical statues was Donatello's greatest gift. As one of a group of remarkable sculptors, architects and painters who brought about an artistic revolution in Florence, he is considered a founder of the Renaissance style. Donatello was a favourite artist of the famous patron Cosimo il Vecchio de' Medici. He was by far the leading Florentine sculptor before Michelangelo, and possibly the most innovative and influential of all Renaissance artists. His *David* was the first full-sized bronze nude to have been cast since Ancient times.

☞ Canova, Castagno, Ghiberti, Michelangelo, Powers

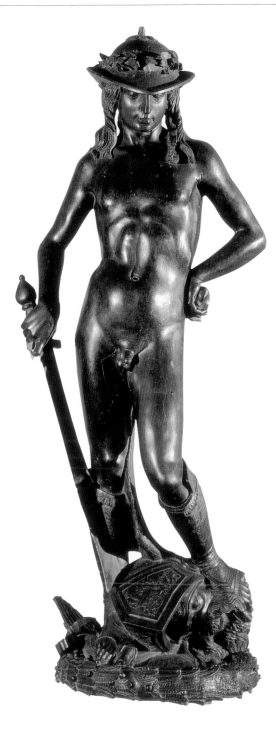

Donatello. **b** Florence, c1386. **d** Florence, 1466. **David**. c1433. Bronze. **h**159 cm. **h**62½ in. Museo Nazionale del Bargello, Florence

Van Dongen Kees Portrait of Dolly

The artist's daughter is painted in flat, decorative sections of intense colour. The beauty of the child is conveyed in an exotic style. Her sensuality is evoked by her blackened, almond eyes and fiery red lips, echoed by the colour of the ribbon under her hat. Van Dongen was a master colourist, as demonstrated for instance in the delicate green tones used to construct Dolly's face. He was born in Holland but settled in Paris and took up French nationality in 1929. He was a member of various movements, including the Fauves and the Expressionists. The influence of both can be seen in his vibrant use of pure colour. Young, talented and precocious, from his early thirties Van Dongen enjoyed an extravagant lifestyle supported by the success he achieved. Some feel his great artistic talent was abused when he began to paint portraits of fashionable women, which soon became somewhat superficial.

☛ Gontcharova, Jawlensky, Matisse, Rouault, Vlaminck

136

Kees van Dongen. b Delfshaven, 1877. d Monaco, 1968. **Portrait of Dolly**. c1911. Oil on canvas. h55 × w46 cm. h21²⁄₃ × w18⅛ in. Private collection

Dossi Dosso Alfonso I d'Este

Gleaming armour and battalions of troops reinforce this image of a great military leader. As Duke of Ferrara, Alfonso led his troops in many battles against Papal and Venetian aggressors. In addition to controlling his army, Alfonso was also an enlightened patron of the arts who attempted to rival the Pope in his ambitious commissions from the greatest artists of the time. (Despite all his efforts, however, Alfonso was never able to secure Raphael or Michelangelo to fulfil any of his requests.) Dosso Dossi was principal Court painter for the Este family and together with his brother Battista provided mainly mythologies, portraits and decorative frescos. The style of this portrait is reminiscent of Venetian art; it is in fact a derivation of a portrait of Alfonso by Titian. Influenced by the Venetians and by Correggio, Dossi later chose to paint mysterious exotic landscapes suffused with an unearthly, glowing light.

☞ Altdorfer, Correggio, Giorgione, Michelangelo, Raphael, Titian

Dosso Dossi (Giovanni Luteri). b Ferrara, c1490. d Ferrara, 1542. **Alfonso I d'Este**. After 1528. Oil on canvas. **h**147 × **w**113.5 cm. **h**58 × **w**44¾ in. Galleria e Museo Estense, Modena

Dou Gerrard

Maidservant at a Window

Elaborately composed, this small, intimate scene shows a young woman servant pouring water from a brass jug over a balustrade which also serves as a window framing the picture. The artist has paid meticulous attention to details such as the fraying cloth, the terracotta pot and the birdcage, giving the painting a gem-like quality. Dou was a pupil of Rembrandt, and it is possible to see the master's influence in some of Dou's earlier pictures. He delighted in depicting everyday or 'genre' scenes, which he filled with a wealth of closely observed detail – he would sometimes even use a magnifying glass to work. This interior, with its theatrical setting, recalls a type used in the Netherlands in the fifteenth century by Jan van Eyck, and was to be a starting point for Jan Vermeer and Pieter de Hooch. Dou was a prosperous and respected artist for much of his life. His workshop was filled with students, who continued producing works in his style until well into the eighteenth century.

☞ Van Eyck, De Hooch, Metsu, Rembrandt, Vermeer

Gerrard Dou. **b** Leyden, 1613. **d** Leyden, 1675. **Maidservant at a Window**. c1640. Oil on panel. **h**37 × **w**28 cm. **h**14½ × **w**11 in. Museum Boymans-van Beuningen, Rotterdam

Dove Arthur

Me and the Moon

A bright circle of colour, representing the moon, dominates this composition. A series of lines and tones surround it like the rings around the moon, or the layers of the imagination. Dark, brooding colours create an air of melancholy nostalgia blowing across this landscape of the soul. The canvas richly evokes feelings for the beauty of nature. Dove's work often suggests nature in a metaphysical, rather than a literal sense; the forms of natural objects are transformed into abstract representations. He wrote: 'I should like to take the wind and water and sand as a motif and work with them, but it has to be simplified in most cases to color and force lines just as music has done with sound.' Born in New York state he visited Europe in 1907–9 where he saw the work of the Fauvists. On his return to the USA he was to paint some of the first abstract paintings in modern art, certain aspects of which are similar to the work of Wassily Kandinsky.

☛ Heckel, Heron, Kandinsky, O'Keeffe, Vlaminck

Dubuffet Jean

Jazz Band (Dirty Style Blues)

The members of a jazz band line up across the picture in a static frieze. Apparently random colours have been applied in an unusual manner with a brush, and the surface of the painting has then been smeared, rubbed and incised to create the outlines of the players. The graffiti-like effect is amusing and enchanting, giving the picture a naive, childlike simplicity. Loosely allied to the Art Informel movement, Dubuffet believed there was more truth in the unspoiled, creative art of the insane and amateur than the professional artist. Indeed he coined the term Art Brut ('raw art'), to describe the kind of art created by psychotics, children and untrained people.

Dubuffet's pieces were often mocked by both the public and art critics, and were even physically attacked in an exhibition in Paris in 1946. Despite this adverse reaction, he has become a widely respected artist.

☛ Appel, Basquiat, Fautrier, Tàpies, Twombly

140

Jean Dubuffet. b Le Havre, 1901. d Paris, 1985. **Jazz Band (Dirty Style Blues)**. 1944. Oil on canvas. **h**97 × **w**130 cm. **h**38¼ × **w**51⅛ in. Private collection

Duccio

The Rucellai Madonna

The traditional subject for altarpieces was an image of the Virgin and Child enthroned, surrounded by angels looking upon them with devotion. Duccio has used this same image, but has included a degree of tenderness that is unusual in paintings of the thirteenth century. Sienese paintings of this time were characterized by their attention to line and colour. Here, the line is expressed by the elongated forms and the gold edge of the Virgin's drapery. The angels' gowns, in particular, exhibit the artist's skilled application of colour. Duccio was the leading painter of Siena during the thirteenth and fourteenth centuries. He was unequalled in the art of panel painting, in which he excelled as a narrator. The fact that this painting was commissioned by a Florentine confraternity when Florence and Siena were traditional enemies attests to Duccio's high reputation outside his native town.

☛ Campin, Cimabue, Giotto, Lorenzetti, Martini

Duchamp Marcel Fountain

This work is a replica of a porcelain urinal which was originally purchased by the artist in 1917 from a plumbing supply firm in New York. Duchamp simply signed the object with the pseudonym R Mutt, then entered it for an art exhibition. The bizarre item exemplifies the notion of taking a commonplace object out of its customary setting and placing it in a new and unfamiliar one. It was through this work that Duchamp first defined the concept of the 'ready-made' or 'found object' – an idea which has influenced countless artists since. In defending the original sculpture in 1917 Duchamp challenged traditional preconceptions of what art is. He stated that it was not important whether or not 'Mr Mutt' had *made* the work with his own hands; what mattered was that he had chosen it. Therefore the creation was not important but the idea and selection was.

☛ Beuys, Broodthaers, Johns, Koons, Man Ray, Oldenburg

142

Marcel Duchamp. b Blainville, 1887. **d** Neuilly, 1968. **Fountain.** 1917/64. Porcelain. **h**33.5 cm. **h**14 in. Indiana University Art Museum, Bloomington, IN

Dufy Raoul

The Paddock

The colourful atmosphere of the racecourse has been captured in this paddock scene. Dufy has painted elegant ladies with parasols, gentlemen in top hats, jockeys on horseback and a sailor propping his bicycle against a tree. In the background, a deep blue sea is littered with cruise-liners and yachts. This is the world of riches and relaxation. From the beginning of the 1920s Dufy visited racecourses regularly with the famous dress designer Paul Poiret. It was Poiret who urged Dufy to study the smart clothes of the fashionable ladies who came to the racecourses to be seen. Although he had earlier been influenced by the Impressionists, the Fauvists and the Cubists, this painting illustrates Dufy's personal mode of expression in the light strokes of outline and vibrant colours. His palette often recalls the French Riviera and Mediterranean. Dufy also designed textiles and painted one of the largest murals ever, for the 1938 Paris Exhibition.

☞ Derain, Van Dongen, Laurencin, Matisse, Vlaminck

Raoul Dufy. b Le Havre, 1877. **d** Forcalquier, 1953. **The Paddock.** c1926. Oil on canvas. **h**81 × **w**125 cm. **h**31⅞ × **w**49¼ in. Private collection

Dürer Albrecht

Self-portrait with Gloves

The technique of placing the sitter's arm on a sill was a well-known method of creating the illusion of proximity between the viewer and the artist's model. See, for example, Leonardo's *Mona Lisa* which also uses the device. Dürer may have learned this visual trick from earlier artists whose works he would have seen while travelling in Italy.

Dürer painted many self-portraits, a subject that was not common at the time and which can be seen as a promotion of the artist's status in society. If a patron can be reproduced in paint, why not an artist? The landscape seen through the open window (as on the right here) was a feature often used by northern artists such as Jan van Eyck

and Robert Campin. An extraordinary and prolific artist, Dürer revolutionized northern European art by combining different aspects of Netherlandish and Italian art. He is also well known for his woodcuts and engravings which spread his fame far and wide in sixteenth-century Europe.

☛ Campin, Cranach, Van Eyck, Grünewald, Leonardo, Rosa

144

Albrecht Dürer. b Nuremberg, 1471. d Nuremberg, 1528. **Self-portrait with Gloves**. 1498. Oil on panel. **h**52 × **w**41 cm. **h**20½ × **w**16⅛ in. Museo del Prado, Madrid

Van Dyck Sir Anthony Charles I on Horseback

Spotless armour, a steady gaze and a regal demeanour – it is apparent that this is a man of great importance. As painter to Charles I, the artist was commissioned to convey the King's majesty to all who saw it. After studying with Peter Paul Rubens in Antwerp, Van Dyck went to London and then on to Italy. Here he adopted a more elegant manner of painting, which he kept all his life. It was in Italy, too, that Van Dyck created a style that began the great tradition of English portrait painting. These works were usually of noblemen with proud postures and slim figures. He was often accused of flattering his sitters, but not all were pleased. The Countess of Sussex reacted to her portrait by saying she felt 'very ill-favorede', and 'quite out of love with myself, the face is so bige and so fate that it pleases me not at all. It lokes lyke on the windes puffinge – but truly I think tis lyke the originale.'

☞ Clouet, Dobson, Gainsborough, Lely, Rubens, Titian

Sir Anthony van Dyck. **b** Antwerp, 1599. **d** London, 1641. **Charles I on Horseback**. c1636. Oil on canvas. **h**367 × **w**292 cm. **h**144¾ × **w**115 in. National Gallery, London

Eakins Thomas

Between Rounds

It is almost impossible not to witness the cheers of the crowd, the smell of cigar smoke and the sweat of the boxer coming from this painting. The fighter, caught in the few moments between rounds, is the focus of the work. Eakins was fascinated with the human form. He often used sporting events such as boxing and rowing to capture the nude in motion. As a teacher he caused an uproar by insisting that his art students should draw from the nude. He had travelled in Europe, and was influenced by the Spanish Realists Diego Velázquez and Jusepe Ribera. It was through these artists in particular that he learned to paint with such vibrant realism. He also often exploited the effects of light and dark to produce a feeling of drama, much as Rembrandt had. Eakins' paintings were largely unappreciated during his lifetime, but he received recognition for his realist approach from the generation that followed.

☛ Bellows, Rembrandt, Ribera, Velázquez

146

Thomas Eakins. b Philadelphia, PA, 1844. d Philadelphia, PA, 1916. **Between Rounds**. 1899. Oil on canvas. **h**127 × **w**101.5 cm. **h**50⅛ × **w**39⅞ in. Philadelphia Museum of Art, Philadelphia, PA

Elsheimer Adam

The Stoning of Saint Stephen

St Stephen died without resistance to demonstrate that his devotion to Christ was more important than his own life. Martyrs can be killed in many different ways; this martyr was stoned to death. Here, a ray of heavenly light shines down on him, encouraging him in his plight. Elsheimer has paid great attention to detail, particularly

to the musculature of the human body. The flying figure on the left and the standing man on the right gave the artist an opportunity to paint figures in action. A German painter and printmaker, Elsheimer travelled to Italy in 1598 where he was strongly influenced by Venetian artists. He combined their use of colour with his own

understanding of light and emphasis on realism to create such works as this. Many of his paintings were copied by other printmakers and his influence stretched well into the seventeenth century.

☛ Altdorfer, Bosch, Caravaggio, Dürer, Michelangelo

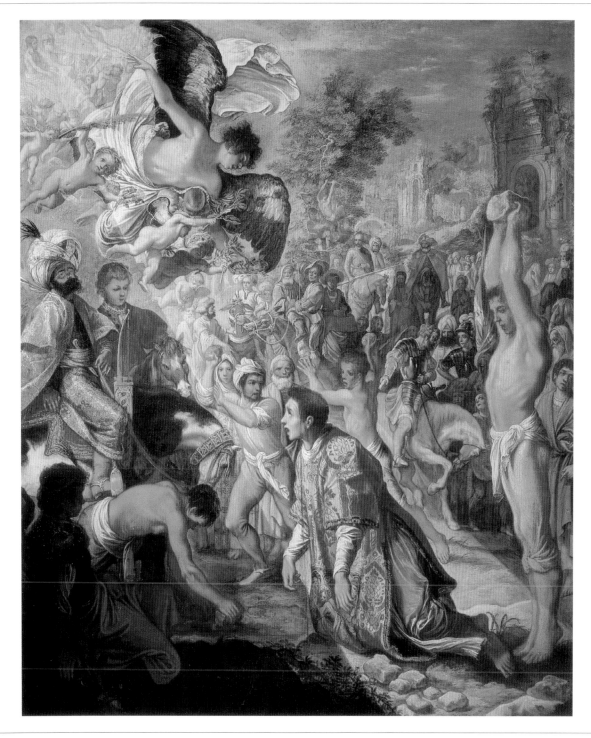

Adam Elsheimer. b Frankfurt, 1578. **d** Rome, 1610. **The Stoning of Saint Stephen**. c1602/5. Oil on copper. **h**34.7 × **w**28.6 cm. **h**13⅝ × **w**11¼ in. National Gallery of Scotland, Edinburgh

Ensor James

Skeletons Fighting for the Body of a Hanged Man

Two skeletons fight in futile combat for the body of a hanged man suspended above them. Masked figures stare at the wretched and pitiful scene. We are invited to gaze with astonishment at this extraordinary and dismal spectacle. The grotesque nature of this painting reflects the artist's own vision: a world ruled by absurdity, in which disconnected thoughts and futile actions play too large a part. With its strong emotional impact and dramatic imagery, Ensor's art was much admired by artists of the German Expressionist movement. He exerted a particularly powerful influence on Emile Nolde, who visited him in 1911. His works often included masks, skeletons, and gruesome and grotesque figures. His paintings and graphic works were very satirical, with a biting, sometimes bitter, humour. Born of English parents, Ensor lived in isolation in Ostend, becoming a Belgian national in 1929.

☛ Beckmann, Bosch, Kokoschka, Nolde, Pechstein

James Ensor. b Ostend, 1860. d Ostend, 1949. **Skeletons Fighting for the Body of a Hanged Man**. 1891. Oil on canvas. **h**59 × **w**74 cm. **h**23¼ × **w**29⅛ in. Koninklijk Museum voor Schone Kunsten, Antwerp

Epstein Sir Jacob Elemental

The pent-up energy of primitive man is conveyed by the tense, compact form of this hunched-up body and by the way the head is positioned as though in surrender to the unknown powers above. The sculpture embodies a poignant juxtaposition: of terror or death, suggested by the frozen grip of the hands, and unborn life, suggested by the figure's foetal position. The strength of the sculpture lies in its deliberately unfinished state, with the chisel and file marks still visible on the unveined alabaster surface. Epstein developed his own unique style, which illustrates direct inspiration from the Ancient and primitive sculpture which he would have seen during visits to the Louvre museum in Paris. Throughout his life Epstein worked in two ways, carving in stone and executing portraits in bronze of a more descriptive nature. His most renowned bronze is a bust of Sir Winston Churchill.

☛ Brancusi, Gaudier-Brzeska, Moore, Rodin

Sir Jacob Epstein. **b** New York, NY, 1880. **d** London, 1959. **Elemental**. 1932. Alabaster. **h**81 cm. **h**31⁷/₈ in. Private collection

Ernst Max

The Forest

The all-enveloping and stifling nature of this forest, in which the only sign of life is a solitary bird trapped in a cage, evokes a feeling of simultaneous enchantment and fear. The tangled trees seem petrified and loom over the bird in wild and irrepressible growth. Like many artists of his time, Ernst worked in many media. He produced an enormous collection of collages and introduced a technique called *frottage*. Similar to brass-rubbing, this involved laying a sheet of paper on a rough surface and drawing on the paper so as to reveal the relief of the object beneath. Because the artist had no control over the picture he was creating, *frottage* was also seen as a method of gaining access to the subconscious. The 'chance' element of this technique, together with the hallucinatory quality of the image it has created, make the picture a fine example of Surrealist preoccupations.

☛ Dalí, Gorky, Lam, Miró, H Rousseau, Tanguy

150

Max Ernst. b Bruhl, 1891. **d** Paris, 1976. **The Forest**. 1927. Oil on canvas. **h**100 × **w**81.5 cm. **h**39½ × **w**32 in. Tate Gallery, London

Estes Richard

Gordon's Gin

Is it real – or is it art? This street scene, complete with advertising billboards, is a celebration of American popular culture. Its startling realism is a surprise and delight. Estes did not invent the subject matter – he simply chose it, photographed it, and then reproduced it exactly as it appeared in the photograph. Estes' hyper-real art was in many ways a reaction to Abstract Expressionism, a movement that had dominated the American art scene since the 1950s. The New Realism and Photorealism movements, born in the late 1960s, said something very different. Gone was emotion, colour, poetry – and in came reality. By using photographs, Estes and other artists perfected their work to the point where reality and illusion became one. What Estes chose to portray was a world familiar to millions of Americans. In this way the everyday was transformed into fine art.

☛ Hamilton, Lichtenstein, Richter, Sherman, Warhol

Richard Estes. b Evanston, IL, 1936. **Gordon's Gin**. 1968. Oil on board. **h**62.2 × **w**81.3 cm. **h**24½ x **w**32 in. Private collection

Etty William

Hero and Leander

Each night Leander would swim across a stretch of sea to meet his lover Hero, a priestess of Aphrodite. She would guide him by holding up a lighted torch. One night, during a storm, Leander drowned. The grief-stricken Hero threw herself from a tower. Here, the two dead lovers are shown in their tragic, final embrace, as their lives drift away. The tones of their glowing, sensual skin are set off against a sombre sea and storm clouds. The black hair and drapery of Hero seem to merge into the dark shadows. Etty's imagination was fired by an obsession with the nude, which he studied and painted throughout his career. His paintings often evoke the sensuous poses and rich colouring of Titian and Peter Paul Rubens. Etty frequently used Classical mythology and allegory as a means of expression. His works were particularly admired by Eugène Delacroix and other Romantic painters.

☛ W Blake, Delacroix, Géricault, Rubens, Titian

152

William Etty. b York, 1787. **d** York, 1849. **Hero and Leander**. 1828–9. Oil on canvas. **h**77 × **w**95 cm. **h**30½ × **w**37¼ in. Private collection

Van Eyck Jan The Arnolfini Marriage

An Italian merchant living in Bruges, Giovanni Arnolfini, holds the hand of Jeanne de Chenany, his bride. The dog, the slippers on the floor, the fruit on the windowsill, the candle, the rosary hanging on a nail, the floor boards and carpet have all been painted with jewel-like precision. Van Eyck was probably asked to paint this picture to commemorate this happy union and, like a witness in a wedding ceremony, he has written *Johannes de eyck fuit hic* ('Jan van Eyck was present') on the far wall. In the mirror beneath, the backs of the betrothed couple are visible and a third figure, who is possibly the painter, witnesses the event. The painting's smooth, enamel-like surface was achieved by applying numerous glazes of pigment mixed with linseed oil. It was then coated with varnish. Using this technique, Jan van Eyck and his brother Hubert are traditionally credited with having 'invented' oil painting. Their style was often imitated, but could never be surpassed.

☞ Campin, Limbourg, Memling, Van der Weyden, Wood

Jan van Eyck. Active in The Hague, 1422. **d** Bruges, 1441. **The Arnolfini Marriage**. 1434. Oil on panel. **h**81.8 × **w**59.7 cm. **h**32¼ × **w**23½ in. National Gallery, London

Fabritius Carel

The Goldfinch

Set against a creamy background, a little goldfinch rests on a green perch. The goldfinch seems so real, it is tempting to reach out and touch it. The simplicity and intimacy of this small painting almost cloud the skill with which it is painted. Fabritius was the most brilliant of Rembrandt's pupils. However, he reversed his master's technique of painting light against dark, and instead painted dark objects on a light background. Fabritius paid special attention to visual accuracy. This particular feature of his work may have influenced the artist Jan Vermeer, who was his student. The careful composition of this work and its startling simplicity also give a foretaste of Vermeer's work. Tragically, Fabritius died during the explosion of a gunpowder store in Delft while working on a portrait. The painting shown here is one of a small number of his works that have survived.

☛ Audubon, Claesz, De Heem, Kalf, Rembrandt, Vermeer

154

Carel Fabritius. b Amsterdam, 1622. d Delft, 1654. **The Goldfinch**. 1654. Oil on panel. **h**34 × **w**23 cm. **h**13¼ × **w**9⅛ in. Mauritshuis, The Hague

Fantin-Latour Henri White and Pink Roses

The roses in this picture seem to glow against the dark background. These are cut flowers that because of their short lives are often seen as symbols of mortality. Each petal has been formed by a thick stroke of paint. The variation of colour has been created by the artist applying pink and white colours to the brush without blending.

Fantin-Latour began his career as a traditional painter, accepted by the Parisian Salon. His romantic vision, however, caused him to move away from the academic approach. By 1863 he was exhibiting along with his Impressionist friends, including Édouard Manet. Besides his still lifes, Fantin-Latour is well known for his groups

of figures. One such picture shows Manet and his artist friends grouped around a portrait of Eugène Delacroix. Fantin-Latour also did a series of lithographs illustrating the music of Wagner and other Romantic composers.

☛ Bazille, Courbet, Delacroix, Manet, Ruysch, Whistler

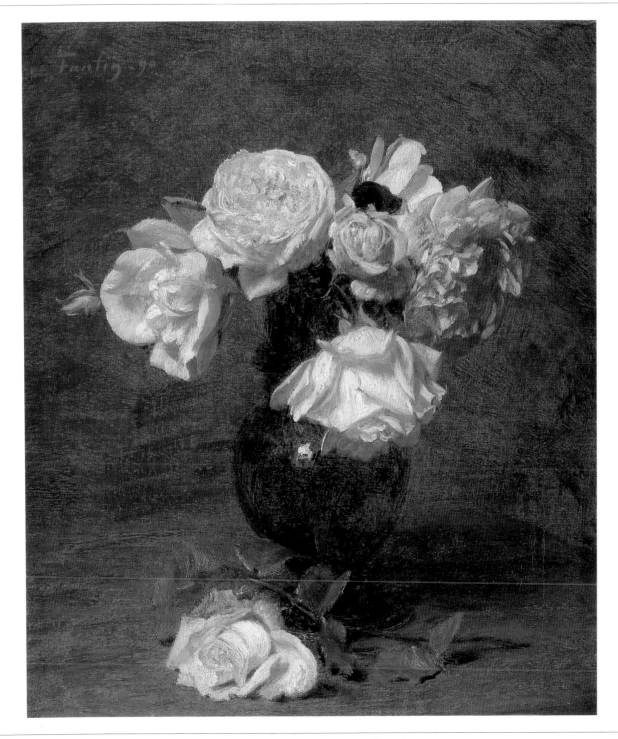

Henri Fantin-Latour. b Grenoble, 1836. **d** Buré, 1904. **White and Pink Roses**. 1890. Oil on canvas. **h**37 × **w**32 cm. **h**14½ × **w**12½ in. Private collection

Fautrier Jean

Sarah

The irregular-shaped, thickly textured central section of this picture shows a distorted female form. The painting was made from paper glued to the canvas, over which the artist applied a thick paste with a spatula. He then coated these areas with coloured powder bonded to the surface with varnish. Fautrier began to work in this unique way during his most creative period, during which his images were largely of the horrors of war. Perhaps he developed this time-consuming and problematic technique in order to express more forcefully his feelings about the state of the world. The free brushwork and the heavily textured surface illustrate the artist's connection with the Art Informel school of painting. Born in France, Fautrier spent his childhood in London and enrolled at the Royal Academy School at the age of 14. He was very active throughout his career and his varied work includes drawings, etchings and sculptures.

☛ Burri, Dubuffet, Ingres, Modigliani, Poliakoff, Tàpies

Jean Fautrier. b Paris, 1898. **d** Chatenay, 1964. **Sarah**. 1943. Oil on paper mounted on canvas. **h**116 × **w**89 cm. **h**45⅝ × **w**35 in. Private collection

Feininger Lyonel Sailing Boats

Overlapping triangles of colour echo the sails of the boats, creating a rhythmic pattern and sense of speed and space. Although born in New York, Feininger's development as an artist took place mainly in Europe. While in Paris he exhibited several paintings and became aware of Cubism. He met the artist Robert Delaunay, who became a major influence on his work. The two artists shared an interest in the emotional effects of colour, as well as in urban architecture as a subject for painting. In 1913 Feininger exhibited with the Blaue Reiter group, which included Wassily Kandinsky among others. A few years later he joined the Bauhaus school, which was closed by the Nazis in 1935. At this point Feininger returned to the USA. He was interested in many aspects of modern life, but favoured architectural and marine views for their geometrical quality.

☛ Balla, Braque, Delaunay, Gris, Hodler, Kandinsky, Picasso

Lyonel Feininger. b New York, NY, 1871. d New York, NY, 1956. **Sailing Boats**. 1929. Oil on canvas. **h**43 × **w**72 cm. **h**17 × **w**28¼ in. Detroit Institute of Arts, Detroit, MI

Flavin Dan

Untitled (To the Citizens of the Republic of France…)

Red, white and blue: the colours of the French Republic glare at us from industrially manufactured fluorescent tubes which have been assembled into a three-dimensional, pillar-like construction. The work was executed to celebrate the bicentenary of the French revolution. Its full name is *Untitled (To the Citizens of the*

Republic of France on the 200th Anniversary of their Revolution), 3. By using objects with the same shape, the sculpture takes on the appearance of a fragment of a monument, or a 'pseudo-monument', as Flavin called his works. The use of coloured light instead of paint adds another dimension. There is neither a frame nor any hard edges

to mark its limits. The light radiates beyond the work, redefining the space in which it is shown and posing the question, where does the art begin and where does it end? This use of light, space and identical, geometric objects, connects Flavin's work with the Minimalist movement.

☛ Buren, Judd, Kelly, LeWitt, Merz, Nauman, Viola

Dan Flavin. **b** New York, NY, 1933. **d** Riverhead, NY, 1996. **Untitled (To the Citizens of the Republic of France…)**. 1989. Blue, red and white fluorescent light. Height dependent on location. Leo Castelli Gallery, New York, NY

Fontana Lucio Spatial Concept

After painting the canvas in monochrome blue the artist has slashed it vertically seven times with a sharp knife. A dramatic image – but what does it mean? Fontana was primarily concerned with the concept of space. By slashing the canvas he relieved it of its tautness, and allowed the viewer to see the space behind. The painting's primary significance lies in the fact that the artist has rejected the traditional picture format. It represents a symbolic and physical escape from the usual flat surface stretched tightly over a wooden frame. In allowing us to look through the canvas the artist creates another dimension and conveys a sense of infinity. Fontana was a member of the Spatialism movement which stressed that space, movement and time were as important as colour, perspective and form. Born in Argentina of Italian parents, in 1905 his family returned to their native country where Fontana lived for the rest of his life.

☞ Kelly, Klein, LeWitt, Lissitzky, Malevich

Lucio Fontana. b Santa Fé, 1899. d Varese, 1968. **Spatial Concept**. 1962. Waterpaint on canvas. **h**52 × **w**52 cm. **h**20½ × **w**20½ in. Private collection

Foujita Tsugouharu Young Girl in the Park

This nostalgic and enchanting scene of a young girl holding a cat was created when the artist was 71 years old. The outline is painted with a fine Japanese brush dripped in black paint. The image was then delicately filled in using only a small amount of colour. This is especially noticeable in the girl's pale flesh tones. Foujita was a master of drawing, and this painting demonstrates how he used simple lines to convey a sense of childlike innocence and purity. The Japanese tradition of art is mainly graphic, and Foujita continued this tradition by exploiting the use of line, while absorbing Western artistic influences. Born in Tokyo, the artist settled in Paris in 1913, where he joined a circle of artists including Marc Chagall, Chaim Soutine and Amedeo Modigliani. His work includes landscapes, nudes and book illustrations. In 1959 he converted to Catholicism and changed his name to Léonard in homage to Leonardo da Vinci.

☛ Chagall, Freud, Hokusai, Laurencin, Modigliani, Soutine

Tsugouharu (Léonard) Foujita. b Tokyo, 1886. d Zurich, 1968. **Young Girl in the Park**. 1957. Oil on canvas. h50.8 × w65.4 cm. h20 × w25¾ in. Private collection

Fouquet Jean

Virgin and Child

Apparently a religious image of the enthroned Queen of Heaven and her Child, this painting also appears to represent a more earthly subject. It is rumoured that the Virgin is actually a portrait of Agnès Sorel, the mistress of Charles VII of France. This woman was also adored by a man named Chevalier who was Fouquet's first patron. As this painting was executed the year Agnès died it is possible that it was commissioned as a memorial to her. Well known as a draughtsman and for his illuminated manuscripts, Fouquet, one of the leading French painters of the fifteenth century, travelled to Italy where he would have seen works by Piero della Francesca and other Renaissance artists. His acute attention to detail – as seen in the jewelled crown and the different textures of the cloth, fur and transparent veil – demonstrate his debt to northern artists such as Jan van Eyck.

☞ Botero, Bouts, Campin, Van Eyck, Piero della Francesca

Jean Fouquet. b Tours, 1425. **d** Tours, before 1481. **Virgin and Child**. 1450. Tempera on panel. **h**95.3 × **w**86.4 cm. **h**37½ × **w**34 in. Koninklijk Museum voor Schone Kunsten, Antwerp

Fragonard Jean-Honoré The Swing

With an air of flirtatious abandon, a beautiful young girl kicks off her dainty shoe as she swings in a luxuriant garden. We can almost hear the provocative rustle of petticoats as her lover gazes at her from his vantage-point in the undergrowth. Bathed in a shaft of glorious sunlight, the girl is the focus of the composition. Her porcelain perfection, pink dress and sweeping upward movement all bring the viewer's eyes – and her lover's – to her. This type of painting, with its frivolity and lightness of touch, characterizes the Rococo period. Fragonard is known for taking this style to its greatest heights. There were other artists at that time – Fragonard's own master, François Boucher, and the Venetian, Giovanni Battista Tiepolo – who were equally important painters. But it was Fragonard who so perfectly embodied the Rococo spirit – all powder, perfume and artifice, with a highly polished finish.

☞ Amigoni, Boucher, Greuze, Lancret, Tiepolo, Watteau

162

Jean-Honoré Fragonard. b Grasse, 1732. d Paris, 1806. **The Swing**. c1768. Oil on canvas. **h**81 × **w**64.5 cm. **h**31⅞ × **w**25⅜ in. Wallace Collection, London

Francis Sam

Around the Blues

Blue splotches of paint have been dripped, flicked and splattered onto the canvas with controlled abandon. Large areas of bare white canvas have been left untouched. Originally painted in 1957, the canvas was reworked by the artist in 1962. The painting is an important and monumental example of Abstract Expressionism. While no reference to the real world can be seen, it captures a particular feeling, movement and atmosphere. It vibrates with an intensity of colour in which the edges of shapes are blurred with emotion. This was the aim of the Abstract Expressionists: to allow movement without restraint, colour without outline, emotion without reality. Francis was a major figure in this group. He was also a master of watercolour. Some of his most famous works are from the 'Blue Ball' series which he created in the 1950s and 1960s.

☛ De Kooning, Pollock, Rothko, Still, Tobey

163

Sam Francis. b San Mateo, CA, 1923. d Santa Monica, CA, 1994. **Around the Blues**. 1957/62. Oil and magna on canvas. **h**274 × **w**487.5 cm. **h**108 × **w**192 in. Tate Gallery, London

Frankenthaler Helen Mountains and Sea

Large splotches of blue, green and red decorate this impressive yet delicate and lyrical composition. The artist has used an unprimed canvas so that the colours seep into it like ink into blotting paper as soon as they are applied to the surface. Although Frankenthaler has decided where to place the colours, the staining is beyond her control as it depends on the absorbency of the canvas. *Mountains and Sea* is her first major stained painting. Its rich colours, fluid forms and ability physically to merge the foreground and background into the canvas had a substantial influence on Kenneth Noland and Morris Louis, who subsequently adopted this innovative technique. The abstracted quality of her landscape, the spontaneity of her colours and the random quality of her staining are all elements that amount to an Abstract Expressionist painting. Her pictures are invariably large and evoke a unique sense of openness and delicacy.

☛ Gorky, Hodler, Louis, Noland, Pollock, Rothko

Helen Frankenthaler. b New York, NY, 1928. **Mountains and Sea**. 1952. Oil on canvas. **h**220 × **w**297.8 cm. **h**86 ⅝ × **w**117¼ in. Collection of the artist. On loan to the National Gallery of Art, Washington, DC

Freud Lucian

Girl with a White Dog

The artist's first wife Kathleen and an English bull terrier recline on a striped sofa. Painted in pale and muted tones, the scene is simple and somewhat bleak. There is almost a sense of complicity between the woman and the dog, as they stare at us with a calm but intense gaze. Freud is renowned for his masterly and near obsessive portrayal of human flesh, with all its flaws boldly displayed. This painting is no exception, as seen in the subtle paint tones he has used to create the detailed, ivory quality of the woman's skin. Freud's paintings captivate the viewer, drawing him into a scene of physical intimacy displayed as though under a harsh electric lightbulb. Although his brushwork has become looser and more expressive in recent years, his preoccupation with the human figure still continues. Grandson of the pioneering Austrian psychoanalyst, Freud moved to London in the 1930s and took British citizenship.

☞ Auerbach, Bacon, Dix, Kossoff, Schad

Lucian Freud. b Berlin, 1922. **Girl with a White Dog**. 1951/2. Oil on canvas. **h**76.2 × **w**101.6 cm. **h**30 × **w**40 in. Tate Gallery, London

Friedrich Caspar David The Wreck of the Hope

The hard, jagged edges of a ruptured ice floe dominate this composition. They have been painted so precisely and crisply that they appear cold to the touch. The luminous light which bathes the scene causes the painting itself to glow. The wrecked ship, part of William Parry's expedition to the Arctic in 1819–20, seen on the right, is tiny in comparison to the ice – thus demonstrating the dominance of nature over man. Friedrich was a major figure in the Romantic movement, which sought to depict emotions such as loneliness and desolation. His paintings always drew out the spiritual nature of landscape, and often depicted nature at its most melancholy: lonely stretches of sea and mountains, or snowscapes bathed in strange and eerie luminosity. He was particularly interested in painting the effects of light and the seasons. His realistic yet symbolic landscapes embody the Romantic spirit, yet remain totally unique.

☛ Bierstadt, Church, Cozens, Nash, Turner

Caspar David Friedrich. b Greifswald, 1774. d Dresden, 1840. **The Wreck of the Hope**. 1824. Oil on canvas. **h**96.7 × **w**126.9 cm. **h**38½ × **w**50½ cm. Kunsthalle, Hamburg

Frink Dame Elisabeth Goggle Head

Fascinating and frightening, this menacing head, its identity hidden by shiny goggles, suggests deliberate violence. It evokes images of sophisticated modern-day criminals, dictators' henchmen, or even Hell's Angels motorbike riders. Smooth in outline, it is executed in the shape of a Classical bust yet possesses a fearsome and disturbing quality. Random scratches, like those inflicted by an animal, cover its surface. Frink was one of the first British sculptors to create works in a Neo-Expressionist style, portraying her own feelings about the complex nature of humankind, its strengths and its vulnerabilities. She is equally well known for her sculptures of horses and dogs, which illustrate the sensitivity of her response to nature. Her last major commission was an impressive and dramatic figure of *The Risen Christ*, a bronze sculpture almost 4 metres (13 feet) high that is now fixed to the façade of Liverpool Cathedral.

☞ Algardi, Baselitz, Epstein, Giacometti, Houdon

Dame Elisabeth Frink. b Thurlow, 1930. d Woolland, 1993. **Goggle Head**. 1969. Bronze. **h**62.2 cm. **h**24½ in. Beaux Arts Gallery, London

Froment Nicolas Virgin and Child

While tending his father-in-law's sheep, Moses is astounded by the vision of a burning bush. As a token of respect to this heavenly apparition, he removes his shoes. On the left an angel appears to witness the event with him. According to the Bible, God spoke to Moses through a burning bush, telling him that he was to deliver the Israelites from their oppressors and lead them to the land of milk and honey. Froment has chosen to include the image of the Virgin and Child because a burning but unconsumed bush was seen as a symbol of Mary who bore a child but remained a virgin. Commissioned by King René of Anjou, this panel forms the central section of a triptych of the Burning Bush, which was painted for the church in which it still stands today. Little is known about this French artist who worked in and around Aix-en-Provence. His acute atttention to detail and great sensitivity to subtle effects of light and colour are elements which he possibly learned from Jan van Eyck.

☛ Van Eyck, Lochner, Schongauer, Van der Weyden, Witz

Nicolas Froment. Active in Uzès, 1450–90. **Virgin and Child**. 1476. Oil on panel. **h**410 × **w**304.2 cm. **h**161½ × **w**119¾ in. Saint Sauveur, Aix-en-Provence

Gabo Naum

Linear Construction in Space No. 2

A nylon string is wound around two intersecting sheets of curved perspex to create a complex three-dimensional pattern of concave and convex folds. It was conceived as part of an unrealized 3-metre (15-foot) commission for the Esso building in New York in 1949. With this extraordinarily ethereal sculpture Gabo has achieved an example of delicacy, transparency and weightlessness that was unprecedented. The sculpture seems to float as if suspended from an invisible cord and, having no beginning or end, it conveys a sense of infinity. Gabo was a Constructivist and this work is an example of the movement in the way that it captures the indefinite expansion of space. Gabo left his native Russia in 1922, and spent time in Berlin and Paris before becoming an American citizen. In 1952, he combined his artistic talents with architecture, constructing an enormous monument for a department store in Rotterdam.

☛ Hepworth, Lissitzky, Malevich, Rodchenko, Tobey

Naum Gabo. b Bryanks, 1890. **d** Waterbury, CT, 1977. **Linear Construction in Space No. 2**. 1957–8. Perspex and nylon string on a wooden base. **h**38 cm. **h**15 in. Private collection

Gaddi Taddeo

Saint Eligius in the Goldsmith's Shop

In the Middle Ages artisans' shops often looked like the workshop in this painting. The large window opening onto the street would have allowed contact with customers. It would also have provided space to display wares. Gaddi was chosen among the best living painters of his time to produce a new high altarpiece for Pistoia Cathedral. This small scene, telling the story of St Eligius, would have formed part of the 'predella', a series of panels appearing under the main scene of an altarpiece. The saint was a goldsmith before becoming a priest, so he is shown here as the patron saint of goldsmiths. Gaddi was the godson of the painter Giotto, and was his disciple for 24 years. The use of vibrant colours and massive figures shows his master's influence. Gaddi was best known as a narrative painter. He was popular especially for his attention to detail and ability to tell a story.

☛ Giotto, Lorenzetti, Lorenzo Monaco, Orcagna

Taddeo Gaddi. b Florence, c1300. **d** Florence, 1366. **Saint Eligius in the Goldsmith's Shop**. c1365. Tempera on panel. **h**35 × **w**39 cm. **h**13¾ × **w**15⅜ in. Museo del Prado, Madrid

Gainsborough Thomas Mr and Mrs Andrews

Mr and Mrs Andrews are resting after an afternoon of shooting. To the right, their estate extends far into the distance. The sheaves of corn tell us it is autumn, and Mr Andrews' dog and shotgun imply that he has been hunting. Gainsborough possibly also intended to include a pheasant shot by this elegant English gentleman in the composition, but never completed the painting. His wife's beautifully executed blue satin dress is unfinished – the outline of a bird is visible on her lap. Robert Andrews and Frances Carter were married in November 1748 and it is thought that this portrait was painted as a celebration of this event. Unlike many of his contemporaries, Gainsborough was not an academic painter. His intuitive sense of style and colour, and superb handling of paint, make him one of the artistic geniuses of eighteenth-century Europe. Although he was a portrait painter by trade his true passion lay in painting the British countryside.

☛ Constable, Van Dyck, Van Eyck, Ramsay, Reynolds

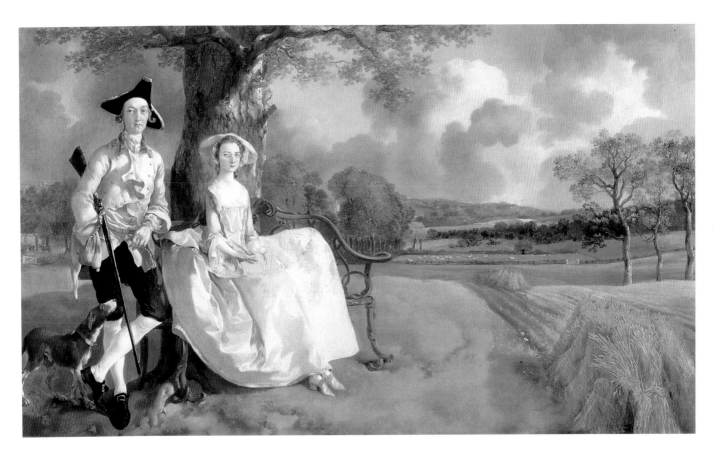

Thomas Gainsborough. **b** Sudbury, 1727. **d** London, 1788. **Mr and Mrs Andrews**. c1750. Oil on canvas. **h**69.8 × **w**119.4 cm. **h**27¼ × **w**47 in. National Gallery, London

Gaudier-Brzeska Henri Red Stone Dancer

Pulsating with all the power and vitality of an African tribal warrior, this statue ostensibly portrays a dancer. The geometrical rhythms of its surfaces are fragmented and distorted to reflect movement. Despite its vigour, the sculpture's gentle coils and the softness of its carving evokes the artist's appreciation of the human form. This piece was sculpted at a point when the artist was concerned with primitive forms and with abstraction. Born in France, he studied in England and settled in London in 1911. In 1914 he enlisted in the French army, and during this time he made wood carvings and continued to exhibit in London. Influenced by the work of Auguste Rodin and Constantin Brancusi who reduced figures to their most simplified form, Gaudier-Brzeska worked as a draughtsman and sculptor and was also closely linked to the Vorticist group. Potentially a great artist, he was killed in action in 1915 at the age of 23.

☞ Archipenko, Brancusi, Epstein, Lipchitz, Moore, Rodin

Henri Gaudier-Brzeska. **b** Saint Jean-de-Bray, 1891. **d** Neuville-Saint-Vaast, 1915. **Red Stone Dancer**. 1914. Red Mansfield stone. **h**85 cm. **h**33½ in. Tate Gallery, London

Gauguin Paul Woman with a Flower

Melancholic and sensual, this beautiful Polynesian woman reaches out to the viewer through the vibrancy of her bright colours and heavy outlines. Although a traditional pose has been used, the artist has avoided the usual rules of Western art. The forms are simple, the colours clash, and there is no depth or perspective. Gauguin personified the turn-of-the-century desire to return to a romantic idea of primitive life. Leaving his family and successful career, he went to live in Tahiti. In his book *Noa Noa* about his life there he wrote, 'I have escaped everything that is artificial and conventional. Here I enter into Truth, become one with nature.' In Tahiti he strove to capture the impulsive, instinctive immediacy of primitive art. Gauguin was among the first to use colour for purely decorative or emotional purposes. This, together with his simplified, non-naturalistic style of painting, has made him one of the most important contributors to modern art.

☛ Cassatt, Van Dongen, Van Gogh, Jawlensky, Matisse

Paul Gauguin. b Paris, 1848. **d** Tahiti, 1903. **Woman with a Flower**. 1891. Oil on canvas. **h**70 × **w**46 cm. **h**27½ × **w**18 in. Ny Carlsberg Glyptotek, Copenhagen

Gentile da Fabriano The Adoration of the Magi

The three Magi are seen paying their respects to the newly born Christ. Each of the kings and the members of their group are elegantly dressed in gilded brocades. In fact, gold pervades this altarpiece, which was commissioned by the Strozzi family to adorn their chapel in the church of Santa Trinità. Only the wealthiest

merchant family in Florence could choose such a subject, and encourage the free use of expensive blue pigment (lapis lazuli) and gold leaf. This practice was frequently employed to show off the patron's social position. Gentile came from the north of Italy but he painted in many different places. His work is typical of the

International Gothic style, characterized by elegant refinement and an interest in secular and natural themes. Gentile reveals this in his realistic depiction of animals, birds and plants in many of his paintings.

☛ Gozzoli, Lorenzo Monaco, Mantegna, Overbeck, Pisanello

Gentile da Fabriano. **b** Fabriano, c1370. **d** Rome, 1427. **The Adoration of the Magi**. 1423. Tempera on panel. **h**173 × **w**220 cm. **h**68⅛ × **w**86⅝ in. Galleria degli Uffizi, Florence

Gentileschi Artemisia Judith and Holofernes

Judith is shown at the gruesome moment when she separates Holofernes' head from his body. Her determined look guides her steady hand, even though blood gushes out towards her and all over the bed. A strong light shining from the left illuminates the otherwise dark space, heightening the tension of the moment. The drama, lighting and colouring of this work are typical of a Baroque painting. The saturated colours of the red velvet bedcover and the contrasting white sheets increase the picture's brutal goriness; it is difficult to imagine this painting being made by a woman living in the seventeenth century. It was in fact created by the high-spirited daughter of Orazio, a well-respected painter. Once unrecognized because she followed in the footsteps of her father, Artemisia is now noted as an important and a fine artist in her own right.

☞ Caravaggio, Guercino, La Tour, Luini, Reni

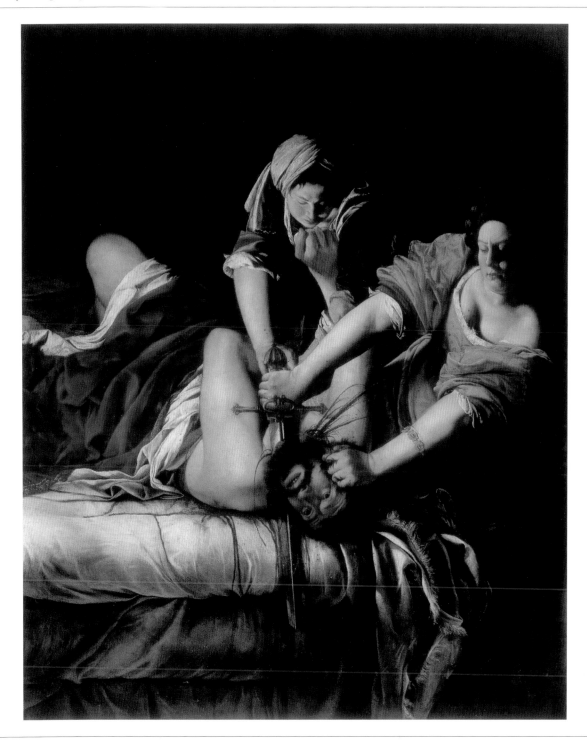

Artemisia Gentileschi. b Rome, 1593. d Naples, 1652. **Judith and Holofernes**. c1620. Oil on canvas. **h**199 × **w**162.5 cm. **h**78⅜ × **w**64 in. Galleria degli Uffizi, Florence

Géricault Théodore Officer of the Hussars

A decorated officer of the Hussars on a rearing mount charges into battle wielding his curved sword. The dynamism and expressiveness of this picture are created by the dramatic diagonal line flowing from top right to bottom left incorporating the horse's head with its flying mane, the dashing soldier as he stretches his arm across the horse's hindquarters, and the flowing tail and hind leg of the horse. The drama is heightened by a turbulent sky lit by fires. The composition is as cleverly balanced as the horse: the main body of the animal, and the rider with his curving sword, create a large circle which stabilizes the picture. Géricault was interested in horses and racing, and because of this developed a brilliantly rapid method of capturing a sense of movement. Painted with gusto in rich colours, this picture characterizes Géricault's style, which was to be such a great inspiration to later painters such as Eugène Delacroix.

☛ Böcklin, Delacroix, Van Dyck, Etty, Stubbs

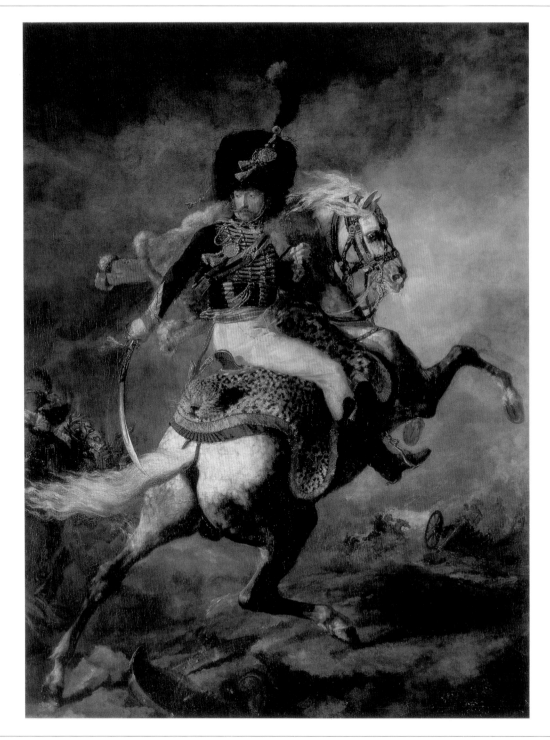

Théodore Géricault. b Rouen, 1791. d Rouen, 1824. **Officer of the Hussars**. 1812. Oil on canvas. **h**349 × **w**266 cm. **h**137½ × **w**104¾ in. Musée du Louvre, Paris

Gertler Mark

The Merry-Go-Round

The open-mouthed figures on the roundabout become hardened into what look like brightly coloured mechanical toys. Whirling around, they have a simplistic yet sinister quality. As several are wearing uniforms, the painting is now viewed as a satire on the horror of war – it was at this time that the atrocities of the First World War were just beginning to dawn on the public. One of Gertler's best-known paintings, it was considered one of the most striking exhibits at the 1917 London Group Exhibition. Gertler was also well known for his still lifes and nudes, which he depicted in a quiet yet individual style. Gertler was born of Polish-Jewish parentage and brought up in a close Yiddish-speaking community. Renowned for being the life and soul of parties, he nevertheless suffered from serious depression. He committed suicide in his London studio at the age of 48.

☛ Bomberg, Van Dyck, Géricault, Lewis, Nash

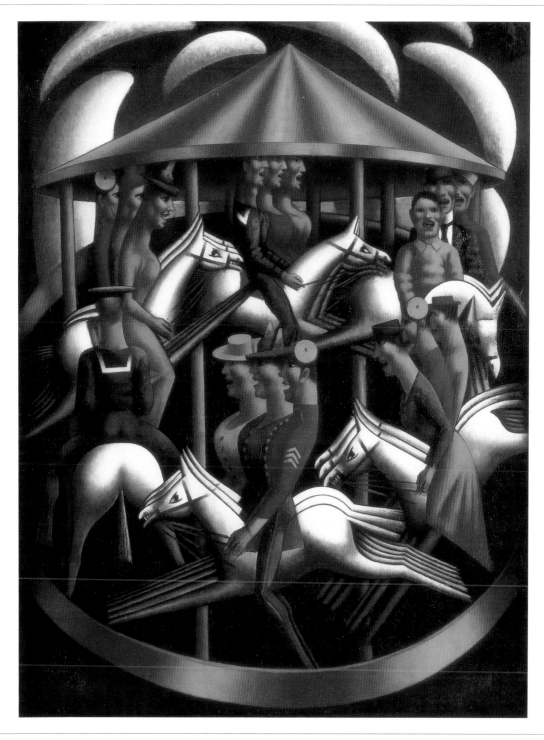

Mark Gertler. **b** London, 1891. **d** London, 1939. **The Merry-Go-Round**. 1916. Oil on canvas. **h**189.2 × **w**142.2 cm. **h**74½ × **w**56 in. Tate Gallery, London

Ghiberti Lorenzo David and Goliath

The artist has created a sense of remarkable depth in this shallow relief. Ghiberti achieved this effect by using the formal principles of perspective. For example, the three-dimensional figures of the foreground are set against a landscape that recedes into the distance. The scene is one of ten of the second set of large bronze doors to the Baptistry in Florence sculpted by Ghiberti. The doors are made up of ten large panels in which episodes from the Old Testament are shown. They are considered by many to express the height of Florentine art, particularly in their mastery of composition and perspective. The doors were a great inspiration to other Florentine Renaissance artists. Many years later Michelangelo praised Ghiberti's work, calling the doors the Gates of Paradise. In the last years of his life Ghiberti wrote his autobiography, which is the earliest by an artist to have survived.

☛ Castagno, Donatello, Michelangelo, Pisano, Della Quercia

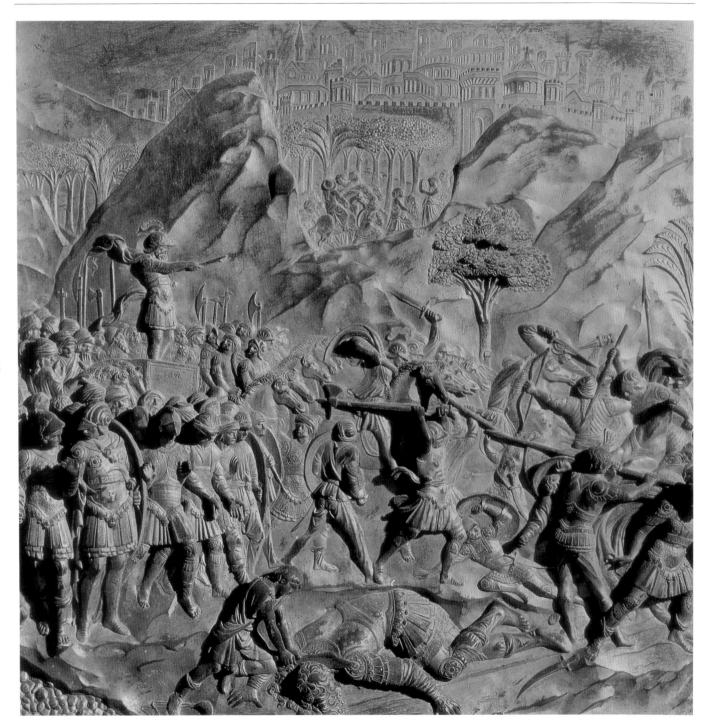

Lorenzo Ghiberti. b Florence, 1378. d Florence, 1455. **David and Goliath**. c1435. Gilt bronze. **h**79.5 × **w**79.5 cm. **h**31¼ × **w**31¼ in. Battistero di San Giovanni, Florence

Ghirlandaio Domenico Portrait of Giovanna Tornabuoni

'Would that art could portray her character and virtue. No painting in the world would be more beautiful.' Despite this comment on the wall behind the sitter, the artist has successfully captured Giovanna's serenity, beauty and elegance. She is seated against a plain background, enabling the viewer to focus on her profile. This was a convention that was regularly used in Florentine Renaissance portraiture. The portrait is all the more poignant as the sitter died the year it was painted, only two years after her marriage. In addition to producing portraits such as this, Ghirlandaio was an experienced fresco painter; indeed, the sitter's likeness also appears in a family chapel in Florence, which was the artist's largest undertaking. Ghirlandaio, at one point Michelangelo's teacher, was especially popular for his use of naturalistic detail and his ability to capture the life and style of his times.

☞ Botticelli, Filippino Lippi, Michelangelo, Pisanello

179

Domenico Ghirlandaio. **b** Florence, 1449. **d** Florence, 1494. **Portrait of Giovanna Tornabuoni**. 1488. Tempera on panel. **h**77 × **w**49 cm. **h**30¼ × **w**19¼ in. Fundación Colección Thyssen-Bornemisza, Madrid

Giacometti Alberto Walking Man

This emaciated, monumental figure with a roughly pitted and textured surface is hauntingly powerful. Through its unnatural, elongated shape, the sculpture is intended to signify solitude and the absolute separation between ourself and our fellow man. It also underlines our fragility and the ephemeral nature of human existence. In contrast to other sculptors, Giacometti did not start with a large mass of material which he chipped and chiselled to find a form hidden within. His technique was to start with a metal skeleton and add clay to it, which he would then cast. Giacometti's singular style of expression kept him apart from the post-Second World War styles of painting and sculpture. Born in Switzerland, Giacometti settled in Paris in 1922. His paintings and drawings reflect the same restless, nervous quality as his sculptures. Made up of sharp, energetic strokes of paint they have a stark and haunting beauty.

☛ Archipenko, Auerbach, Dubuffet, Frink, Rodin, Smith

180

Alberto Giacometti. b Stampa, 1877. **d** Chur, 1966. **Walking Man**. 1960. Bronze. **h**183 cm. **h**72 in. Private collection

Giambologna

The Rape of a Sabine

Swirling with immense energy and furious movement, this tightly compacted composition, with its twisting outlines, creates a feeling of drama suitable for the subject. The illusion of writhing motion is initiated by the Sabine's outstretched arms, continued through the muscular, heroic figure of the Roman clasping the hips of his prey and resolved in the dominated man straddled below. The smoothly polished, sinuous form invites us to walk around the statue and to view it equally from all angles, rather than from a single viewpoint. Giambologna's use of the exaggerated gesture and his ability to convey a fervid sense of energy characterize the Mannerist style. Giambologna was strongly influenced by Michelangelo, and adapted his powerful forms to create a new kind of fluidity and elegance in sculpture. His numerous works include a number of fountains for the gardens of the Medici family.

☛ Bourdelle, Cellini, Michelangelo, Rosso Fiorentino

Giambologna (Jean de Boulogne). b Douai, 1529. **d** Florence, 1608. **The Rape of a Sabine**. 1581/3. Marble. **h**410 cm. **h**161½ in. Loggia dei Lanzi, Florence

Gilbert & George

Thumbing

Two figures in alternating blue, red and white clothing appear in what seems to be a window. A tall building in the distance dominates the background. With mock-serious expressions, the figures seem to be posing in a deliberately prankish manner. Perhaps they are 'thumbing' their noses at the conventions of traditional art. Gilbert & George have lived and worked together since 1967. As self-styled 'living sculptures', they portray themselves to the public in a variety of ways and media. Whatever they do or however they use themselves, it is usually with humour and deliberate bad taste. With their narcissistic pretensions they make themselves into objects of ridicule. Their work almost defies categorization, although with its gaudy colours and large scale, and in the way it debunks traditional art-historical values, it has affinities with the Pop Art movement.

☞ Koons, Lichtenstein, Sherman, Warhol

Gilbert & George (Gilbert Proesch and George Pasmore). (Gilbert) **b** Dolomites, 1943. (George) **b** Devon, 1942. **Thumbing**. 1991. Photo-piece. **h**169 × **w**142 cm. **h**66½ × **w**56 in. Anthony d'Offay Gallery, London

Gilman Harold · An Eating House

This portrayal of working-class people in a humble interior has been painted with sensitivity and intensity. The artist has created a shallow space in which the bare walls and range of benches and tables appear as flat decorative colour planes of vermilion and emerald greens. The surface of the painting bears a grid mark which was imposed when the painting was still wet. Gilman probably used some kind of device to transfer the design from this painting to a smaller version, which bears the same title. With its clear, accurate portrayal of an ordinary scene and its intensity of colour, it is a fine example of work by an artist of the Camden Town Group.

Sometimes called the 'English Post-Impressionists' because of their use of colour, this group of artists advocated the honest study of everyday life. The group often met in Walter Sickert's studio in Camden Town, an area of north London, hence its name.

☞ Hammershøi, Modersohn-Becker, Orpen, Sickert, Vuillard

Harold Gilman. **b** Rode, 1878. **d** London, 1919. **An Eating House**. 1913/14. Oil on canvas. **h**57.2 × **w**74.9 cm. **h**22½ × **w**29½ in. Sheffield City Art Galleries, Sheffield

Giordano Luca The Dream of Solomon

Sleeping on his luxurious bed, the young King Solomon has a vision of God appearing amid a swirl of clouds and angels. God invests him with the heavenly light of Divine wisdom, for which Solomon is to become famous. Above him sits Minerva, the goddess of knowledge. The books and the lamb she holds are symbols of learning and patience. The

building behind is a reference to the Temple of Jerusalem, built during Solomon's reign. The scene is painted with great vigour and expression. This, together with its decorative colour, characterizes Giordano's style and that of the late Baroque period. One of the most important decorative painters of the second half of the seventeenth

century, Giordano was nicknamed 'Luca Fa Presto' because he worked so quickly. His airy compositions and delicate colours look forward to such great eighteenth-century painters as Giovanni Battista Tiepolo.

☞ Bernini, Delacroix, Domenichino, Reni, Tiepolo

Luca Giordano. **b** Naples, 1632. **d** Naples, 1705. **The Dream of Solomon**. c1693. Oil on canvas. **h**245 × **w**361 cm. **h**96½ × **w**142 in. Museo del Prado, Madrid

Giorgione

The Tempest

Why is a naked woman feeding her child out in the open as a thunderstorm looms in the distance? Is this painting just an excuse to depict a poetic landscape, or does it have greater significance? No one has in fact been able to identify the subject of this picture, although many theories have been put forward. Indeed, much

controversy surrounds this artist. There are no signed and dated works by him and matters are further confused by the fact that after his early death, many of Giorgione's pictures were completed by his pupils, including Titian. Of all the Venetian painters Giorgione embodies the best of their painterly style. His loose, light brushstrokes and

handling of colour and tone are all hallmarks of Venetian painting. Centuries after his death, Giorgione's pastoral landscapes were still much admired, and influenced great landscape painters such as Nicolas Poussin.

☛ Allston, Giovanni Bellini, Poussin, Titian

Giorgione. **b** Castelfranco, c1477. **d** Venice, 1510. **The Tempest**. c1508. Oil on canvas. **h**79.5 × **w**73 cm. **h**31¼ × **w**28¾ in. Galleria dell'Accademia, Venice

Giotto

The Lamentation

A group of men and women mourn the death of their Saviour as angels await his arrival in the heavenly realm. Emotional gestures, pained expressions and bright colours heighten the intensity of Mary's grief as she bends over Christ's dead body. Giotto caused a revolution in painting. He was one of the earliest artists to depict the illusions of real life, in terms of emotion and space, on a flat surface. This work, one of the many scenes depicting the life of the Virgin, is considered one of the most important works of the development of Western art. With Cimabue Giotto is often regarded as the founder of modern painting, as he broke away from the static, stereotyped conventions of his day. In 1334 he was appointed surveyor to Florence Cathedral and architect to the city. This was a tribute to his great fame as a painter rather than a consequence of any architectural knowledge.

☛ Cimabue, Duccio, Gaddi, Memling, Pisano, Van der Weyden

Giotto di Bondone. b Vespignano, 1267. **d** Florence, 1337. **The Lamentation**. c1305. Fresco. **h**200 × **w**185 cm. **h**78¾ × **w**72⅞ in. Cappella dei Scrovegni, Padua

Giulio Romano Room of the Giants

The artist has painted an entire room in fresco from floor to ceiling. Standing in the middle, the viewer feels surrounded by tumbling rocks and raging thunderbolts. With their bulging muscles, the Titans of Mount Olympus toss massive boulders as if they were as light as feathers, while the gods contemplate the chaos on Earth below. With its illusionistic perspectives and melodramatic emotion the fresco epitomizes the Mannerist style. Giulio Romano was both an architect and a painter. He began his career as one of Raphael's chief pupils, and his assistant. After his master's death he completed a number of Raphael's unfinished frescos in the Vatican. Later Giulio moved to Mantua, where he became Court painter to the Duke, a position once held by Andrea Mantegna. Here he excelled as an architect. He often designed buildings in order to shock and surprise the spectator, the most important of these being his own house in Mantua.

☛ Mantegna, Michelangelo, Raphael, Rosso Fiorentino

Giulio Romano (Giulio Pippi). **b** Rome, 1492. **d** Mantua, 1546. **Room of the Giants**. c1527. Fresco. Palazzo del Tè, Mantua

Van der Goes Hugo The Fall of Man

Part lizard, part human, the serpent in this depiction of the fall of Adam and Eve is quite disturbing. Standing by the Tree of Knowledge, Eve, modestly covered by a strategically placed iris, stretches her arm to reach for a second apple, having already taken a bite of the first. The care with which each leaf, blade of grass and lock of hair is individually painted is astounding. (Notice the extraordinary plaits on top of the serpent's head.) This scene forms the left-hand panel of a diptych (an altarpiece made of two panels hinged together). The clear, luminous colours and straightforward description of the figures shown here are typical of painting in the Netherlands in the fifteenth century. The artist's fame spread as far as Italy, where one of his altarpieces caused a sensation in Florence. He is said to have been seized by madness while on a journey to Cologne in 1481; he died, still insane, the following year.

☛ Bouts, Campin, G David, Van Eyck, Memling, Van Scorel

188

Hugo van der Goes. b Ghent, 1440. d Brussels, 1482. **The Fall of Man**. c1470. Oil on panel. **h**35.5 × **w**23.2 cm. **h**13⅞ × **w**9⅛ in. Kunsthistorisches Museum, Vienna

Van Gogh Vincent Sunflowers

Brilliant and startling, this simple vase of sunflowers explodes with razor-sharp vibrancy. The brushstrokes have been laden with thick paint, which Van Gogh applied like a sculptor slapping clay onto a relief. The colours – shades of yellow and brown – and the technique express a beautiful world of hope and of sunlight. At the time this work was painted, however, such a world was slipping slowly but relentlessly from the painter's desperate grasp. Perhaps the surface of the painting – agitated, almost manic – reflects the artist's state of mind as he neared the end of his tragically short life. A painter who loved nature and could see pure beauty in simple things, Van Gogh stated that he would rather paint trees seen from a window than imaginary visions. A Dutchman by birth, Van Gogh ended his emotionally fraught life on 29 July 1890 in the French town of Auvers-sur-Oise.

☛ Auerbach, Derain, Gauguin, Matisse, Pechstein

Vincent van Gogh. b Groot-Zundert, 1853. d Auvers-sur-Oise, 1890. **Sunflowers**. 1888. Oil on canvas. **h**92 × **w**73 cm. **h**36⅛ × **w**28½ in. National Gallery, London

Gontcharova Natalia Street in Moscow

In a tranquil street, a woman dressed in elegant black walks out of the picture. Behind her a coachman calmly waits in his carriage. Apart from the woman's sad steps, there is no movement in this scene, which is a crystallization of a moment in time. All the forms have been reduced to simple, flat shapes – the squares and rectangles of the street and buildings, the circles of the wheels, and the shape of the woman's hat reflected in that of the cart. The forms have been painted in muted tones, adding to the atmosphere of sadness. An air of forlorn hope blows through the painting. Gontcharova was profoundly interested in the popular folk art of Russia, and her own work for a time exuded a primitive quality that came from this interest. In 1915 she settled in Paris where she designed a number of stage sets for Sergei Diaghilev's *Ballets Russes*.

☛ Appel, Chagall, Jawlensky, Modersohn-Becker, Wallis

190

Natalia Gontcharova. b Russia, 1881. **d** Paris, 1962. **Street in Moscow**. 1909. Oil on canvas. **h**65 × **w**79 cm. **h**25½ × **w**31 in. Private collection

Gorky Arshile The Waterfall

This apparently abstract painting is based on a small waterfall in a wood. It evokes a strong impression of a stream pouring through a rock, surrounded by overhanging trees and greenery. Vibrant colours evoke the serenity of bright sunlight and the sound of falling water. The beauty of the work lies in the artist's ability to express an almost spiritual peace through the images of forest and water. The painting shows the magical, dream-like elements typical of the Surrealist movement, towards which Gorky was moving at the time, and the spontaneity of Abstract Expressionism. Born in Armenia, Gorky emigrated to the USA in 1920. One critic has referred to him as an artist-in-exile, for whom art became a homeland. Gorky would often use images from his native land in his paintings. After years of poverty, he achieved brief recognition but hanged himself after suffering severe psychological trauma.

☛ Dalí, Ernst, Frankenthaler, De Kooning, Lam, Rothko

Arshile Gorky. b Khorkom Vari, 1904. d Sherman, CT, 1948. **The Waterfall**. 1943. Oil on canvas. **h**154 × **w**113 cm. **h**60½ × **w**44½ in. Tate Gallery, London

Goya Francisco

Portrait of the Duchess of Alba

Dressed in the fashionable black costume of the elegant *majas* of Madrid, a veil cascading in folds around her head, the Duchess of Alba exudes an air of aristocratic beauty. Her monochrome but opulent clothing is described with marvellous energy. Set against a cloudless sky, she seems about to step into the viewer's presence. The Duchess was a prominent figure in Madrid society. It is likely that she was romantically involved with Goya at the time, suggested here by the words 'Solo Goya' to which she points, and the fact that 'Goya' and 'Alba' are inscribed on the rings of her hand. As he grew older Goya spent more time creating scenes of fantasy and terror. Although he remained a Court painter, many of his paintings were politically inspired by the French occupation of his country at that time. At the time of his death, Goya had completed some five hundred oil paintings and nearly three hundred etchings and lithographs.

☛ Gainsborough, Manet, Ramsay, Reynolds, Velázquez

Francisco Goya y Lucientes. b Fuentendos, 1746. **d** Bordeaux, 1828. **Portrait of the Duchess of Alba**. 1797. Oil on canvas. **h**210 × **w**148 cm. **h**82½ × **w**58⅛ in. Hispanic Society of America, New York, NY

Van Goyen Jan

A Castle by a River with Shipping at a Quay

The warm, brown tones give a wonderful rustic air to the building on the right with its turrets and bay windows. Looking along the river into the distance, the colour gradually loses its strength. The low horizon evokes the flat plains of the Dutch landscape. This is emphasized by the vast, dominating, grey sky, a feature that was so important to seventeenth-century Dutch painters and which takes up almost three-quarters of the painting. Van Goyen was one of the first to capture a sense of light and atmospheric effects. Most of his paintings were based on drawings that he made while travelling around the countryside, and it appears that he used these again and again, as the same scene appears in a number of his paintings. Van Goyen had many pupils and imitators. He produced countless works, and was certainly a great influence on landscape painting of the seventeenth and eighteenth centuries.

☛ Avercamp, Bonington, Boudin, Hobbema, Ruisdael

Gozzoli Benozzo The Journey of the Magi

Fur-trimmed capes, gold bridles, velvet robes and splendid horses – this is truly a magnificent procession. The subject of the Magi was often a favourite of affluent patrons because the use of opulent colours and gold leaf would highlight their own wealth and status. This example appears as a fresco on the walls of a chapel inside the palace of Cosimo de' Medici in Florence. It was unusual to have a chapel inside a private house, but Cosimo's magnificent palace broke with many traditions of the day. Gozzoli has included portraits of the family in the fresco, and the elegant young Magus in the gold robe is said to be Lorenzo de' Medici. The fresco is only a part of the chapel's decoration. A pupil of Fra Angelico and contemporary of the very different Andrea Mantegna, Gozzoli's rich sense of decorative pageantry provides a fine example of the International Gothic style.

☛ Fra Angelico, Gentile da Fabriano, Mantegna, Uccello

194

El Greco

The Burial of Count Orgaz

Swirling forms and colours have been used here to create a dynamic, visionary image of Heaven. The subject of the painting, Count Orgaz, was a Toledan dignitary who was so pious that the saints Augustine and Stephen appeared miraculously at his funeral to lower his body into the tomb. Above, his soul ascends to the heavenly realm as members of the local nobility and clergy look on. Born in Crete, El Greco trained in Venice and Rome before moving to Toledo. The fashionable style at that time was the Classical manner of Michelangelo, Raphael and Titian. El Greco transformed these powerful influences into his own distinctive, intensely spiritual style with its elongated forms, sweeping movement and bright, sometimes unearthly, colours. In this way, El Greco's work can be seen to epitomize the Mannerist movement at its height.

☛ Andrea del Sarto, Michelangelo, Raphael, Titian

El Greco (Domenikos Theotocopoulos). **b** Crete, 1541. **d** Toledo, 1614. **The Burial of Count Orgaz**. 1586. Oil on canvas. **h**487.7 × **w**360.7 cm. **h**192 × **w**142 in. San Tomé, Toledo

Greuze Jean-Baptiste The Guitarist

Dressed in theatrical clothes, a young man listens intently as he carefully tunes his guitar. His tired, wide-open eyes and bedraggled look hint at the struggles of his outwardly jovial life. This is a richly painted scene, complete with all the details of the seventeenth-century Flemish genre painters, whose manner Greuze has tried to emulate. Greuze's scenes of everyday life often had a moral tale to tell. These pictures became increasingly popular in eighteenth-century France and were widely praised by moral philosophers such as Denis Diderot. When the style of the day shifted towards Neo-Classical artists such as Jacques-Louis David, however, Greuze went out of fashion. Unfortunately, his desire to remain popular led him to use painting in an insincere and sentimentalized manner. For this reason many of his paintings have been overlooked for their important contribution to art until recently.

☞ J-L David, Hogarth, Honthorst, Steen, Terbrugghen

Jean-Baptiste Greuze. **b** Tournus, 1725. **d** Paris, 1805. **The Guitarist**. c1760. Oil on canvas. **h**71 × **w**57 cm. **h**28 × **w**22½ in. Musée des Beaux-Arts, Nantes

Grimshaw Atkinson Nightfall down the Thames

A full moon dominates this riverscape, casting a green light over the River Thames and the ships floating on it. The reflection of light on the water leads the viewer's eye to the dome of St Paul's Cathedral in the distance. In such mysterious moonlight, however, the well-known London landmark looks strangely different to the way it would look in daylight. The composition of the painting is symmetrical and smooth. It is unbroken by any movement except the vertical pattern of the skeleton-like masts across the skyline. Grimshaw is best known for this kind of night townscape, which was often lit by bright moonlight. Like his contemporary James McNeill Whistler, whose nocturnal scenes are well known, and who supposedly commented, 'I thought I had invented the Nocturne until I saw Grimmy's moonlights', Grimshaw had a great love for the River Thames.

☛ Friedrich, Spilliaert, Turner, Whistler

Atkinson Grimshaw. b Leeds, 1836. **d** Leeds, 1893. **Nightfall down the Thames**. 1880. Oil on board. **h**40.2 × **w**63.1 cm. **h**15⁷/₈ × **w**24⁷/₈ in. Leeds City Art Gallery, Leeds

Gris Juan

Glasses, Newspaper and a Bottle of Wine

The artist has used sliced sections of newspaper to create this unusual interpretation of a still life. The objects – glasses, newspaper and bottle of wine – have been taken whole and then fragmented, painted and glued back together again within the confines of parallel vertical planes in the Cubist technique. Gris has created a sense of perspective and different levels of space by positioning these planes in front of or behind each other. The importance of this work lies in its innovative method of portraying different sections of an object simultaneously, while rejecting the conventions of light and shade. The artist has thus created a new kind of reality. Although Gris was never a Cubist by intention, this work is seen as an example of the movement's style. Spanish by birth, Gris lived most of his working life in Paris and his work remained essentially Cubist in form until his death.

☛ Archipenko, Braque, Kupka, Léger, Picasso, Schwitters

198

Juan Gris. **b** Madrid, 1887. **d** Paris, 1927. **Glasses, Newspaper and a Bottle of Wine**. 1913. Collage, gouache, watercolour, coloured chalks and charcoal on paper. **h**45 × **w**29.5 cm. **h**17³/₄ × **w**11⁷/₈ in. Private collection

Gros Antoine-Jean, Baron Napoleon Bonaparte on the Bridge at Arcole

A victorious Napoleon defeats the Italians at the battle of Arcole in 1796. The strong character of Bonaparte's face was obviously studied from life and gives the painting a very realistic feeling. This is not a generalized representation of victory but rather a depiction of a specific, contemporary event. Although trained by his close friend the Neo-Classical painter Jacques-Louis David, Gros became a leader in the move towards Realism and Romanticism in French painting at the end of the eighteenth century. His sombre palette and naturalistic compositions were a reaction to the strong colours and theatrical set-pieces of the Neo-Classicists. Gros was made official war painter by Napoleon, and successfully captured the atmosphere of the moment. In the 1820s, however, Gros attempted to return to a more Neo-Classical style, and his popularity diminished. He slipped into obscurity, and committed suicide in 1835.

☞ J-L David, Delacroix, Géricault, Lawrence

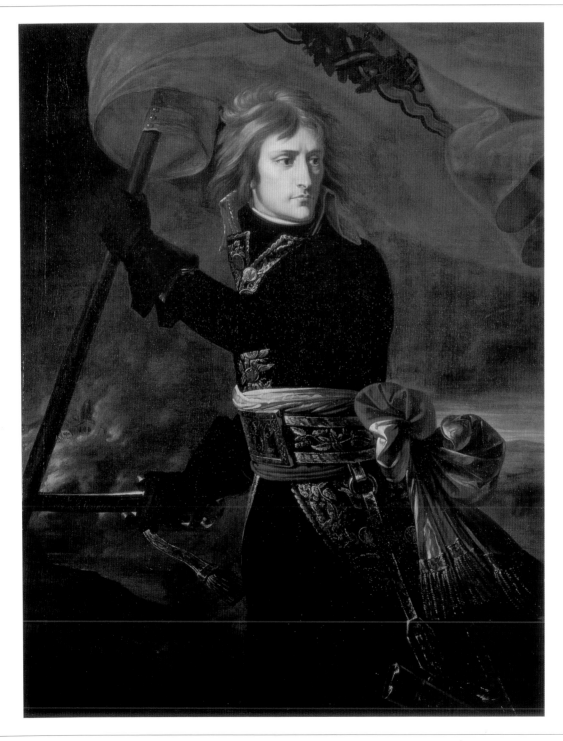

Baron Antoine-Jean Gros. b Paris, 1771. d Bas-Meudon, 1835. **Napoleon Bonaparte on the Bridge at Arcole**. 1796/7. Oil on canvas. **h**134 × **w**104 cm. **h**52¾ × **w**41 in. Hermitage Museum, St Petersburg

Grosz George

Berlin Streetscene

An elegant lady in heels and a fur collar haughtily curls her nose at a dapper gentleman who winks at her in a fashionable street. Only interested in their own flirtatious exchanges, they do not notice the old man in a threadbare suit begging for money. This watercolour scathingly caricatures the appalling social conditions of post-First

World War Germany. A satire on the affected patriotism, selfish greed and depraved sensuality of the period, it is one of many which the artist produced that have a nightmarish quality. Grosz's disgust at a decaying society of distorted morals, propaganda and self-indulgence led him to vent his anger through his biting satirical caricatures,

and eventually to emigrate to the USA. His work gradually came to combine the satire of old with a new romanticism. He began his career as a caricaturist and became a leading member of the Dada group in Berlin after 1918.

☞ Daumier, Dix, Hausmann, Schwitters

George Grosz. b Berlin, 1893. d Berlin, 1959. **Berlin Streetscene**. 1930. Watercolour, ink and oil on paper. **h**60 × **w**46 cm. **h**23½ × **w**18 in. Private collection

Grünewald Matthias The Crucifixion

A book in one hand, John the Baptist points towards the dying figure of the crucified Christ. The Latin inscription behind his arm reads, *Illum oportet crescere, me autem minui* ('He must increase, but I must decrease'). Christ's elongated fingers are splayed by the force of the nails, blood trickles from the gash in his side, and his flesh is covered in festering wounds. Mary Magdalene kneels at the foot of the cross with her perfume pot beside her, and the Virgin Mary faints into the hands of John the Evangelist. Grünewald's aim was that the viewer should be moved with the same intensity of emotion as the figures in the painting. He was a contemporary of Albrecht Dürer and considered as popular. Ironically, however, he was known by the wrong name for three hundred years; his real name was in fact Mathis Gothardt Neithardt and he was misnamed Grünewald by a seventeenth-century biographer.

☛ Dürer, El Greco, Masaccio, Orozco, Rouault

Matthias Grünewald (Mathis Gothardt Neithardt) . b Würzburg, 1470/5. d Halle, 1528.**The Crucifixion**. c1515. Oil on panel. **h**269 × **w**307 cm. **h**106 × **w**120⅞ in. Musée d'Unterlinden, Colmar

Guardi Francesco An Architectural Caprice

Through an arcade a piazza opens out, and a wide staircase leads up to a monumental building. The scene is peppered with incidental detail, such as the sheets draped over the balcony and the elegantly dressed nobles giving coins to the beggar-boy. All of this animates and enlivens the picture. Although it is an invented cityscape, Guardi used elements of his native city to create a plausible Venetian view. Guardi owes much to the example of Canaletto, an artist with whom he has always been closely associated and who was perhaps his master. Unlike Canaletto's precise technique, however, Guardi's style is characterized by the freedom and spontaneity of his brushwork, adding a great sense of gusto to the scene. Full of romantic, half-invented elements, Guardi interprets rather than reproduces Venice, capturing a sparkle of light and movement which is absent from Canaletto's interpretations of the same city.

☞ Bellotto, Bordone, Canaletto, Pannini, Siberechts

Francesco Guardi. **b** Venice, 1712. **d** Venice, 1780. **An Architectural Caprice**. c1770/80. Oil on canvas. **h**54 × **w**36 cm. **h**21⅓ × **w**14¼ in. National Gallery, London

Guercino

Jacob Receiving Joseph's Coat

The elderly Jacob is seen at the moment of being given the cloak of his favourite son Joseph, whom his jealous brothers have sold into slavery. The cloak is stained with the blood of a goat in order to fool Jacob into thinking Joseph has been killed by a wild animal. Jacob raises his right hand and rolls his eyes heavenward, as if pleading with God. The cloak rests on a marble balustrade, which takes on the appearance of a mortuary slab. Dramatically set against a sombre sky, the figure of Jacob dominates the canvas with its robust monumentality. The condensed, heightened emotion of the picture makes this a masterpiece of the Baroque spirit. Guercino was a pupil at the Carracci Academy, but was also influenced by the realism and intensity of Caravaggio's art. Although dramatic lighting similar to Caravaggio's has been used, in this painting it has been softened to enhance the richness of the colours.

☛ Caravaggio, Carracci, Jordaens, Reni, Ribera

Guercino (Francesco Barbieri). b Cento, 1591. d Bologna, 1666. **Jacob Receiving Joseph's Coat**. c1625. Oil on canvas. **h**115.5 × **w**94 cm. **h**45½ × **w**37 in. Burghley House, Stamford

Guston Philip

Sleeping

A tramp-like figure, possibly the artist himself, lies in a dark and gloomy place. The cartoon character has been portrayed with deliberate clumsiness, the paint applied in bold, forceful strokes with a limited palette of reds, pinks, black and white. Painted in the last phase of the artist's career, this work is an ironic comment on low-life urban society. Although Guston was closely associated with the Abstract Expressionists in his earlier period, in 1970 he publicly abandoned this style for a rather raucous form of figuration with the explanation, 'I got sick and tired of that purity, wanted to tell stories.' Using a comic-strip technique and harsh discordant colours, his paintings comment on such social topics as the homeless and the Ku Klux Klan. Guston taught painting until the late 1950s when he was awarded a Ford Foundation grant and his international reputation was swiftly established with a major retrospective at the Guggenheim Museum in 1962.

☛ Baselitz, Kline, De Kooning, Pollock, Rothko

Philip Guston. **b** Montreal, 1913. **d** Woodstock, NY, 1980. **Sleeping**. 1977. Oil on canvas. **h**213.3 × **w**175.2 cm. **h**84 × **w**69 in. Private collection

Hals Frans

Portrait of a Young Man with a Skull

The young man has been painted with dazzling vigour and spontaneity. The artist's furious brushstrokes give the painting an almost impressionistic quality. This creates a strong sense of character and movement in the boisterous youth, whose real presence is suggested by his hand thrusting out of the canvas and into the viewer's space.

The painting is probably not a true portrait but what was known as a 'vanitas' scene, dwelling on the inevitability of death and the shortness of life. The skull represents death, while the young man symbolizes youth and vigour. Hals was a successful portrait painter who worked in Holland in the early seventeeth century. He is well known for his vivid style, using rapid brushwork to capture fleeting gestures and expressions. However, this quality is quite different from his contemporary Rembrandt's more introverted insight into the personality of the sitter.

☛ Claesz, Honthorst, Rembrandt, Rubens, Terbrugghen

Frans Hals. b Antwerp, 1581. d Haarlem, 1666. **Portrait of a Young Man with a Skull**. c1626/8. Oil on canvas. **h**92 × **w**81 cm. **h**36 × **w**32 in. National Gallery, London

Hamilton Richard

Just What is it That Makes Today's Homes So Different, So Appealing?

This collage of a stylized 1950s interior is a landmark in post-war art. The artist has combined cut-up photographs and cuttings from magazines to create a consumer paradise – albeit a wittily sardonic one. The 'POP' on the oversized lollipop is crucial as it is probably the first visual reference to the word which heralded a major new movement in art.

The imagery Hamilton has used embodies the Pop Art movement which used symbols from contemporary mass media, popular culture and advertising. Hamilton played a seminal role in the development of the British strain of Pop Art. This collage was made for an exhibition called 'This is Tomorrow', in London's Whitechapel Art Gallery.

For Hamilton in the 1950s, the indispensable categories for tomorrow's world were: 'Woman Food History Newspapers Cinema Domestic appliances Cars Space Comics TV Telephone Information.' He is now using computer technology to create innovative works.

☛ P Blake, Hausmann, Jones, Schwitters

206

Richard Hamilton. b London, 1922. **Just What is it That Makes Today's Homes So Different, So Appealing?** 1956. Collage on paper. **h**26 × **w**25 cm. **h**10¼ × **w**9¾ in. Kunsthalle, Tübingen

Hammershøi Vilhelm Interior with a Girl at the Clavier

Cool, delicate pastel tones suggest a scene of peaceful serenity, with a girl seated at a clavier with her back to the viewer. A white tablecloth with crisp folds leads the eye into the shallow depth of the room, which is enclosed by a pale-coloured wall. The uncluttered composition recalls the spare, austere style of Japanese prints, yet the whole painting breathes a freshness and vitality, and is flooded with the clear, sharp Scandinavian light. Hammershøi was a Danish painter of quiet interiors in muted colours, chiefly grey, and his refined style has something mystical about it, suggesting the work of seventeenth-century Dutch artists such as Jan Vermeer and Pieter de Hooch.

His art has a timeless quality, but it also offers a nostalgic escape into the past. Although he had to wait a long time for recognition of his work, he was much respected by his contemporaries.

☛ Bonnard, De Hooch, Metsu, Sickert, Vermeer

Vilhelm Hammershøi. **b** Copenhagen, 1864. **d** Copenhagen, 1916. **Interior with a Girl at the Clavier**. 1901. Oil on canvas. **h**56 × **w**44 cm. **h**22 × **w**17 in. Private collection

Hartung Hans T 1956/7

Harsh, dramatic lines of black paint dominate a pale, bland background. There is strength and energy in the heavy calligraphy of the bundled sheaves of lines, assembled in a criss-cross pattern. Hartung's forceful and expressive image is an example of the intuitive and spontaneous work known as Art Informel. The essence of Hartung's image is that when he started with his brush and blank canvas he had no preconceptions of the finished object. Born in Germany, Hartung settled in Paris in 1935 and subsequently assumed French citizenship. He became one of the most famous French abstract painters. His elegant and distinctive work usually incorporates calligraphy, not unlike that used in Chinese art, and the paintings are generally untitled and can only be distinguished by numbers. He joined the French Foreign Legion at the outbreak of the Second World War, and lost a leg in 1944.

☞ Dubuffet, Fautrier, Riopelle, Soulages, Tàpies

Hans Hartung. **b** Leipzig, 1904. **d** Paris, 1992. **T 1956/7**. 1956/7. Oil on canvas. **h**161 × **w**122 cm. **h**63³/₈ × **w**48 in. Private collection

Hassam Childe

The Room of Flowers

A woman in a pink dress lounges on a divan, lazily reading in a light-filled room crowded with books, paintings, tables, chairs, ornaments and flowers. The house is on the Maine-New Hampshire coast and belonged to Celia Thaxter who used it to entertain poets and artists (Hassam among them). Hassam worked as a wood engraver and illustrator before going to Boston and then to Paris to study art. He was converted to French Impressionism on seeing the work of Claude Monet, although his initial academic training hindered him from completely adopting its principles. Many of his early paintings, atmospheric scenes of city streets in rain, snow or twilight, stress fleeting impressions of movement. He chose times of day or weather conditions which presented technical challenges, such as reflections on wet pavements, and he also favoured studies of women. Hassam was popular in his own lifetime, and often won medals and awards.

☛ Cassatt, Chase, Hammershøi, Monet, Sargent, Whistler

Childe Hassam. **b** Boston, MA, 1859. **d** New York, NY, 1935. **The Room of Flowers**. 1894. Oil on canvas. **h**86.4 × **w**86.4 cm. **h**34 × **w**34 in. Private collection

Hausmann Raoul The Art Critic

Holding a Venus pencil in his right hand, a heeled shoe glued to his brain, his eyes and mouth hidden by superimposed features and with a sharp segment of a 50 Deutschmark banknote embedded in his neck, Hausmann's view of this art critic is both critical and controversial. Through whose eyes does he really see?

Whose words does he really speak? And whose payroll is he on? One of the many self-proclaimed inventors of photomontage, Hausmann used cut-up photographs and pages from newspapers and magazines to construct his world of cynical imagery. This work is an example of the Dada movement, whose members would incorporate

ordinary objects into their art, often employing an absurd sense of humour. In 1923, Hausmann abandoned painting and four years later invented the optophone, an apparatus which turned kaleidoscopic forms into music.

☞ P Blake, Ensor, Grosz, Hamilton, Schwitters

210

Raoul Hausmann. b Vienna, 1886. d Limoges, 1971. **The Art Critic**. 1919/20. Photomontage. **h**31.7 × **w**25.4 cm. **h**12½ × **w**10 in. Tate Gallery, London

Hayter Stanley William Claduègne

Continuous wave-like patterns created by curving ribbon forms charge this hypnotic print with a swirling rhythm and a feeling almost of electricity. The sharp colours give this pattern, which has neither beginning nor end, an acidity that paradoxically also has the qualities of velvet. Although born of a long line of artists, Hayter began his career in the oil industry before becoming one of the foremost graphic artists of his time, ceaselessly experimenting with textures and colours in new techniques. He was one of the earliest members of the Surrealist movement, but made his greatest mark as a master innovator of printmaking and engraving. Most of his life was spent in Paris where, in 1926, he founded the famous studio, Atelier 17, an experimental workshop where artists of all nationalities, such as Pablo Picasso, Marc Chagall, Alberto Giacometti and Yves Tanguy, could work together. During the Second World War, it moved to New York, but returned to Paris in 1950.

☛ Chagall, Giacometti, Hartung, Picasso, Riley, Tanguy

Stanley William Hayter. b London, 1901. **d** Paris, 1988. **Claduègne**. 1972. Etching on paper. **h**49 × **w**60 cm. **h**19¼ × **w**23½ in. Private collection

Heckel Erich

Windmill, Dangast

Waves of bright, loosely applied colours sweep up the canvas in rhythms and encircle the windmill on the brow of a hill, the focal point of the painting. Red, yellow, blue, green and black clash vigorously with each other, creating a vibrating tension, yet this simple composition has a strange, lyrical quality. Heckel studied architecture before turning to painting and was a superb lithographer. He fled from his native Germany to Switzerland in 1944, after over seven hundred of his paintings were removed from German museums by the Nazis. His work was much influenced by Vincent van Gogh and the Fauves – a name given to several artists whose paintings were full of distortions, flat patterns and vivid colours. He eventually formed part of a small group who wished to free themselves from established artistic doctrines, developing an intensely Expressionistic style called 'Die Brücke', or the bridge, which suggests a connection of their art to that of the future.

☞ Derain, Van Gogh, Kirchner, Matisse, Vlaminck

Erich Heckel. **b** Döbeln, 1883. **d** Hemmenhofen, 1944. **Windmill, Dangast**. 1909. Oil on canvas. **h**69 × **w**80 cm. **h**27 × **w**31½ in. Wilhelm-Lehmbruck-Museum, Duisburg

De Heem Jan Davidsz Still Life of Dessert

A profusion of fruits and exotic foods mingle with an array of ornate goblets, jars and wine bottles on a sumptuously laid table. This rich visual feast glows with lavish, sensual colour and, although appearing haphazard, was in fact composed with great care. In the Netherlands at the time, artists would display their skill by painting a wide range of objects, often with rich allusions and hidden symbolism of Christian, philosophical and metaphysical ideas. This work, however, is purely a celebration of the senses. De Heem is considered by many to be the greatest Dutch still-life painter, whose deep, brilliant colours and sure touch suggest that he may have studied the works of Jan Vermeer. He was the most gifted of a family of artists, and inspired still-life painters of the seventeenth and eighteenth centuries, as well as Henri Matisse, who admired this particular work so much that he made two copies of it.

☛ Arcimboldo, Claesz, Kalf, Matisse, Ruysch, Snyders, Vermeer

Hepworth Barbara Hollow Form with White Interior

Holes in the wood invite the viewer to peer through them. Made from the scented African hardwood guarea, the piece has been polished smooth, its gleaming surface contrasting sharply with the chiselled and painted hollows. Although abstract in style, the sculpture, the curves of which may reflect the artist's early memories of the undulating Yorkshire countryside, conveys a sense of harmony with the natural world. Hepworth began, like Henry Moore, by piercing holes in her works and went on to carve out the insides, as in caves hollowed out by the sea, often using string or wire to suggest a musical instrument. Although Henry Moore was an influence, she developed her own spare and economic style largely of abstract sculpture, without allying herself to any particular movement. She married the painter Ben Nicholson and settled in St Ives, Cornwall, where she drew inspiration from its dramatic coastline and landscape.

☞ Archipenko, Arp, Gabo, Moore, Nicholson

Barbara Hepworth. **b** Wakefield, 1903. **d** St Ives, 1975. **Hollow Form with White Interior**. 1963. Partially painted guarea wood. **h**99 cm. **h**39 in. Gimpel Fils, London

Heron Patrick

Fourteen Discs: July 20, 1963

Blocks of pure tint are arranged with delicate precision in order to create harmony of form and colour. Either painted or inscribed on the canvas are a series of discs. With no subject matter to disturb the visual purity of the group of different forms and colours, this abstract has subtle lyrical qualities and could be seen as a refined sensual meditation. Heron, a painter, writer and textile designer, was a conscientious objector during the Second World War, and worked as a farm labourer. He was associated with the artist Ben Nicholson and the sculptor Barbara Hepworth in St Ives in Cornwall, and all three, in their different ways, followed an abstract style. As well as teaching at the Central School of Art in London, he was also an art critic for some years. Many one-man exhibitions of his work have been held worldwide.

☛ Hepworth, Klee, Lanyon, Matisse, Miró, Noland

Hicks Edward

The Peaceable Kingdom

Wide-eyed animals, cherubic children and an idealized landscape give this painting a sense of natural order. In the background, William Penn, the founder of the US state of Pennsylvania, concludes a treaty with the Indians, further emphasizing goodwill and harmony. The naive style and basic colour scheme reinforce the work's simple message. For Hicks, the Peaceable Kingdom represented the eleventh chapter of the book of Isaiah, which praises peace between men and animals. It was a subject that Hicks returned to again and again, and scores of versions exist, each with minor variations. Hicks, an active Quaker preacher, began as an apprentice to a coachmaker, painting decorative panels for coaches, and went on to paint tavern signs. His landscapes reflected the Christian values he preached and he sold them to finance his missionary travels. His honest approach is typical of early American painting.

☞ Agasse, Bassano, J Bruegel, Catlin, H Rousseau

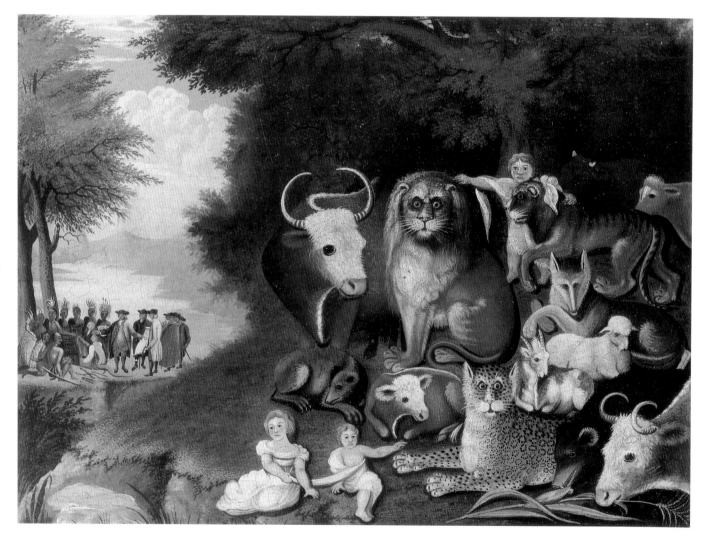

Edward Hicks. b Bucks County, PA, 1780. d Langhorne, PA, 1849. **The Peaceable Kingdom**. c1833/4. Oil on canvas. **h**44.5 × **w**59.3 cm. **h**17½ × **w**23½ in. Philadelphia Museum of Art, Philadelphia, PA

Hilliard Nicholas

Young Man Leaning Against a Tree

The motto 'My praised faith causes my suffering', inscribed in Latin at the top of this portrait, echoes the themes of love found in contemporary sonnets by Shakespeare. This miniature, idealized portrait of a lovesick young dandy may have been a gift to a woman with the intention of showing his love was sincere. Hilliard, probably the most famous English painter of his time, believed that portraits should be painted without shadows so as to flatter the sitter, and according to his own account, Queen Elizabeth I agreed with him. He trained as a goldsmith in his father's shop and began painting miniatures at the age of 13. He later worked for the Queen as a goldsmith and portrait painter, selling miniatures of her to toadying courtiers for huge sums of money. He set a new tradition in portrait painting, but never achieved in his larger works in oils the quality and delicacy of his miniatures, many of which were actually worn as jewellery.

☛ Dobson, Holbein, Kneller, Moroni

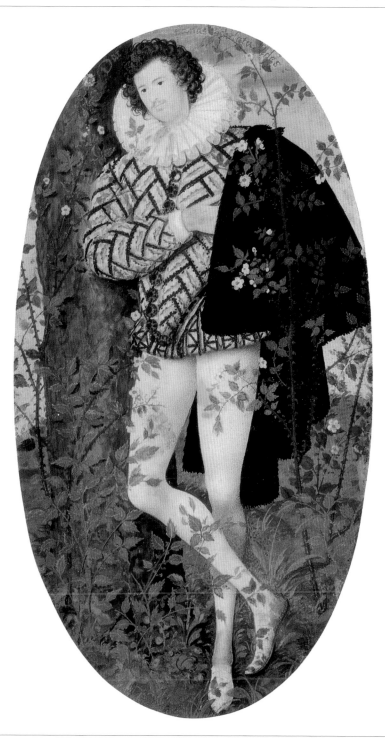

Nicholas Hilliard. b Exeter, c1547. **d** London, 1619. **Young Man Leaning Against a Tree** (portrait miniature). c1590. Watercolour on vellum. **h**13.4 × **w**7 cm. **h**5¼ × **w**6¾ in. Victoria and Albert Museum, London

Hiroshige Andô

Moonlight, Nagakubo

Trudging wearily across a wooden bridge over a river are three figures and a donkey, silhouetted against the moon. In contrast, a comical group of figures in the foreground is shown as if in daylight. Firm, rigid outlines define the shapes, which are filled in with solid blocks of colour. The Japanese artist Hiroshige was a younger contemporary of Katsushika Hokusai, and was much impressed by the older master's more austere style, although his own works are freer and more realistic in colour. His prints have come to epitomize Japanese art in their unsophisticated, poetic simplicity. Seen in their own day as merely popular art, his landscapes had an electrifying effect on European artists at the end of the nineteenth century, when they began to be imported to the West. The Impressionists in particular were profoundly influenced by Hiroshige's fresh approach, and Claude Monet collected a large number of his prints.

☛ Degas, Hokusai, Monet, Utamaro, Whistler

218

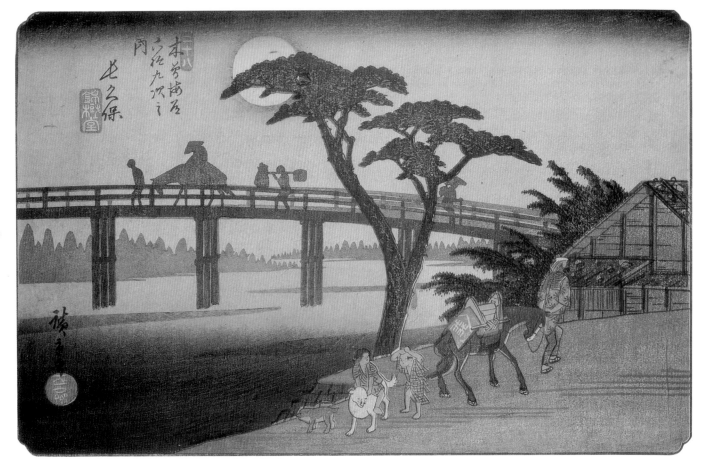

Andô Hiroshige. b Edo, 1797. d Edo, 1858. **Moonlight, Nagakubo**. 1840. Polychrome woodblock print on paper. **h**22 × **w**34 cm. **h**8½ × **w**13½ in. British Museum, London

Hobbema Meindert Road on a Dyke

Warm brown tones dominate this peaceful, autumnal scene. Winding paths which lead the eye into the picture create an illusion of depth. Hobbema was meticulous in reproducing accurately the play of light on every leaf and blade of grass, and the ripples made by the ducks on the pond. Animals and humans are secondary here to the beauty of the landscape itself; only a close look reveals the houses, half-hidden by trees. Hobbema was a friend and pupil of Jacob van Ruisdael, and the two men even occasionally painted the same views, but Ruisdael tended to give the scene drama, while Hobbema preferred to give the impression of a particular place. In the 1670s, at the height of his powers, he became, by marriage, collector of Amsterdam's wine tax, and from that moment his painting dwindled almost to nothing. For the last 40 years of his life, he devoted his energy not to art but to inspecting casks of wine.

☛ Bierstadt, Constable, Corot, Van Goyen, Ruisdael

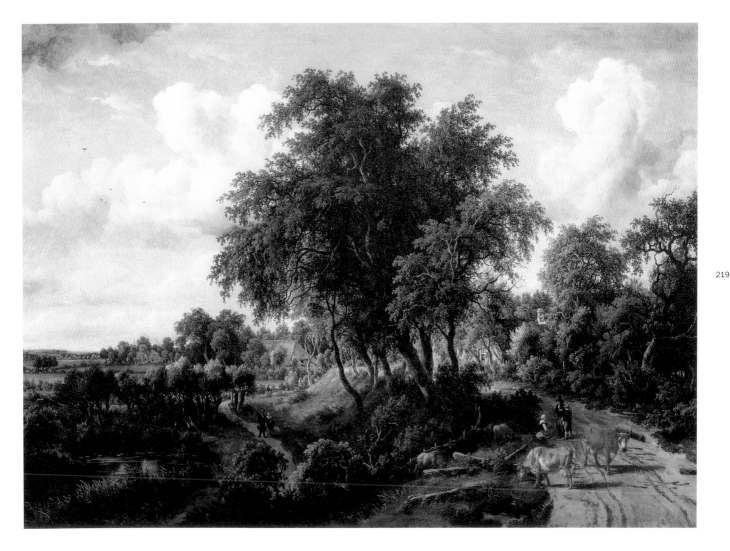

219

Meindert Hobbema. b Amsterdam, 1638. d Amsterdam, 1706. **Road on a Dyke**. 1663. Oil on canvas. **h**108 × **w**128.3 cm. **h**42½ × **w**50½ in. Private collection

Hockney David A Bigger Splash

Under the intense, Californian sun, an unseen figure creates a splash in a pool. Hockney applied paint with rollers, using small brushes for the splash to suggest its sound exploding in the stillness. In one of his most consciously planned and evocative images, he contrasts the fleeting moment with the skilled technique that captured it.

A conscientious objector who worked as a hospital orderly during his National Service, he was persuaded away from abstract art by fellow-student R B Kitaj, and from his earliest work was associated with the Pop Art movement. A visit to California (where he eventually settled) inspired the famous series of swimming pool and lawn and

sprinkler paintings, which coolly observe this expensive, leisured world. A brilliant draughtsman, and very much a painter of a city and a point in time, he sometimes works from photographs, even for portraits. His varied work includes scenery for opera.

☞ P Blake, Hamilton, Hopper, Kitaj

220

David Hockney. b Bradford, 1937. **A Bigger Splash**. 1967. Acrylic on canvas. **h**243.8 × **w**243.8 cm. **h**96 × **w**96 in. Tate Gallery, London

Hodgkin Howard Lovers

At first sight this painting seems abstract, but in fact it represents a memory of a real encounter. The ecstasy of the lovers is conveyed through the dramatic swirls of intense colour. As is his habit, Hodgkin uses wood as a base for the painting and carries the paint over onto the frame itself, incorporating it into the picture. He has said that painting must relate to relationships, and he usually shows people captured at a precise moment, reflecting some intense, personal memory. During time spent in India, Hodgkin was attracted by traditional Indian art. Its influence can be seen in his use of brilliant colour and his preference for small-scale works. His style, however, is entirely individual and personal. An inventive and prolific printmaker, he has also developed a strong reputation in this field. In 1985, Hodgkin won the UK Turner Prize for contemporary art.

☛ Chagall, Heron, Kossoff, Matisse, Rodin, Rothko

Howard Hodgkin. b London, 1932. **Lovers.** 1984–9. Oil on panel. **h**171.5 × **w**185.4 cm. **h**67½ × **w**73 in. Private collection

Hodler Ferdinand

Lake Thun

Highly ordered and symmetrical, the formal elements of this painting have been carefully balanced to create a sense of calm. In the cool air of early morning the lake is pink, reflecting the glow of the rising sun. Our view of it has been restricted, flattened and simplified as if to present us with only the essence of the scene, with all unnecessary detail eliminated, and composed in a rhythmic pattern of layers of forms and colour. Hodler evolved a highly decorative style of landscape with strong colours and outlines, using parallel motifs for his effects. He was influenced by Camille Corot and Gustave Courbet in the early part of his career but later his paintings showed the artist's interest in Symbolism, with its hidden meanings in objects, and in Art Nouveau, with its curling tendrils and stylized leaves. The linear, flat style which he eventually developed, using colour as an important element, heralds the Expressionist movement.

☛ Böcklin, Corot, Courbet, Denis, Frankenthaler, Witz

Ferdinand Hodler. b Bern, 1853. **d** Geneva, 1918. **Lake Thun**. 1905. Oil on canvas. **h**80.2 × **w**100 cm. **h**31½ × **w**39⅓ in. Musée d'Art et d'Histoire, Geneva

Hofmann Hans

Fairy Tale

Swirling brushstrokes, applied with verve and panache, mingle together in a multitude of vibrant colours. Hofmann sought in this formless abstract to express the spirit or soul. He deliberately avoided both applying the paint with conscious care, and having a preconceived idea of how he wanted the painting to look, as if his artist's hand, left to itself, would create the image he wanted. In his drive to reproduce the visions in his mind's eye, Hofmann even eliminated the brush, pioneering the technique of pouring or dribbling the paint directly onto the canvas to create strong explosive patterns. This search for the ultimate expression of a mood or emotion, free from all artistic conventions, was known as Abstract Expressionism. Hofmann, as painter and teacher, was one of its most important advocates and his work greatly influenced Jackson Pollock. Born in Bavaria, Hofmann lived in both Munich and Paris for several years before emigrating to the USA in 1932.

☛ Frankenthaler, Gorky, De Kooning, Pollock

Hans Hofmann. **b** Weissenberg, 1880. **d** New York, NY, 1966. **Fairy Tale**. 1944. Oil on wood. **h**152 × **w**92 cm. **h**59½ × **w**36 in. Private collection

Hogarth William

Breakfast Scene, from *Marriage à la Mode*

It is after noon, a chair lies overturned, cards are strewn on the carpet and the debt collector rolls his eyes in exasperation. Late nights of drinking and gambling, overspending on an opulent house and the whims of an indolent wife are satirized in this portrait. For Hogarth, criticism of taste was also criticism of manners and he mocks the grotesque objets d'art on the mantelpiece, the florid, fantastical clock and the marble bust which looks more like a pig than a Roman noble. Apprenticed to an engraver, he learned the trade and eloped with the engraver's daughter. Tiring of conventional art forms, he specialized in scathing, even savage, visual commentaries on social conditions, made up of a series of pictures which told a story. Engravings were made from the original oils and their immense popularity made him famous. Although his works parallel those of the Rococo painters in France, his comic wit and style are utterly English.

☞ Boucher, Chardin, Fragonard, Steen, Watteau

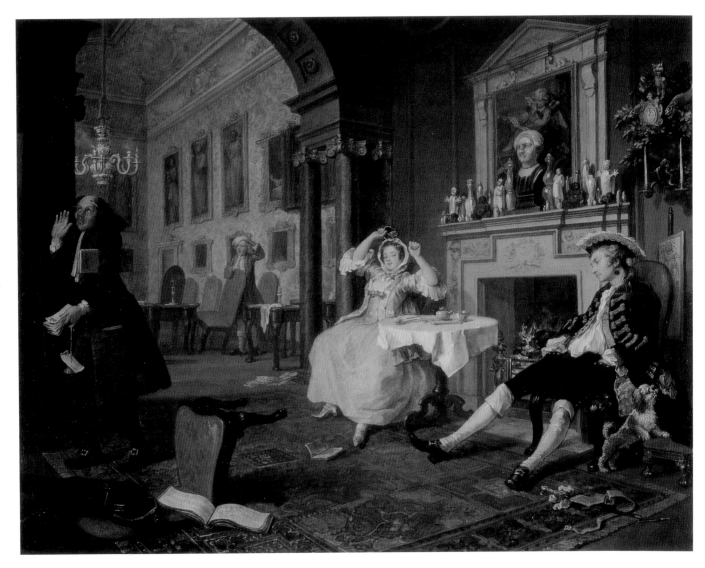

William Hogarth. **b** London, 1697. **d** London, 1764. **Breakfast Scene, from *Marriage à la Mode***. c1745. Oil on canvas. **h**71 × **w**91.5 cm. **h**28 × **w**36 in. National Gallery, London

Hokusai Katsushika Mount Fuji in Clear Weather

Majestically simple and unsophisticated, this view of the much venerated Mount Fuji is direct and immediate. For many, this is the ultimate representation of Japan's most famous landmark. Rather than following the conventions of perspective, the Japanese artist Hokusai produced an image straight from his imagination, a view as fresh and pure as it appeared in his mind's eye. He was apprenticed to a wood engraver who taught him conventional painting and book illustration, but he later abandoned this for the coloured woodcut designs of the Ukiyo-e (or 'floating world') school, which concentrated on ordinary things in everyday life. He delighted in feats of artistic skill, dashing off in a few strokes of the brush the momentary landing of a sparrow on an ear of corn, for example. The bold simplicity of his designs and use of colour greatly influenced European artists, particularly Édouard Manet and his circle.

☛ Hiroshige, Hodler, Manet, Utamaro, Whistler

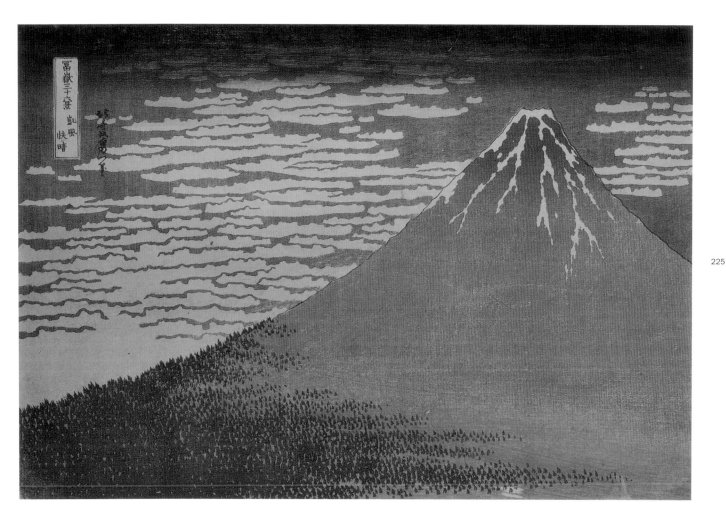

225

Katsushika Hokusai. b Asakusa, 1760. **d** Honjo, 1849. **Mount Fuji in Clear Weather.** c1823–9. Polychrome woodblock print on paper. **h**27 × **w**38 cm. **h**10½ × **w**15 in. British Museum, London

Holbein Hans The Ambassadors

The two sitters, so confident of their importance, are Jean de Dinteville, the French Ambassador to England, and his friend, George de Selve, Bishop of Lavaur. An elaborate collection of musical, astronomical and scientific instruments symbolizes their learning and power. The sundial sets the scene precisely at 10.30 am on 11 April.

Holbein shows that all this magnificence and arrogance must end in the grave, however, by contrasting their splendid richness with symbols of death: the broken string on the lute, and the distorted skull yawning before them which can be seen only if standing to one side of the picture. Holbein was the greatest portrait painter of his time

and was appointed official painter to the English Court. His portraits of Henry VIII, his queens and ministers illustrate Holbein's masterful technique and gift for revealing character. He died in London, a victim of plague.

☛ Claesz, Dürer, Van Eyck, Hals, Massys, Sittow

226

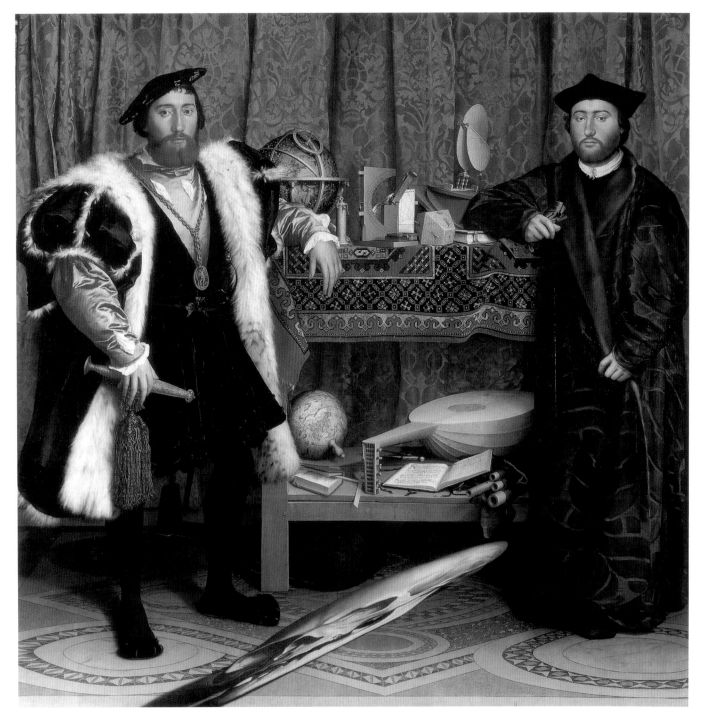

Hans Holbein. b Augsburg, 1497/8. d London, 1543. **The Ambassadors**. 1533. Oil and tempera on panel. **h**207 × **w**209 cm. **h**81½ × **w**82½ in. National Gallery, London

Homer Winslow

Breezing Up

Three young boys and a fisherman weigh down the starboard side of a sailboat as it tacks against the breeze. Painted in the same year that Mark Twain wrote *Huckleberry Finn*, *Breezing Up* evokes a sense of childhood, fresh air and summers outside that is typical of Homer's work of the mid-nineteenth century. His work is indeed considered the most authentic expression of American country life in the 1860s and 70s. The small boat is registered in Gloucester, Massachusetts, a small town on the New England coast that was popular among artists and where Homer spent many summers during the 1870s. Although Homer's choice of subject matter and his honest representation of the world around him is sometimes compared to the work of the contemporary French Impressionists, he was never directly influenced by them. With Thomas Eakins, Winslow Homer is considered the leading American representative of naturalism, the realistic depiction of the contemporary world.

☛ Bellows, Bingham, Eakins, Pissarro

227

Winslow Homer. b Boston, MA, 1836. **d** Prout's Neck, ME, 1910. **Breezing Up**. 1876. Oil on canvas. **h**61.5 × **w**97 cm. **h**24⅛ × **w**38⅛ in. National Gallery of Art, Washington, DC

Honthorst Gerrit van The Concert

Musical frolics and fun spill out of this lyrical painting of merrymaking. Seen from below, a group of women sing in a window, accompanying themselves on lutes. The red curtains and bright lighting suggest a theatrical setting, reflected in the rich and colourful draperies and feathers of the figures. When in Rome in the early part of his career, Honthorst was influenced by Caravaggio, who used strong *chiaroscuro* in his works, with one intense light source and deep shadows. Subjects like '*The Concert*' were popular with Caravaggio and his followers, and Honthorst's night scenes were so well liked in Italy that he was nicknamed 'Gerard of the Night'. On his return to Utrecht, he helped to establish a tradition of painting in this style and, on visits to England, painted portraits of Charles I and his wife, Henrietta Maria. Later, his style changed again, so that he followed the manner of Anthony van Dyck.

☞ Caravaggio, Dou, Van Dyck, Greuze, Terbrugghen

Gerrit van Honthorst. b Utrecht, 1590. d Utrecht, 1656. **The Concert**. 1624. Oil on canvas. **h**168 × **w**178 cm. **h**66 × **w**70 in. Musée du Louvre, Paris

De Hooch Pieter Woman and a Maid with a Pail in a Courtyard

This peaceful picture of a domestic event is carefully built up of tiny, meticulously observed details. The clear light gives the scene a sharp reality, in which the two figures would seem almost locked in a timeless, enclosed world were it not for the open door of the courtyard looking out onto a street. The doorway was a favourite device of De Hooch's: he would often paint a dark foreground, with an open door leading to a brightly lit inner room. There is an atmosphere of calm, of ordinary, everyday life, but there is also a sense that its quiet and simplicity are in themselves beautiful. De Hooch's early paintings usually showed two or three people engaged in household tasks, in a room flooded with light. His later works abandoned these wonderfully lit, simple homes for rather forced scenes of high life. The people in them became richer, while the paintings themselves were poorer, and lost the quality of light.

☛ Dou, Metsu, Steen, Ter Borch, Vermeer

Pieter de Hooch. **b** Rotterdam, 1629. **d** Amsterdam, 1684. **Woman and a Maid with a Pail in a Courtyard**. 1660–5. Oil on canvas. **h**53 × **w**42 cm. **h**20¾ × **w**16 in. Hermitage Museum, St Petersburg

Hopper Edward

People in the Sun

Fully clothed, silent and motionless, sun-worshippers sit in precisely staggered chairs, each person isolated from the next. The stillness of the scene, with its strongly contrasting light and shadow, is cold and uninviting. Hopper's obsession with sunlight is the major theme in this work, as it was in all his later paintings, and he uses it to create jagged outlines and an oppressive atmosphere. Always pursuing the oddness of the mundane, Hopper's style was unaffected by contemporary European art movements or by American abstraction. His figures are anonymous and withdrawn, as if Hopper wanted to stress their separateness from each other, rather than what has brought them together. One of North America's most popular artists, Hopper's work reveals the loneliness, the ugliness, the banality and also the unexpected beauty of the everyday world.

☛ Boudin, Hockney, Segal, Wyeth

Edward Hopper. b Nyack, NY, 1882. **d** New York, NY, 1967. **People in the Sun**. 1960. Oil on canvas. **h**102.5 × **w**153.3 cm. **h**40⅜ × **w**60⅜ in. Smithsonian Institution, Washington, DC

Houdon Jean-Antoine Bust of Denis Diderot

This life-sized terracotta bust of the French philosopher still bears the marks of the sculptor's hands as he modelled the wet clay. Diderot's eyes look away from the viewer, separating his world from ours. Following the same style of the Roman busts of Antiquity, the sculpture for which this is a study is smooth and flawless, but this rougher working model gives insight into the mind of the artist as he developed his ideas into three dimensions. Houdon, the most celebrated French sculptor of the eighteenth century, narrowly escaped imprisonment during the Revolution. His most numerous works, however, are portraits, which include some of the greatest men of his time. His fame was such that the Americans commissioned from him a statue of their general, George Washington, to honour his victory in the American War of Independence; it stands in the Capitol at Richmond, Virginia.

☛ Algardi, Canova, Frink, Roubiliac

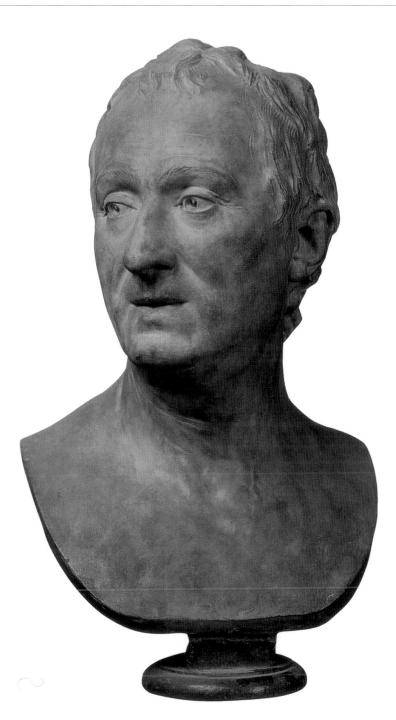

Jean-Antoine Houdon. b Versailles, 1741. d Paris, 1828. **Bust of Denis Diderot**. c1771. Terracotta. **h**41 cm. **h**16⅛ in. Musée du Louvre, Paris

Hunt William Holman The Awakening Conscience

Looking into this typical Victorian drawing room, we see a woman start up guiltily from her lover's knee, in mid-song, suddenly aware that what she is doing is wrong. Victorian values are reflected here, and the picture was intended to be a moral commentary. The patterned fabrics, grainy woods, busy wallpaper and garish colours are typical of Hunt's meticulous, almost obsessive, attention to detail. With Dante Gabriel Rossetti and John Everett Millais he founded the Pre-Raphaelite Brotherhood, dedicated to observing nature accurately, but was the only one who remained faithful to its principles. Of all the Pre-Raphaelite painters he and Ford Madox Brown were most interested in representing moral and social values in contemporary Victorian life. Hunt tried to paint 'in direct application to Nature', using friends rather than professionals as models. He completed few pictures, spinning each one out as if he lacked the motivation to finish it and begin another.

☞ Fra Angelico, Botticelli, Brown, Millais, Rossetti

William Holman Hunt. **b** London, 1827. **d** London, 1910. **The Awakening Conscience**. 1853. Oil on canvas. **h**76.2 × **w**55.9 cm. **h**29¼ × **w**21¾ in. Tate Gallery, London

Ingres Jean Auguste Dominique The Bather of Valpinçon

Named after the collector who first bought the picture, Ingres' *Bather of Valpinçon* is a calm representation of Classical beauty in the human nude. Softened by the delicate reflected light, the bather suggests a cold, languid eroticism, made ambiguous by her refusal to meet the viewer's gaze. The only sound or movement is that of a small spout of water, and the spartan interior seems to freeze the scene in time and space. Ingres was a superb draughtsman, but remained emotionally detached from his subjects and showed little interest in the expression of the human face. The polished perfection of his work was inspired by his Renaissance idol, Raphael. A leading figure in the Classical tradition of nineteenth-century France, Ingres painted many idealized and exotic oriental scenes with voluptuous nudes, although all the detail was second-hand, since he never travelled outside Europe.

☞ Boucher, Canova, J-L David, Leighton, Maillol, Prud'hon

Jean Auguste Dominique Ingres. **b** Montauban, 1790. **d** Paris, 1867. **The Bather of Valpinçon**. 1808. Oil on canvas. **h**146 × **w**97.5 cm. **h**57½ × **w**38⅓ in. Musée du Louvre, Paris

Ivanov Alexander

The Appearance of Christ to the People

St John the Baptist, wearing a cloak over his tunic of animal skins, raises his reed cross to the crowd that presses around him, and preaches the word of God to his followers. Ivanov illustrates the two things that mattered most to this rough visionary: his foretelling of the coming of Christ and the baptisms he carried out in the river Jordan. On the left, some of the newly baptized can be seen clambering up the bank. Ivanov used Classical postures and dress, and adopted the restrained style of the Renaissance, hoping to achieve the same noble grandeur and harmony as the great painters Raphael and Michelangelo. Most of his adult life was spent in Rome, where he came under the influence of the Nazarenes, a religious artistic group. Although many of his Biblical paintings never got beyond the drawing stage, they combined a sense of mysticism with historical accuracy and original visual imagery.

☛ Canova, J-L David, Ingres, Overbeck, Poussin, Prud'hon

234

Jawlensky Alexei von Schokko

This strong, reflective portrait of a fashionable woman has been painted in bold outlines. The intense clashing colours evoke powerful emotions of sensuality, yet her mask-like face suggests a sexual remoteness. The importance of this painting lies in Jawlensky's complete reliance on colour to construct the image and to give it its emotional power. The title of the painting originates in the young model: she asked for a cup of hot chocolate (*Schokko*) and thus adopted the nickname. Russian-born, Jawlensky spent most of his life in Germany but his style was rooted in the art of his native country. It combined Fauvist elements, such as hard outlines and strong colour, with those of peasant art or the mysticism of Russian religious icons. This can be seen in one of his best-known works, the abstract series 'Heads', where features are reduced to straight, thick lines. The human face was a favourite theme: in his last series of paintings, 'Meditations', it became a symbol of tragedy.

☛ Van Dongen, Gontcharova, Kandinsky, Marc

Alexei von Jawlensky. **b** Kuslovo, 1864. **d** Wiesbaden, 1941. **Schokko**. 1910. Oil on board mounted on canvas. **h**75 × **w**65 cm. **h**29½ × **w**24½ in. Private collection

John Gwen

The Precious Book

Cool tones dominate this simple portrait of a young girl reading. The white handkerchief in which she cradles the book, her absorption in it, and the picture's title itself imply that the book is special and deserves reverence. Born in Wales, Gwen John learned draughtsmanship at the Slade School in London, studied in Paris under James McNeill Whistler and developed an idiosyncratic personal style that was at once delicate and neurotic. Her portraits in particular (usually of women) had an obsessive quality. She modelled for the sculptor Auguste Rodin, became his mistress and moved to France to be near him, but this one-sided and disastrous liaison almost caused her to abandon her own work. During her lifetime, most of it spent in obscurity and self-neglect, she was overshadowed by her younger brother, Augustus, but is now recognized as the greater artist. She died unrecognized, a semi-religious recluse.

☞ Cassatt, Hammershøi, Morisot, Rodin, Sickert, Whistler

236

Gwen John. b Haverfordwest, 1876. **d** Dieppe, 1939. **The Precious Book**. c1920. Oil on canvas. **h**26.4 × **w**21 cm. **h**10⅜ × **w**8¼ in. Private collection

Johns Jasper

Three Flags

Johns chose to represent the American flag not because he was particularly nationalistic but because he was looking to paint the most banal, easily recognizable subject he could find. What better than the Star-Spangled Banner? Johns' flag does not fly from a mast in glory, it is not carried by a victorious soldier. It is flat, like a real flag would be if it were pinned on a wall. Johns has not represented a flag but presented us with a flag. He is not trying to fool us into believing that it is real, however. Encaustic, a medium used primarily by the Greeks, gives the painting a thick, relief-like surface. Johns has superimposed three differently sized flags on top of one another, reinforcing the image, almost like a flashing light and creating a strange optical effect. With fellow American Robert Rauschenberg, Johns is regarded as one of the most important influences on American Pop Art.

☛ Duchamp, Lichtenstein, Oldenburg, Rauschenberg, Thiebaud

237

Jasper Johns. b Augusta, GA, 1930. **Three Flags**. 1958. Encaustic on canvas. **h**76.5 × **w**116 cm. **h**30⅛ × **w**45½ in. Whitney Museum of American Art, New York, NY

Jones Allen

Man Woman

One of a series of paintings with the collective title 'Hermaphrodite', the headless male and female bodies melt into one another. The male figure in the brightly striped tie is in fact a self-portrait of the artist. In his preoccupation with sexuality, Jones wanted to show here the unity with another human being that can only be achieved by the sexual act. He was deeply influenced by Jungian psychology, and by the philosophy of Nietzsche who believed that the creation of art depends upon artists being able to integrate the male and female elements of their natures. *Man Woman*, an early example by Jones of a Pop Art work, is a visual representation of this theory.

His paintings often tell a story. In the late 1960s and 1970s he was to explore further the erotic ideas in his work and consequently many of his images of women are seen as sexually provocative.

☛ Hamilton, De Kooning, Polke, Warhol, Wesselmann

238

Allen Jones. b Southampton, 1937. **Man Woman**. 1963. Oil on canvas. h213 × w188.5 cm. h84½ × w74½ in. Tate Gallery, London

Jordaens Jacob

The Four Evangelists

The four Evangelists contemplate the Scriptures which in turn inspire their own writings. Jordaens gives us an insight into their personalities as they are absorbed in the study of the sacred text which rests on a table. The half-length figures dominate the space, almost obliterating the background of red velvety drapery and a glint of sky. A pupil of Peter Paul Rubens, Jordaens has captured his master's vivid colouring, brushwork and skill in portraying natural flesh tones. The vigorous realism of the composition owes far more to the influence of Caravaggio, however, whose style Jordaens would have seen reflected in works by the Italian painter's followers in Utrecht. Although his early paintings were technically weak, but robust, Jordaens developed as an artist, his style became more sombre and he was later patronized by the kings of Spain and Sweden.

☛ Caravaggio, Guercino, Honthorst, Rubens, Terbrugghen

Jacob Jordaens. b Antwerp, 1593. **d** Antwerp, 1678. **The Four Evangelists.** c1625. Oil on canvas. **h**134 × **w**118 cm. **h**53 × **w**46½ in. Musée du Louvre, Paris

Judd Donald

Untitled

This sculpture, from the series 'Stacks', consists of a vertical arrangement of identical rectangular boxes, attached to a wall at right-angles in a mathematical sequence. It demonstrates Judd's simplification of shape, volume, colour and surface, and reduces art to its basic essential: the cube. Minimalist in style, like all his other pieces, the work is deliberately intended not to represent, imitate or express anything, nor is it 'composed' in any traditional sense. To achieve minimal personal contact with his work, the metal or plexiglass boxes he used were put together in a factory, spray-painted and placed in position by other people. All his pieces were called 'Untitled' and were as plain as possible because he believed that a work of art should be looked at as a whole, not as a collection of parts. In addition to sculpture, Judd designed his own furniture and designed and built several houses.

☞ Andre, Flavin, Johns, LeWitt, Ryman

Donald Judd. b Excelsior Springs, MO, 1928. d New York, NY, 1994. Untitled. 1993. Brass and green plexiglass. h457.2 cm. h180 in. Private collection

Kahlo Frida

What the Water Gave Me

The artist's hallucinations and imaginings run riot in this painting. It shows a bathtime reverie, in which images of death, pain and sexuality float on the water's surface. As in many of her pictures, it is a kind of self-portrait, with Kahlo's own legs painted from the bather's viewpoint, showing her deformed foot with its cracked big toe. Her injuries, as the result of a serious road accident at the age of 15, destroyed her hopes of becoming a doctor. This painting, considered to be her most Surrealist, is also the most complex of all her works, with its multitude of minute and irrationally arranged detail. She was married to the painter Diego Rivera; they had a turbulent relationship, and at one time she became a lover of Leon Trotsky. Kahlo has become something of a cult figure partly because from the mid-1940s she suffered from spinal problems and, bedridden, continued to paint, often in terrible pain, until her death.

☛ Brauner, Carrà, De Chirico, Dalí, Delvaux, O'Keeffe, Rivera

Frida Kahlo. b Mexico City, 1907. **d** Mexico City, 1954. **What the Water Gave Me**. 1938. Oil on canvas. **h**96.5 × **w**76.2 cm. **h**38 × **w**30 in. Private collection

Kalf Willem

Still Life with Lobster, Drinking Horn and Glasses

A collection of exotic and opulent objects laid out on the table is here painted with great brilliance and depth of colour. A lobster, a drinking horn with its glittering mount of silver filigree work, crystal goblets, a lemon and a Turkish carpet are painted with such fine attention to detail that Kalf creates the illusion that they are real and could be touched. Each object has been carefully placed so that the group forms a harmony of colour, shape and texture. The warm light enveloping the objects gives them a luxurious, jewel-like quality and their rarity, sumptuousness and extravagance reflect the refined tastes of Dutch seventeenth-century collectors, in a period when still lifes were immensely popular. Kalf lived and worked mainly in Amsterdam. The deep, rich colours of the paintings of this still-life painter may have been influenced by the work of his contemporary, Jan Vermeer.

☛ Claesz, De Heem, Sánchez-Cotán, Vermeer

Willem Kalf. b Rotterdam, 1622. **d** Amsterdam, 1693. **Still Life with Lobster, Drinking Horn and Glasses**. c1653. Oil on canvas. **h**86.4 × **w**102.2 cm. **h**34 × **w**40¼ in. National Gallery, London

Kandinsky Wassily Cossacks

Colours, lines and shapes, hills and Cossacks with lances blend together in this strangely captivating semi-abstract painting. There is great beauty in its simple composition and a sense of delight in the free brushstrokes. Kandinsky believed that the true artist seeks to express only inner, essential feelings. Having originally trained in Munich for a career in law, Kandinsky soon recognized that his true gifts were in the world of art and he became one of the first and greatest pioneers of 'pure' abstract painting. He returned to Russia to teach from 1914 to 1922, founding the Russian Academy. The Russian influence in his work can be seen in his references to icons and folk art. For a time, he taught at the famous Bauhaus school of modern design. Kandinsky became aware of the power of abstract art after he saw 'extraordinary beauty, glowing with an inner radiance' in an abstract painting, before realizing that it was one of his own, seen upside-down.

☞ Delaunay, Gontcharova, Kirchner, Klee, Kupka, Miró

243

Wassily Kandinsky. b Moscow, 1866. **d** Paris, 1944. **Cossacks**. 1910/11. Oil on canvas. **h**95 × **w**130 cm. **h**37⅓ × **w**51⅛ in. Tate Gallery, London

Kapoor Anish

Installation: It is Man, Untitled II Parts

Like a standing stone from a prehistoric site, the sandstone beacon (*It is Man*) seems wrapped in a mysterious aura. In the foreground, randomly placed slabs (*Untitled 11 Parts*) have been transformed by the application of more than a dozen coats of blue pigment, lending them an ethereal, weightless quality. Kapoor has tried to combine the spiritual with the forces of nature in these works, and to show in a new dimension – that of sculpture – that there is poetry in all natural things. His sculptures, often made from stone or fibreglass, coated with layers of powdered pigment, often involve more than one of the senses, particularly touch. They show the traditions of both East and West, and reflect ideas from philosophy, mythology and everyday life gathered on visits to his native India. In keeping with a culture that expresses philosophical or spiritual theories in terms of sensual images, some of his pieces take on the character of a totem, with extravagant forms and loud colour.

☛ Friedrich, Gabo, Klein, Long, Moore, Noguchi

244

Anish Kapoor. b Bombay, 1954. **It is Man**. 1989. Sandstone and pigment. **Untitled II Parts**. 1990. Slate and pigment. Installed at Centre National d'Art Contemporain, Grenoble. Lisson Gallery, London

Kauffmann Angelica David Garrick

In an unusual and disarming approach, Kauffmann has captured the private, sensitive side of the great actor David Garrick's personality. The way in which Garrick turns around in his chair to look out at the viewer is touching and intimate; he was more often shown in a highly dramatic pose, as if he were standing on stage.

Born in Switzerland, Kauffmann began painting portraits of Italian notables at the age of 11, and was persuaded by Sir Joshua Reynolds to go to London. She soon became famous for her Classical and mythological pictures, and for her portraits. In the 1770s she was commissioned to do murals for houses built by the designer Robert Adam

and his brother, whose soft colours and Antique style were well suited to her work. Many engravings were made of these Classically inspired, idyllic scenes which were used in the manufacture of objets d'art; their popularity made her name famous.

☛ Gainsborough, Poussin, Rosa, Vigée-Lebrun

245

Angelica Kauffmann. b Chur, 1741. **d** Rome, 1807. **David Garrick**. 1764. Oil on canvas. **h**84 × **w**69 cm. **h**33 × **w**27⅛ in. Burghley House, Stamford

Kelly Ellsworth

Red Blue Green Yellow

Paint has been applied, without any evidence of the artist's hand, in flat areas of defined pure colour. A yellow panel has been placed on the floor at right-angles to the main painting, as if to sever any connection it might have with the ground, and suggesting a three-dimensional quality. In its emphasis on pure colour, use of space and incorporation of two flat surfaces, this work reflects the theories of the Post-Painterly Abstractionist movement of the 1960s. It is one of a group known as 'Specific Objects', hovering between painting, relief and sculpture, and attacks preconceived ideas of the differences between sculpture and painting. Kelly studied in Boston and at the Académie des Beaux-Arts in Paris. His work is extremely varied: he has introduced broadly curving edges to his paintings and sculptures, and sometimes has eliminated colour altogether in favour of black, white and grey.

☛ Albers, Louis, Newman, Ryman, Stella

Ellsworth Kelly. b Newburgh, NY, 1923. **Red Blue Green Yellow**. 1965. Oil on canvas (bottom panel mounted on masonite). **h**222.2 × **w**137.1 × **d**222.2 cm. **h**87½ × **w**56 × **d**87 in. Margo Leavin Gallery, Los Angeles, CA

Kiefer Anselm Song of the Wayland

This monumental and awe-inspiring image of burned and ploughed fields under a raised horizon involved the use of a wide range of materials. The title refers to the myth of Wayland, the master blacksmith. Crippled by his king to prevent him leaving, Wayland raped the king's daughter and killed his two sons, then forged himself wings for his escape. Kiefer's association of this evil parable with destruction so powerfully portrayed in the scorched landscape conjures up haunting memories, including the Holocaust. The theme of German culture, distorted during the Third Reich by Nazi doctrine, is central to his work. This painting could be seen as Neo-Expressionist in context (the revival of a style that emphasized the artist's reaction to an experience, rather than the facts of the experience itself). Kiefer's varied work includes large black-and-white woodcuts in bold outlines, and 'books' made from photographs or woodcuts.

☛ Baselitz, Beckmann, Boltanski, Hofmann, Kitaj

Anselm Kiefer. b Donaueschingen, 1945. **Song of the Wayland**. 1982. Oil, emulsion, straw, photograph and lead wing on canvas. **h**280 × **w**380 cm. **h**110⅓ × **w**149⅔ in. Private collection

Kirchner Ernst Ludwig Self-portrait with Model

Rough brushstrokes and vitriolic colours which clash violently contribute to a feeling of desperate energy. The painting appears almost too small to contain the scene, suggesting a sense of expansion as if the colours were straining at the edges. This painting is characteristic of the sensual, vibrant colour, dramatic intensity and angular outlines of Expressionism. Kirchner was part of a group of Expressionists who called themselves 'Die Brücke', or the bridge, implying that they connected the art of the past with that of the future. There was some rivalry between himself and Erich Heckel, another member of the group: Kirchner would sometimes date his works too early, trying to prove that he was more innovative than the others. From 1917 Kirchner lived in Switzerland on health grounds as he was suffering from tuberculosis. In 1937, many of his works were confiscated by the Nazis as 'degenerate'; he committed suicide a year later.

☛ Van Gogh, Heckel, Kandinsky, Munch, Velázquez

248

Ernst Ludwig Kirchner. b Aschaffenburg, 1880. **d** Davos, 1938. **Self-portrait with Model**. c1910. Oil on canvas. **h**149.9 × **w**100.3 cm. **h**59 × **w**39½ in. Kunsthalle, Hamburg

Kitaj R B

If Not, Not

The Gatehouse at Auschwitz dominates the scarred landscape, scattered with figures and fragments. The theme is clearly the genocide of the European Jews. Figures in the foreground contrast with the dream-like scenery, and include Kitaj's self-portrait as the grey man with the hearing-aid. This complex and seductive painting draws together a wide range of literary and artistic references, including T S Eliot's poem *The Waste Land*. In these strong references to visual culture and literature, Kitaj is interpreting the British Pop Art movement. A painter of sharp intellect and literary allusion, he often portrays panoramas of suffering people, in landscapes that are harsh and uncompromising. These heartfelt paintings, which he often feels are never finished, create a vision of a world that is cruel, in which only Nature herself is spared. He lives and works mostly in England.

☛ Boyd, Burra, Hamilton, Kiefer, Lewis, Nash, Nolan

R B (Ronald Brooks) Kitaj. b Cleveland, OH, 1932. **If Not, Not**. 1975–6. Oil on canvas. **h**152.4 × **w**152.4 cm. **h**60 × **w**60 in. Scottish National Gallery of Modern Art, Edinburgh

Klee Paul

Senecio

This adaptation of the human face is divided by colour into rectangles. Flat geometric squares are held within a circle representing a masked face and displaying the multi-coloured costume of a harlequin. A portrait of the artist-performer Senecio, it can be seen as a symbol of the shifting relationship between art, illusion and the world of drama. This painting demonstrates Klee's principles of art, in which the graphic elements of line, colour planes and space are set in motion by an energy from the artist's mind. In his imaginative doodlings, he liked, in his own words, to 'take a line for a walk'. From 1921 to 1931 he was a brilliant teacher at the Bauhaus school of design, publishing many writings on his theory of art. Two years later, the Nazis exiled him from Germany, when over one hundred of his works were removed from German galleries as 'degenerate'.

☛ Albers, Braque, Delaunay, Dine, Feininger, Picasso

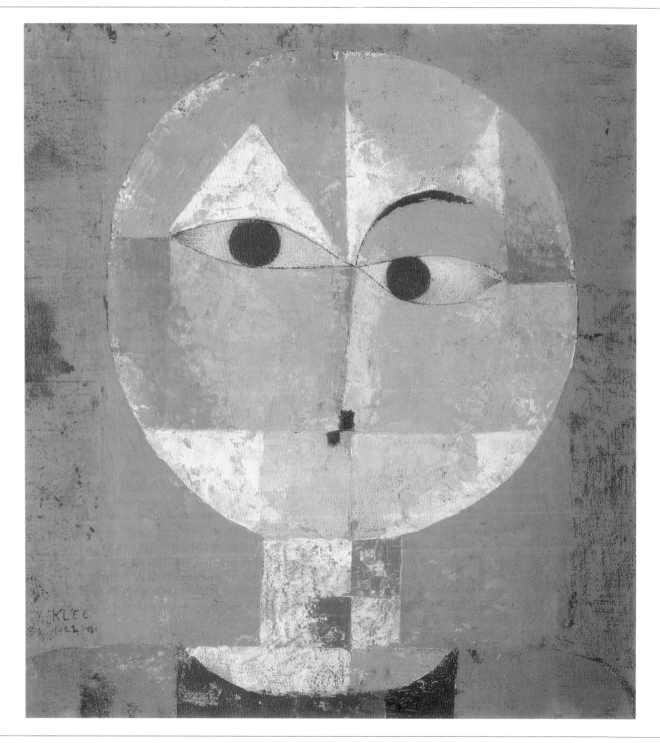

250

Paul Klee. b Munchenbuchsee, 1879. d Muralto-Locarno, 1940. **Senecio**. 1922. Oil on canvas mounted on panel. **h**40.5 × **w**38 cm. **h**15⁷⁄₈ × **w**15 in. Kunstmuseum, Basel

Klein Yves

IKB 79

IKB stands for International Klein Blue, a paint which Klein mixed personally and then patented. Its brilliant colour is maintained by the addition of synthetic resin to the blue pigment. Most of Klein's paintings are blue, as blue was an important colour to him, conveying a sensation of spirituality and freedom which is peculiar to his work. The power of the painting lies in its ability to invade the viewer's sensibility and exert a strong meditative influence. Klein is considered to be one of the most important post-war international artists and was a leader of the European Neo-Dada movement, a style intended to shock and outrage. His work includes paintings that were deliberately burned, and the extraordinary 'Anthropométries' series, for which female models were smeared with the famous blue paint and dragged across the canvas under Klein's direction, to the accompaniment of his own symphony. Tragically, he died of a heart attack at the age of only 34.

☛ Christo, Fontana, Heron, Rothko

Yves Klein. b Nice, 1928. **d** Paris, 1962. **IKB 79**. c1959. Pigment and synthetic resin on canvas. **h**139.7 × **w**119.7 cm. **h**55 × **w**47⅛ in. Tate Gallery, London

Klimt Gustav

The Kiss

In a mass of patterns and shapes, the form of a kissing couple emerges from a field of flowers. Gold predominates the colour scheme, punctuated by the bright colours of the flowers and the rich decorative designs on the clothing. The eroticism of the image is conveyed through sensuous line, bold pattern and luscious colours which create a dream world that is also luxurious and decadent. Essentially a decorator, Klimt was a leader of the Vienna Secession, a group of artists and craftsmen who revolted against the conservative and moralizing works of the previous generation. Their new style is often called Art Nouveau. He produced a number of portraits, mainly of women, and some large allegorical and mythical paintings. Although he was most successful as a designer for the applied arts (such as mosaic), his murals for Vienna University were unpopular and considered pornographic.

☛ Burne-Jones, Moreau, Mucha, Schiele

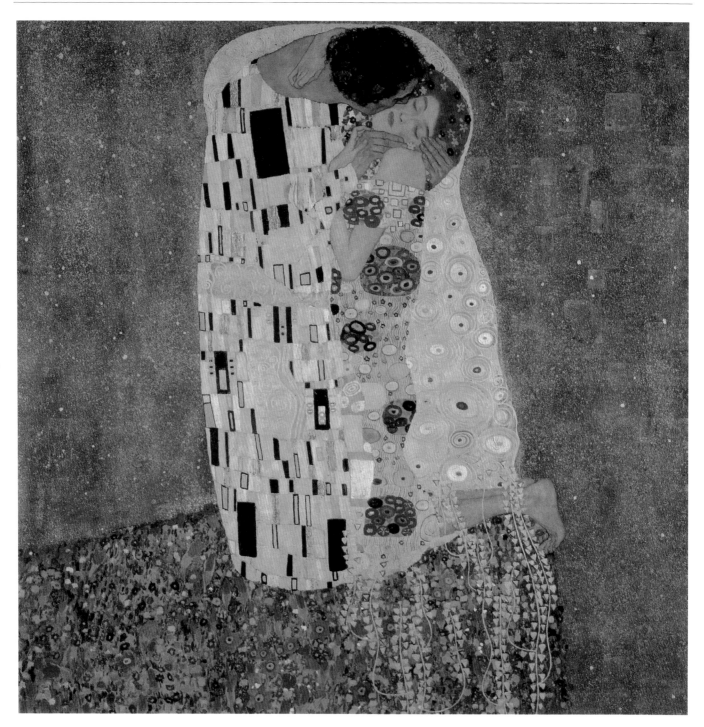

252

Gustav Klimt. b Vienna, 1862. d Vienna, 1918. **The Kiss**. 1907/8. Oil on canvas. **h**180 × **w**180 cm. **h**70⁷/₈ × **w**70⁷/₈ in. Österreichische Galerie, Vienna

Kline Franz

Untitled

A total of five black, wide brushtrokes float on a thickly painted and richly textured white background, evoking sensations of vast spaces. Kline was inspired by the techniques of graphic illustration, and by the massive sections of partly constructed or demolished girders, railways, scaffolding and bridges of New York. The power of the painting lies in this expression of the violent tension between solid space represented by the dark paint, and vast, open space, represented by the white. Its connection to the American Abstract Expressionist movement (of which Kline was a leading representative) is demonstrated by the spontaneous gestures of the energetic yet simple brushstrokes. Kline was influenced by oriental calligraphy and normally limited his colour schemes to black, white and grey but by 1959 he began incorporating vivid colour into his paintings.

☛ Hartung, De Kooning, O'Keeffe, Pollock, Still, Tobey

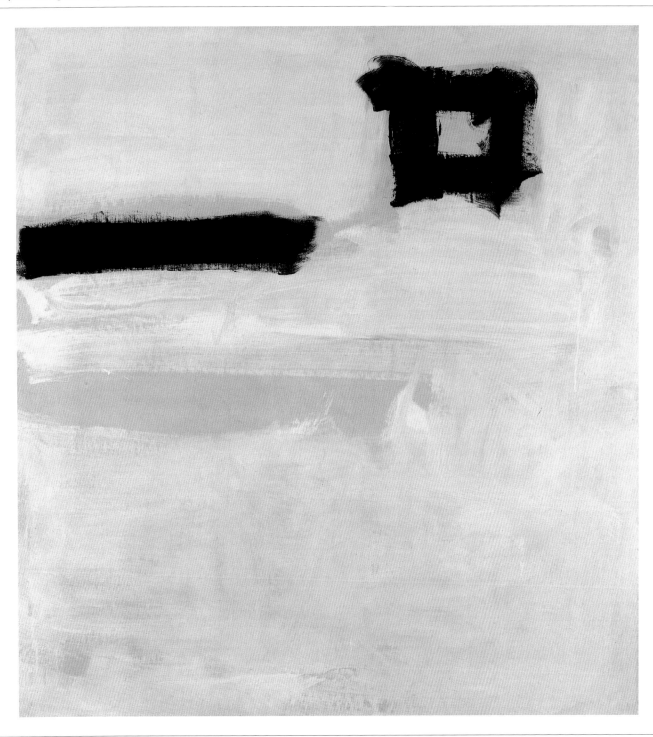

Franz Kline. b Wilkes-Barre, PA, 1910. d New York, NY, 1962. **Untitled**. 1951. Oil on canvas. **h**182.9 × **w**198.2 cm. **h**72 × **w**78 in. Private collection

Kneller Sir Godfrey John, First Duke of Marlborough

Everything about this portrait is luxurious: the gold braid, white silk, plush blue velvet, fluffy white feathers and curly wig all contribute to the magnificence of the sitter. He may be identified as a holder of the Order of the Garter by his gold chain, the blue band around his calf and the embroidery on his robe. Kneller's portraits of British nobility often repeated the pose and garments seen here. His practice was to paint the figure and the background first, then fill in the face when he was able to study the sitter in the flesh. On his arrival in London, Kneller quickly became a leading portrait painter. He established a workshop with a large team of specialized assistants, which enabled the mass-production of portraits such as this one. He painted ten reigning monarchs including every English sovereign from Charles II to George II, and was massively conceited, believing that the world would have been a better place had God consulted him at the Creation.

☛ Dobson, Van Dyck, Hilliard, Lely, Moroni

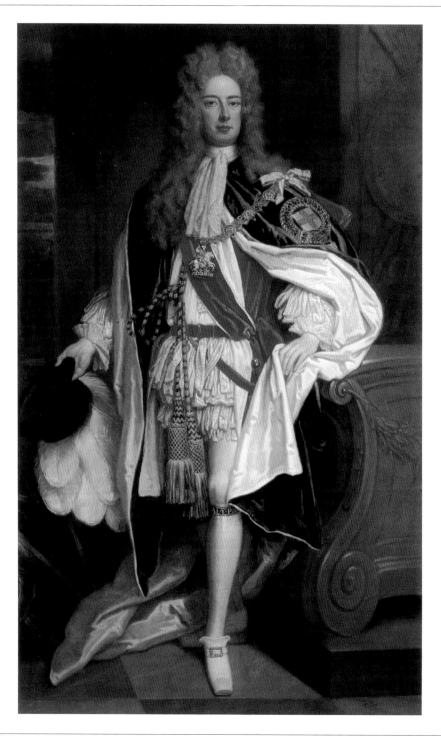

254

Sir Godfrey Kneller. b Lübeck, c1646. **d** London, 1723. **John, First Duke of Marlborough.** c1705. Oil on canvas. **h**218.4 × **w**132 cm. **h**86 × **w**52 in. Blenheim Palace, Woodstock

Kokoschka Oskar Portrait of a 'Degenerate Artist'

All the contours and peculiarities of the artist's face are outlined in a multitude of colour tones to suggest his anxiety and anger. This self-portrait shows Kokoschka as a self-proclaimed 'degenerate artist' whose innovative art was suppressed by the Nazis during the war. The violent brushwork appears both spontaneous and untidy, but behind it there is control, bringing together the jarring colours into a structured whole. Kokoschka's exaggeration and distortion of colour to convey deep emotions make this painting a prime example of Expressionism, a movement to which he was deeply committed. He taught at the Dresden Academy of Art, and also wrote Expressionist drama. Many of his works, with their vivid colour and restless energy, were politically symbolic. The tense situation in Germany forced him to leave Austria in 1934 for London, where he lived until finally settling in Switzerland in 1953.

☛ Beckmann, Dürer, Ensor, Munch, Nolde, Soutine

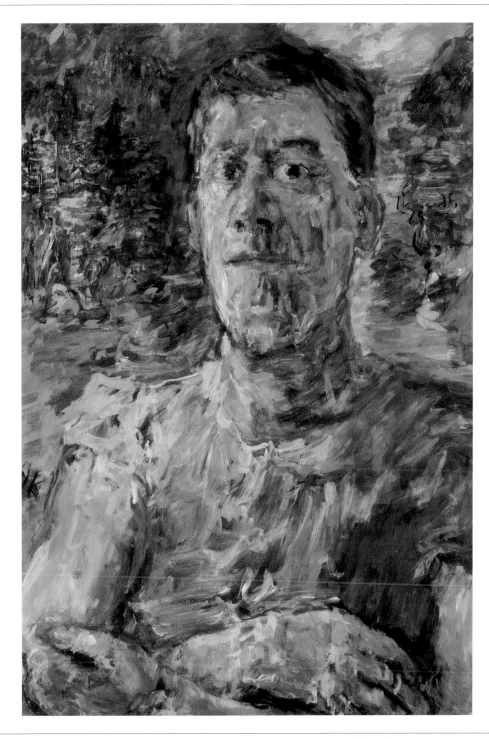

Oskar Kokoschka. b Pochlarn, 1886. **d** Montreux, 1980. **Portrait of a 'Degenerate Artist'**. 1937. Oil on canvas. **h**110 × **w**85 cm. **h**43¼ × **w**33½ in. Scottish National Gallery of Modern Art, Edinburgh

De Kooning Willem Marilyn Monroe

The exhibitionist and slightly dizzy quality of the stunningly beautiful Hollywood star is captured here. Paint has been applied in swift forceful gestures to build up the image layer by layer. This painting, from a series entitled 'Women', belongs to one of De Kooning's non-abstract, or figurative, phases. He recognizes that, like all female sex-symbols, Monroe is often viewed more as an object than as a whole person, and he portrays her almost as a shop-window dummy, with no trace of eroticism. De Kooning was involved with the New York-based Abstract Expressionists, who stressed the importance of spontaneity and of 'gestural' painting where colour is splashed or dribbled onto the canvas. Unlike many members of this group, however, De Kooning did not restrict himself to pure abstraction: his overriding subject has been the human (particularly female) figure. His artistic career encompassed many phases and in the 1970s he turned to figurative sculpture.

☞ Appel, Baselitz, Frankenthaler, Guston, Warhol

256

Willem de Kooning. b Rotterdam, 1904. **Marilyn Monroe**. 1954. Oil on canvas. **h**127 × **w**76.2 cm. **h**50 × **w**30 in. Private collection

Koons Jeff

Puppy

Evocative of the softness and cuddliness of a small puppy, a huge sculpture stands like a war memorial in the forecourt of an eighteenth-century building. It consists entirely of living plants, whose exuberant flowers provide colour, while their withering away, which will lead to the work's self-destruction, is a metaphor for the impermanence of life.

Koons' works are monuments of glitzy kitsch, or bad taste, in our age of throwaway culture, and the more shiny they appear, the more they appeal to his magpie eye. At one time Koons was a commodities trader, and he likes to include consumer goods of one sort or another in his sculptures. Floating in the centre of an aquarium or entombed in a slab

of plexiglass may be a vacuum cleaner or a basketball. When he cannot achieve the effect he wants, he may even have a new material specially made for a piece, sometimes at enormous expense.

☛ Dine, Duchamp, Lichtenstein, Sherman

Jeff Koons. b York, PA, 1955. **Puppy**. 1992. Flowering plants, steel, wood and earth. **h**11.5 m. **h**38 ft. Originally at Schloss Arolsen, Germany. Now dismantled

Kossoff Leon

Christchurch No. 1

This imposing church in London's Spitalfields dominates the scene in muted colours, thickly applied. Large brushfuls of paint, dragged or dripped onto the board, form a sort of churned-up, mud-like morass. The image of ordinary people in everyday life is unpretentious and deliberately avoids the picturesque. Although Kossoff was born and brought up in the East End of London, there is nothing English about his work. In fact he is more often associated with the Neo-Expressionists working in continental Europe. His pictures – usually portraits of family or friends and local scenes – always have great personal significance for him, and it is the vividness of his memory of this area of London which gives the painting such vitality and power. Working from charcoal drawings, Kossoff seeks out the universal quality in his subjects, while never becoming sentimental or overdramatic.

☛ Auerbach, Bomberg, Freud, Van Gogh, Lowry, Rembrandt

Leon Kossoff. b London, 1926. **Christchurch No. 1**. 1991. Oil on board. **h**146.7 × **w**100.4 cm. **h**57¾ × **w**39⅓ in. Anthony d'Offay Gallery, London

Krøyer Peder Severin Summer Evening on the Southern Beach

Immersed in their own private world, two elegantly dressed women walk on a deserted beach. The cool blue tones of the sea and sky, merging together on the horizon, and the almost grey sand, create an atmosphere of clarity and tranquillity. Scandinavian painters put a great deal of effort into capturing the effects of the clear northern light, often choosing simple subjects which took on fresh, pastel tones under the Arctic sun, and avoiding strong colours and deep shadows. Born in Norway, Krøyer was particularly interested in the effects of light at different times of day, and how lamplight is affected by daylight. Initially influenced by the Spanish painter Diego Velázquez, he painted realistic scenes of Spanish and Italian workmen, which were noted for their moving pathos. He later became the leader of a seaside colony of artists at Skagen in Denmark, and his works became more cheerful. His last years, however, were dogged by mental illness.

☛ Boudin, Hammershøi, Spilliaert, Velázquez, Zorn

Peder Severin Krøyer. **b** Stavanger, 1851. **d** Skagen, 1909. **Summer Evening on the Southern Beach**. 1893. Oil on canvas. **h**100 × **w**150 cm. **h**39½ × **w**55 in. Skagens Museum, Skagen

Kupka Frantisek Cathedral

Composed of a geometrical series of pure and dappled colours, arranged vertically and diagonally, this painting has an almost mesmeric quality. The rather dark tones seem to shimmer, and the broken colours appear constantly to merge and divide from each other. Kupka went beyond simply painting what the cathedral looked like, and tried instead to convey the light, sounds and impressions of the cathedral as they affected his imagination. Born in Czechoslovakia, he trained in Prague and Vienna before working as an illustrator in Paris where he pursued his interest in theosophy (a study of religion or philosophy based on an intuitive idea of God) and practised as a spiritualist medium. He and Wassily Kandinsky became pioneers of a new style of pure abstraction, derived from Cubism but more 'pure', which they called Orphism. Behind it was the idea that artists would paint new structures made of elements which they had created from their imaginations, and made real.

☞ Delaunay, Gris, Kandinsky, Mondrian, Pollock

Frantisek Kupka. **b** Opoczno, 1871. **d** Puteaux, 1957. **Cathedral**. 1913. Oil on canvas. **h**180 × **w**150 cm. **h**70⁷/₈ × **w**59 in. Private collection

Lam Wifredo

The Jungle

Gathered at the edge of a jungle, into which their long, slender limbs seem to merge, is a group of strange creatures straight out of Lam's imagination. The mystery of the jungle is reflected in these extraordinary beasts which inhabit its unfathomable depths; greenish animals with vague, un-animal-like shapes and tribal heads, conjured up from hallucinatory dreams. In this, his best-known work, Lam brings together many elements – Latin-American, African and Oceanic – fusing them with the conventions of the European Modern Movement. He often made use of voodoo, folklore, totems, and jungle scenes – providing a brooding sense of forbidden fruits. Of Cuban origin, at one time he was involved with the Surrealists, who encouraged artists to follow the irrational promptings of their unconscious minds, producing dream-like and disturbing images. Both Lam and his friend Pablo Picasso were influenced by African and Oceanic sculpture.

☛ Bellmer, Brauner, Ernst, Giacometti, Matta, Picasso

Wifredo Lam. b Sauga la Grande, 1902. d Paris, 1982. **The Jungle**. 1943. Gouache on paper mounted on canvas. **h**239 × **w**230 cm. **h**94¼ × **w**90½ in. Museum of Modern Art, New York, NY

Lancret Nicolas

A Lady and a Gentleman with Two Girls in a Garden

Elegantly dressed figures sipping chocolate from porcelain cups in a landscaped garden suggest a typically French setting. Although this is a refined, formal scene, it also shows an intimate family group. The youngest daughter has abandoned her doll in favour of a taste of the hot chocolate which is tenderly offered by her mother, while the father watches over them all with an affectionate eye. The composition has been made more interesting by placing the figures to one side of the canvas, rather than in the centre. Lancret excelled at these pastoral evocations of aristocratic life, before the Revolution swept it away forever. Failing as a history painter, he spent the rest of his days painting *fêtes galantes*, pictures of figures in pastoral settings. He was famous for his portrayal of fairs, balls and village weddings in the style of his popular contemporary, Antoine Watteau.

☛ Boucher, Fragonard, Liotard, Prud'hon, Watteau

262

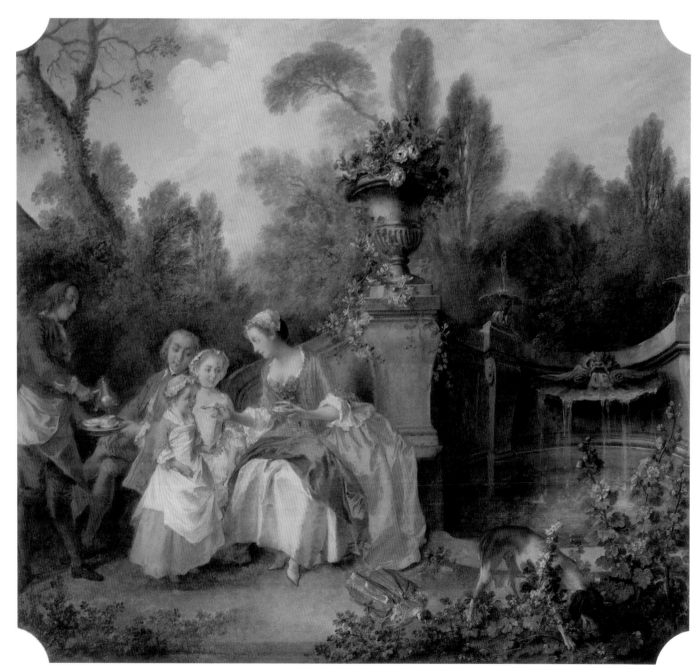

Nicolas Lancret. b Paris, 1690. d Paris, 1743. **A Lady and a Gentleman with Two Girls in a Garden**. c1742. Oil on canvas. **h**88.9 × **w**97.8 cm. **h**35 × **w**38½ in. National Gallery, London

Landseer Sir Edwin Wild Cattle at Chillingham

As if showing their proud defiance in the face of adversity, the cows dominate this composition. In fact they have been disturbed by the presence of a frog. Destined for the Earl of Tankerville at Chillingham Castle, Northumberland, this fine painting demonstrates the qualities that made Landseer so popular: he appealed to Victorian taste by endowing animals with the semblance of human emotions. Inspired by the images of the Romantic novelist Sir Walter Scott, he travelled to Britain's remote places and painted animals and landscapes that he knew might one day be threatened. His father was an engraver who taught him to sketch animals from life and he was only 12 when he first exhibited at the Royal Academy. Queen Victoria's favourite artist, his most famous works are the bronze lions in Trafalgar Square. Despite his sentimentality, there is some evidence of a gratuitous cruelty which may have contributed to his mental breakdown. He died insane.

☛ Agasse, Cuyp, Marc, Stubbs

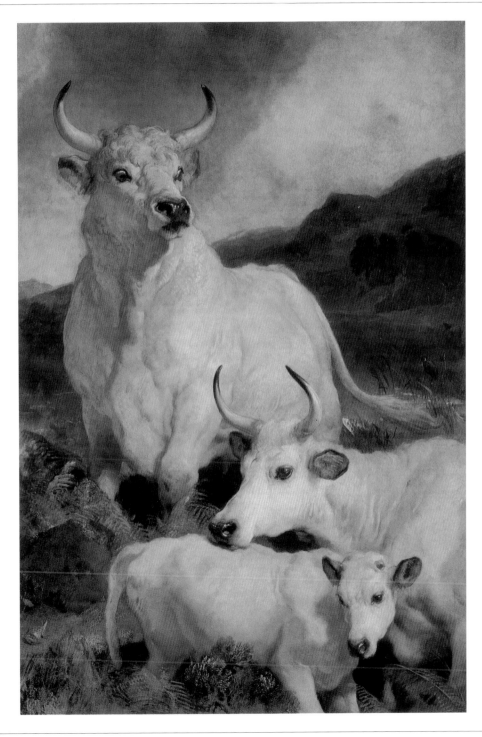

Sir Edwin Landseer. b London, 1802. d London, 1873. **Wild Cattle at Chillingham**. 1867. Oil on canvas. **h**228 × **w**156 cm. **h**89¾ × **w**61½ in. Laing Art Gallery, Newcastle upon Tyne

Lanyon Peter

Fly Away

The white mass, large yellow triangle, red bands and bold fluent brushstrokes of *Fly Away* form an apparently abstract composition. Lanyon embraced this heavily painted expressionistic style in the 1950s. In 1959 he took up glider flying and was able to obtain a totally new vision of the Cornish landscape. With this in mind, the blue-black rectangle on the right becomes the sea, the single white brushstroke and thin line of yellow become the quays of a harbour, and the red and yellow shapes assume the forms of elements of an aircraft floating in the atmosphere. Born in the English artists' colony of St Ives, Cornwall, Lanyon lived and worked there with associates Naum Gabo, Patrick Heron and Ben Nicholson for most of his life. He is acknowledged as an artist who reinvented the British landscape in the 1950s. Lanyon's career was unfortunately cut short by a fatal gliding accident in 1964 at the age of 46.

☛ Frankenthaler, Gabo, Heron, De Kooning, Nicholson

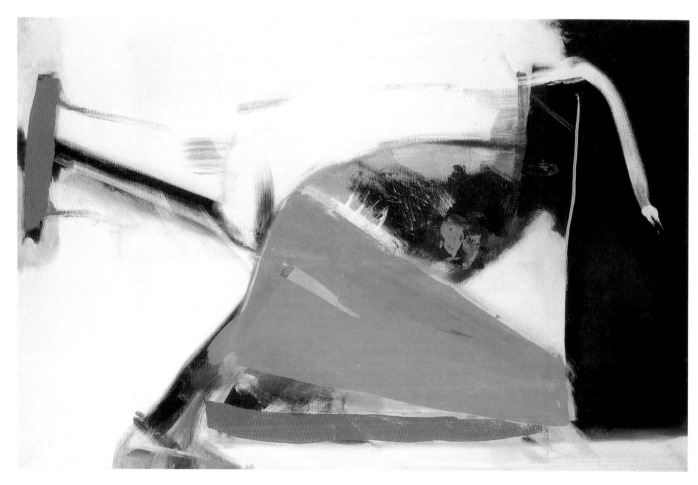

264

Peter Lanyon. b St Ives, 1918. **d** Taunton, 1964. **Fly Away**. 1961. Oil on canvas. **h**122 × **w**183 cm. **h**48 × **w**72 in. Gimpel Fils, London

La Tour Georges de The Cheat with the Ace of Diamonds

The card players' shifty eyes suggest that not one of them is honest. Only one cheat, however, obviously withholds two cards behind his back. The bright light, casting deep shadows, heightens the warm colours of their clothes. By contrast, the background is in total darkness, intensifying the areas of light. Although this is a Baroque painting, there is a geometric simplicity in the figures – for example in the oval face of the seated woman – that harks back to painters of the early Italian Renaissance such as Piero della Francesca. Many artists at this time travelled extensively, but La Tour spent his entire life in the French province of Lorraine. He specialized in candlelit scenes, achieving eerie effects with warm, glowing reds and browns, and their luminous quality is reminiscent of the works of Caravaggio. One of his paintings was accepted as a gift by the King of France, who liked it so much that he had all the works by other painters removed from his chambers.

☞ Caravaggio, Honthorst, Lucas, Piero della Francesca

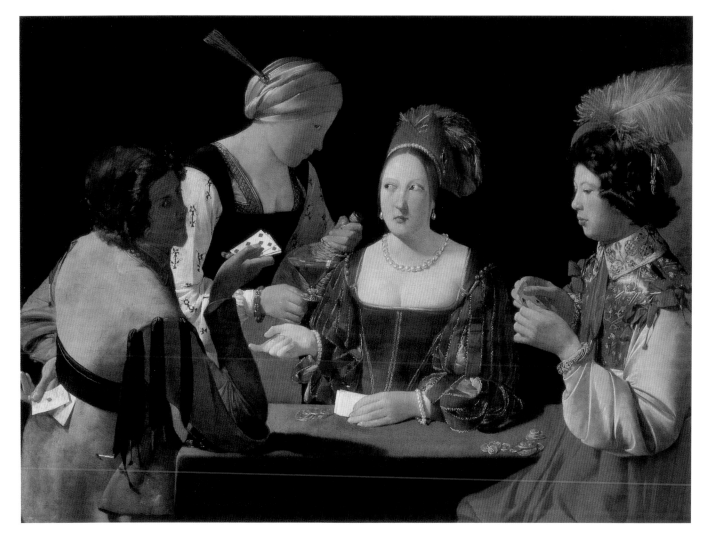

Georges de La Tour. **b** Vic-sur-Seille, 1593. **d** Lunéville, 1652. **The Cheat with the Ace of Diamonds**. c1647. Oil on canvas. **h**106 × **w**146 cm. **h**41½ × **w**57½ in. Musée du Louvre, Paris

Laurencin Marie The Dancers

Five beautiful dancers in diaphanous costumes practise their movements in this enchanting scene. The seductive pastel shades in which they are painted are typical of Laurencin's work, magnifying their almost ethereal quality. Her paintings convey her curious vision of a world peopled entirely by beautiful young girls, and perfectly embody the artistic mood of the 1920s in their lighthearted and decorative tone. She resisted the pressure of contemporary movements in art and retained her own individual style, demonstrated here in a straightforward portrayal of the dancers without any extraneous 'message'. Besides painting, she also illustrated books with watercolours. Laurencin had the advantage of being included in a social circle that included Pablo Picasso, Georges Braque, Henri Matisse, Juan Gris and Robert Delaunay and she held many artistic discussions in her Paris apartment.

☛ Degas, Dufy, Foujita, Toulouse-Lautrec, Utrillo

Marie Laurencin. b Paris, 1883. **d** Paris, 1956. **The Dancers**. 1937. Oil on canvas. **h**53.3 × **w**64.1 cm. **h**21 × **w**25¼ in. Private collection

Lawrence Sir Thomas The Duke of Wellington

Although the inscription on this work states that this is how the Duke appeared at the battle of Waterloo, it is most unlikely that Wellington could have sustained such a staged pose with a fierce battle raging around him. Lawrence's approach is more staid and less realistic than that of Antoine-Jean Gros in the windswept portrait of

his opponent, Napoleon, but like Gros, Lawrence wanted to achieve a romantic vision of a great leader – and furthermore, a victorious one. The son of an innkeeper, he was famed for his portraits at the age of ten, painting Queen Charlotte at the age of only 20 and being appointed royal painter on the death of Joshua Reynolds.

With a reputation extending to Europe, he was commissioned by George IV to paint all the major figures in the struggle against Napoleon. His best work has great force; his worst was probably dashed off to pay debts: he had a huge income but was in constant difficulty.

☛ Clouet, Van Dyck, Géricault, Gros, Marini

Sir Thomas Lawrence. b Bristol, 1769. d London, 1830. **The Duke of Wellington**. 1818. Oil on canvas. **h**396.2 × **w**243.8 cm. **h**156 × **w**96 in. The Bathurst Collection, Sapperton

Léger Fernand

The Builders

The massive scale of the building is cleverly conveyed by cutting off the image at the top and bottom, so that it appears to stretch away endlessly in both directions. Strong horizontals and verticals etch its outline against the sky in intense primary colours. The massive robot-like workers, scrambling about on the girders, and the passing clouds contrast dramatically in shape and colour with the ironwork skeleton. Trained in an architect's office, Léger was fascinated by industrial technology, and by the dynamic shapes of machinery and construction work. There is evidence in this painting of the Cubist movement in its harsh, angular lines and its focus on machinery. Léger worked in many areas: ceramics, stained glass, stage designs for the Swedish Ballet and even film – he made the first 'abstract' film, using objects as 'actors'. Among his last works were huge decorative murals for the UN building in New York.

☛ Boccioni, Braque, Brown, Delaunay, Gris, Picasso

Fernand Léger. b Argentan, 1881. **d** Gif-sur-Yvette, 1955. **The Builders**. 1950. Oil on canvas. **h**299.8 × **w**200 cm. **h**118 × **w**78¾ in. Musée National Fernand Léger, Biot

Leighton Frederic, Lord The Bath of Psyche

A sensuous, porcelain-skinned goddess gazes at her reflection as she prepares for her bath. The soft yellows, whites and flesh tones create a sense of calm while her elongated body is accentuated by the Ionic column behind her and the tall, thin shape of the canvas. The brushstrokes, invisible to the eye, are as smooth and polished as the still surface of the water. Leighton, who studied art in Europe, was a leader of Classicism in Britain, his style and choice of subject being profoundly influenced by the statues and mythology of Antiquity, which was in direct opposition to the Medievalism of the Pre-Raphaelites. He had an immediate success when his first picture was purchased by Queen Victoria. His paintings became hugely popular through mass-produced reproductions, and he was also an excellent sculptor. Leighton was later elected President of London's Royal Academy.

☛ Alma-Tadema, Burne-Jones, Cranach, Ingres, Rossetti

Lord Frederic Leighton. **b** Scarborough, 1830. **d** London, 1896. **The Bath of Psyche**. 1890. Oil on canvas. **h**189.2 × **w**62.2 cm. **h**72¼ × **w**24¼ in. Tate Gallery, London

Lely Sir Peter

Charles I with James, Duke of York

Glancing nervously at his father's face, a son hands him a letter opener. The lack of intimacy between them may reflect the real relationship between father and son, as Charles I was a prisoner at Hampton Court when this portrait was painted. James, along with his brothers and sisters, lived at Syon House under the guardianship of the Duke of Northumberland. As few visits to the King were allowed, this is an important record of one such meeting. The subtle tones and rich modelling are hallmarks of Lely's style. The choice of Lely for this commission demonstrates his increased status as portrait painter to royalty, succeeding Anthony van Dyck. Ten years after he became a Master in the Haarlem Guild, Lely was in London and had painted the King as well as the royal children. A flood of portraits followed which made him one of the most influential portrait painters of the seventeenth century.

☞ Dobson, Van Dyck, Holbein, Kneller, Reynolds

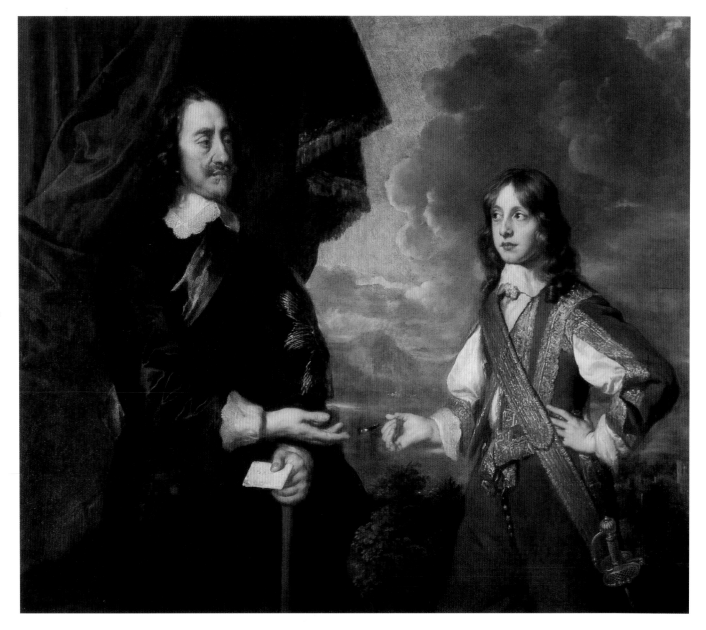

Sir Peter Lely. b Soest, Westphalen, 1618. d London, 1680. **Charles I with James, Duke of York**. 1647. Oil on canvas. **h**126.4 × **w**146.7 cm. **h**49¾ × **w**57¾ in. Syon House, Isleworth

Leonardo da Vinci — Mona Lisa

The *Mona Lisa* is famous all over the world for her enigmatic smile and for being one of the few paintings by the most esteemed of the Renaissance masters, Leonardo da Vinci. The identity of the sitter remains unknown, and some debate still rages over whether the figure is indeed a man or a woman, but the painting, with its haunting landscape, rises above this controversy in the quality of its execution. A traditional Renaissance portrait in composition, its beauty lies in the oil painting technique (known as *sfumato*) created by Leonardo, which allowed the artist to execute subtle, atmospheric shading that was impossible to produce with the egg-based tempera paint used by contemporary artists.

Equally adept in anatomy, engineering and scientific and aeronautic pursuits, Leonardo completed a remarkably small number of paintings during his lifetime. Fortunately, numerous drawings and sketchbooks have survived to reflect the diverse talents of this genius.

☛ Dürer, Ghirlandaio, Massys, Ramsay, Sittow

Leonardo da Vinci. b Vinci, 1452. d Amboise, 1519. **Mona Lisa**. 1503/6. Oil on panel. **h**77 × **w**53 cm. **h**30¼ × **w**21 in. Musée du Louvre, Paris

Lewis Wyndham

A Battery Shelled

The characteristically tortured landscape is painted in harsh, angular outlines. Billowing smoke from the shelled battery is shown as a series of segmented towers, and bomb craters appear as rigid waves, while the figures in the background are portrayed as mechanical robots. Lewis served on the Western Front, first as bombadier, then as war artist. This, his major work of that period, shows that he has toned down his pioneering abstract style in order to record the war, yet its brutality makes it clear that he thought war itself was absurd. Lewis, a novelist, art critic and superb portraitist, was in his time the most influential experimentalist of British art. He founded the Vorticist movement, a kind of Cubism that existed only in England, which superimposed views of an object from several angles to suggest its three-dimensional shape. Tragically, he was blind for the last six years of his life.

☞ Bomberg, Braque, Friedrich, Nash, Picasso

272

Wyndham Lewis. **b** At sea (off Nova Scotia), 1882. **d** London, 1957. **A Battery Shelled**. 1919. Oil on canvas. **h**152.5 × **w**317.5 cm. **h**72 × **w**125 in. Imperial War Museum, London

LeWitt Sol

Open Geometric Structure IV

This white, open-cube structure is based on mathematical guidelines. By showing projecting cubes that are defined only by their edges, LeWitt exploits the contradiction between what we know to be there and what we actually see, a characteristic that links this work to Conceptual Art. The ideas of the Minimalist movement can be seen in the work's rigid adherence to geometric mathematical calculations and its impersonal nature, with no fixed centre of interest. LeWitt worked for an architect before becoming an artist and made Minimalist sculptures which he called 'structures'. He has said that the idea behind a work is more important than the work itself, and the planning is more important than the construction. His wall drawings, a series of lines, are sold like patterns, with a 'licence' to draw them in. He then usually obliterates his own wall drawings once they have been exhibited.

☛ Andre, Buren, Flavin, Judd, Vasarely

Sol LeWitt. b Hartford, CT, 1928. **Open Geometric Structure IV**. 1990. Painted wood. **h**98 × **w**438 cm. **h**38⅞ × **w**172½ in. Lisson Gallery, London

Lichtenstein Roy In the Car

Lichtenstein's blown-up comic strip creates a powerful impact with its bold primary colours and direct style. The original cartoon is faithfully reproduced but on a large scale, imitating the coarse screen technique (Ben Day dots) that is used for printing cheap comics and newspapers. Lichtenstein used mass-produced imagery and the materials and products of the industrial environment, often extracting images from their original context and parodying them. By magnifying and over-simplifying these images he was not making a social comment on the content but trying to make people more aware of the aesthetics of 1960s USA. A prime exponent of American Pop Art, in which artefacts, mass media and products from modern life were used as art forms in themselves, Lichtenstein has continued to use popular imagery in his work. In 1993 a major retrospective exhibition of his work was held at the Museum of Modern Art in New York.

☛ Dine, Hamilton, Oldenburg, Rosenquist, Warhol

Roy Lichtenstein. b New York, NY, 1923. **In the Car**. 1963. Magna on canvas. **h**172 × **w**203.5 cm. **h**67¾ × **h**80⅛ in. Scottish National Gallery of Modern Art, Edinburgh

Limbourg Pol, Jean and Herman de January

A fine example of miniature painting, this is a page from one of the greatest manuscripts of northern European art. Illustrating January, identified by the stellar chart with the constellations of Capricorn and Aquarius, the festive banquet depicted in the main scene includes a portrait of the Duc de Berry who commissioned the manuscript. He is wearing a large fur hat and an elaborate blue and gold robe. Most of the paintings in this Book of Hours were executed by three brothers who joined the Duke's court in around 1410 and who all died in the same year as their patron, before the manuscript was complete. Their work is praised for its unprecedented attention to everyday detail and for its marvellous sense of narrative. A Book of Hours was used during the Middle Ages as a prayer book for private devotion. It recorded the daily cycle of monastic services throughout the year and this particularly sumptuous example devotes a single page to each month.

☛ Beauneveu, Del Cossa, Van Eyck, Fouquet

Liotard Jean-Étienne The Chocolate Pot

This charming portrayal of a maid carrying a tray with a cup of chocolate is striking for its direct and simple approach to an informal subject. The cool clarity of the picture's tones and the unbroken outline of the figure emphasize the pattern formed by the maid's colourful clothes against the plain background. This work has all the lightness and gaiety of Liotard's French Rococo contemporaries but without their artifice, and it looks forward to the figures of Jean Auguste Dominique Ingres and Édouard Manet. Liotard spent some years in Constantinople, where he was probably influenced by the tradition of Turkish miniature painting, whose characteristics can be seen here in the even lighting, clear tones and slightly formal expression of the maid. On his return to Europe he continued to wear the Turkish dress and beard he had adopted, enjoying the notoriety this gave him. In England, his portraits were successful, despite their being described by Walpole as 'too like to please'.

☛ Chardin, Fragonard, Greuze, Ingres, Manet, Watteau

Jean-Étienne Liotard. b Geneva, 1702. **d** Geneva, 1789. **The Chocolate Pot.** c1745. Pastel on parchment. **h**82 × **w**52 cm. **h**32¼ × **w**20½ in. Staatliche Kunstsammlungen, Dresden

Lipchitz Jacques

Half-standing Figure

The strict, mathematical composition of this work, with its layers of solid stone and intervening spaces, shows that the sculptor wanted to represent architectural, geometric forms, while creating a lyrical, harmonious whole. Lipchitz was one of the earliest sculptors to understand the principles of Cubism and to apply them to three dimensions, fragmenting forms to reconstruct them in terms of space and formal qualities of composition. Born in Lithuania, and training initially as an engineer, Lipchitz developed a very individual abstract style, making what he called 'transparent sculptures'. His later work of figures and animals in bronze was more dynamic and non-abstract. From 1941 he lived mainly in the USA and executed some important commissions there. In 1946 Lipchitz was commissioned to sculpt a Madonna for a modern church in France.

☞ Archipenko, Brancusi, Braque, Gaudier-Brzeska, Gris, Smith

Jacques Lipchitz. b Druskieniki, 1891. d Capri, 1973. **Half-standing Figure**. 1915. Stone. **h**98 cm. **h**38½ in. Tate Gallery, London

Lippi Filippino

Portrait of an Old Man

The plain blue background, unadorned pale tunic and hat highlight the wrinkled face and gentle eyes of this old man, whose portrayal is striking because it is so direct and straightforward. He sits at an angle and although not looking directly at the viewer most of his face can still be seen. The old man's identity is unknown, yet much of his personality shines through this portrait, which is painted in the graceful and simple style that characterized Filippino's work. Aged 12 when his father, Fra Filippo Lippi, died, he set off alone for Florence and a year later was working with Sandro Botticelli, a former pupil of his father. His first major commission was to complete a Florentine fresco left unfinished by Masaccio, and it is his frescos that have made his name. Years spent in Rome allowed him to study Roman remains, which became so important to him that they would crop up repeatedly in his paintings, whether they were appropriate to the subject or not.

☛ Botticelli, Ghirlandaio, Filippo Lippi, Masaccio

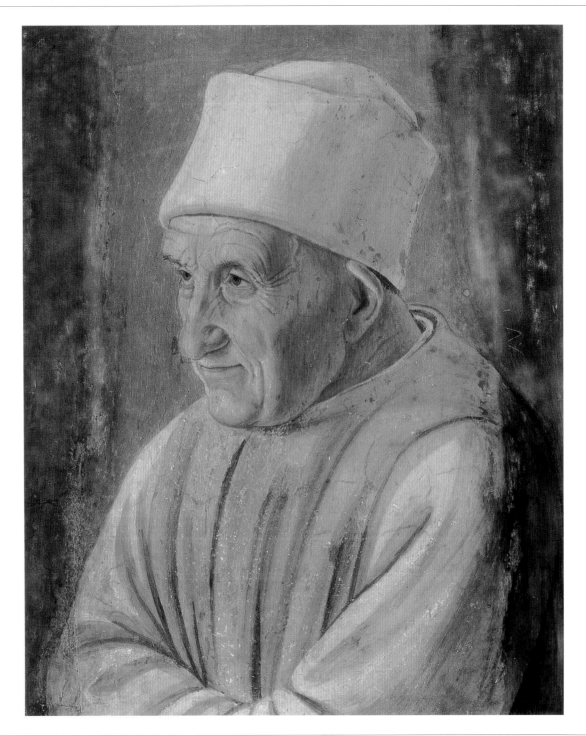

Filippino Lippi. b Florence, 1457. **d** Florence, 1504. **Portrait of an Old Man**. c1485. Fresco. **h**47 × **w**38 cm. **h**18½ × **w**15 in. Galleria degli Uffizi, Florence

Lippi Fra Filippo The Coronation of the Virgin

An elaborate hierarchy defines the realms of the angels, saints, clerics and donors who look on at this coronation. Lippi's rotund figures and understanding of space ensure that the figures are not crushed together in an unrealistic manner. By employing the rules of perspective and subtle lighting techniques, the artist has depicted the crowd in a logical way. The viewer is drawn into the composition by means of the angel in the foreground and the bishop in the green robe on the left who looks directly out from the painting. The cleric looking out on the far left is a self-portrait of Lippi, who was sent as an orphan to a monastery at the age of eight to become a monk but found himself unsuited to the life. He eloped with a nun (who became the model for many of his Madonnas) but although he was later released from his vows in order to marry her, no wedding ever took place. Their son, Filippino, also became an important Renaissance artist.

☛ Fra Angelico, Filippino Lippi, Martini, Lorenzo Monaco

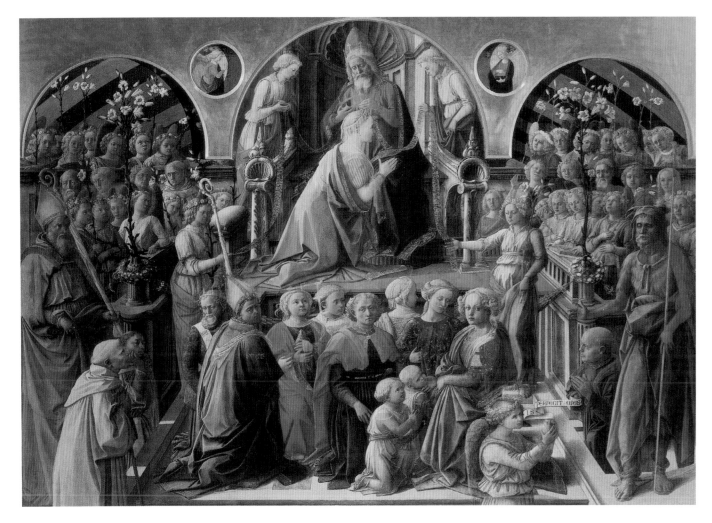

Fra Filippo Lippi. b Florence, c1406. **d** Spoleto, 1469. **The Coronation of the Virgin.** 1441/7. Tempera on panel. **h**200 × **w**287 cm. **h**78¾ × **w**113 in. Galleria degli Uffizi, Florence

Lissitzky El

Composition

Revolving geometric objects painted in delicate colours appear to be floating in the air, thus creating a sense of depth and an illusion of space. Some of the shapes are given three dimensions, and this suggestion of architectural forms was developed in Lissitzky's later works. In its concentration of pure form and colour, the drawing shows the influence of Suprematism, an abstract art form invented by Kasimir Malevich based on pure geometric figures. Lissitzky trained first as an engineer, then as an architect. Marc Chagall appointed him professor of architecture and graphic art at the art school in Vitebsk, where he came under the influence of Malevich. His series of 'Prouns' is well known – a number of abstract works of straight lines, dramatic architectural qualities and an overall flatness, with no suggestion of depth. Lissitzky's creative versatility extended to designs for costumes, exhibitions, posters and books.

☞ Chagall, Van Doesburg, Gabo, Malevich, Moholy-Nagy

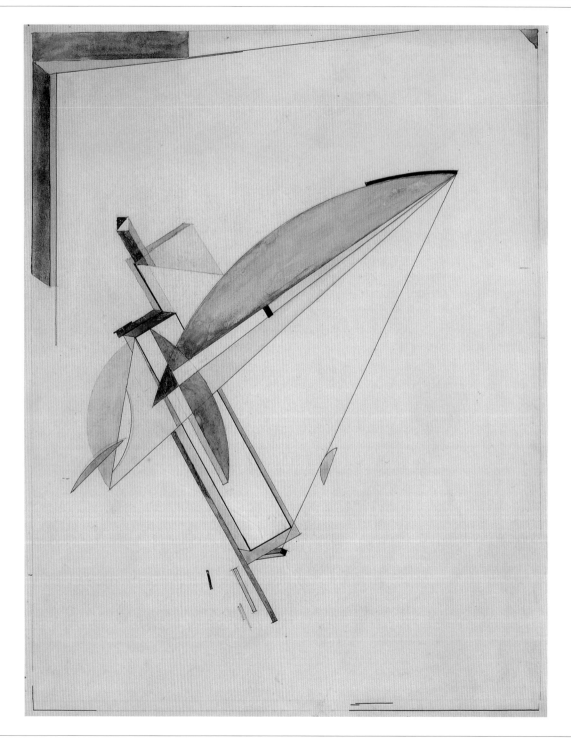

El Lissitzky (Eleazer Lissitzky). b Smolensk, 1890. d Moscow, 1941. **Composition**. c1920. Gouache, ink and pencil on paper. **h**41 × **w**33 cm. **h**16⅛ × **w**13 in. Private collection

Lochner Stefan

The Virgin and Child in a Rose Arbour

Doll-like angels serenade the Virgin and offer fruit to the Christ Child while God the Father watches from above. The arboured rose garden in which the Virgin sits is a traditional symbol of her purity. With its grace and mysticism, its subtle technique, the sweetness of the Virgin's face and the pure colours of the robes, the work has a number of characteristics typical of Lochner. This is the earliest known work by this lyrical painter, who has been described as the last of the Gothic artists, and who was principal master at the Cologne school. The gentle modelling of his figures was given the name 'soft style'. Many images of the Virgin and Child painted by other fifteenth-century German artists in the Rhine valley bear similarities to this pretty and poetical painting, as do the images of the Virgin that can be found in some contemporary illuminated manuscripts.

☛ Botero, Campin, Van Eyck, Limbourg, Schongauer

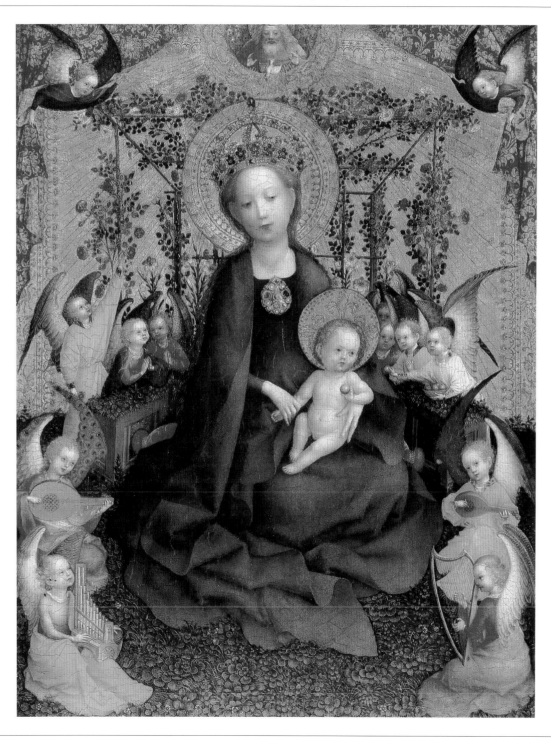

Stefan Lochner. Active in Cologne, 1442. **d** Cologne, 1451. **The Virgin and Child in a Rose Arbour**. c1440. Oil on panel. **h**50.5 × **w**40 cm. **h**19⅞ × **w**15¾ in. Wallraf-Richartz Museum, Cologne

Long Richard

Cornwall Slate Line

This linear sculpture has been created out of pieces of slate picked up on a walk through the Cornish countryside. Each one has been chosen at random, but is carefully placed in a straight line which can be moved to any place capable of accommodating its massive size. This work can be considered as Conceptual as the installation of the line represents the *idea* of the walk, which has already taken place. Long has extended the definition of sculpture to include a dimension of time; his sculptures are a record of the artist's journey through a landscape. This approach has taken him to all corners of the world. He marks his journey in different ways; he may leave a simple sculpture of stones, brushwood or seaweed, using basic shapes known to man for millions of years. Some of his sculptures are permanent, such as a line of rocks laid high in the Himalayan wilderness; the less permanent are exhibited in the form of photographs or maps.

☛ Andre, Buren, Christo, Judd

Richard Long. **b** Bristol, 1945. **Cornwall Slate Line**. 1990. Delabole slate. l2,540 × w230 cm. l999 × w87 in. Installed at Tate Gallery, London. Anthony d'Offay Gallery, London

Longhi Pietro

Exhibition of a Rhinoceros at Venice

Painted with a precise observation of detail born of an almost scientific curiosity, a rhinoceros stands in an enclosure, placidly munching hay, an exotic spectacle for a bemused audience dressed in costume for the Venetian carnival. This odd painting commemorates the rhinoceros which was toured around the European capitals by its captor, and brought to Venice in 1751. Longhi's small-scale pictures of middle-class Venetian life were theatrical and witty, but never satirical (unlike, for example, those by William Hogarth in England). One of the most charming of all Venetian eighteenth-century painters, if somewhat innocent, Longhi dispassionately recorded the everyday events that captured his imagination. His many paintings were imitated by others or repeated by pupils, and although they show no great artistic genius, they form a valuable record of an eighteenth-century Venetian society, long past its peak and slipping into decadence.

☞ Agasse, Hicks, Hogarth, Teniers

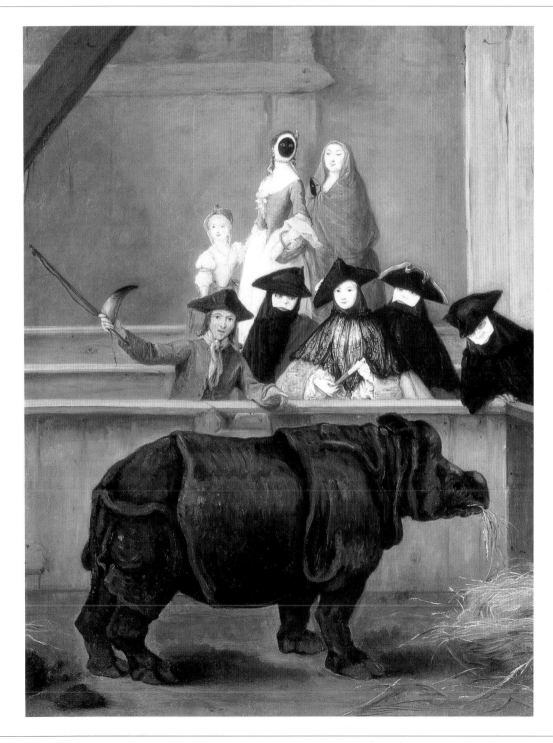

Pietro Longhi. b Venice, 1702. d Venice, 1785. **Exhibition of a Rhinoceros at Venice**. c1751. Oil on canvas. h60 × w47 cm. h23½ × w18½ in. National Gallery, London

Lorenzetti Ambrogio Allegory of Good Government

Dominating the composition from his magnificent throne sits the personification of Good Government. He is dressed as a judge in black and white – the colours of Siena. At his feet sit the twins Senius and Ascanius, feeding greedily from a she-wolf – characters from Roman mythology used to symbolize the city's ancient origins. On the left is Peace, a

Classically-inspired figure dressed in gauzy white robes and reclining on a suit of armour. Crowding round the platform are members of the Sienese community. This fresco is part of a cycle painted on the walls of the council chamber in Siena's town hall in order to inspire responsible government. The imagery is highly complex but Lorenzetti

rose to the challenge and, by adding a wealth of incidental detail, proved himself to be one of the most brilliant and original artists of the fourteenth century. Together with his brother Pietro, Ambrogio was responsible for numerous civic and religious commissions in his native Siena.

☛ Duccio, Martini, Della Quercia, Raphael

Ambrogio Lorenzetti. Active in Siena, 1319. **d** Siena, c1348. **Allegory of Good Government** (detail). c1338/40. Fresco. Palazzo Pubblico, Siena

Lorenzo Monaco The Coronation of the Virgin

The construction of this painting is typical of early Renaissance altarpieces. The principal scene is surrounded by smaller paintings set into the frame. The sequence of small panels along the lower edge combines to form a 'predella' depicting the Nativity. Above are scenes from the life of a saint; the gables show the Annunciation and Christ in Glory, while on each side, the frame is filled with individual saints. The way in which Lorenzo has crowded the saints around the Virgin and Christ, and his use of a dazzling range of colours, place him in the transitional period between the late Gothic and early Renaissance periods. Lorenzo was a monk and took his vows in a monastery famous for its illumination of manuscripts. He began as a miniaturist but progressed to altarpieces, painting this one for the high altar of Santa Maria degli Angeli in Florence.

☛ Duccio, Gaddi, Giotto, Filippo Lippi, Lorenzetti, Martini

Lorenzo Monaco. b Siena, c1370. **d** Florence, c1424. **The Coronation of the Virgin.** 1414. Tempera on panel. **h**450 × **w**350 cm. **h**177⅛ × **w**137¾ in. Galleria degli Uffizi, Florence

Lotto Lorenzo A Lady as Lucretia

The Latin inscription praising Lucretia's exemplary life is clearly meant to associate the lady in this portrait with the Roman Lucretia who, after being defiled by the son of Tarquin, stabbed herself rather than live as a spoiled woman. Virtuous women from Antiquity were much admired during the Renaissance. Lotto's early works show the strong influence of Venetian painters such as Giovanni Bellini, but he was impressionable, reflecting a multitude of his contemporaries before developing his own idiosyncratic style based on the Venetian interest in colour and light. His account book has survived (a rare occurrence), and shows that he was a difficult individual who achieved little financial success. A skilful portrait painter, able to bring his subjects vividly to life, his career took him from his native Venice to many parts of northern Italy. A few years before his death he became a lay brother in a monastery.

☞ Giovanni Bellini, Dossi, Luini, Palma Vecchio

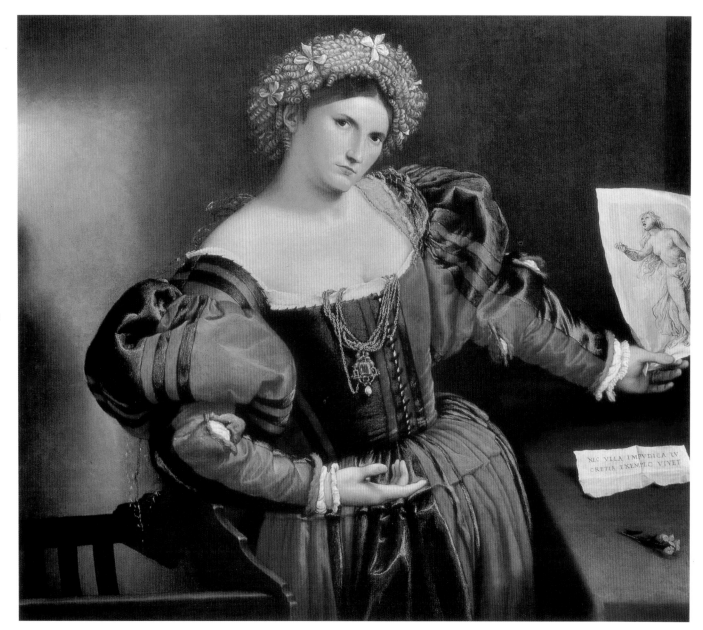

Lorenzo Lotto. **b** Venice, c1480. **d** Loreto, c1556. **A Lady as Lucretia**. c1530. Oil on canvas. **h**95.9 × **w**110.5 cm. **h**37¾ × **w**43½ in. National Gallery, London

Louis Morris

Alpha Phi

Thinned acrylic paint is poured in wing-like diagonal parallel lines, staining the bare canvas. As the rivulets of bright colour cover so small a proportion of the massive expanse, its dazzling near-emptiness irresistibly suggests a Zen-like spirit of meditation. Louis had developed in this work a new way of painting by rejecting shape and light in favour of pure colour, as the fabric of the canvas is literally soaked in paint. This concern with colour by saturation without visible brushstrokes, which magnifies the flatness of the picture plane, demonstrates the painting's connection with the Post-Painterly Abstraction movement in the USA. Louis usually worked on series of paintings at one time. These include the group 'Veils', in which the paint was poured vertically down the canvas, covering most of its area, and the 'Unfurleds' series, to which *Alpha Phi* belongs.

☛ Frankenthaler, Hodler, Kelly, Noland, Rothko

Morris Louis. **b** Baltimore, MD, 1912. **d** Washington, DC, 1962. **Alpha Phi**. 1961. Acrylic on canvas. **h**259.1 × **w**495.1 cm. **h**102 × **w**194⅞ in. Tate Gallery, London

Lowry L S

Coming from the Mill

Factory workers pour in a stream from the mill at Salford. Observed with great affection and captured in muted colours, the scene has been painted straight onto the canvas with no preliminary sketch. Lowry portrays William Blake's 'dark satanic mills' with great sympathy and charm. Although often referred to as 'matchstick people', his figures are full of movement, vital and alive. This work provides a fascinating pictorial record of the industrial north of England, with its cotton mills and rows of back-to-back houses, scenes which often exist only as memory today. Lowry's raw style of painting is idiosyncratic and entirely individual, uninfluenced by the French Post-Impressionists. A clerk all his working life who kept away from the public eye, he studied art in his spare time and was not discovered until 1939, when he was 52, and then almost by accident. His first one-man exhibition followed immediately.

☞ W Blake, Burra, Gontcharova, H Rousseau

L S (Lawrence Stephen) Lowry. b Manchester, 1887. d Glossop, 1973. **Coming from the Mill**. 1930. Oil on canvas. h42 × w52 cm. h16½ × w20½ in. Salford Museum and Art Gallery, Salford

Lucas van Leyden The Card Players

Fashionably dressed in felt hats and colourful cloaks, a group of men and women sit round a table playing cards. Others look passively on, or take a more active interest in the proceedings. This charming picture, with its profusion of bright colours and careful composition, is fresh and appealing. A superb draughtsman, Van Leyden liked to portray amusing scenes from everyday life. At the age of nine he learned to paint on glass and only a year later was a competent engraver. He was said to be a pupil of his father, although all his father's works have been lost. Van Leyden and Mabuse travelled to Flanders, giving banquets for local painters, and he also spent time in Italy. The influence of Albrecht Dürer can be seen in his numerous woodcuts and engravings: Van Leyden is believed to have been the first engraver to etch onto copper instead of iron.

☛ Dürer, Honthorst, La Tour, Mabuse, Terbrugghen

Lucas van Leyden. b Leyden, 1494. d Leyden, 1533. The Card Players. c1520. Oil on panel. h34 × w48 cm. h14 × w18 in. Wilton House, Salisbury

Luini Bernardino

The Executioner Presents John the Baptist's Head to Herod

The Baptist's head is placed on a dish for Salome to take in to Herod, but instead of presenting a scene of horror, Luini tackles the subject with calm decorum. Salome's only gesture is to gently avert her eyes from the gory spectacle before her, with no indication of the revulsion or shock that we might expect in the circumstances. Luini was more interested in harmoniously balancing the elements of his picture than in illustrating a real life event. In fact, drama and tension were beyond his range of pictorial expression; he was better suited to painting tender Madonnas and saints in rich colours, using his subtle skill to create soft, smoky contours. Luini's style was entirely dominated by Leonardo da Vinci, who had come to Milan by 1483. Although he could not match Leonardo's profound analysis of character and feeling, Luini's imitations of Leonardo's work made him one of the most popular Milanese painters of his time.

☛ Gentileschi, Ghirlandaio, Leonardo, Lotto

290

Bernardino Luini. **b** Luini, c1481. **d** Milan, 1532. **The Executioner Presents John the Baptist's Head to Herod**. 1527–31. Tempera on panel. **h**51 × **w**58 cm. **h**20 × **w**22⅞ in. Galleria degli Uffizi, Florence

Mabuse

Saint Luke Painting the Virgin

St Luke sits at a lectern in a church, drawing the Virgin and Child, his hand guided by an angel. Mabuse was one of the first Flemish painters to visit Italy, and the influences of this trip can be seen clearly in the Renaissance-inspired architectural setting, in the way the light comes from one direction (that of the halo around the Virgin), and in the heavy, sculptural forms of the figures. However, the traditions of northern painting are also reflected in the lyrical folds of the draperies, which are entirely Flemish, and in the uncomfortable pose of the kneeling saint. Mabuse was one of a group of Netherlandish artists, nicknamed 'the Romanists', who wanted to follow the ideals of the Italian High Renaissance but were hampered by their Flemish realism and painstaking technique. Although he borrowed poses and details, the essence of Classicism escaped him. In 1527 he travelled in Flanders with Lucas van Leyden.

☞ Dürer, Van Eyck, Lucas van Leyden, Massys

Mabuse (Jan Gossart). b Maubeuge, c1478. d Middelburg, 1532. **Saint Luke Painting the Virgin**. c1525. Oil on panel. **h**109.2 × **w**81.9 cm. **h**43 × **w**32¼ in. Kunsthistorisches Museum, Vienna

Magritte René

The Treachery of Images

Magritte appears to contradict reality by nonsensically naming something that does not need to be named, at the same time as denying that it is what it obviously is. By writing 'This is not a pipe' beneath the picture of one, he illustrates that the image of an object must not be confused with something tangible and real. One of Magritte's most famous images, the painting questions the concepts of definition and representation. All is not as it appears to be, Magritte is saying; the picture thus presents a challenge to ordered society and an assault on the accepted way in which people see and think. Initially inspired by Giorgio de Chirico, Magritte's Surrealist paintings often use fantastic, disturbing and dream-like images, such as a steam train emerging from the centre of a fireplace, or a sky in which the clouds have turned into French loaves. Born in Belgium, Magritte began his career as a commercial artist, and this may be reflected in the sharpness and clarity of his work.

☛ Bellmer, Brauner, De Chirico, Dalí, Delvaux, Tanguy

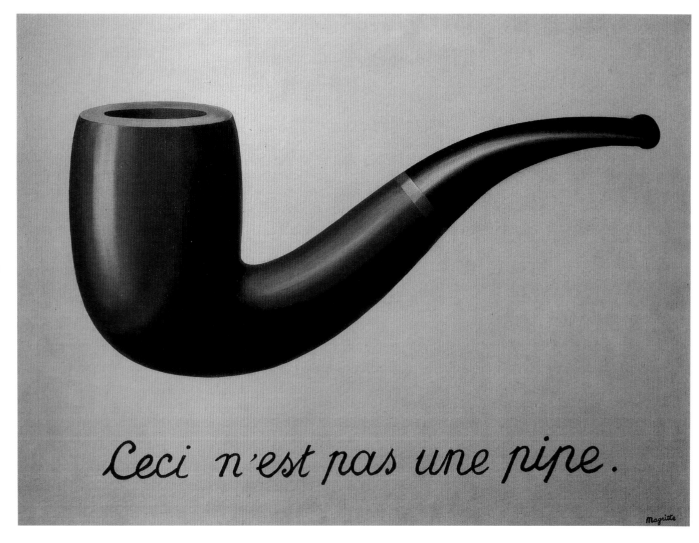

292

René Magritte. b Lessines, 1898. d Brussels, 1967. **The Treachery of Images**. 1928–9. Oil on canvas. **h**60 × **w**81 cm. **h**23⅝ × **w**31⅞ in. Los Angeles County Museum of Art, Los Angeles, CA

Maillol Aristide

The Three Nymphs

Originally conceived as a classic representation of the mythic Three Graces, this bronze statue has great solidity and weightiness in its smooth, rounded curves and restrained movements. Although Maillol's concept changed while he was working on the preparatory plaster casts, the mirroring effect of the three nudes, which gives the impression of three views of the same girl, is also typical of Classical representations of the Three Graces. Maillol did not adopt the rough surfaces, fluid shapes and intense energy of his contemporary, Auguste Rodin. He was more interested in calm than in drama, in timeless serenity than in fleeting expressions and emotions, seeking the eternal rather than the momentary. After spending several years designing tapestries, in the second half of his life he concentrated almost exclusively on sculpting the female nude, and revived the Classical ideas of Greece in the fifth century BC, in which figures had a fixed and monumental quality.

☛ Botticelli, Canova, Ingres, Powers, Rodin, Rubens

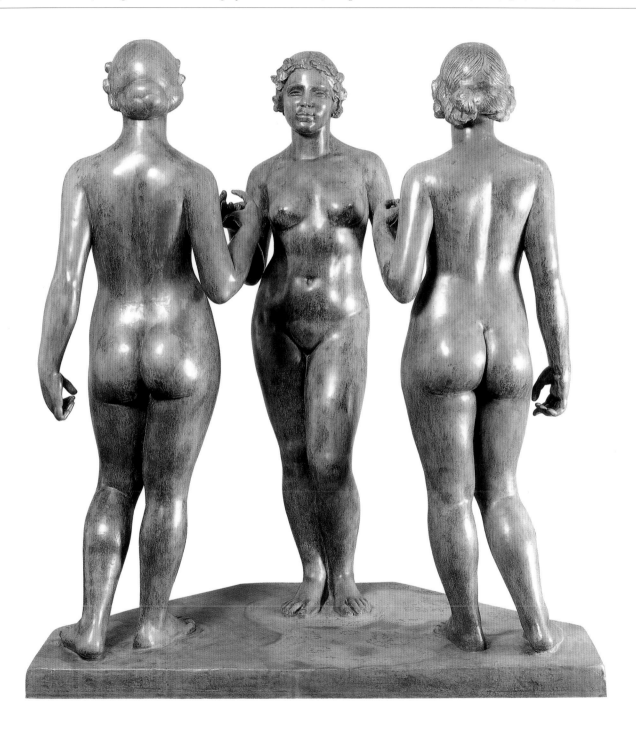

293

Aristide Maillol. b Banyuls-sur-Mer, 1861. **d** Perpignan, 1944. **The Three Nymphs**. 1930–7. Bronze. **h**160 × **w**144 cm. **h**63 × **w**56¾ in. Private collection

Malevich Kasimir Suprematism

Geometric elements painted in basic colours appear to float as if suspended on the canvas. Malevich has created a complex composition by overlapping the forms to convey a sense of perspective and depth. A Suprematist work, it banishes every trace of subject, relying solely on the interaction between form and colour. Malevich was the founder of Suprematism, a system which strove to achieve absolute purity of form and colour. For him, this method constituted an expression of pure artistic feeling, or what he called 'non-objective sensation'. In 1918, he took the development of non-objective art to its logical conclusion in a series of works entitled 'White on White', consisting of a white square on a white background, the abstract to end all abstracts. Realizing at this point that he could take the concept no further, he reverted to figurative painting.

☛ Gabo, Lissitzky, Moholy-Nagy, Popova, Rodchenko

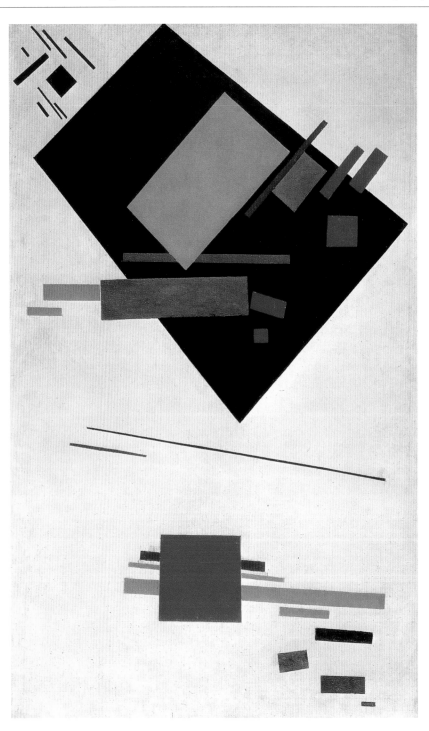

Kasimir Malevich. b Kiev, 1878. d Leningrad, 1935. **Suprematism**. 1915. Oil on canvas. **h**101.5 × **w**62 cm. **h**40 × **w**24 in. Stedelijk Museum, Amsterdam

Man Ray

Tomorrow

Displayed on a curved surface and ambiguous in its distorted triple exposure, this photograph suggests movement and sexual tension, dramatically emphasizing the female form. Man Ray was one of the most inventive photographers of his time, experimenting with and pioneering new techniques in what was then an exciting new medium. His rich, fertile imagination and irrational techniques as an artist fitted in well with the principles of Dada, an anti-art movement intended to shock and outrage. After studying art in New York, Man Ray founded a Dadaist group there and became a leading figure in the development of the Modern Movement. In the 1920s he moved to Paris, where he made several Surrealist films. Solarized images and the famous rayograph, a photographic image made without a camera, were his invention. Always at the forefront of the avant-garde, he influenced several generations of artists.

☛ Brauner, Dalí, Leighton, Sheeler, Sherman

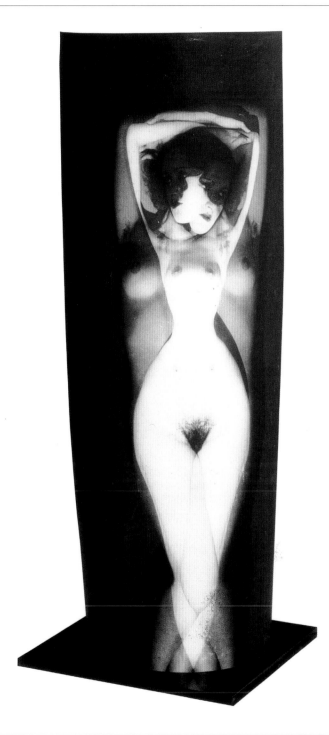

Man Ray. b Philadelphia, PA, 1890. d Paris, 1976. Tomorrow. 1932. Triple exposure photograph. h41 cm. h16⅛ in. Private collection

Manet Édouard

Déjeuner sur l'herbe

A nude woman sits in a glade, nonchalantly picnicking with two young gallants in contemporary clothes. The large canvas is treated with broad applications of colour, and the stark, direct lighting reduces the modelling of the figures to the bare minimum. Basing his figures on a composition by Raphael, and evoking the pastoral atmosphere of Giorgione,

Manet has consciously tried to evoke the high ideals of Renaissance art. This daring mixture of ancient and modern – contemporary bohemian life given the context and scale of Classical art – led to this painting being widely condemned by the critics when first shown. Manet's aim was to liberate artists from the doctrines of academicism

and literary subjects. An artistic rebel, he developed a brilliant technique with much use of black. Later he was influenced by the Impressionists' lighter colours. It is ironic that he scandalized both art critics and public, yet revered conventional artists like Diego Velázquez and Titian.

☞ Courbet, Degas, Giorgione, Tissot, Titian, Velázquez

Édouard Manet. b Paris, 1832. d Paris, 1883. **Déjeuner sur l'herbe**. 1862–3. Oil on canvas. **h**215 × **w**271 cm. **h**84¾ × **w**106½ in. Musée d'Orsay, Paris

Mangold Robert

Attic Series III

This irregularly shaped canvas, whose bottom edge is parallel with the floor, has been painted with a roller. One of a series of 28 and named after the Greek pots in the Metropolitan Museum in New York, this Minimalist work has no image, suggests no emotion and is without movement. Mangold deliberately distorts a precise geometric form to question the way in which we perceive things. Often more interested in the preparation of an idea than in turning it into a work of art, Mangold is fascinated by works made up of sections put together to make a whole, and he likes an element of visual illusion. Through the years Mangold's painting has been highly varied and has included spray-painted wood panels and works on canvas which explore geometric proportions in canvas shape and content. In the last decade he has taken on a more lyrical palette reminiscent of Henri Matisse.

☞ Andre, LeWitt, Lissitzky, Matisse, Nicholson, Ryman

Robert Mangold. **b** North Tonawanda, NY, 1937. **Attic Series III**. 1990. Acrylic and coloured pencil on canvas. **h**229 × **w**310 cm. **h**90⅛ × **w**122 in. Private collection

Mantegna Andrea The Agony in the Garden

Five angels appear to Christ as he prays, while three of his Apostles sleep in the foreground, unaware that Judas and a crowd of soldiers are on their way to arrest Christ. Every aspect of the scene – the bizarre rock formations, the imaginary town, the rigid folds of drapery – is painted in stony, precise detail. Mantegna was of humble birth,

but was adopted and taught by a minor painter, becoming one of the most important artists of his time. His style, as that of other Renaissance artists, was inspired by ancient Roman sculpture. Many of his works are in fact executed in *grisaille*, a painted imitation of marble or bronze relief. For much of his life Mantegna was Court painter to the

Duke of Mantua, for whom he formed a major collection of Classical works of art. He was also a pioneer in the art of engraving and his engravings on Classical subjects were later to influence Albrecht Dürer and others.

☛ Carpaccio, Dürer, Giulio Romano, Uccello

298

Andrea Mantegna. **b** Isola di Carturo, c1430/1. **d** Mantua, 1506. **The Agony in the Garden**. c1460. Tempera on panel. **h**63 × **w**80 cm. **h**24¾ × **w**31½ in. National Gallery, London

Manzù Giacomo The Cardinal

With only a hand appearing to disturb the geometric unity of his voluminous robes, a cardinal reflects in priestly solemnity on the authority of his office. His conical shape is at once severe and lyrical, with no suggestion of the body beneath. A feeling for continuous, undisturbed outlines has contributed to the statue's lyrical qualities. Manzù's work represents a thread of harmony and figurative order running through the fragmented schisms of twentieth-century art. The first Italian artist for whom a museum was created during his lifetime, Manzù was born the son of a shoemaker, and was apprenticed to a plasterer and a woodcarver before he began to study art. He was commissioned to make religious reliefs and statues of saints for many churches including St Peter's in Rome and also for the University of Milan. He later taught sculpture, reviving the Classical techniques of working in bronze.

☞ Algardi, Bacon, Brancusi, Maillol, Marini

Giacomo Manzù. b Bergamo, 1908. d Bergamo, 1991. **The Cardinal**. 1955. Bronze. h208 cm. h81⅞ in. Galleria Internazionale d'Arte Moderna di Ca' Pesaro, Venice

Marc Franz

Little Yellow Horses

Three yellow, curvaceous horses dominate the foreground of a detached hilly landscape. The main theme is colour, yellow signifying the passive female element, while the sensual red of the horses' flanks contrasts with the spiritual blue of the background. It is this use of luminous colour, coupled with the representation of the animals as symbols of a life-force and as projections of the artist's imagination, that make this one of Marc's most memorable images. In the way it uses colour and symbols to express the artist's inner feelings it is a good example of the work of the group of Expressionist artists called Der Blaue Reiter ('the blue rider'). The two most important members, Wassily Kandinsky and Marc, invented the name because Marc liked horses, Kandinsky liked riders and they both liked blue. Most of Marc's paintings were of horses in strong colours, but from 1912 his work became more abstract. Tragically, he was killed at Verdun in 1916.

☛ Delaunay, Jawlensky, Kandinsky, Marini, Stubbs

Franz Marc. **b** Munich, 1880. **d** Verdun, 1916. **Little Yellow Horses**. 1912. Oil on canvas. **h**66 × **w**104.5 cm. **h**26 × **w**41⅛ in. Staatsgalerie, Stuttgart

Marin John

Maine Islands

Painted as if seen through a window, this watercolour plays with the ambiguities of space. Marin has taken a favourite subject, a traditional seascape, and simplified it into its most basic forms and bright colours. Standing in a room overlooking an expanse of sea dotted with islands, he has enclosed the scene within a window frame, making the view itself look like a flat painting hung on a wall. By doing this he is playing a visual game with perceptions of flatness and depth. Marin originally trained and worked as an architect, and his early works show the influence of James McNeill Whistler. He went on to develop a unique and individual style, filtered through Fauvism (with its distortions, flat patterns and violent colour) and Cubism (with its fragmentation of forms and play on perceptions), but seen from an American perspective. Although he sometimes painted in oils, he is best known for his watercolours, usually of landscapes or studies of architecture.

☛ Davis, Diebenkorn, Hodler, Turner, Whistler

John Marin. **b** Rutherford, NJ, 1870. **d** Addison, ME, 1953. **Maine Islands**. 1922. Watercolour on paper. **h**42.8 × **w**50.1 cm. **h**16⅞ × **w**19¾ in. Phillips Collection, Washington, DC

Marini Marino

Horseman

Solid and enigmatic, this statue with its simple outlines conveys a primitive sense of vitality and power. It is formal and sober, but rich in pathos and poetical feeling. Marini produced a series of horsemen which were inspired by seeing peasants fleeing from their villages in wartime. Like Giacomo Manzù, Marini was an individualist, never part of any artistic group or movement, and remaining faithful only to his own vision. The only influence upon him was that of the statues of Classical Greece. His best-known theme was that of the horse and rider, and he explored many versions of it over a long period of years. A leading Italian sculptor, he often combined different techniques to obtain the effect he wanted, but he was also a painter, whose portraits included such major figures as the composer Igor Stravinsky, the author Henry Miller and the artist Marc Chagall.

☛ Chagall, Clouet, Epstein, Lawrence, Manzù

302

Marino Marini. b Pistoia, 1901. d Viareggio, 1980. **Horseman**. 1947. Bronze. **h**101.6 cm. **h**40 in. Museum of Modern Art, New York, NY

Martin John

The Great Day of His Wrath

Concentrated into this huge landscape, under an ominously dark sky, are all the intensely dramatic effects that Martin could muster to show the awesome power of nature. It is nothing less than the end of the world. Mountains crumble, fires rage and bolts of lightning fall as God exacts his final revenge on mankind. In the centre, tiny figures, naked in their shame and disgrace, are sucked into the primeval void from whence they came. Nicknamed 'Mad Martin', this visionary began as a struggling heraldic and enamel painter, before his fertile imagination produced the grandiose and lurid visionary paintings that created a sensation in England and Europe, and influenced J M W Turner and others. Inspired by the works of John Milton, his huge canvases showed Biblical subjects on a vast scale, peopled with tiny figures, exotic architecture and lurid, menacing skies. Paralysis from a stroke brought his career to an abrupt end.

☞ Bosch, Church, Cole, Cozens, Friedrich, Turner

John Martin. **b** Haydon Bridge, 1789. **d** Douglas, 1854. **The Great Day of His Wrath**. c1853. Oil on canvas. **h**196 × **w**303 cm. **h**77³⁄₈ × **w**119³⁄₈ in. Tate Gallery, London

Martini Simone

The Annunciation

This painting depicts the moment in the Annunciation when Gabriel first appears to the Virgin to announce that she is to be the mother of Christ. His billowing cape and extended wings suggest that he has only just arrived. The words of his greeting are engraved on the gold background, as if issuing from his mouth at that very moment. Mary recoils in horror at Gabriel's message, turning away from him and pulling her cloak around her for protection. The white lilies and Mary's book, traditional attributes of Annunciation scenes, are depicted with unusual realism. With its elegant figures and richly patterned surface this work is one of the most perfect examples of the fourteenth-century Gothic style. Martini worked for some of the most important and enlightened patrons of his day, including the Sienese government, the poet Petrarch and King Robert of Anjou.

☛ Fra Angelico, Duccio, Lorenzo Monaco, Tintoretto

Simone Martini. b Siena, c1284. **d** Avignon, 1344. **The Annunciation.** 1333. Tempera on panel. **h**184 × **w**210 cm. **h**72½ × **w**82¾ in. Galleria degli Uffizi, Florence

Masaccio

The Holy Trinity

The vaulted arch in this painting is a perfect illustration of the linear perspective which fascinated contemporary Florentine artists. Masaccio painted this scene so that all the sightlines converge on a single point, just as we would see the lines painted on a straight road getting smaller as they stretch into the distance. The vaulting, columns and pilasters reflect the renewed interest in Classical architecture at the time. The figures have an impression of real, physical presence, of a solidity unknown before Masaccio. In his short life, this pioneer became one of the greatest fifteenth-century Florentine painters, and an influence on those who followed. Original and authoritative, he had the ability to convey the drama of a situation through a telling glance or gesture, and his economical techniques suggest a real sense of light and space. His major surviving works are frescos. Tragically, this brilliant painter died before he was 30.

☛ Grünewald, Masolino, Piero della Francesca, Rouault

Masaccio (Tommaso di Giovanni). **b** San Giovanni Valdarno, 1401. **d** Rome, c1428. **The Holy Trinity**. c1420. Fresco. **h**667 × **w**317 cm. **h**262½ × **w**124⅞ in. Santa Maria Novella, Florence

Masolino

Saint Peter and Saint Paul

The two saints may be identified by the objects in their hands. Paul holds a sword, from his days as a soldier, whereas Peter holds the keys of Heaven, given to him by Christ. Originally part of an altarpiece for the church of Santa Maria Maggiore in Rome, this panel was a collaboration between Masolino and Masaccio; the figures have Masaccio's characteristic solidity. Masolino is the more delicate artist of the two, as seen here in the soft features of Peter's face, and the relationship of colours in the robes. Masolino and Masaccio frequently worked together; Masolino, although the elder of the two, was profoundly influenced by Masaccio's style – so much so that experts often have difficulty in working out who painted what in their collaborations. The names Masolino and Masaccio, meaning 'Little Tom' and 'Big Tom', may have come from an attempt to tell them apart. After Masaccio's early death, Masolino reverted to the International Gothic style of his youth.

☛ Giotto, Lorenzo Monaco, Masaccio, Sluter, Uccello

Masolino da Panicale. **b** Florence, c1383. **d** Florence, c1433. **Saint Peter and Saint Paul**. c1428. Oil on panel. **h**114.5 × **w**54.4 cm. **h**45 × **w**21³⁄₈ in. Philadelphia Museum of Art, Philadelphia, PA

Massys Quentin Portrait of a Notary

The cross, feather, rose, paper and writing instruments indicate that this man is a notary, someone who certifies documents for the public, but his actual identity is not known. There is a directness in the way he looks out at the viewer, and a precision in the whole painting, from the accurate likeness of the sitter to the landscape beyond

the arcade. Massys was profoundly influenced by Leonardo da Vinci and Albrecht Dürer, and his sitters are usually seen against a wooded or mountainous landscape (similar to that in the *Mona Lisa*). There are other indications of Leonardo's influence: some of his original and ironical drawings are similar to Leonardo's caricature

heads of old men and women, called 'grotesques'. According to legend, Massys was a blacksmith who transformed himself into a musician and man of culture. A distinguished and realistic portrait painter, he developed a highly polished technique.

☞ Dürer, Holbein, Leonardo, Memling, Sittow

Quentin Massys. b Louvain, 1465/6. **d** Antwerp, 1530. **Portrait of a Notary**. c1510. Oil on panel. **h**80 × **w**64.5 cm. **h**31½ × **w**25¼ in. National Gallery of Scotland, Edinburgh

Matisse Henri

The Dinner Table (Harmony in Red)

A flurry of primary colours dominates this dazzling painting of the interior of a room with a woman laying a table. The entire surface is harmonized into a vibrant, unified pattern of pure colour which has been skilfully integrated into the structural composition, saturating the room. The tablecloth merges with the wall, and the forms have been completely flattened, distorted and simplified. This enhances the lyrical flow of the ornamental forms and iridescent colours. Matisse has used colour as a means of expression rather than description and has deliberately flouted the conventional rules of drawing and perspective. He and his followers were called 'Fauves', or wild beasts, due to the primitive savagery of their style. Matisse's Fauvist manner spanned the years 1905–8 and his style continued to develop throughout his long career. Colour always played a central role in his work, however, as can be seen in the vibrant paper collages he produced in his last years.

☞ Bonnard, Derain, Gauguin, Van Gogh, Heron, Kirchner

Henri Matisse. b Le Cateau-Cambrésis, 1869. d Cimiez, 1954. **The Dinner Table (Harmony in Red)**. 1908. Oil on canvas. **h**180 × **w**246 cm. **h**71 × **w**97 in. Hermitage Museum, St Petersburg

Matta Roberto Sebastian Echaurren Untitled

Strange shapes inhabit this fantastical, amorphous landscape. Visions from a dark imagination dart spontaneously across the picture surface and beyond, like electrical currents. They seem to resist any polar attraction to direct them into a semblance of compositional unity or rhythm. An unnatural blue-ish colour suffuses the scene with an aura of mystery and other-worldliness, while the pictorial forms seem to be the result of a bizarre symbiosis of organic limbs and mechanical components extending into infinite space. Matta first trained as an architect, but turned to painting in 1937. He spent the war years in New York and came into contact with many members of the Surrealist movement. His style of painting, using the 'automatic' technique of entirely free brushstrokes without rational control, is typical of Surrealism, and was to inspire Jackson Pollock and Arshile Gorky among others.

☞ Bellmer, Brauner, Gorky, Lam, Pollock

309

Roberto Sebastian Echaurren Matta. **b** Chile, 1911. **d** Civitavecchia, Italy, 2002. **Untitled**. 1950. Oil on canvas. **h**130 × **w**195 cm. **h**51⅛ × **w**76¾ in. Latin American Masters, Beverly Hills, CA

Memling Hans

Descent from the Cross

Poignantly simple, this emotional moment in the Christian story has been reduced to three men who support Christ's body, and a glimpse of the ladder which leans against the cross. The figures are crowded into the foreground of the picture, while the landscape behind is a visible, but not prominent, part of the composition.

Memling was born in Germany, but spent most of his life in Bruges, where he became the leading painter of his day. His style was influenced by Hugo van der Goes and he often copied the latter's compositions. Memling's versions, however, lack the dramatic tension of the elder artist. It may be this lack of artifice which has made

Memling such an approachable and popular figure in the history of art. His realistic faces, luminous colours and simple, yet self-assured compositions evoke the quintessential elements of Netherlandish painting.

☛ Bouts, Van der Goes, Grünewald, Van der Weyden

Hans Memling. **b** Seligenstadt, 1433. **d** Bruges, 1494. **Descent from the Cross**. 1480/90. Oil on panel. **h**53.7 × **w**38 cm. **h**21⅛ × **w**15 in. Capilla Real, Granada

Mengs Anton Raphael Self-portrait

Dressed in a simple brown cloak with a red underjacket, Mengs presents us with a completely informal, unpretentious image of himself. His rather shabby clothing, unkempt hair and drained features with tired, swollen eyes are an honest depiction of an exhausted man, worn out with hard work and inner struggle. Many painters have made self-portraits, the best known being those of Vincent van Gogh and Rembrandt. These searching introspections, plumbed into the inner psyche, give a penetrating insight into the character of the artist. Often, as in this painting, all concrete details apart from a brush and a folder of sketches are excluded. A German by birth who worked mostly in Rome and Spain, Mengs was a painter of religious and historical subjects in the restrained emotions and heroic style of the Neo-Classical era, yet here he has let us have a glimpse of his real personality.

☛ Van Gogh, Kauffmann, Raeburn, Rembrandt, Vigée-Lebrun

Anton Raphael Mengs. **b** Aussig, 1728. **d** Rome, 1779. **Self-portrait**. c1774. Oil on canvas. **h**102 × **w**77 cm. **h**40¼ × **w**30¼ in. Hermitage Museum, St Petersburg

Merz Mario

Unreal City

The words *città irreale* ('the unreal city') are inscribed in neon light within a triangular framework. It is a brash, succinct statement on the artificial and transitory nature of contemporary urban life – but also an enigmatic and puzzling work. Its very elusiveness can be interpreted as the source of infinite ambiguities of meaning, demonstrating Merz's interest in exploring the fleeting, subtly changing processes of thought as a comment on the bland standardization of modern technological culture. Merz was an exponent of Arte Povera, a new form of Conceptual Art developed in Italy in the 1960s which aimed at disassociating artistic creation from the notion of high culture. As the name suggests, the defining criteria for Arte Povera were poverty and lack of refinement, whether of means, materials or effect; banality was raised to the level of art and commonplace objects were invested with metaphysical significance.

☛ Beuys, Flavin, Nauman, Oldenburg, Viola

Mario Merz. b Milan, 1925. **Unreal City**. 1968. Iron, wire mesh, wax and neon light. **h**200 × **w**164 cm. **h**78¾ × **w**64½ in. Stedelijk Museum, Amsterdam

Metsu Gabriel

The Music Lesson

A delicate air of mystery enshrouds this little interior, in which a man and a woman are seated at a virginal. Ostensibly a music lesson, the picture probably also depicts a scene of courtship, where music acts as the accompaniment of love. The calm, balanced mood of this painting is achieved by its cool luminosity, as in the pale tones of the wall. Brilliant areas of pure colour, such as in the woman's red bodice and the man's blue hose, create delicate spatial harmonies. The carefully structured composition is based on the stable horizontals and verticals of the spinet, picture-frames and chair, with few diagonals intruding. Metsu was a pupil of Gerard Dou, who specialized in domestic interior scenes. His paintings are rich in subtle poetical allusions, providing revealing insights into the lives of the Dutch middle classes in the seventeenth century.

☞ Dou, Hammershøi, De Hooch, Ter Borch, Vermeer

Gabriel Metsu. b Leyden, 1629. **d** Amsterdam, 1667. **The Music Lesson**. c1658. Oil on canvas. **h**38.4 × **w**32.2 cm. **h**15⅛ × **w**12¾ in. National Gallery, London

Michelangelo

The Doni Tondo

With its intriguing composition, stunning colours and monumental figures, this painting is considered one of the masterpieces of Western art. The Virgin, Joseph and the Infant are masterfully entwined to create an animated composition. The sculpted nudes in the background are unrelated to the Holy Family but they give Michelangelo an opportunity to show off his skill for depicting muscles and the play of light over the surface of the human body. The vibrant colours are surprising compared with other works by Michelangelo but they are consistent with the brilliant colours he used in the Sistine Chapel in Rome (revealed through cleaning). This painting is often called the *Doni Tondo* because it was owned by the Doni family in Florence and because it is round (*tondo*) in shape. Michelangelo was not just a painter but a sculptor, architect, poet and military engineer and is considered to be one of the greatest masters of the Renaissance.

☞ Bronzino, Della Robbia, Rosso Fiorentino, Palma Vecchio

Michelangelo Buonarroti. **b** Caprese, 1475. **d** Rome, 1564. **The Doni Tondo**. c1503/4. Tempera on panel. **diam**.120 cm. **diam**.47¼ in. Galleria degli Uffizi, Florence

Millais Sir John Everett Mariana

The richness of this painting is reminiscent of a jewel-encrusted Medieval book cover. The entire room, with its stained glass, velvet wall coverings and suggestive religious atmosphere, reflects the Victorian taste for decorative craftsmanship inspired by Gothic designs. The superbly crafted details of the painting – from the garden outside to the delicacy of Mariana's embroidery on the table – and the subject, taken from a contemporary poem by Tennyson, bring together the main features of the Pre-Raphaelite movement. Millais was probably the most fêted of all Victorian artists. A fashionable and technically brilliant academic painter, he was a co-founder of the Pre-Raphaelite Brotherhood which sought to emulate painters earlier than Raphael, the sixteenth-century High Renaissance master. Their aim was to reintroduce a style of fresh Christian sincerity painted with detailed clarity.

☛ Burne-Jones, Hunt, Simone Martini, Raphael, Rossetti

Sir John Everett Millais. b Southampton, 1829. d London, 1896. **Mariana**. 1851. Oil on canvas. **h**59.7 × **w**49.5 cm. **h**23½ × **w**19½ in. Private collection

Millet Jean-François The Gleaners

Three peasant women collect the scanty remains of the harvest after it has been reaped. In the distance, the harvesters are loading up the plentiful crop. The cool, golden light gives a noble dignity to the figures, but this painting is more than a mere depiction of rural life. It is also a harsh social comment on the poor, peasant classes, reduced to labouring over the slim pickings left by the rich, who are far away on the horizon. Millet transformed scenes of heart-breaking poverty into images of epic heroism, depicting the noble toil of peasants and their intimacy with the land with flagrant realism. Although this provoked much criticism among his contemporaries, this painting is now regarded as one of the masterpieces of the nineteenth century. Millet's drawings are also notable for their sculptural simplification of form and their monumental qualities.

☞ Corot, Courbet, Daubigny, Pissarro, T Rousseau

Jean-François Millet. **b** Gruchy, 1814. **d** Barbizon, 1875. **The Gleaners**. 1857. Oil on canvas. **h**83 × **w**110 cm. **h**32¾ × **w**43¼ in. Musée d'Orsay, Paris

Miró Joan

Women, Bird by Moonlight

Playing and mingling acrobatically with one another, these imaginary, frolicking figures project themselves vivaciously into the foreground. The background paint has been rubbed away to show the canvas underneath, lending it a raw, earthy quality. Evoking imagery from a primitive world, the magical figures conjure up thoughts of

prehistoric cave-paintings, restored to us with all their freshness. The painting forms part of a series entitled 'Women and Birds' and is considered to be one of the most important of all this Spanish artist's works. In its portrayal of weird, hallucinatory beings, which seem to spring from a subconscious dream-world, the picture is

typical of the Surrealist movement, of which Miró became a prominent member. He worked with Max Ernst on the creation of the decor for Sergei Diaghilev's ballet *Romeo and Juliet*, and also executed a wide range of lithographs, etchings and ceramics throughout his life.

☛ Arp, Baumeister, Brauner, Dalí, Ernst

Joan Miró. **b** Montroig, 1893. **d** Palma, 1983. **Women, Bird by Moonlight**. 1949. Oil on canvas. **h**81.5 × **w**66 cm. **h**32 × **w**26 in. Tate Gallery, London

Modersohn-Becker Paula Old Poorhouse Woman with a Glass Bottle

Gazing out in a deep reverie, an old woman firmly holds a foxglove in her hand. She sits at the very edge of the picture-plane in front of a field of poppies and an inverted bottle. The flowers, bottle and woman are all painted with great solidity; their massive shapes easily fill the canvas. Modersohn-Becker's sensitivity to colour is equally important to the composition. The sky, for example, glows with a luminous yellow-green light. Although she was born in Germany and worked there most of her life, the artist's frequent trips to Paris gave her contact with the thick, textural technique of Vincent van Gogh and the solid, simple forms and colours of Paul Gauguin. This work was painted in the last year of Modersohn-Becker's life; she died tragically early at the age of 31. In its simplification of colour and form, and emphasis on line, her work anticipates German Expressionism.

☞ Gauguin, Van Gogh, Gontcharova, Jawlensky, Nolde

Paula Modersohn-Becker. b Dresden, 1876. d Worpswede, 1907. **Old Poorhouse Woman with a Glass Bottle**. 1907. Oil on canvas. **h**96 × **w**80.2 cm. **h**37¾ × **w**31½ in. Ludwig Roselius Sammlung, Bremen

Modigliani Amedeo Nude

The female model leans against a chair in a plain interior which provides no distractions, allowing us to gaze at her beauty. The nude was Modigliani's main pictorial subject and this is considered to be one of his most beautiful portrayals. It is also one of his earliest works. The girl's submissive and serene expression gives the painting an erotic charge. The elongated, angular lines, and the almost sculptural quality of the sitter's face, are typical of the artist's work. Modigliani developed his own individual, restrained style of painting and was not closely affiliated to any movement although he was profoundly influenced by Cubism, African sculpture and the work of Paul Cézanne. A painter and sculptor, Modigliani lived at an exhausting pace. Born in Italy, he went to Paris in 1906 and spent the rest of his short life there. When he died, aged 35, of tuberculosis, his beloved girlfriend Jeanne Hébuterne committed suicide.

☛ Boucher, Brancusi, Cézanne, Foujita, Munch, Picasso

Amedeo Modigliani. b Livorno, 1884. d Paris, 1920. **Nude**. c1912. Oil on canvas. **h**92.1 × **w**60 cm. **h**36¼ × **w**23⅝ in. Courtauld Institute Galleries, London

Moholy-Nagy László CHX

A perfect illusion of objects suspended in space is created by this painting. The artist has placed geometric forms within the confines of a narrowing grid pattern to create an impression of three-dimensionality and perspective. The importance of this painting lies in the way it explores the ability of light and colour to move objects in a seemingly infinite environment.

Influenced by the ideas of the Russian Constructivist movement, the artist has stripped the geometric forms of all ornamentation, using them to demonstrate the relationship between space and volume. Moholy-Nagy studied many fields of artistic creation and was active in industrial design, photography, sculpture, cinematography, writing and stage design. One of his notable commercial achievements was the creation of the special effects for Alexander Korda's movie *More Things to Come*. Hungarian by birth, Moholy-Nagy lived in Germany from 1920 to 1937 when he settled in Chicago and founded The Institute of Design.

☛ Gabo, Lissitzky, Malevich, Rodchenko

László Moholy-Nagy. **b** Bácsborsód, 1895. **d** Chicago, IL, 1946. **CHX**. 1939. Oil on canvas. **h**76 × **w**96.5 cm. **h**29⅞ × **w**38 in. Private collection

Mondrian Piet Composition

A simple black grid pattern interspersed with vivid sections of primary colour is boldly displayed in this geometrical composition. Mondrian developed a style that banished the conventions of three-dimensional space and the curved line. He wished to build his pictures from the simplest elements – straight lines and primary colours – which he moved around the canvas until he found the perfect composition balance. His aim was to create an objective art of discipline whose laws would somehow reflect the order of the universe. The use of pure line and colour highlights the painting's connection to the De Stijl movement, of which Mondrian was a leading member. He left his native Holland in 1938, and travelled to London, where his studio was destroyed by bombing. After two years he went on to New York and his compositions became slightly more colourful, reflecting the more restless rhythms of life in the land of Broadway and boogie-woogie.

☛ Albers, Van Doesburg, Judd, Malevich, Rodchenko

321

Piet Mondrian. b Amersfoort, 1872. **d** New York, NY, 1944. **Composition.** 1929. Oil on canvas. **h**45 × **w**45 cm. **h**17¾ × **w**17¾ in. Solomon R Guggenheim Museum, New York, NY

Monet Claude

Waterlily Pond

Shimmering with mingling colours and reflections, this landscape is airy and saturated with light. Monet has achieved this effect by covering his canvas with individual brushstrokes of different colours, creating a rich mist of blues, reds and greens that glint like light on the surface of water. When Monet built a water-garden at his house in Giverny he began to see its pictorial possibilities and it became a subject which he painted again and again until his death. His first series of paintings of the garden, executed in the summers of 1899 and 1900, reflect the constant variations of light and air across the surface of the water-lily pond. Monet was not only a leading member of the Impressionist movement, but his experiments with paint, colour and light also formed a starting point for abstract art. His near-contemporary Paul Cézanne described him as 'only an eye, but God what an eye!'.

☛ Cézanne, Kupka, Pissarro, Seurat, Sisley, Turner

Claude Monet. b Paris, 1840. d Paris, 1926. Waterlily Pond. 1899. Oil on canvas. h88 × w93 cm. h34¾ × w36¼ in. National Gallery, London

Moore Henry

Recumbent Figure

Monumental and almost primeval, this carved statue seems to have been created more by the forces of nature than by man. Semi-abstract in form, its smooth and rounded outlines suggest the work of the elements, while at the same time evoking the soft curves and flowing outlines of a female body. Inspired by the vitality of ancient and primitive sculpture, Moore revived the tradition of direct carving into stone or wood. In so doing he emphasized the natural textures of his material, and in his massive works he consciously reflected the contours and qualities of landscape and rock. As a result, the simple, solid shapes of his sculptures have a powerfully brooding presence. One of the distinguishing hallmarks of his figures or groups was that they were often pierced. Moore's works are frequently displayed in the open air, and several of his commissions stand outside major buildings in North America and Europe.

☛ Bourdelle, Hepworth, Maillol, Manzù, Rodin

Henry Moore. b Castleford, 1898. d Much Hadham, 1986. **Recumbent Figure**. 1938. Green Hornton stone. **h**88.9 × **w**132.7 cm. **h**35 × **w**52¼ in. Tate Gallery, London

Morandi Giorgio Still Life

Remote and imprisoned in their austere, cool tones, a collection of jugs, cups and containers is enveloped in a neutral background; they appear to exist in a complete vacuum. A sense of mystery pervades this simple, intimate scene. With its harmonious composition and subtle colour variations it conveys an air of meditative serenity. Morandi almost exclusively painted still lifes of bottles and jugs throughout his long career. He sought to express the pure, poetic beauty of these objects in his powerfully simple, contemplative compositions. While he was influenced briefly by Giorgio de Chirico's idea of Metaphysical Painting, Morandi's withdrawn, sensitive personality led him to stand aloof from the intellectual turmoil and experiments of many contemporary artists. The sense of calm meditation that pervades his paintings invites comparison with the work of Jean-Baptiste-Siméon Chardin and Paul Cézanne rather than that of his contemporaries. He is also known for his etchings.

☞ Cézanne, Chardin, De Chirico, Nicholson, De Staël

Giorgio Morandi. b Bologna, 1890. d Bologna, 1964. **Still Life**. 1960. Oil on canvas. **h**38 × **w**33.5 cm. **h**14⁷⁄₈ × **w**13¹⁄₈ in. Private collection

Moreau Gustave

Galatea

A sensual, naked nymph sits languidly in an exotic grotto, which is fantastically decorated with a profusion of colourful anemones, corals and other mineral flora. She is watched by an eerie, three-eyed monster. This picture is based on a story from Greek mythology, telling of the unrequited love of the Cyclops, Polyphemus, for the Nereid, Galatea. The technicolour myriads of underwater blooms, and the softness of the execution, give the painting a magical, dream-like quality. Moreau was associated with the Symbolist movement, whose painters moved away from the objective naturalism of the Impressionists. They preferred to derive their inspiration from an imaginative synthesis of often literary or mythological sources. As in this painting, they used colour and form to imbue their work with expressive rather than descriptive meaning. Moreau also painted a large number of watercolours, which were highly acclaimed by his contemporaries.

☛ Bonnard, Klimt, Modigliani, Mucha, Redon, Vuillard

Gustave Moreau. **b** Paris, 1826. **d** Paris, 1898. **Galatea**. 1880. Oil on panel. **h**85 × **w**67 cm. **h**33⅜ × **w**26⅜ in. Private collection

Morisot Berthe

The Cradle

A young mother is watching devotedly over her sleeping baby in a cradle. The tenderness and love implicit in this painting are achieved not only by the careful disposition of the two figures but also in the subtle harmonies of colours and delicate brushwork. The sensitive handling of textures, such as the diaphanous veil draped over the crib and the satin curtain behind the woman (the artist's sister), enhance the intimacy of the scene. Morisot was the great-granddaughter of the eighteenth-century painter Jean-Honoré Fragonard. She was taught by Édouard Manet (who became her brother-in-law) and the even light and directness of this work owe much to his influence. Later, she was to be heavily influenced by Pierre Auguste Renoir. Although she often exhibited her paintings alongside those of the Impressionists, Morisot's work retained a feminine delicacy all of its own.

☛ Cassatt, Corot, John, Manet, Renoir, Reynolds

Berthe Morisot. b Bourges, 1841. d Paris, 1895. **The Cradle**. 1872. Oil on canvas. **h**56 × **w**46 cm. **h**22 × **w**18 in. Musée d'Orsay, Paris

Moroni Giovanni Battista Portrait of the Duke of Albuquerque

Splendidly regal, this man has been captured by Moroni in all his pompous dignity and luxurious clothing. He is carrying a sword, which probably refers to his readiness to defend the honour of his family and city in times of conflict. This chivalrous attitude is further reflected in his restrained and proud bearing, and also in the inscription on the wall: 'Here I am with no fear, and of death I have no terror.' It is an intimate and confident portrait, blending a striking realism with the artist's love of rich colours and sumptuous effects which he derived from the Venetian masters Giorgione and Titian. Free from unnecessary background detail, the simplicity of the composition lends distinction to the sitter. Moroni's grandiose treatment of the full-length portrait (especially those depicting ordinary people) made him one of the leading exponents of this type of picture in the sixteenth century.

☛ Dossi, Giorgione, Kneller, Lotto, Titian

Giovanni Battista Moroni. **b** Albino, 1520/5. **d** Bergamo, 1578. **Portrait of the Duke of Albuquerque**. 1560. Oil on canvas. **h**116 × **w**86 cm. **h**45⅝ × **w**33⅞ in. Private collection

Motherwell Robert — Elegy to the Spanish Republic No. 134

Broad, massive forms are dramatically applied in black paint on the white canvas. These heavy, slow-moving shapes have engendered numerous and varied interpretations – from phallic symbols to musical notes – but none, in themselves, are totally convincing. The painting's quality lies in its power to suggest so many rich and varied analogies, however diverse they may be. As the title suggests, it is one of the numerous works in the artist's 'Elegy' series, inspired by the Spanish Civil War. It has become one of Motherwell's most renowned images. Married to fellow artist Helen Frankenthaler, Motherwell was one of the principal members of the Abstract Expressionist movement. His spontaneity of technique and attention to formal rather than narrative qualities epitomize their approach. Apart from his paintings, Motherwell also made numerous drawings, prints and inspired collages of ripped paper which incorporate paint.

☛ Flavin, Frankenthaler, Kline, Louis, Ryman, Soulages

Robert Motherwell. **b** Aberdeen, WA, 1915. **d** Cape Cod, MA, 1991. **Elegy to the Spanish Republic No. 134**. 1974. Acrylic on canvas. **h**237.5 × **w**300 cm. **h**93½ × **w**118⅛ in. Graham Gund Collection, Cambridge, MA

Moulins Master of Coronation of the Virgin

Elegantly dressed in rich red and blue velvet brocades, the Virgin and Child are portrayed surrounded by angels and bathed in a mystical light. Behind them is a fantastical visionary background, and a crescent moon lies at their feet. The Master's refined technique brings out the luminous opulence of the jewels in the crown, and the elongated features of the Virgin have a marvellous lyrical quality. This highly accomplished artist was influenced by Hugo van der Goes and adopted the restrained elegance of his Flemish contemporaries. One of the great French fifteenth-century painters, he was named after his principal work, a triptych in Moulins Cathedral. Little is known about him, including his real name, which has produced several theories about his identity. Some experts believe that he may have been the Court painter to the French King, Charles VIII.

☛ Van Eyck, Van der Goes, Filippo Lippi, Van der Weyden

Master of Moulins. Active 1480–1500. **Coronation of the Virgin**. c1500. Oil on panel. **h**157 × **w**142 cm. **h**61¾ × **w**55⅞ in. Notre Dame, Moulins

Mucha Alphonse

La Trappistine

As noble and spiritual as Joan of Arc, yet sensually provocative and appealing, a dream-like seductress stands resting her hand on a bottle of liqueur. The round decoration surrounding her head like a halo gives this temptress an almost divine appearance of rare beauty. Delineated in elongated, curvilinear strokes and coloured in pale, watery tones, this advertising poster is an example of the stylish elegance of Art Nouveau, of which Mucha was one of the chief exponents. The artists of the Art Nouveau style attempted to blend all categories of art into a decorative unity based on graceful, elegant linear forms. Mucha was largely responsible for popularizing many of the style's key motifs, such as undulations of flowing hair and flowers on slender twining stems. A prolific graphic artist, Mucha also designed jewellery, stained glass, furniture, stage sets and costumes. He spent much of his career in Paris, but returned to his native Czechoslovakia in 1910.

☞ Klimt, Moreau, Munch, Toulouse-Lautrec

Alphonse Mucha. **b** Ivancice, 1860. **d** Prague, 1939. **La Trappistine**. 1897. Lithograph on paper. **h**206 × **w**77 cm. **h**81 × **w**30⅓ in. Suntory Ltd Collection, Osaka

Munch Edvard

The Madonna

A mysterious sensuality draws us into this vibrant painting of the Madonna, daringly depicted in a pose of naked abandon. Uneasily provocative, she exudes a challenging sexuality, but there is also an underlying sense of tragedy in her deep black hair and dark eyes. The swirling, tempestuous background seems to evoke a troubled soul. Munch's own life was tinged with death, illness and nervous crises. Born in Norway, he began his career painting in a more conventional manner but soon became interested in the work of Vincent van Gogh and Paul Gauguin. Instead of painting the world around him he began to seek to express his innermost feelings and desires through his art. The frenetic energy and simmering passions of his intense paintings made him a founder of the style known as Expressionism, in which emotive distortions and exaggerated colours are used to achieve maximum expressiveness.

☛ Bernini, Gauguin, Van Gogh, Kokoschka, Modigliani

Edvard Munch. **b** Løte, 1863. **d** Oslo, 1944. **The Madonna**. 1894/5. Oil on canvas. **h**91 × **w**71 cm. **h**35¾ × **w**28 in. Nasjonalgalleriet, Oslo

Murillo Bartolomé Esteban — The Immaculate Conception of the Escorial

A visionary painting of deep piety and religious sentiment, this depiction of the Madonna in the heavenly realm was commissioned for the Hospital de los Venerables Sacerdotes in Seville. The softness of the brushwork and the delicate yet rich colouring, bathed in a gentle light, imbue the composition with tenderness. Swirling, playful *putti* surround the Madonna like an aureole. The composition follows the form prescribed by seventeenth-century Spanish art theorists, but the painting is fired with Murillo's own brand of spiritual devotion. Compared with the harsh, almost brutal realism and heightened emotions of his Spanish contemporaries, Jusepe Ribera and Francisco de Zurbarán, Murillo's style is more tender and sentimental, reminiscent of the sixteenth-century Italian artist Correggio. His works were much in demand throughout Europe and were widely copied and imitated well into the nineteenth century.

☛ Andrea del Sarto, Correggio, Ribera, Velázquez, Zurbarán

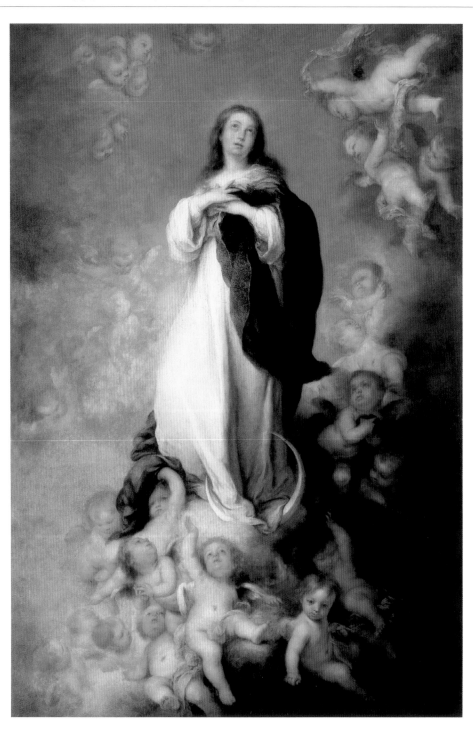

Bartolomé Esteban Murillo. b Seville, 1618. **d** Seville, 1682. **The Immaculate Conception of the Escorial.** c1678. Oil on canvas. **h**274 × **w**190 cm. **h**108 × **w**74¾ in. Museo del Prado, Madrid

Nash Paul

Dead Sea

This nightmarish image of a vast, static sea of wrecked metal is an imaginative and visionary transformation of a set of photographs taken by the artist at a dump for wrecked German aircraft near Oxford. Wings, wheels and fuselage are discernible in this mass of metal carnage. A bleak moonlight permeates the whole scene and evokes an eerie atmosphere of death and destruction. It is one of Nash's most compelling statements as an official war artist to the Air Ministry in the Second World War, capturing the tragedy and triumph of those bitterly glorious years. Although influenced by Surrealism, Nash remained essentially an artist of visionary landscapes. The dramatic content of his work is sometimes associated with the Neo-Romantics, who practised a strongly theatrical, romantic style of painting in the 1930s and 40s. His artistic range included engravings, book illustrations, industrial design and photography.

☞ Bomberg, Burra, Friedrich, Lewis, Wadsworth

333

Paul Nash. b London, 1889. **d** Boscombe, 1946. **Dead Sea**. 1940–1. Oil on canvas. **h**101.6 × **w**152.4 cm. **h**40 × **w**60 in. Tate Gallery, London

Nauman Bruce

Life Death, Knows Doesn't Know

Flickering neon lights flash words which are boldly written in coloured capital letters. A sense of wonder and enchantment is generated both by the medium, through which the messages mysteriously appear like judgements from on high, and by the words themselves, which flash on and off in arbitrary sequences. The overlapping phrases contradict each other and can be taken to represent the ambiguities inherent in human communication and the multi-layered meanings of worldly experience. The use of signs and symbols to convey 'hidden' meanings and messages has been a popular feature of art (especially in northern Europe) since the Middle Ages. Nauman takes this idea to its ultimate expression by means of representation and association: the work of art has itself become the message, presented in a pure and distilled form.

☞ Beuys, Flavin, Merz, Oldenburg, Viola

Bruce Nauman. b Fort Wayne, IA, 1941. **Life Death, Knows Doesn't Know**. 1983. Neon tubing with clear glass suspension frames. **diam.**203.2 cm. **diam.**80 in. Anthony d'Offay Gallery, London

Newman Barnett Covenant

Austere in its restraint and direct in its simplicity, a flat field of red is divided and ordered by two thin, vertical stripes of brown and cream-white. Traditional artistic techniques have been discarded in favour of creating a pure tension between the asymmetrical blocks of smooth colour. The arrangement of the stripes encourages the viewer to concentrate on the spatial experience of pure colour; they make the picture plane almost open out before us. These stripes, which came to be known as 'zips', were to become a trademark of Newman's style, making him one of the most minimalistic of the American Abstract Expressionist painters. Rather than beauty, Newman sought to suggest a sort of mystical abstraction; he intended that we should not only look at his paintings but also sense the refined spirituality and mysticism suggested by their colours and sheer size. He was deeply influential on younger painters of the 1960s.

☛ Flavin, Judd, Reinhardt, Rothko, Ryman, Serra

Barnett Newman. b New York, NY, 1905. d New York, NY, 1970. **Covenant**. 1949. Oil on canvas. **h**121.9 × **w**152.4 cm. **h**48 × **w**60 in. Hirshhorn Museum and Sculpture Garden, Washington, DC

Nicholson Ben

August 1956 (Val d'Orcia)

A series of lyrical, arabesque lines, typical of Nicholson's work in the 1950s, weave between some apparently abstract forms that on closer inspection turn out to be everyday objects such as bottles, glasses, plates and jugs. Only the essence of the flat, coloured outlines has been captured, each reduced to a fragmented geometrical shape that is arranged on a white table set against a half-grey, half-brown background. Nicholson was interested in the innovations of Cubism, where forms are split and viewed simultaneously from different angles, as well as in the pure structural compositions of Piet Mondrian. Both of these influences are synthesized in his painting. A pioneer of abstract art, Nicholson played a significant role in the European avant-garde while maintaining attachment to the landscape and still-life forms. His career spanned over 60 years, embracing his revolutionary carved reliefs, paintings, drawings and prints.

☛ Braque, Hepworth, Mondrian, Morandi, De Staël

Ben Nicholson. b Denham, 1894. **d** London, 1982. **August 1956 (Val d'Orcia)**. 1956. Oil and pencil on board. **h**122 × **w**214 cm. **h**48 × **w**84 in. Tate Gallery, London

Noguchi Isamu Stone of Spiritual Understanding

Suspended in mid-air like a gravity-defying, magical object, a solid bronze stone exudes the vitality and palpable presence of the forces of nature. Its sheer rawness is presented unashamedly, as if to assert that the stone's inner qualities are more significant than anything it could be carved, or cast, to represent. Buddhist philosophy (which strongly influenced Noguchi) ascribes such principles to natural objects. Noguchi believed sculpture to be 'the perception of space, the continuum of our existence'. Working briefly with Constantin Brancusi (from 1927 to 1928), he derived much of his inspiration from the older sculptor's work. His own sculptures, however, are invested with a new elemental and primordial dynamism, of which the material itself is the essence. In addition to sculpture Noguchi concerned himself with theatre and costume designs, garden plans and even playground facilities.

☛ Bourgeois, Brancusi, Calder, Kapoor, Moore, Smith

Isamu Noguchi. b Los Angeles, CA, 1904. d New York, NY, 1988. **Stone of Spiritual Understanding**. 1962. Bronze, wood and metal. **h**133 cm. **h**52¼ in. Museum of Modern Art, New York, NY

Nolan Sir Sidney

Gray Sick

A bearded man, with his hands clenched and an intense expression on his face, is secured to the back of a camel with rope. The relentless heat and scorching desert are evoked by the cloudless, oppressive blue sky and the ridges of eroded earth underfoot. In August 1860 a group of 18 men left Melbourne on the first expedition to cross Australia. Although the expedition completed its objective it was badly organized and ended in disaster. Charles Gray, one of the explorers, suffered from severe headaches and dysentery and had to be lashed to the saddle of his camel; he died at sunrise on 17 April 1861. In 1949 Nolan travelled from his native Melbourne to paint in the outback of Queensland, describing the lives of explorers and the toll of the forces of nature upon them. He also painted a series of paintings of the notorious bushranger Ned Kelly. Nolan is widely recognized as the leader of the modern Australian school of painting.

☛ Boyd, Cole, Kitaj, Marini

338

Sir Sidney Nolan. b Melbourne, 1917. **d** London, 1992. **Gray Sick**. 1949. Enamel and oil on board. **h**92 × **w**120 cm. **h**36 × **w**47 in. Collection of Lord McAlpine of West Green

Noland Kenneth Gift

Concentric circles of paint surrounded by bare canvas create the image of an apparently spinning target. This illusion of movement is produced by the irregular staining caused by the paint as it is absorbed into the unprimed canvas. Concentrating the effect of colour by using a thinned acrylic paint for this staining, Noland leaves a large area unpainted in order to achieve maximum visual intensity. He was one of the first artists to exploit the possibilities of bare canvas in this way. The technique of staining adds a visual ambiguity: the paint actually becomes part of the weave of the canvas. This painting is connected to the Post-Painterly Abstractionist movement in its exploitation of the flat canvas surface and in the precisely centred image, which generates no physical or emotional reverberation beyond itself. Noland often painted in series, using the same motif recurrently. These included the target, chevron and lozenge shapes.

☞ Albers, Frankenthaler, Louis, Ryman, Stella

Kenneth Noland. b Asheville, NC, 1924. **Gift**. 1962. Acrylic on canvas. **h**182 × **w**182 cm. **h**72 × **w**72 in. Tate Gallery, London

Nolde Emil

Red Poppies

Watery splotches of colour seem to float across the paper. The shapes of the poppies and their vivid red colour are the most important elements of the composition. Nolde trained as a furniture-maker, turning to painting later in his career. Most of his works are imbued with the deep emotions characteristic of the German Expressionist artists of whom he was perhaps the most powerful. His goal was to 'grasp what lies at the very heart' and 'transform nature by infusing it with one's own mind and spirit'. Common subjects for Nolde included Biblical scenes and landscapes, many of which were based on the expression of his own beliefs. He was initially swept up by the nationalism of the Nazis, only to be condemned by Hitler as a menace to society and officially prohibited to paint, draw or produce any kind of art whatsoever. He nevertheless continued to do so and lived and worked in Germany for the rest of his life.

☛ Ensor, Modersohn-Becker, Pechstein, Vlaminck

340

Emil Nolde. b Nolde, 1867. **d** Seebüll, 1956. **Red Poppies.** c1920. Watercolour on paper. **h**34.3 × **w**48.3 cm. **h**13½ × **w**19 in. Leonard Hutton Galleries, New York, NY

O'Keeffe Georgia

Radiator Building

Rising above the dusky street-lights of a New York night and topped by a gleaming, decorative pinnacle, a tall skyscraper towers over the surrounding buildings. Its slender form is punctuated by the bright lights of the windows, giving it the appearance of a glittering jewel in the night sky. A strange light projects upwards from behind, illuminating the misty, wintery sky and the vaporous emanation on the right. Balancing this on the left is a glowing red horizontal band with neon light. O'Keeffe's work is sometimes termed 'Precisionist' because of its machine-like clarity. As well as simplified renditions of urban architecture she is known for her paintings of mountains, bones and flowers – the latter often on a giant scale. Her clear, simple forms, bordering on naivety, and unconventional choice of subject matter, made her a pioneer of a new modernism in the USA.

☛ Davis, Estes, Hopper, Sheeler

Georgia O'Keeffe. b Sun Prairie, WI, 1887. d Santa Fe, NM, 1986. **Radiator Building**. 1927. Oil on canvas. **h**121.9 × **w**76.2 cm. **h**48 × **w**30 in. Fisk University, Nashville, TN

Oldenburg Claes Giant Hamburger

Absurd and kitsch, this massively over-sized version of a twentieth-century icon evokes a sense of incredulity. The artist's desire to imitate and displace one of the most potent symbols of American culture enhances its power and impact. Not only in its unconventional subject matter but also in its soft form it crushes all preconceived notions of traditional sculpture being solid and hard. Oldenburg was an American Pop artist concerned with making art from materials and products from the commercial environment. He wanted his art to reflect contemporary, everyday life in all its complexity and change. This work clearly takes its cue from the American 'fast-food' empire that was developing, at meteoric speed, in the 1960s. In 1964 Oldenburg established a shop in Green Street, New York, from which he sold painted plaster replicas of food and other commodities.

☛ Dine, Duchamp, Hamilton, Lichtenstein, Segal, Warhol

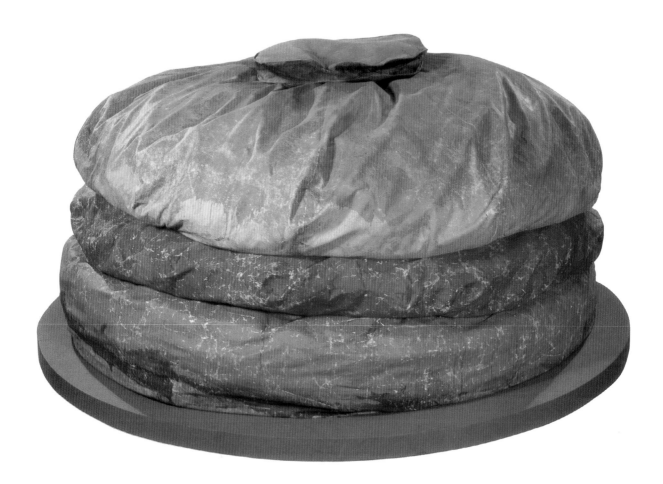

Claes Oldenburg. **b** Stockholm, 1929. **Giant Hamburger**. 1962. Printed sailcloth stuffed with foam. **h**132 × **w**213 cm. **h**52 × **w**82⁷/₈ in. Art Gallery of Ontario, Toronto

Orcagna

Saint Matthew Surrounded by Scenes of his Life

Both the central figure in this painting – Matthew, the patron saint of Florentine bankers – and the use of gold leaf, allude to the Bankers' Guild who commissioned this work to adorn the church of Orsanmichele. This style of painting, called 'gold ground' because of its background, is typical of fourteenth-century Florence. The figures are idealized, colourful and highly patterned, but they do not have the realism and depth evident in the work of Giotto (Orcagna's artistic predecessor in Florence) or in later works. As was customary, this painting was a collaboration between the master and his assistants, working in a single workshop. In this case, Orcagna (local slang for 'archangel' – his real name was Andrea di Cione) was the main master, but he died before the work was finished. It was completed, in his style, by his younger brother Jacopo, who was a member of the workshop.

☛ Duccio, Giotto, Lorenzo Monaco, Masolino

Orcagna (Andrea di Cione). **b** Florence, c1320. **d** Florence, 1368. **Saint Matthew Surrounded by Scenes of his Life**. c1367. Tempera on panel. **h**291 × **w**265 cm. **h**114⅝ × **w**104⅜ in. Galleria degli Uffizi, Florence

Organ Bryan

Charles, Prince of Wales

The Prince of Wales sits in a relaxed pose, dressed in casual clothes in front of a green fence. Painted almost entirely of blue and green, only a few elements in the painting are not in these two colours – the Union Jack, the Prince's face, and his boots and shirt collar. Organ revolutionized the traditional approach to portraits of the monarchy. He has not chosen to depict his sitter with the pomp and ceremony associated with his position, but as an intelligent, aware and sensitive man who has just finished a friendly game of polo. In the 1970s Organ was commissioned to paint the portraits of four members of the British royal family, three of which now hang in London's National Portrait Gallery. A consummate draughtsman and insightful portrayer of character, Organ was also the first non-French citizen to be commissioned to paint a French President (François Mitterrand).

☛ Hockney, Kauffmann, Richter, Sutherland

344

Bryan Organ. **b** Leicester, 1935. **Charles, Prince of Wales**. 1980. Acrylic on canvas. **h**177 × **w**178 cm. **h**70 × **w**70⅛ in. National Portrait Gallery, London

Orozco José Clemente Modern Migration of the Spirit

This sensational image is a scene from Orozco's large fresco portraying Christ as a militant revolutionary destroying his cross. A mountainous junk heap of various remnants of modern civilization rises up behind him. While creating this work, the artist developed a technique which evolved from his meticulous study of ancient Mexican mural paintings and masonry. The evocative message seems to be that the all-powerful Creator-Destroyer figure of Christ is calling for the total destruction of the prevailing forms of modern politics, religion and society. The Expressionist nature of this fresco is implicit in its principal theme of dramatic upheaval and change, subjects which Orozco had been passionate about since the Mexican Revolution of 1910. He was a politically committed artist and promoted the cause of peasants and workers by painting large murals depicting scenes from the life and history of the Mexican people. He maintained a preference for working in the medium of fresco.

☞ Botero, Grünewald, Rivera, Rouault, Siqueros, Tamayo

José Clemente Orozco. b Jalisco, 1883. **d** Mexico City, 1949. **Modern Migration of the Spirit**. 1933. Fresco. Dartmouth College, Hanover, NH

Orpen Sir William The Café Royal in London

Under the glittering ceiling of a fashionable meeting-point for well-to-do Edwardians, a congregation of successful artists gathers together. The stiff demeanour and elegant dress-code give a sense of formal bohemianism to this group portrait of Orpen and his friends, which includes the artists Augustus John, William Nicholson, James Pryde and Alfred Rich. Orpen has diluted this stiffness by depicting two of the figures chatting between tables. A highly acclaimed society portraitist in his day, Orpen owed his success to his confident style and precise, angular technique which captured the often haughty, 'upper-crust' Edwardian character of his sitters. Orpen specialized in 'conversation pieces', which was a type of group portrait where the sitters are engaged in some everyday occupation. One of the most famous of these is his *Homage to Manet*, with Walter Sickert and other artists grouped in front of Édouard Manet's *Portrait of Eva Gonzalès*.

☛ Bazille, Manet, Renoir, Sargent, Sickert

Sir William Orpen. b Stillorgen, 1878. d London, 1931. **The Café Royal in London**. 1912. Oil on canvas. **h**138 × **w**114 cm. **h**54⅓ × **w**44⅞ in. Musée d'Orsay, Paris

Van Ostade Adriaen Interior with Peasants

In a cluttered interior, a mother and child sit by a window as three boorish men carouse noisily in the background. The household is clearly one of great poverty, emphasized by the mussel- and egg-shells strewn around the untidy floor. Other objects in the scene, such as the spinning-wheel and wool-winding frame, represent not the pastimes of the idle rich but the instruments of hard labour for the poor. The baby's refusal of its mother's food may refer to a moral message ('Poverty comes to those who refuse what is offered to them') although the overall tone of the painting is more decorative than moralizing. Ostade was a prolific artist who specialized in painting scenes from daily life (called 'genre' paintings), many of which featured peasants in interiors. In his later works, his palette became more colourful and his peasants better behaved and their rooms tidier. One of his pupils was Jan Steen, who also depicted this type of popular subject matter.

☞ P Bruegel, De Hooch, Rembrandt, Steen, Vermeer

Adriaen van Ostade. b Haarlem, 1610. **d** Haarlem, 1685. **Interior with Peasants**. 1663. Oil on panel. **h**34 × **w**40 cm. **h**13⅓ × **w**15¾ in. Wallace Collection, London

Overbeck Johann Friedrich The Adoration of the Magi

Figures based on simple geometric forms; a landscape which recedes into a hazy distance; colours dominated by the blue and gold robe of the Virgin and the subject of the Adoration: all are elements more appropriate to a fifteenth-century Italian altarpiece than a nineteenth-century German painting. Overbeck idolized the artists of the Italian Renaissance and sought to recreate their style. This work is even painted on a wood panel, in the manner of a Renaissance altarpiece. After 1810, Overbeck left Germany for Rome where he was better able to study the masters he so admired. There he converted to Roman Catholicism and co-founded an artistic group which became known as the 'Nazarenes'. The Nazarenes aimed to revive the spirit of early Medieval religious brotherhoods, and set up their workshop in an abandoned cloister. Their work was influential on the Pre-Raphaelite Brotherhood in England.

☛ Fra Angelico, Brown, Gentile da Fabriano, Gozzoli

348

Johann Friedrich Overbeck. b Lübeck, 1789. d Rome, 1869. **The Adoration of the Magi**. 1813. Oil on panel. **h**49.7 × **w**66 cm. **h**19½ × **w**26 in. Kunsthalle, Hamburg

Palma Vecchio

The Holy Family with Mary Magdalene and the Infant Saint John

Colour and light effects are as important to this painting as its subject. The tones in the Virgin's robe, for example, fluctuate from dark to light red as the garment drapes over her knees. In contrast to this realistic depiction, the Virgin's face is idealized into a cherubic image. These characteristics are deeply rooted in Venetian painting and follow the painterly tradition of Giorgione. Like the older artist, Palma Vecchio specialized in the placement of a religious subject in an idyllic, pastoral setting. These often featured plump, sweet-faced blonde women, who became a hallmark of the artist's style. He was an accomplished portrait painter and also received a large number of ecclesiastical commissions. These included several large altarpieces depicting the Virgin and Child surrounded by saints (a composition called a *sacra conversazione*). His most famous is the Santa Barbara altar in Santa Maria Formosa, Venice.

☛ Giorgione, Michelangelo, Sebastiano del Piombo, Titian

Palma Vecchio. b Serina, c1480. **d** Venice, 1528. **The Holy Family with Mary Magdalene and the Infant Saint John**. c1520. Oil on panel. **h**87 × **w**117 cm. **h**34¼ × **w**46 in. Galleria degli Uffizi, Florence

Pannini Giovanni Paolo Roman Capriccio

Pannini has combined a selection of Rome's ancient monuments in one image, creating a celebration of its glorious past. The circular building to the left is the Colosseum, with Trajan's column standing in front; at its base is the figure of the Dying Gaul. On the right stand the Arch of Constantine in the background and a set of three free-standing Corinthian columns in the foreground. Born in Piacenza, Pannini moved to Rome where the city's impressive ruins inspired him to paint views of historical events, scenes of contemporary life, and imaginary combinations of actual buildings, but in the wrong context (such as the work shown here). He was the first painter to specialize in views of this kind and his enormous output of work became very popular among tourists, equal in some ways to the views of Venice by Canaletto, whose style was at first similar to his own.

☛ Canaletto, Guardi, Poussin, Siberechts

Giovanni Paolo Pannini. **b** Piacenza, c1692. **d** Rome, 1765. **Roman Capriccio**. 1734. Oil on canvas. **h**97.2 × **w**134.6 cm. **h**38¼ × **w**53 in. Maidstone Museum and Art Gallery, Maidstone

Parmigianino

The Madonna with the Long Neck

The elongated, languid features of the Virgin, Child and attendant angels were purposefully exaggerated by the artist – hence this painting's popular title. Parmigianino has taken the static harmony associated with fifteenth-century paintings, such as those by Raphael and Perugino, and infused the composition with a new vibrancy and movement. This tendency is often called Mannerism, because of its conscious stylization and attempt to rework the balanced proportions of the Renaissance. Parmigianino's elegant and intimate paintings exemplify the early Mannerist style. He usually used compositions with a few figures, rather than crowd scenes, so as to lay emphasis on the grace and languor of his figures. A native of Parma – from where he took his name – Parmigianino spent most of his life working there. This painting, however, was made after he had spent some time in Rome, where he studied the work of artists such as Raphael.

☛ Correggio, El Greco, Pontormo, Raphael, Signorelli

Parmigianino. b Parma, 1504. **d** Casalmaggiore, 1540. **The Madonna with the Long Neck**. c1532. Oil on panel. **h**219 × **w**135 cm. **h**86¼ × **w**53⅛ in. Palazzo Pitti, Florence

Patenier Joachim

Saint Jerome in a Rocky Landscape

Fantastic geological structures dominate this visionary landscape, which has been conjured up from Patenier's fertile imagination. The grand, sweeping vista is punctuated by tiny figures and architectural confections. Carefully observed and sensitively depicted, the detailed topography of the scene makes it a convincing setting for the diminutive figure of the hermit saint to inhabit. Patenier has unified light, atmosphere and physical elements to create what must be one of the earliest real landscape paintings – a genre whose popularity has never dimmed. The smooth finish and technical perfection of the painting are typical of Patenier's style. His naively imaginative landscapes had a great and lasting influence on Flemish painting; with their extraordinary blend of fantasy and naturalistic detail they anticipate the works of Jan Bruegel in particular.

☛ Altdorfer, Antonello, J Bruegel, Van Eyck, Leonardo, Reni

Joachim Patenier. b Place unknown, c1485. **d** Antwerp, 1524. **Saint Jerome in a Rocky Landscape**. c1500. Oil on panel. **h**36 × **w**34 cm. **h**14¼ × **w**13½ in. National Gallery, London

Pechstein Max Hermann Meadow at Moritzburg

All elements of this townscape are exaggerated. The perspective is distorted, the buildings and figures are reduced to basic shapes while the vivid pinks, blues, greens and yellows heighten the emotion of the scene. The paint has been applied to the canvas in varying degrees of thickness. At times it is so thin that the white canvas shows through the paint. The artist has deliberately ignored the realities of the natural world in search of a more expressive type of art. Pechstein was part of a group of artists with similar, Expressionist, goals who linked themselves in a movement called 'Die Brücke' ('the bridge'). Pechstein was one of the first artists of this group to achieve popularity.

Perhaps this is because his paintings tended to be more decorative and less profound than those from other artists in the group, such as Ernst Ludwig Kirchner. His vibrant sense of colour was greatly influenced by the work of Henri Matisse and other Fauvist painters.

☛ Heckel, Kirchner, Matisse, Nolde, Schmidt-Rottluff

Max Hermann Pechstein. b Zwickaw, 1881. **d** Berlin, 1955. **Meadow at Moritzburg.** 1910. Oil on canvas. **h**70.2 × **w**80.3 cm. **h**27⅝ × **w**31⅝ in. Leonard Hutton Galleries, New York, NY

Perugino

The Virgin and Child with Saints

Altarpieces with a Virgin and Child surrounded by the patron saints of a family often adorned family chapels. Here the saints Michael the Archangel, Catherine of Alexandria, Apollonia and John the Evangelist are included, each identifiable by his or her attributes, representative of the saint's life. Apollonia, for example, holds the forceps that were used to pull out all her teeth in an attempt to get her to renounce the Christian faith. The gracefully elongated, rather sentimentalized figures, with drooping postures and tilted heads, are typical of Perugino's style. As was customary at the time he generally employed simple compositions, such as the arrangement used here with the Virgin and Christ above and four saints below. Perugino worked throughout Italy, especially in Umbria, but is perhaps best known as the teacher of Raphael whose early works are very close to his master's style.

☞ Andrea del Sarto, Della Quercia, Raphael, Signorelli

Perugino (Pietro Vannucci). b Città della Pieve, 1445/50. **d** Fontignano, 1523. **The Virgin and Child with Saints**. c1497. Oil on panel. **h**276 × **w**213 cm. **h**108⅔ × **w**83¾ in. Pinacoteca Nazionale, Bologna

Picabia Francis

Amorous Parade

There is nothing inherently erotic about this machine, but its title triggers our imagination. Within moments, the gangling apparatus has become charged with sexual connotations of a hilarious, yet unsettling, nature. This fantastic, complex contraption is primarily intended as a comment on man's activities and experiences. It could be interpreted as a parody of the noisy thrashing of love-making. In its playful ambiguity it displays Picabia's innovative and unusual imagination, which has invested an inanimate, un-erotic object with sexual undertones. This irrational and absurd humour connects the painting with the non-conformist Dada movement. Picabia was a leading figure in this anti-art, anti-reason movement, and together with Marcel Duchamp helped create a Dadaist group in the USA. He later turned to Surrealism, and in the 1920s and 30s produced a remarkable series of collages.

☛ Davis, Duchamp, Grosz, Hausmann, Léger

PARADE AMOUREUSE

Francis Picabia. b Paris, 1879. d Paris, 1953. **Amorous Parade**. 1917. Oil on canvas. **h**96.5 × **w**73.7 cm. **h**38 × **w**29 in. Private collection

Picasso Pablo Weeping Woman

The searing emotion of grief experienced by this distraught woman is reflected with great intensity in the harsh colours and rigid paint-strokes. The viewer's attention is immediately focused on the cold blue and white area around her mouth and teeth; her eyes and forehead are dislocated – literally broken up with sorrow. The figure echoes those of Picasso's monumental painting *Guernica*, executed in the same year, which portrays the massacre of women and children in the Spanish Civil War. The work shown here is one of the most expressive examples from a series by Picasso entitled 'Weeping Women'. The way the woman's face has been distorted and fragmented is a development of Cubist ideas. Picasso, who with Georges Braque was the inventor of Cubism, executed an immense body of work through his long and much publicized life. Born in Spain, Picasso moved to Paris in 1901 and spent the rest of his life in France. He is considered the greatest artist of the twentieth century.

☛ Boccioni, Braque, Gris, Jawlensky, Kupka, Léger

356

Pablo Picasso. b Malaga, 1881. d Mougins, 1973. **Weeping Woman**. 1937. Oil on canvas. **h**60.8 × **w**50 cm. **h**24 × **w**19⅝ in. Tate Gallery, London

Piero della Francesca The Baptism of Christ

St John baptizes Christ in the River Jordan. In the middle distance, a man removes his tunic so that he too can be blessed. Three angels with glorious multi-coloured wings, robes and wreaths in their hair witness this peaceful scene as the Holy Spirit, in the guise of a dove, descends from the heavens. The tranquillity and serenity of this composition are achieved by the series of vertical lines formed by the standing figures and tree trunk and the gentle bends of the river as it slowly glides into the distance. Piero's fascination with linear perspective – a subject of intense interest to early Italian Renaissance artists – is noticeable in the treatment of the figures and trees in the background, which decrease in size as they recede into the distance. At the end of his life Piero abandoned painting to concentrate on writing scholarly treatises on perspective and geometry. He remains one of the most popular artists of the fifteenth century.

☛ Fra Angelico, Filippo Lippi, Masaccio, Uccello

Piero della Francesca. **b** Borgo Sansepolcro, 1410/20. **d** Borgo Sansepolcro, 1492. **The Baptism of Christ**. 1450s. Tempera on panel. **h**167 × **w**116 cm. **h**66 × **w**45¾ in. National Gallery, London

Piero di Cosimo Perseus Freeing Andromeda

Fantastic, curly crests of waves echo the horror of the monster attacking Andromeda who is chained to a rock. Racing to the rescue of his true love, Perseus is first depicted flying into the scene from the right, and later standing on the monster's back, poised to slay the beast. Subjects from Classical mythology were popular in Renaissance painting because they implied that the owner was acquainted with Ancient texts, which were enjoying a fashionable revival at this time. This work is one of a series which once hung in the palace of the Strozzi family in Florence. Piero di Cosimo often depicted his subjects in a bizarre fashion, which led to rumours of his own eccentric behaviour. He lived for many years as a recluse and is reputed to have eaten nothing but hard-boiled eggs – which is an unlikely tale. He also worked on designs for masques, festivals and processions.

☞ Botticelli, Perugino, Pollaiuolo, Raphael, Signorelli

Piero di Cosimo. b Florence, 1461/2. d Florence, 1521. **Perseus Freeing Andromeda**. c1515. Oil on panel. **h**66 × **w**152 cm. **h**26 × **w**59¾ in. Galleria degli Uffizi, Florence

Pietro da Cortona Glorification of the Rule of Urban VIII

Painted on the ceiling of one of Rome's most sumptuous palaces, this ambitious fresco is a celebration of the powerful and noble Barberini family. It also represents an allegory of Divine Providence. The daunting grandeur of this composition is based around an illusionistic architectural structure, which is seen from below, with the sky appearing to open out above. This type of perspective, known as *sotto in sù* (Italian for 'up from under') is typical of Baroque ceiling decoration. The spectator's attention is quickly channelled by the swirling fluidity of the design to its focal point, where angels carry the papal tiara and St Peter's keys – representing the Papacy of Urban VIII, himself a member of the Barberini family. All sense of mass and gravity is dissolved in the sparkling colours and brilliant light, making this one of the great masterpieces of Baroque art.

☛ Bernini, Domenichino, Giordano, Guercino

359

Pietro da Cortona (Pietro Berrettini). **b** Cortona, 1596. **d** Rome, 1669. **Glorification of the Rule of Urban VIII**. 1633–9. Fresco. Palazzo Barberini, Rome

Piper John

Holkham, Norfolk

Solid architectural forms are highlighted in bright yellow, white and pink, beneath a dramatically stormy sky. The water in the foreground reflects the sketchy buildings and a fountain. Sombre tones evoke a brooding feeling, with the charged emotional content of the English Romantic landscape tradition. The composition has been reduced and distilled into an almost abstract form. Piper experimented with abstract art in the 1930s but, disillusioned with the limitations of non-representational painting, had returned to a more naturalistic approach by the time this picture was painted. His deeply personal style is characterized by a synthesis of Romanticism and topographical accuracy.

During the Second World War he was an official British war artist and in that capacity produced a number of watercolours depicting the bombed areas of Bath and Coventry. A versatile artist, Piper worked in fields as varied as book illustration, stained glass, textiles and theatre design.

☛ Bonington, Cozens, Nash, Turner, Siberechts

John Piper. b Epsom, 1903. **d** Fawley, 1992. **Holkham, Norfolk**. 1939. Oil on canvas mounted on panel. **h**51 × **w**76 cm. **h**20 × **w**30 in. Private collection

Pisanello

Ginepro d'Este

Her hair pulled back to reveal a high forehead, and dressed in an elaborately embroidered gown, this elegant woman is portrayed as being at the height of fashion. She is identifiable as a member of the noble Este family of Ferrara from the pattern on her sleeve. The sprig of juniper (*ginepro* in Italian) pinned to her shoulder, alludes to the sitter's first name. She is shown in profile, a pose which recalls the artist's skills as a portrait medallist. The profiles in his medals were as crisply rendered as in this painting. Such natural details as the flowers and butterflies are typical of the International Gothic style, of which Pisanello was the main Italian exponent after Gentile da Fabriano. His numerous drawings of animals, although conforming to the decorative conventions of the time, demonstrate a lively interest in the realistic depiction of nature.

☛ Gentile da Fabriano, Ghirlandaio, Mantegna

Pisanello (Antonio Pisano). b Pisa, c1395. **d** Place unknown, c1455. **Ginepro d'Este**. c1440. Tempera on panel. **h**43 × **w**30 cm. **h**17 × **w**12 in. Musée du Louvre, Paris

Pisano Andrea

Saint John the Baptist

Sculpted with a delicacy of line and lyrical fluency, this bronze relief shows St John baptizing a group of people in the River Jordan. Behind him is a mountain with trees, completely out of scale but conveying the setting successfully within the limited space. Pisano probably trained as a goldsmith. Such a skill would have enabled him to apply refinement and meticulous detail to the figures, which have been executed with elegant, curving swathes of drapery. This panel comes from the first of three sets of doors made for the Baptistry at Florence, for which Pisano sculpted 28 scenes from the life of the Baptist, the city's patron saint. (The other two sets of doors were made in the fifteenth century by Lorenzo Ghiberti.) Each scene is set within a quatrefoil frame, a fashionable form imported from Gothic France. He influenced Donatello, Ghiberti and Luca della Robbia.

☛ Ghiberti, Giotto, Piero della Francesca, Della Quercia

362

Andrea Pisano. **b** Pontedera, c1290. **d** Orvieto, 1348. **Saint John the Baptist**. 1330/3. Gilt bronze. **h**50 × **w**43 cm. **h**19²⁄₃ × **w**16⁷⁄₈ in. Battistero di San Giovanni, Florence

Pissarro Camille Landscape at Chaponval

This tranquil landscape embodies the bucolic peacefulness of the countryside. Vibrant hatching strokes have been used to enliven the painting's surface. With a very simple subject and a restricted palette of colours, Pissarro has achieved a range of subtle effects. A feeling of intimacy and direct personal contact with the scene, reminiscent of the paintings of Camille Corot, is enhanced by the skyline landscape which is depicted in a series of horizontal bands with very little sky showing. These bands, made up of field, houses and sky, seem almost to sit on top of one another. His reduction of the landscape to a spontaneous, intricate web of rapidly applied pure tones is typical of the experiments of the Impressionists. Born in the West Indies, Pissarro arrived in Paris in 1855 where he became a prolific artist and a key figure in the Impressionist circle. He was the only artist to exhibit at all the Impressionist exhibitions.

☛ Boudin, Cézanne, Corot, Daubigny, Monet, Sisley

Camille Pissarro. b St Thomas, 1831. **d** Paris, 1903. **Landscape at Chaponval**. 1880. Oil on canvas. **h**54 × **w**65 cm. **h**21¼ × **w**25½ in. Musée d'Orsay, Paris

Poliakoff Serge Abstract Composition

A series of flat, two-dimensional planes of colour interpenetrate in a lyrical formation. The geometric composition is defined by the shape of the canvas; this is apparent in the artist's quartering of the dominant forms of colour. Poliakoff's mastery of the brush is demonstrated by the multiplicity of hues that have been incorporated within each colour section. This controlled, expert handling of the paint (ground by the artist himself), combined with the positioning of the intersecting abstract forms of colour, make this picture an important example of the post-war Art Informel movement. A Russian emigré who came to Paris in 1923 with his aunt, the singer Nadia Poliakoff, he began his first abstract compositions in 1937. He achieved fame when he was awarded the Kandinsky Prize for painting in 1947, from which time he progressed steadily towards his foremost position among the abstract painters of the École de Paris in the 1950s.

☛ Delaunay, Riopelle, Soulages, De Staël, Vieira da Silva

364

Serge Poliakoff. b Moscow, 1906. **d** Paris, 1969. **Abstract Composition**. 1952. Oil on canvas. **h**89 × **w**130 cm. **h**35 × **w**51⅛ in. Archives Serge Poliakoff, Paris

Polke Sigmar

Three Girls

The female nude is represented by a chorus line of strippers, their fetishistic stilettos crushing a male underfoot. His impotence is symbolized by a flightless bird. Conventional fine art images – the supine nude, and the knight triumphant over the serpent – are transposed into soft porn. Polke left East Germany for Düsseldorf in the 1960s. Together with Gerhard Richter and others he formed a German branch of the Pop Art movement then emerging in Britain and the USA. He boldly combines the atmospheric colour experiments of Abstract Expressionism with photography, and graphics appropriated from comic books and pulp fiction. His work demolishes the barriers between 'high' art and 'low' popular culture. Polke's subject matter is often provocative: his paintings of the 1970s and 1980s, with their images of concentration camps and traces of bodily fluids, confront the taboo of Germany's wartime history.

☛ Baselitz, Jones, De Kooning, Sherman, Wesselmann

Sigmar Polke. **b** Oelsnitz, 1941. **Three Girls**. 1979. Mixed media on paper. **h**99.8 × **w**69.9 cm. **h**39⅜ × **w**27½ in. Anthony d'Offay Gallery, London

Pollaiuolo Antonio Apollo and Daphne

Daphne is seen in the process of transforming herself into a laurel tree in order to escape from Apollo. (Smitten with her, he subsequently wore a laurel wreath in deference to her memory.) This small scene is painted in a delicate, jewel-like manner. Mythological paintings of this size often adorned chests or cupboards in Renaissance Florence, but it is not clear if this painting was ever set into a piece of furniture. Antonio and his brother Piero were important Florentine goldsmiths, sculptors and painters who executed commissions for the city of Florence and its cathedral, and for prominent Florentine families such as the Medici. Antonio is also famous for his engravings, especially the *Battle of the Nudes* in which he explored the human form in a variety of positions. Fascinated by anatomy, he was one of the first artists to dissect the human body in order to understand its inner workings and structures.

☛ Botticelli, Raphael, Van Scorel, Verrocchio

Antonio Pollaiuolo. **b** Florence, c1432. **d** Florence, 1498. **Apollo and Daphne**. c1470. Oil on panel. **h**29.5 × **w**20 cm. **h**11⅝ × **w**7⅞ in. National Gallery, London

Pollock Jackson

Number 1A, 1948

Pollock's violent method of dripping and smearing paint onto the canvas in dramatic, sweeping gestures is strikingly apparent in this painting. He would pour and fling the paint, using sticks and knives, onto an unstretched canvas which had been tacked to a hard wall or floor. This enabled him to walk around it and allowed him almost to *become* the gesture of the painting. Pollock's highly innovative technique became known as Action Painting. Such radical elements as the abandonment of easel painting and the lack of traditional perspective make this work an important landmark in post-war international art. Its connection with Abstract Expressionism lies in its energetic technique and freedom of expression. Pollock's paintings are not as random as they may seem; the artist has said, 'I want to express my feelings rather than illustrate them...I *can* control the flow of paint: there is no accident, just as there is no beginning and no end.' Pollock died in a car crash in 1956.

☛ Frankenthaler, Hofmann, Kline, De Kooning, Motherwell

Jackson Pollock. **b** Cody, WY, 1912. **d** Springs, Long Island, NY, 1956. **Number 1A, 1948**. 1948. Oil on canvas. **h**172.7 × **w**264.2 cm. **h**68 × **w**104 in. Museum of Modern Art, New York, NY

Pontormo Jacopo The Visitation

This painting depicts the Biblical episode of the Virgin, pregnant with Christ, meeting her cousin Elizabeth, who is pregnant with John the Baptist. Pontormo has subordinated the story as a whole to the embrace of these two women. Any superfluous detail has been eliminated. The emotion of the meeting has been heightened by the use of bright, almost fluorescent, colours and elongated figures with dark, sunken eyes. Distorted shapes and intensely brilliant hues are characteristic of Pontormo's style, which provides a fine example of Mannerism at its height. He trained in the Florentine school but as his painting style suggests, he was something of an eccentric.

His neurotic and withdrawn character is revealed in his diary, which chronicles the details of his daily life, sometimes to the point of obsession. Agnolo Bronzino was a pupil and follower.

☞ Beccafumi, Bronzino, Parmigianino, Rosso Fiorentino

368

Jacopo Pontormo. b Pontormo, 1494. **d** Florence, 1556. **The Visitation**. 1530/2. Oil on panel. **h**202 × **w**156 cm. **h**79½ × **w**61½ in. Pieve di San Michele, Carmignano

Popova Ljubov

Space-Force Construction

Overlapping geometric shapes, painted in muted colours, appear to be floating on the unpainted plywood background. The interplay of these various circles, curves and diagonal lines is enhanced by multicoloured shadows which contribute to the effective play of light. A further sense of depth is created by the diagonal lines, which appear to extend beyond the picture. In its emphasis on colour and form and the use of added shadow to increase perspective, the painting demonstrates the influence of Constructivism. From 1921 Popova turned her talents towards textile, costume and set design. In tune with the spirit of Constructivism, she believed that art should serve a useful purpose, claiming that 'no artistic success has given me such satisfaction as the sight of a peasant or a worker buying a length of material designed by me'. One of the most important members of the Russian avant-garde, she died prematurely of scarlet fever, at the height of her career.

☛ Lissitzky, Malevich, Moholy-Nagy, Rodchenko, Tatlin

Ljubov Popova. b Moscow, 1889. d Moscow, 1924. **Space-Force Construction**. c1920–1. Oil on panel. **h**77.7 × **w**77.7 cm. **h**30⅝ × **w**30⅝ in. Private collection

Poussin Nicolas — The Arcadian Shepherds

An elegiac inscription – *Et in Arcadia Ego* ('Even in Arcadia I [ie Death] am present') – on an ancient Roman sarcophagus arouses the curiosity of a group of shepherds. This melancholy phrase sets the tone for the bucolic, enigmatic painting. Its warm, autumnal colours and carefully staged figures give a resigned, tragic air to the picture, as the shepherds' pastoral idyll is broken by the reminder that death occurs even in the most perfect of worlds. Reminiscent of the mysterious paintings of Giorgione, this work also represents Poussin's more serene strain of the Baroque spirit, which was based on the Classicism of Raphael and the Antique. In sharp contrast to the theatrical emotionalism of such contemporaries as Peter Paul Rubens and Gianlorenzo Bernini, Poussin's paintings emphasize form and moral content. They were highly praised by the intellectuals in Rome.

☛ Bernini, Claude, J-L David, Giorgione, Raphael, Rubens

Nicolas Poussin. **b** Les Andelys, 1594. **d** Rome, 1665. **The Arcadian Shepherds**. 1638–9. Oil on canvas. **h**85 × **w**121 cm. **h**33½ × **w**47½ in. Musée du Louvre, Paris

Powers Hiram

The Greek Slave

Gracefully and smoothly carved, a statuesque young woman stands, apparently peacefully, looking to her left. On closer inspection, we notice that her hands, held tenderly by her side, are in fact tied to chains. At first glance she appears to be a Greek goddess, at second she is a Greek Christian, sold to the Turks as a slave. (Poignantly coinciding with the Greek War of Independence, the statue was well received.) The soft surface and grace of her form give a calm and subtle lyricism to the figure. Powers was one of the leading American sculptors of the nineteenth century. He achieved great fame with *The Greek Slave*, one of his best-loved works, which was cast in many copies.

His preciseness of handling, emotional restraint and choice of subject matter – reminiscent of the work of the Greeks and Romans – are all ingredients that link him to the high ideals of Neo-Classicism, the style which then dominated European and American sculpture.

☛ Canova, Donatello, Leighton, Maillol, Moore

Hiram Powers. b Woodstock, VT, 1805. **d** Florence, 1873. **The Greek Slave**. c1843. Marble. **h**166.4 cm. **h**65½ in. Yale University Art Gallery, New Haven, CT

Primaticcio Francesco Danaë

Danaë is depicted naked, seated on her bed in a sumptuously coloured room, with her maid and *putti* in attendance; above her falls a shower of gold. In Greek mythology, Danaë was locked in a bronze tower by her father Acrisius, King of Argos, when an oracle predicted his murder by a son of hers. Zeus appeared in the form of a shower of gold to seduce her. In 1532 Primaticcio was summoned by Francis I to France, to work with Rosso Fiorentino on the decoration of the King's palace at Fontainebleau. There he devised elaborate decorative schemes, specializing in a combination of painting and stucco in high relief such as that shown here. Primaticcio was a painter, sculptor and architect; his combined skills gave the interior decoration of the palace its full, opulent expression. He greatly influenced the formation of the French Renaissance style, but sadly many of his decorative schemes have now been destroyed.

☛ Cellini, El Greco, Pontormo, Rosso Fiorentino

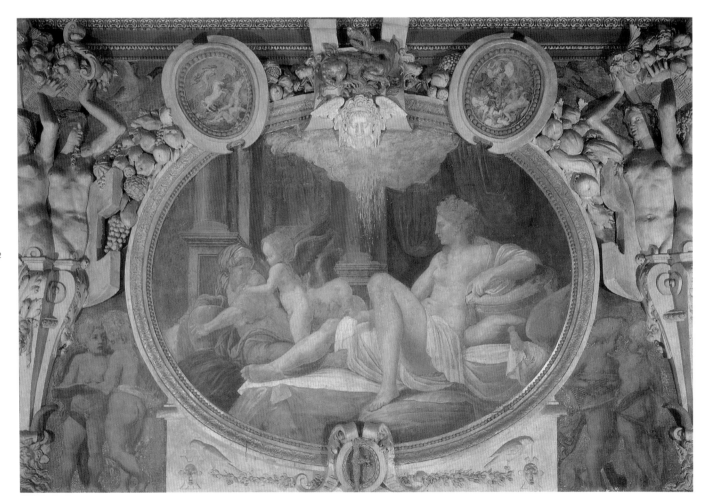

Francesco Primaticcio. b Bologna, 1504. **d** Paris, 1570. **Danaë.** c1533–40. Oil on panel with stucco reliefs. **h**105 × **w**254 cm. **h**41⅓ × **w**100 in. Château de Fontainebleau, Fontainebleau

Prud'hon Pierre-Paul The Empress Josephine

A beautiful and thoughtful young woman rests on a red shawl in a rocky glade. The delicate sleeve of her Empire-style dress has slipped from her shoulder as she gazes, deep in thought, across the picture. Once married to a viscount who was guillotined during the French Revolution, Josephine married Napoleon I in 1796.

Riddled with infidelity, their relationship was passionate and unpredictable. Josephine was unable to bear her husband a son, and the marriage was declared null and void in 1810. Napoleon commissioned this portrait shortly after his consecration as Emperor. A Frenchman by birth, Prud'hon travelled to Italy in 1784 where he was

deeply impressed by the work of Antonio Canova, Correggio and Leonardo da Vinci. Supported by both of Napoleon's wives, he became a rival of Jacques-Louis David and is known for his depictions of romantic and mysterious women.

☛ Canova, Correggio, J-L David, Leonardo

Pierre-Paul Prud'hon. b Cluny, 1758. **d** Paris, 1823. **The Empress Josephine**. 1805. Oil on canvas. **h**244 × **w**179 cm. **h**96 × **w**70½ in. Musée du Louvre, Paris

Della Quercia Jacopo Virgin and Child with Saints

This free-standing group of statues of the Madonna and Child with Saints decorates an altar in a Sienese church. The Madonna's solid pose and the heavy folds of her gown lend her an air of great monumentality, yet she also expresses human tenderness and charm. A graceful 'S' curve is apparent in her stance, which gives a lyrical movement from her inclined head through to her left foot, emphasized by the flow of drapery. This pose (known as *contrapposto*) is reflected in the figures of the saints. Such a delicate swaying movement is a typical feature of Gothic art, although Della Quercia has also given the forms a solidity characteristic of the new ideas of the Renaissance. A contemporary of Donatello and Lorenzo Ghiberti, Della Quercia's work became very well known – even Michelangelo copied one of his works when he painted the Sistine ceiling.

☞ Cimabue, Donatello, Duccio, Ghiberti, Michelangelo

374

Jacopo della Quercia. **b** Siena, 1374/5. **d** Siena, 1438. **Virgin and Child with Saints** (detail). c1423–5. Gilt wood. **h**140 cm. **h**55.1 in. San Martino, Siena

Raeburn Sir Henry

The Reverend Robert Walker Skating on Duddingston Loch

Revelling in the winter weather on the frozen lake of an Edinburgh suburb, a sprightly Church minister is depicted nonchalantly ice-skating in an exaggerated, semi-theatrical pose. His conservative, black attire stands out sharply against the blurred grey of the background. The depiction of a member of the Church establishment in such a manner not only reveals the humour of the painter, but also his intimacy with the sitter. As one of Scotland's most popular artists, Raeburn captured the personalities of Edinburgh's Golden Age during the Enlightenment. He is said to have produced over 1,000 portraits. These included poets, scholars, philosophers and local dignitaries, as well as the colourful Highland lairds, who were freely painted with humour and joviality. Raeburn was knighted by King George IV in 1822 and the following year, only a few months before his death, was appointed His Majesty's Limner for Scotland.

☛ Goya, Mengs, Ramsay, Vigée-Lebrun

Sir Henry Raeburn. b Stockbridge, 1756. d Edinburgh, 1823. **The Reverend Robert Walker Skating on Duddingston Loch**. 1784. Oil on canvas. **h**76 × **w**64 cm. **h**30 × **w**25⅛ in. National Gallery of Scotland, Edinburgh

Ramsay Allan

Lady Robert Manners

Softly modelled, this exquisite oval portrait exudes a sense of tenderness and a sympathetic grasp of character. Painted with a feathery sense of touch and executed in muted, pastel colours, the form and demeanour of the noble lady are conveyed with flattering delicacy. The son of a poet, Ramsay was one of the foremost portraitists of his day – the Scottish counterpart to Sir Joshua Reynolds and Thomas Gainsborough. Although he worked mainly in London, becoming the Court Painter to George III in 1760, he first trained in Edinburgh before continuing his studies in Italy. Here he was impressed by the elegance of the contemporary Italian painters, especially Pompeo Batoni who produced many portraits of aristocratic English visitors to Rome. Ramsay went on to develop his own style of captivating charm and sensitivity. He was also much influenced by the refined finesse of contemporary French art.

☛ Batoni, Gainsborough, Mengs, Raeburn, Reynolds

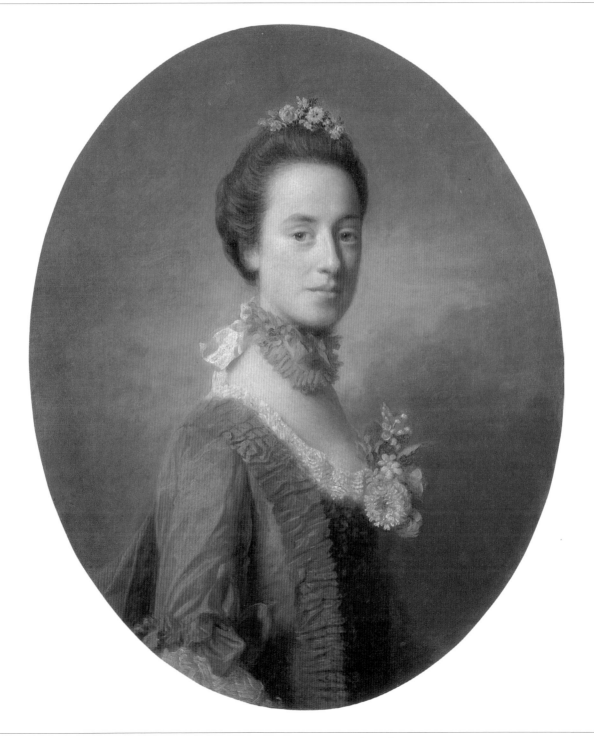

Allan Ramsay. **b** Edinburgh, 1713. **d** Dover, 1784. **Lady Robert Manners**. c1756. Oil on canvas. **h**74.3 × **w**61.6 cm. **h**29¼ × **w**24¼ in. National Gallery of Scotland, Edinburgh

Raphael

The School of Athens

A group of animated men, young and old, gather in a vast hallway. Five figures crouch over a compass and slate to discuss geometry, while others (holding a globe and a starry sphere) discuss astronomy. In turn these bustling groups debate the seven liberal arts. The two figures at the centre of the composition, walking towards us with assurance and appearing to exude an unreal sense of calm, are Plato and Aristotle, the two greatest philosophers of the Ancient world. In October 1508 Pope Julius II commissioned a group of artists to redecorate his private apartments. *The School of Athens* and other frescos in the Stanza della Segnatura took Raphael about three years to complete.

Younger than either Leonardo da Vinci or Michelangelo, Raphael is seen with them to epitomize the high point of Renaissance art. A prolific and ambitious man, an architect, painter and designer of sculpture, Raphael is considered one of the greatest draughtsmen of Western art.

☛ Perugino, Pollaiuolo, Poussin, Leonardo, Michelangelo

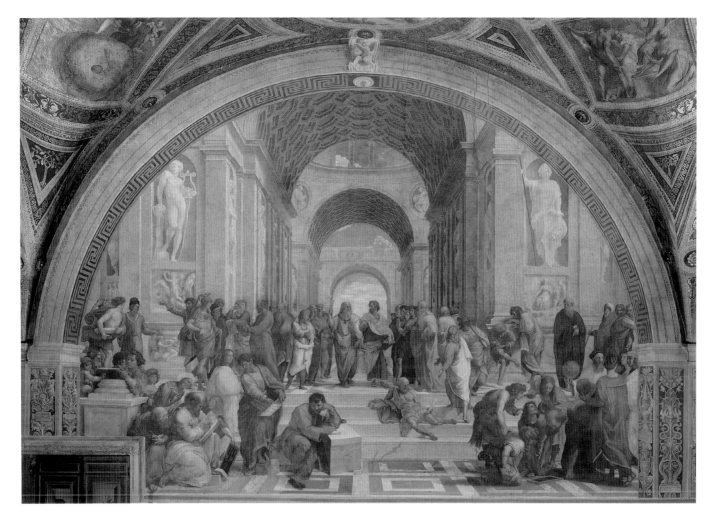

Raphael (Raffaello Sanzio). b Urbino, 1483. d Rome, 1520. **The School of Athens**. 1508–11. Fresco. w770 cm. w303 in. Palazzo del Vaticano, Rome

Rauschenberg Robert Reservoir

An assortment of commonplace objects is boldly displayed against a bespattered background. The clock at the upper left was set when the artist began to work on the painting; the other clock was set to record the time of completion. This 'combine' painting illustrates Rauschenberg's method of selecting and combining groups of disparate images and objects. He did not do this in order to make social comment but rather to break away from the traditional idea of picture space. He wanted, in his own words, 'to act in the gap between' art and life. Rauschenberg incorporated mundane objects into his work as naturally as many artists had traditionally used paint. This provided much of the inspiration for the Pop Art movement in the USA. One of the most notorious gestures of this self-consciously avant-garde figure was his cabled reply to a request by Parisian gallery-owner Iris Clert for a portrait: 'This is a portrait of Iris Clert if I say so – Robert Rauschenberg.'

☛ Broodthaers, Duchamp, Hamilton, Johns, Schwitters

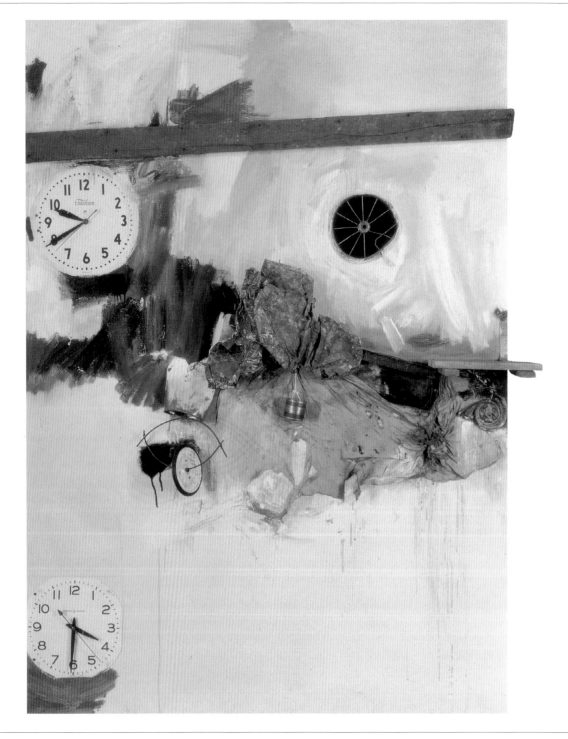

Robert Rauschenberg. b Port Arthur, TX, 1925. **Reservoir**. 1961. Oil, pencil, fabric, wood and metal. **h**217.2 × **w**158.7 cm. **h**85½ × **w**62¼ in. National Museum of American Art, Washington, DC

Redon Odilon

The Cyclops

In this scene from Greek mythology, Polyphemus, the giant Cyclops, spies upon the naked nymph Galatea, with whom he is hopelessly in love. The giant's huge eye casts a longing gaze over the object of his devotion. More horrifying than Gustave Moreau's rather more romantic treatment of the same theme, Redon's interpretation has a terrifyingly nightmarish quality. In accordance with Symbolist theories, Redon was more interested in exploring the inner psyche than in depicting reality in a straightforward manner. His aim was to find a form of artistic expression that would inspire introspection and thought on the part of the viewer. His belief in an enchanted inner vision led to the creation of highly imaginative paintings and lithographs, with fantastical subjects representing fragments of dreams. Redon also produced vibrantly colourful landscapes and flower paintings. His work was very influential on the work of a group of younger Symbolists who called themselves the Nabis.

☛ Bonnard, Denis, Matisse, Moreau, Rouault, Vallotton

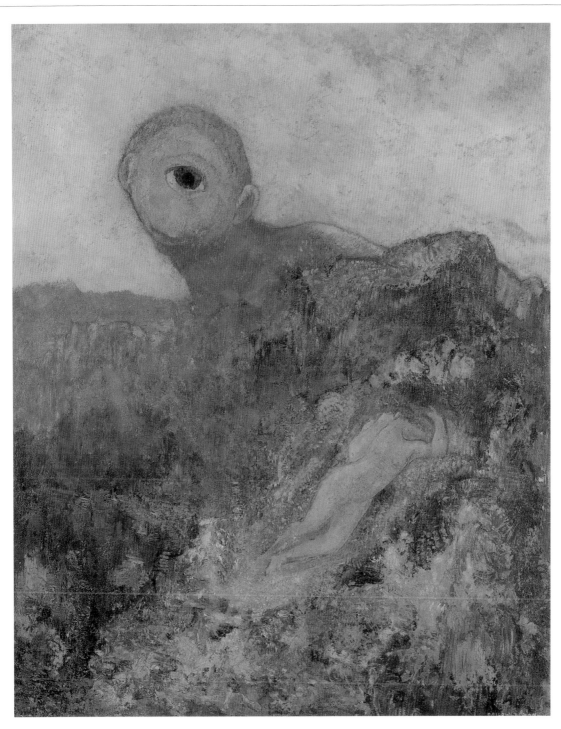

Odilon Redon. b Bordeaux, 1840. **d** Paris, 1916. **The Cyclops**. 1898/1900. Oil on panel. **h**64 × **w**51 cm. **h**25¼ × **w**20⅛ in. Rijksmuseum Kröller-Müller, Otterlo

Rego Paula

The Family

An apparently innocent family scene is undermined by disturbing, sexually-charged undercurrents. The main action takes place between the furious youth and his determined sister who conveys an incestuous sexual thrill as she presses her body close, helping her kind, trusting mother to undress him. This theme of rebellion and domination, with all its erotic undertones, provides the twist and ambiguity of the scene. The painting is representative of the style for which Rego has become internationally renowned. Simple yet sinister, her paintings are characterized by their monumentality and psychological drama. They often deal with ambiguous relationships between men, women and children. Rego has also executed etchings based on her own interpretation of nursery rhymes and J M Barrie's *Peter Pan*, providing us with disturbing scenes from the traditional stories.

☞ Balthus, Modersohn-Becker, Spencer, Weight

380

Paula Rego. b Lisbon, 1935. **The Family**. 1988. Acrylic on paper mounted on canvas. **h**213.4 × **w**213.4 cm. **h**84 × **w**84 in. Saatchi Collection, London

Reinhardt Ad

Abstract Painting, 1959

A glowing suffusion of deep red envelops this canvas. Distilled and immaculate, its pure surface is violated only by a very faint cross, barely visible to the naked eye. A shrouded atmospheric aura emanates from the painting's depths. The iconic image of the cross has been treated in an abstract way, taking the expressive qualities of colour to their fullest extreme. Nothing is allowed to intrude upon the stark intensity of the work. Reinhardt reduced art to its ultimate essence. Associated with the Abstract Expressionists in the USA, he entirely eschewed all literal and painterly overtones in his search to refine the purest of statements. Also a theoretician and teacher, he was adamant that art should be completely separate from life, and life from art, saying, 'Art is art-as-art and everything else is everything else. Art-as-art is nothing but art.' Only abstract art, he believed, could express this pure standard.

☛ Kelly, Newman, Rothko, Ryman

Ad Reinhardt. b Buffalo, NY, 1913. d New York, NY, 1967. **Abstract Painting, 1959**. 1959. Oil on canvas. h274.3 × w101.6 cm. h108 × w40 in. Private collection

Rembrandt

Jacob Blessing

The solemnity of this important Old Testament episode, in which Jacob blesses his grandsons, is expressed in the bold, uncluttered composition and luminous tones of this painting. The artist's technique of applying his paint in broad, thick strokes, then building it up with glazes, gives the scene added depth and gravity. Each of the figures is also invested with a deep, religious sentiment. Jacob, the elderly patriarch, is treated with a modest yet monumental dignity, as Joseph and his wife observe him with humility and pious respect. The rich, velvety red of the drapery in the foreground, and Joseph's flamboyant turban, provide visual relief to the overall severity of the subject matter.

Much of Rembrandt's work reflects his abilities to penetrate the human character. Less superficially dramatic than his contemporary, Peter Paul Rubens, Rembrandt's vast output also reflects the restrained emotions and devout spirit of Calvinist Holland.

☛ Caravaggio, Fabritius, Michelangelo, Rubens

Rembrandt Harmensz van Rijn. **b** Leyden, 1606. **d** Amsterdam, 1669. **Jacob Blessing**. 1656. Oil on canvas. **h**176 × **w**210 cm. **h**69¼ × **w**82¾ in. Staatliche Kunstsammlungen, Kassel

Reni Guido

Saint Jerome and the Angel

This intensely spiritual painting shows an ascetic St Jerome translating the Bible into Latin, sitting in a cave. A vision of an angel appears to him, inspiring and helping him with his arduous task. The imposing figure of St Jerome, swathed in rich red drapery, dominates the canvas. Reni's feeling for naturalism is expressed in the saint's greying hair and sagging muscles, vestiges of Caravaggio's influence. His devout, often ecstatic paintings made Reni one of the early masters of the Baroque style, which employed a dramatic sense of movement and rich colour to create a powerfully expressive effect. Reni's formal composition and colouring, however, are based on the Classical training he would have received as a pupil at the Carracci Academy in Bologna. Perhaps because of their subject matter, his paintings were highly popular in the seventeenth and eighteenth centuries.

☛ Antonello, Caravaggio, Carracci, Hals, Domenichino

Guido Reni. b Bologna, 1575. **d** Bologna, 1642. **Saint Jerome and the Angel**. 1640–2. Oil on canvas. **h**198 × **w**149 cm. **h**78 × **w**58²⁄₃ in. Detroit Institute of Arts, Detroit, MI

Renoir Pierre Auguste · Ball at the Moulin de la Galette

Men in top hats and boaters and women in pretty dresses chatter, drink and dance under the glowing lights of this famous Parisian dance hall. Renoir loved this subject and painted it a number of times, reproducing the patterns made by the light as it catches the figures moving around the floor. Many of Renoir's friends acted as models for the dancers. The couple in the middle distance are his favourite model Marguerite Legrand and the Spanish painter Don Pedro de Solares y Cardenas. Like all Impressionists, Renoir painted from life as he sat in the dance hall; his friends assisted him each day in moving his canvases back and forth to his studio. At the time the *Moulin de la Galette* was painted, Renoir was working very closely with Claude Monet. They spent much time painting outdoors, capturing the fleeting effects of sunlight as it scatters across a landscape. With his 'rainbow palette', Renoir painted over 6,000 canvases of women, children, flowers and fields.

☛ Bazille, Cassatt, Monet, Morisot, Sisley, Toulouse-Lautrec

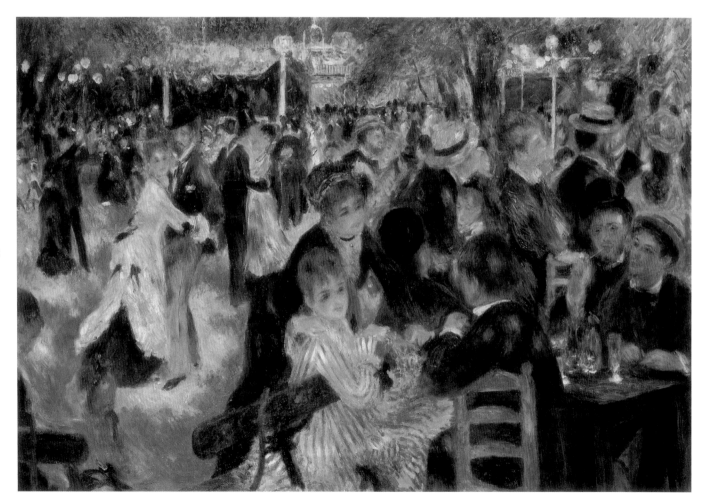

Pierre Auguste Renoir. b Limoges, 1841. **d** Cagnes, 1919. **Ball at the Moulin de la Galette.** 1876. Oil on canvas. **h**78 × **w**114 cm. **h**31 × **w**44½ in. Private collection

Reynolds Sir Joshua

The Countess Spencer with her Daughter Georgiana

The tenderness of this charming portrait is emphasized by the delicate way in which the mother clasps her arms around her young daughter. The lace and silk of the Countess's dress are skilfully painted with a minimum number of brushstrokes. This rather loose manner of painting is continued in the shaggy hair of the dog, and the cloudy sky in the background. Reynolds is best known for the manner in which he married the Grand Style of the great Italian masters with portraits of the English aristocracy. Although grandeur and formality are minimized in this picture, they are alluded to in the background elements of the column, drapery and brooding clouds.

Reynolds is credited with having elevated portrait-painting in Britain to a height equalling that of the great Italian masters. His status during the reign of George III was such that when the King formed the Royal Academy in 1768, Reynolds was appointed its first President.

☛ Dobson, Gainsborough, Lely, Morisot, Ramsay

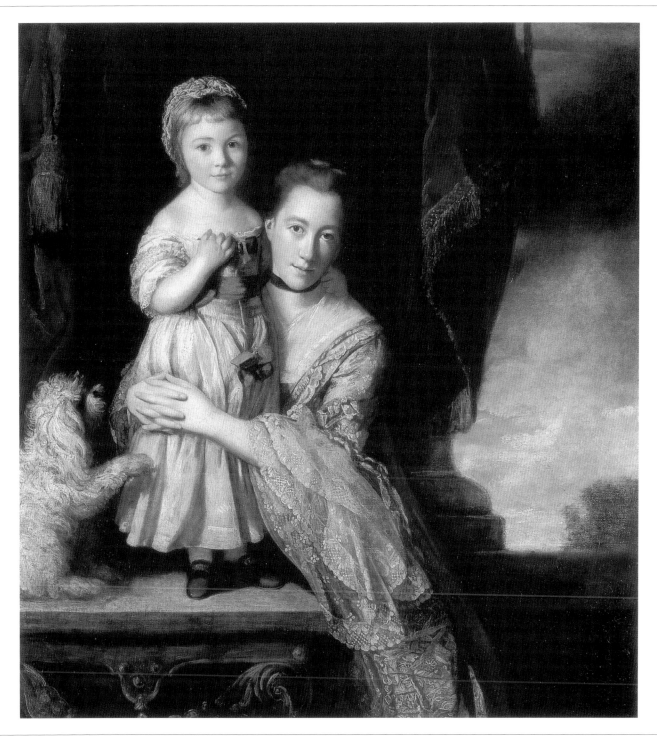

Sir Joshua Reynolds. b Plympton, 1723. d London, 1792. **The Countess Spencer with her Daughter Georgiana**. 1760/1. Oil on canvas. **h**122 × **w**115 cm. **h**48 × **w**45¼ in. Collection of The Earl Spencer, Althorp

Ribera Jusepe

Saint Paul the Hermit

St Paul the Hermit was the first Christian saint to seek a life of solitude, meditation and asceticism. Here he is depicted as an old man, worn out by the frugal austerity of a life spent in the Egyptian desert. Yet he is still fired by religious ardour as he contemplates the skull before him, a symbol of man's mortality. The harsh, theatrical lighting emphasizes the saint's sagging muscles, furrowed brow and expressive hands, giving the painting a startling sense of realism. Ribera's art invokes the fervent spirituality of seventeenth-century Spain, which is expressed with a strong and dramatic use of light and shade (*chiaroscuro*) derived from the Italian artist Caravaggio. Ribera settled in Naples in 1616, and his style laid the foundation for the great tradition of Neapolitan painting with its emphasis on what one critic has called 'the poetry of the repulsive'.

☛ Caravaggio, El Greco, Guercino, Reni, Zurbarán

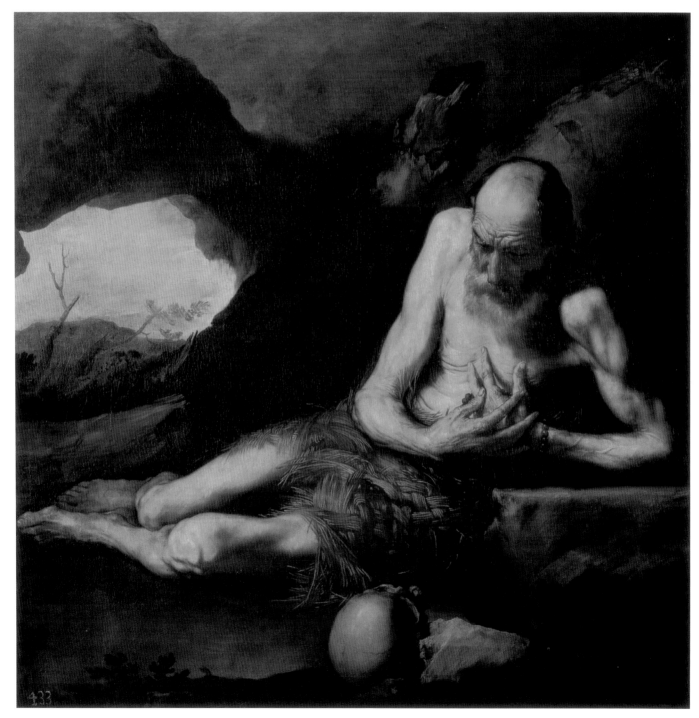

Jusepe Ribera. **b** Valencia, 1591. **d** Naples, 1652. **Saint Paul the Hermit**. 1640. Oil on canvas. **h**143 × **w**143 cm. **h**56¼ × **w**56¼ in. Museo del Prado, Madrid

Richter Gerhard Betty

The artist's daughter Betty is painted with photographic detail. She sits very near to the surface of the picture, as in a close-up camera shot. The painting could not really be called a portrait of Betty, however, as it teaches us very little about her. Richter has chosen to paint his daughter as she turns away; her face is invisible. Instead he has concentrated on the red, white and pink patterns of her jacket and dress, and her hair gathered at the back of her head. Richter has undermined accepted notions of painting and representation, giving us a painting that looks like a photograph, a portrait that literally turns its back on convention. Continually discovering new ways of expression, Richter's work is extremely diverse. The wall in the background of this painting resembles some of the very different abstract works that Richter creates. These monochrome, thickly painted canvases evoke sadness and despair and were executed in response to the Vietnam War.

☛ Dix, Estes, Organ, Schad

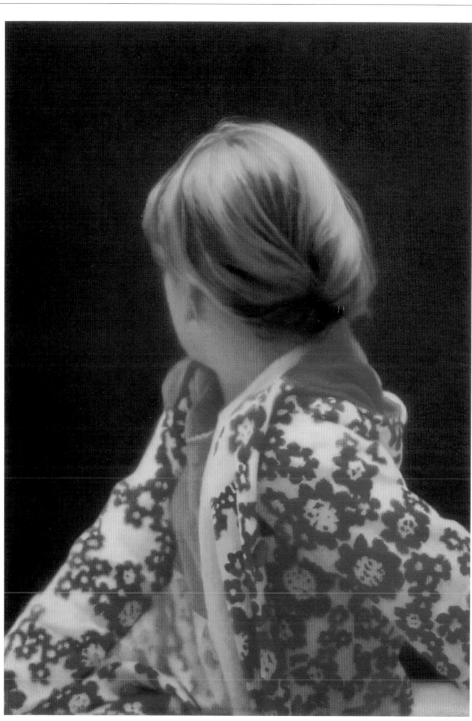

Gerhard Richter. **b** Waltersdorf, 1932. **Betty**. 1988. Oil on canvas. **h**102 × **w**72 cm. **h**40⅛ × **w**28¾ in. Collection of the artist

Riley Bridget

Cataract 3

Red, turquoise and grey curves undulate across the canvas in a uniform sequence, evoking an illusionary sense of movement. The canvas seems distorted by the almost hallucinatory image, as its colours appear to vibrate with a dazzling intensity. This technique of exploring and exploiting the fallibility of the eye provokes a powerful sensation on the spectator. The painting's connection with the Op Art movement is apparent in the interplay of colour and lines which produces a stunning, shimmering optical illusion. Riley's aims go beyond the merely scientific, however. She sees the elements she uses as being as much a part of nature as are trees, clouds and hills. More than a sum of their formal and colouristic parts, her paintings vibrate with a magical lyricism. Riley's first paintings, in the early 1960s, were almost exclusively in black and white. Her work has developed dramatically over the years and she has recently tended to paint straight parallel lines in intensely vibrant colours.

☛ Albers, Louis, Vasarely, Vieira da Silva

388

Bridget Riley. b London, 1931. **Cataract 3**. 1967. Emulsion on canvas. **h**221.9 × **w**222.9 cm. **h**87⅜ × **w**87¾ in. British Council, London

Riopelle Jean-Paul Large Composition

Irregular patches of vivid colour create a lyrical image, like a mosaic of flickering light. The densely layered paint is applied directly from the tube with a palette knife, creating intense areas of pure colour which are interwoven with threads of pigment. The structure of this painting is based on the ink and watercolour works Riopelle had developed a couple of years earlier, combining free calligraphic gestures and coloured *taches* or stains. This is one of the first paintings to exploit this technique, and demonstrates Riopelle's controlled use of thick areas of flaming colour. The heavily textured surface and free application of paint connect this work to the Art Informel movement.

Although born in Montreal, Riopelle lived in Paris from 1948. Although he moved away from Surrealism, he continued to work in an abstract format while developing a looser paint application.

☛ Fautrier, Hartung, Pollock, Tobey, Vieira da Silva

Jean-Paul Riopelle. b Montreal, 1923. **d** Ile aux Grues, 2002. **Large Composition**. 1949–51. Oil on board. **h**170.2 × **w**260.5 cm. **h**67 × **w**102½ in. Private collection

Rivera Diego

The Tortilla Maker

The peace and tranquillity of this kitchen, where peasant women are preparing tortilla, are conveyed by the painting's simplicity of colour and form. Executed at a time when Rivera was beginning to paint frescos, the influence of this specialized technique can clearly be seen in the sensitive handling of the warm, glowing colours, which express a sense of nostalgia and intimacy. The importance of the painting lies in its representation of Mexican culture, and the way in which it reflects Rivera's firm convictions about the essential human dignity of people. Although he was earlier influenced by Cubism, this painting demonstrates Rivera's ability to work in the Classical style, using the Mexican subjects that were so close to his heart. He was also deeply inspired by the ancient Mayan and Aztec cultures. Rivera was active in the Mexican Revolution and throughout his career remained a politically committed artist. He is renowned for his large-scale murals.

☛ Botero, Gauguin, Kahlo, Rego, Spencer, Tamayo

Diego Rivera. **b** Guanajuato, 1886. **d** Mexico City, 1957. **The Tortilla Maker**. 1926. Oil on canvas. **h**107.3 × **w**89.5 cm. **h**42½ × **w**35¼ in. University of California, San Francisco, CA

Della Robbia Luca Madonna and Child between Two Angels

'Della Robbia blue' has become a standard term for the glaze pioneered by the Della Robbia family. The depth of the blue is heightened by the juxtaposition with a pure white glaze. Reliefs such as this are categorized neither as painting nor sculpture; they fall between the two media. Like his contemporary Lorenzo Ghiberti, Luca della Robbia was concerned with the depiction of three-dimensional space in a shallow plane. His introduction of colour, however, enabled him also to reproduce the colouristic effects of a painter. The subtle modelling and crisp lines of this sculpture could not have been achieved without a strong understanding of drawing – the basis for both painting and sculpture. Luca was ranked by contemporaries as one of the great artistic innovators of the fifteenth century. His flourishing workshop was inherited by his nephew, Andrea, who continued to produce terracotta sculptures. Andrea introduced a broader range of colours while using similar subject matter.

☛ Ghiberti, Filippo Lippi, Pisano, Della Quercia

Luca della Robbia. **b** Florence, 1400. **d** Florence, 1482. **Madonna and Child between Two Angels**. 1475/80. Glazed terracotta. **diam**.100 cm. **diam**.39⅓ in. Museo Nazionale del Bargello, Florence

Rodchenko Alexander

Composition (Overcoming Red)

Triangular shapes balanced in front of circles create a three-dimensional illusion, which is enhanced by the dark shading on the left diagonals of the triangles. The flat forms are divided by colour and appear to rotate. Composed of strictly geometric designs traced with a compass and ruler, the painting reflects the artist's search

to create elementary shapes in pure, primary colours. In the same year as this painting Rodchenko exhibited his famous *Black on Black* painting, a response to Kasimir Malevich's 'White on White' series. Rodchenko's desire to reduce painting to its abstract, geometric essentials led to his incorporation into the Constructivist movement. In

common with other members of this group he later gave up easel painting in favour of design and the applied arts. He was particularly active in industrial design, typography and photography, the latter often exploiting unusual perspectives and angles of vision.

☛ Van Doesburg, Gabo, Lissitzky, Malevich, Tatlin

Alexander Rodchenko. **b** St Petersburg, 1891. **d** Moscow, 1956. **Composition (Overcoming Red)**. 1918. Oil on canvas. **h**78.5 × **w**62 cm. **h**30⅞ × **w**24⅜ in. Annely Juda Fine Art, London

Rodin Auguste

The Kiss

Two lovers are locked in an infinite embrace. The emotional force and vitality of this monumental sculpture have made it into one of the world's best-known works of art. The softly flowing forms of the lovers contrast starkly with the block of roughly hewn marble to which they are attached – symbolic of their earth-bound union. Both passion and despair are evoked by the paradox of the sensuality of flesh rendered so believably in cold inanimate stone, emphasizing as one critic put it 'the impossible union of souls by their bodies'. Rodin's interest in the idea of liberating the human figure from stone reflects his admiration for Michelangelo. He belongs to a universal tradition of sculpture and is both a product of late Romanticism and a herald of modern art. The pulsating energy and form of his statues, such as this, have had an enormous impact on twentieth-century artists.

☛ Bourgeois, Brancusi, Canova, Giambologna, Michelangelo

Auguste Rodin. b Paris, 1840. **d** Meudon, 1917. **The Kiss**. 1886. Marble. **h**183.6 cm. **h**72⅓ in. Musée National Auguste Rodin, Paris

Romney George

Mrs Mary Robinson, 'Perdita'

Confidently attired in a fashionable black silk cape and a grey muff, her powdered hair folded behind a white cap, an elegant lady looks toward us with a coy demeanour. Her pretty features are sharply delineated in a soft, formal style. Mrs Mary Robinson was an actress, and was nicknamed 'Perdita' after playing that role in Shakespeare's *A Winter's Tale* at the Drury Lane Theatre in London. An attractive and charming woman, she enjoyed a brief liaison with the Prince of Wales around the time that this portrait was made. Thomas Gainsborough and Joshua Reynolds also painted her. Romney was a fashionable portraitist, and at one time was considered the equal of Gainsborough and Reynolds.

After a visit to Rome he dreamed of painting ambitious historical works in the 'Grand Style', but despite numerous preparatory drawings this dream was never realized. His popularity as a portrait painter declined in the 1790s and he left London to return to his native Kendal, where he died.

☛ Gainsborough, Lawrence, Raeburn, Ramsay, Reynolds

George Romney. **b** Dalton-le-Furness, 1734. **d** Kendal, 1802. **Mrs Mary Robinson, 'Perdita'**. 1781. Oil on canvas. **h**76 × **w**63 cm. **h**30 × **w**24¾ in. Wallace Collection, London

Rosa Salvator

Self-portrait

Regarding us over his shoulder with a rueful, disdainful expression, the artist appears to be admonishing us with disapproval. Indeed, inscribed on the tablet he holds are the words, 'Be silent, unless what you have to say is better than silence.' The stern message of this sombre self-portrait is made ever more real by Rosa's dark cloak and hat, giving him an almost sinister quality; the strange, horizonless sky appears to make him loom threateningly above us. Rosa was greatly influenced by the almost cruel realism of Jusepe Ribera, who had settled in Naples by 1616, and his own much-admired 'savagery' was evident even in his poetic landscapes. This particular quality was to be important for the Romantic landscapists of the later eighteenth and nineteenth centuries. Rosa was not only a painter but turned his hand to engraving, poetry, music and acting.

☛ Dürer, Kauffmann, Mengs, Ribera, Vigée-Lebrun

Salvator Rosa. **b** Naples, 1615. **d** Rome, 1673. **Self-portrait**. c1640. Oil on canvas. **h**116 × **w**94 cm. **h**45¾ × **w**37 in. National Gallery, London

Rosenquist James Study for Marilyn

This striking image seduces the viewer with its brash colours and erotic overtones. The visual devices Rosenquist has used are those of commercial advertising: the half-open lips, perfectly manicured nails and provocatively placed stick give off suggestive signals, while the bold cropping of the image and the flat, commercial colours used have an immediate impact. These facile images are undermined, however, by the baffling composition of the canvas – why is one-half of the woman's face (supposedly that of Marilyn Monroe) obscured by a large glass tumbler? The painting demonstrates the power of advertising, which has become one of the foundations of urban society. Its use of popular imagery links it with the Pop Art movement in America. Rosenquist had impeccable credentials as a Pop artist: his early years were spent painting billboards and gasoline signs around the USA. He turned to painting as an art form in 1960.

☛ De Kooning, Lichtenstein, Oldenburg, Warhol, Wesselmann

396

James Rosenquist. b Grand Forks, ND, 1933. **Study for Marilyn**. 1962. Oil on canvas. **h**95.2 × **w**91.5 cm. **h**37½ × **w**36 in. Private collection

Rosselli Cosimo The Virgin and Child Enthroned with Saints

The simple harmony of this composition is typical of fifteenth-century Florentine altarpiece design. The presence of saints John the Baptist and Zenobius (patron saints of Florence) indicates that this altarpiece once stood in a Florentine church. The desires of Renaissance clients often dictated more than just the subject of an altarpiece; in this case, St Andrew and St Bartholomew were probably included because they were the patron saints of the commissioning client. Blue paint, made of ground lapis lazuli (a semi-precious stone), was the most expensive of all tempera pigments, so the more blue included in a painting, the more expensive it became. Blue was therefore reserved for the most important passages in a painting, such as the robes of the Virgin. The use of perspective in painting was an issue of great artistic debate in Renaissance Florence. Here Rosselli's use of one-point perspective is visible in the marble floor tiles. Rosselli's pupils included Piero di Cosimo.

☞ Masaccio, Piero della Francesca, Piero di Cosimo

Cosimo Rosselli. b Florence, 1439. **d** Florence, 1507. **The Virgin and Child Enthroned with Saints.** c1478. Tempera on panel. **h**190.5 × **w**175.2 cm. **h**75 × **w**69 in. The Fitzwilliam Museum, Cambridge

Rossetti Dante Gabriel The Day-dream

The painting itself gives no indication as to the nature or subject matter of the absorbing day-dream of this beautiful woman, yet her reverie is so consuming that both her book and her flower lie forgotten in her lap. The many hues of green which surround her in the folds of her dress, and the leaves on the branches which enshrine her, add to the overall sensuality of this painting. As with many of Rossetti's works it presents us with an idealized vision of womanhood. Rossetti was a co-founder of the Pre-Raphaelite Brotherhood, whose artistic aim was to return to the simplicity of paintings before the time of the Italian High Renaissance artist Raphael, as a reaction against contemporary Victorian art. This work illustrates certain characteristic Pre-Raphaelite techniques, such as the use of luminous expanses of bright colour, meticulous attention to detail and the study of outdoor subjects. Rossetti also wrote poetry which echoed the themes in his paintings.

☛ Fra Angelico, Botticelli, Burne-Jones, Hunt, Millais, Moreau

Dante Gabriel Rossetti. b London, 1828. d Birchington-on-Sea, 1882. **The Day-dream**. 1880. Oil on canvas. **h**159 × **w**93 cm. **h**62½ × **w**36½ in. Victoria and Albert Museum, London

Rosso Fiorentino

Moses and the Daughters of Jethro

Jethro's seven daughters were prevented from watering their father's flock by a group of obstinate shepherds whom Moses fought off single-handedly. Moses' twisted and muscular body is seen in the centre of the composition fiercely beating a figure on the floor. The static, stunned daughter top right, the billowing pink cloak top left, and the intertwined forms, contorted poses and oddly perverse scattering of truncated limbs in the foreground, show Rosso Fiorentino at the height of Mannerism. This style was a development from the stability and order associated with Renaissance artists such as Perugino. Towards the end of his career, Rosso left his native Italy to work on the palace of François I of France at Fontainebleau. Rosso, who earned his name because of his shock of red hair, was rumoured to have committed suicide; it is more likely that he died from natural causes.

☛ Bourdelle, Bronzino, Giulio Romano, Pontormo, Primaticcio

Rosso Fiorentino (Giovanni Battista di Jacopo). b Florence, 1494. **d** Fontainebleau, 1540. **Moses and the Daughters of Jethro**. c1523. Oil on canvas. **h**160 × **w**117 cm. **h**63 × **w**46 in. Galleria degli Uffizi, Florence

Rothko Mark

Untitled

Rectangular expanses of intense colour float upon the canvas. Their blurred edges make the colour masses appear to vibrate with a misty, magical quality. An ethereal luminosity suffuses the painting, dissolving all tension of form and contrasts of tones into an inner glow. Restrained yet deeply evocative, Rothko's works give the feeling of containing some burning truth, as if they represented the embodiment of long and arduous meditation. Born in Russia, Rothko emigrated to the USA with his parents in 1913. Largely a self-taught painter, he usually worked on a huge scale. He wanted to immerse the viewer in a total colour experience, saying, 'I paint large pictures because I want to create a state of intimacy. A large picture is an immediate transaction; it takes you into it.' Rothko was a leading figure in Abstract Expressionism, and his formless canvases evoke the true spirit of the movement – an ultimate response to the unattainable mysteries of the human psyche.

☛ Heron, Kelly, Newman, Pollock, Ryman, Serra, Still

Mark Rothko. b Dvinsk, 1903. **d** New York, NY, 1970. **Untitled**. 1951–5. Oil on canvas. **h**189 × **w**101 cm. **h**74⅓ × **w**39¾ in. Tate Gallery, London

Rouault Georges Christ on the Cross

Christ, the Cross and the surrounding figures are depicted in simple, outlined areas of colour. The Cross dominates the composition and fills the entire canvas. Rich colours and crudely drawn forms add to the power of this image of salvation. The whole effect, especially the heavy black lines which delineate the coloured areas, is reminiscent of stained glass. Rouault was indeed apprenticed in stained glass before entering the studio of Gustave Moreau to train as a painter. In this print Rouault has used luminous streaks of colour to express his profound religious devotion. He has used the medium of aquatint, a form of etching that gives fluid, paint-like effects. The expressive, emotional content of his work recalls contemporary German Expressionist painting. Nevertheless, Rouault's style was completely his own, characterized by bright, emotive colours and harsh black outlines.

☛ Grünewald, Kirchner, Masaccio, Orozco, Pechstein, Vlaminck

Georges Rouault. **b** Paris, 1871. **d** Paris, 1958. **Christ on the Cross**. 1936. Aquatint on paper. **h**64.8 × **w**48.7 cm. **h**25½ × **w**19⅛ in. Private collection

Roubiliac Louis-François Sir Isaac Newton

This statue of Sir Isaac Newton – mathematician, physicist, astronomer and philosopher – proudly proclaims its subject's status as a man of unique talent. The grandiose marble is imposing and monumental, as if Roubiliac wished to convey Newton's supreme genius through his towering presence. The features are vividly sculpted with a superbly confident technique, and brought to a smooth, highly polished finish. The resulting statue breathes an air of vitality and restrained exuberance. As befits the eighteenth-century Age of Reason, Roubiliac's work exudes the calm grandeur of greatness. As a young man, he left his native France and settled in England, where he made his name with a statue of Handel carved for London's Vauxhall Gardens. He became a highly acclaimed sculptor, gaining numerous commissions. His wide range of work includes statues of men of the Enlightenment and nobles, and numerous portrait busts and monuments.

☛ Canova, Houdon, Moroni, Powers

Louis-François Roubiliac. b Lyons, 1702. d London, 1762. **Sir Isaac Newton**. 1755. Marble. **h**183 cm. **h**72 in. Trinity College, Cambridge

Rousseau Henri The Monkeys

Three monkeys peer out from behind the thick foliage of the jungle, while an unusual bird perches on a delicate branch laden with heavy leaves. The uninhibited imaginativeness of the scene is typical of Rousseau's view of the world. The intense colours, crisply painted shapes and meticulous attention to detail demonstrate his naive style. This imaginary jungle derives its inspiration from Rousseau's numerous visits to the Parisian botanical garden, the Jardin des Plantes. Rousseau was an amateur painter who attracted the attention of the Parisian avant-garde when he exhibited at the Salon des Indépendants in 1885. He became widely admired by Pablo Picasso and his circle for his fresh, direct vision, so obviously untrammelled by academic training. Rousseau's nickname Le Douanier ('the customs agent') stems from his profession in the French Customs service.

☞ Ernst, Gauguin, Hicks, Lam, Picasso, Vlaminck

Henri Rousseau (Le Douanier). b Laval, 1844. **d** Paris, 1910. **The Monkeys**. 1906. Oil on canvas. **h**145.5 × **w**113 cm. **h**57⅓ × **w**44½ in. Philadelphia Museum of Art, Philadelphia, PA

Rousseau Théodore The Forest of Fontainebleau, Morning

A simple forest scene is painted in shimmering, pearly tones. Composed within an encircling arch of trees, the painting is marvellously fresh and intimate. The cows, enveloped by the misty, early morning air, are delicately reflected in the silvery puddle in which they stand. Rousseau has given careful attention to the depiction of the damp forest with its pale, subtly changing dawn light. Inspired by the work of Jacob van Ruisdael and other Dutch landscapists of the seventeenth century, as well as by the Englishman John Constable, he wished to introduce a freer, un-academic style of landscape to French painting. In the 1840s he settled in the village of Barbizon, in the forest of Fontainebleau, where he began to paint the surrounding countryside with intimacy and realism. Rousseau became one of the founders of the Barbizon School, who aimed to paint the scenery and peasant life of their adopted locale in an unprettified, direct manner.

☞ Constable, Corot, Daubigny, Hobbema, Millet, Ruisdael

404

Théodore Rousseau. b Paris, 1812. **d** Paris, 1867. **The Forest of Fontainebleau, Morning**. 1850. Oil on canvas. **h**98 × **w**134 cm. **h**38½ × **w**52¾ in. Wallace Collection, London

Rubens Sir Peter Paul The Judgement of Paris

Mercury, with his billowing cloak, has led three goddesses to Paris. They are Juno, with a peacock, Venus, with Cupid, and Minerva, with her helmet and shield bearing a Gorgon's head. Adorned with jewels and very little else, the women stand before Paris who holds the golden apple he will award to the most beautiful of the three. Rubens has displayed this most popular of mythological subjects with the verve and grandeur so typical of the Baroque style that he pioneered. Sumptuous colour and sinuous brushstrokes have been used to evoke the rich sensual female figures. In 1630 Rubens married the 16-year-old Hélène Fourment. After this date his style became imbued with a lyrical tenderness. To achieve this, Rubens used rich colours inspired by the Venetian masters, Titian and Veronese. Rubens' fluid brushwork and luscious colouring, and the rich emotion of his compositions, contributed to his reputation as the greatest Baroque painter north of the Alps.

☛ Van Dyck, Jordaens, Maillol, Titian, Veronese

Sir Peter Paul Rubens. b Siegen, 1577. d Antwerp, 1640. **The Judgement of Paris**. 1632–5. Oil on panel. **h**144.8 × **w**193.7 cm. **h**57 × **w**76¼ in. National Gallery, London

Ruisdael Jacob van

A Mountainous Wooded Landscape with a Torrent

Warmly spacious, with a wealth of closely observed naturalistic detail, this landscape's rich, autumnal tones celebrate the beauty of the countryside. It is not a static scene of chocolate-box prettiness, however; the restless, moving sky suggests that the weather is about to change, while the gushing river reminds us of the potentially destructive power of natural forces. Ruisdael instilled a sense of grandeur and drama into his works, which depict both the flat plains of his native Holland and the more rugged and dramatic areas of northern Germany. This painting demonstrates how the expressive possibilities of the sky became increasingly important to Dutch painters, not only serving to balance the composition but also breathing air and space into the scene. The appeal of Ruisdael's work lies in its naturalistic approach. He is acclaimed by many as the greatest and most versatile of all seventeenth-century Dutch landscape painters.

☞ Claude, Constable, Van Goyen, Hobbema

Jacob van Ruisdael. b Haarlem, 1628. d Amsterdam, 1682. **A Mountainous Wooded Landscape with a Torrent**. c1655. Oil on canvas. **h**77.5 × **w**95 cm. **h**31 × **w**38 in. Private collection

Ruysch Rachel

Still Life of Flowers

Resplendent against a backdrop of Classical buildings and a distant statue, a crystal vase glows with the luminous textures of colourful flowers. The scrupulous rendering of detail and the artist's brilliant technique give an added sense of depth and clarity to the surface of this painting. A veil of rich, creamy light descends gently onto the softly depicted floral arrangement. A further demonstration of Ruysch's technical skill is the inclusion of insects on the flowers, a commonly used device at the time. Floral still lifes were a popular subject in Dutch seventeenth-century painting. They were regarded not only as a celebration of nature but as a symbol of the transience of life on earth: even natural beauty will eventually decay. Ruysch was one of the most successful Dutch painters of floral still lifes, excelling at naturalistic depictions of beautiful bouquets. Her paintings continue to be as highly prized as the jewel-like arrangements they imitated.

☛ Fantin-Latour, De Heem, Kalf, Vermeer

Rachel Ruysch. **b** Amsterdam, 1664. **d** Amsterdam, 1750. **Still Life of Flowers**. 1689. Oil on canvas. **h**67.2 × **w**55.2 cm. **h**26½ × **w**21¾ in. Private collection

Ryman Robert Courier II

White enamel paint has been applied to a thin, unframed aluminium sheet screwed to the wall with metal bolts. These fasteners form an integral part of the blank composition, which aims to rid the painting of any trace of painterly illusion. The work provides the spectator with an ecstatic tranquillity that is constant in its intensity; it also demonstrates the unique interaction between the flatness of the picture's surface and the wall-plane behind. The work's connection with Minimalism is demonstrated by the lack of emotion and illusionism in the painting's construction. Ryman's work concentrates on emphasizing the qualities of the materials used – both the paint itself and its support (canvas, plastic, aluminium and so on). From the mid-1960s he has used exclusively white paint, so as not to distract attention from these concerns. He continues to experiment with a wide range of media and brushstrokes.

☛ Andre, Kelly, Mangold, Rothko, Serra, Tobey

Robert Ryman. b Nashville, TN, 1930. **Courier II**. 1985. Impervo on aluminium. **h**40.6 × **w**40.6 cm. **h**16 × **w**16 in. Private collection

Salviati Francesco Charity

Salviati was a great admirer of Michelangelo and has adapted the intertwined figures of the *Doni Tondo* for this painting of Charity. Not only is the composition similar, but the obsession with muscular form and the play of light over the surface of the skin are also derived from Michelangelo. While Salviati achieves a strikingly three-dimensional, sculptural quality, this painting is too studied and self-conscious to merit the same status as Michelangelo's masterpiece. Nevertheless, this work is characteristic of the Florentine art of the time, which had become somewhat encumbered by the genius of the previous generation. Also influenced by the graceful fluidity of the work of Parmigianino, Salviati was the earliest and most convinced of the converts to a Roman ideal of Mannerism. He took his surname from one of his early patrons, Cardinal Salviati.

☛ Bronzino, Michelangelo, Parmigianino, Signorelli

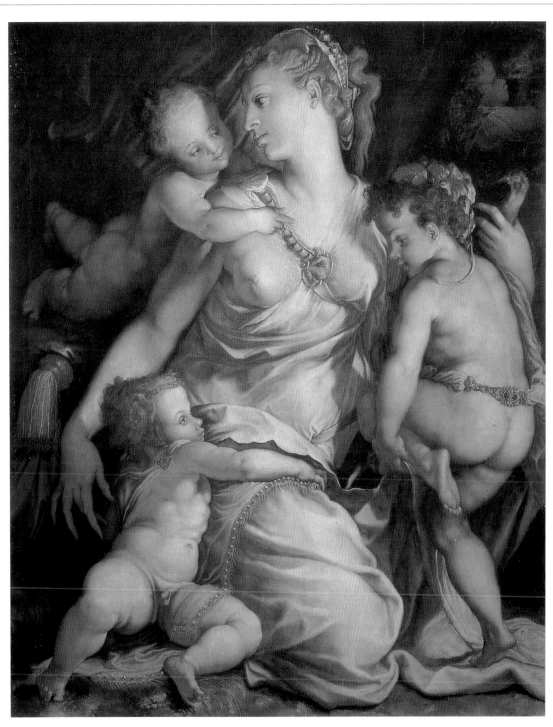

Francesco Salviati. b Florence, 1510. **d** Florence, 1563. **Charity**. 1543/5. Oil on panel. **h**156 × **w**122 cm. **h**61½ × **w**48 in. Galleria degli Uffizi, Florence

Sánchez-Cotán Juan Still Life

Painted with astonishing immediacy and presence, this simple still life is startlingly illusionistic. The fruit and vegetables assume a monumental quality as a result of their meticulous depiction and dramatic lighting by the artist. The way they have been positioned – either hanging from strings or placed on an ambiguous window-like structure – is highly unconventional since it goes against the tradition of northern still lifes. These were generally set table-pieces depicting lavishly prepared food and its trappings. Here, by contrast, the vegetables are humble and unadorned and have been taken out of the context of eating. The message, if any, is ambiguous, but the austerity and sense of order of the painting seem to imply some higher purpose. Sánchez-Cotán's still lifes contributed to the elevation of the genre to a status that was more than merely decorative. He became a Carthusian monk in 1603 and also painted religious pictures in Granada and Seville.

☛ De Heem, Kalf, Ruysch, Snyders, Zurbarán

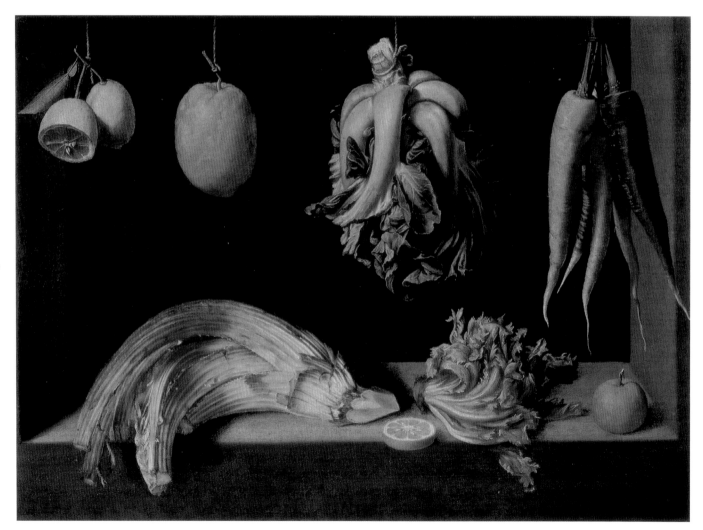

Juan Sánchez-Cotán. b Orgaz, 1561. **d** Granada, 1637. **Still Life**. c1600–10. Oil on canvas. **h**69.5 × **w**96.5 cm. **h**27⅓ × **w**38 in. Private collection

Sargent John Singer Paul Helleu Sketching with his Wife

Even though the names of the couple in this painting are known, the subject matter and execution are closer to an Impressionist painting than an official portrait. Just as the Impressionists worked outdoors, Helleu sits on a bank painting directly from nature. Sargent would have been seated opposite and would also have painted his friend from direct observation. The handling of the paint is also Impressionistic. Short, sharp strokes of colour define the reeds and grasses while the moored canoe is an exercise in the play of light over its red surface. Sargent was not one of the Impressionists, but he is clearly trying to emulate their style in this picture. He also maintained a great admiration for the Old Masters, particularly Frans Hals and Diego Velázquez. Born in Italy of American expatriate parents, Sargent settled in London where he became a prolific and fashionable painter of Edwardian society portraits.

☛ Hals, Monet, Orpen, Tissot, Velázquez

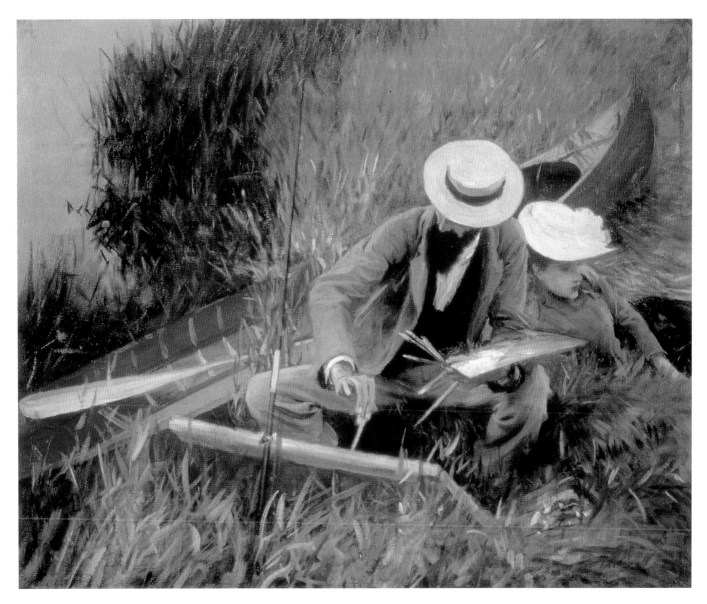

411

John Singer Sargent. **b** Florence, 1856. **d** London, 1925. **Paul Helleu Sketching with his Wife**. 1889. Oil on canvas. **h**66 × **w**81.5 cm. **h**26 × **w**32 in. The Brooklyn Museum, New York, NY

Sassetta

Saint Francis of Assisi Renouncing his Earthly Father

This scene depicts the moment when St Francis renounces his family in favour of life in the Church. Francis had given to the Church money belonging to his father, who then appealed to the civil courts. Francis tore off his clothes, saying that they were his father's and he no longer recognized any father but God. In this scene he has abandoned his clothes at the feet of his enraged father and runs to the Bishop, who offers both real and symbolic protection. This panel was once part of a large double-sided altarpiece which told the story of the life of St Francis and originally stood in the church of San Francesco in the town of Borgo Sansepolcro. Sienese painters of the early fifteenth century were less interested in perspective and proportion than their Florentine counterparts; this scene is therefore not as realistic as a Florentine work of the same period would be. What it lacks in realism, however, it makes up for in its graceful sophistication and subtle use of colour.

☛ Duccio, Giotto, Piero della Francesca

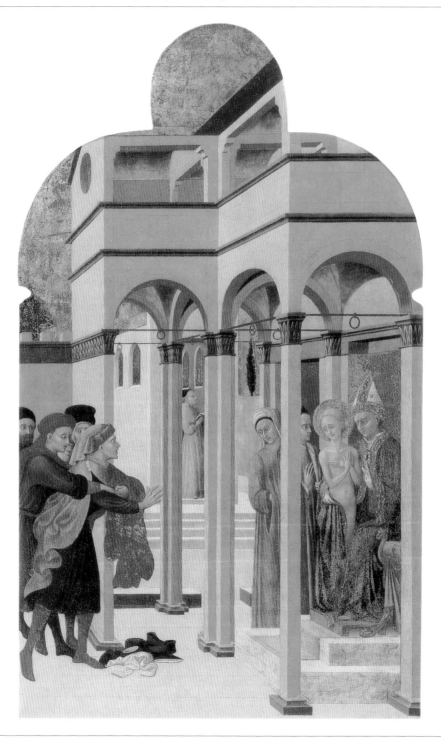

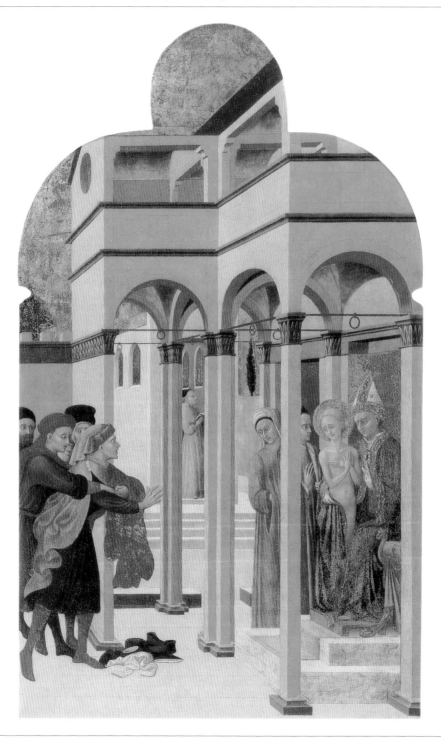

Sassetta (Stefano di Giovanni). b Siena, c1392. d Siena, 1450. **Saint Francis of Assisi Renouncing his Earthly Father**. 1444. Tempera on panel. **h**87.5 × **w**52.5 cm. **h**34½ × **w**20¾ in. National Gallery, London

Savery Roelandt

Orpheus

Surrounded by a motley collection of the animals and birds of the forest, who are drawn by the irresistible charm of his music, Orpheus reclines in a rocky, wooded glade near a river. He is seen playing a violin, the honeyed tones of which mesmerize the colourful array of exotic creatures. Savery delighted in richly detailed, lush, decorative landscapes with an assortment of flora and fauna. Although highly fantastic and idealized, and very much in the Mannerist tradition, the topography of these landscapes is in fact based on the Alpine scenery Savery saw while travelling in Switzerland in the early 1600s. He made several dozen paintings of Orpheus and the Garden of Eden which gave him the opportunity of depicting his favourite subjects in magical worlds. His lively, detailed paintings, which are crammed with incident, show the influence of Jan Bruegel.

☛ J Bruegel, Hicks, Patenier, Piero di Cosimo

413

Roelandt Savery. b Courtrai, 1576. **d** Utrecht, 1639. **Orpheus.** 1628. Oil on panel. **h**53 × **w**82 cm. **h**21 × **w**32 in. National Gallery, London

Schad Christian

Portrait of Doctor Haustein

With a catheter in his breast pocket, Doctor Haustein stares candidly out of the painting at us. Behind him looms the menacing shadow of his lover, a model called Sonja. The macabre tension created by this painting was almost prophetic: three years after it was completed Haustein's wife committed suicide because of her failed marriage, and in 1933 the doctor poisoned himself when he learnt that the Gestapo were about to arrest him. Schad himself was uninterested in politics and concentrated on subjects that had psychological rather than social implications. Isolated and introspective, his subjects often take on a hallucinatory degree of reality. Schad has been described as the coldest of the New Objectivity painters, a group of German artists who aimed to achieve a new kind of unidealized, objective realism. His work has all the precision and exactitude of a surgical operation, and this painting is typical of his style.

☞ Beckmann, Dix, Grosz, Richter, Sheeler

Christian Schad. b Miesbach, 1894. **d** Keilberg, 1982. **Portrait of Doctor Haustein**. 1928. Oil on canvas. **h**80.5 × **w**55 cm. **h**34¾ × **w**21⅔ in. Fundación Colección Thyssen-Bornemisza, Madrid

Schiele Egon

Seated Woman with Bent Knee

Charged with a nervous energy, Schiele's model is portrayed seated on the ground in an informal pose. She looks directly at the viewer; her gaze and pose are erotic, yet the painting is less threatening than many of Schiele's portraits of women. Her sinewy features, anguished hands and contorted neck make this powerfully compact picture all the more

disturbing. Schiele's intense and distorted images are uncompromising in their expression of human feeling. Deeply affected by Sigmund Freud's explorations of the unconscious, Schiele's work gave form to his own anxieties and insecurities. His career was brief but prolific, and many of his works are sexually explicit. Indeed, this led to the

artist's brief imprisonment for 'making immoral drawings'. The acute nervous intensity of his style has made him one of the most important Expressionist painters, although he never formally identified himself with the movement. He died prematurely of influenza, just as his work was recognized.

☛ Balthus, Baselitz, Klimt, Kokoschka, Munch

Egon Schiele. b Vienna, 1890. **d** Vienna, 1918. **Seated Woman with Bent Knee**. 1917. Gouache, watercolour and black crayon on paper. **h**46 × **w**30 cm. **h**18⅛ × **w**12 in. Národní Galerie, Prague

Schmidt-Rottluff Karl Flowering Trees

The dark rich colours and harsh treatment of forms, such as the violently delineated tree that dominates the landscape, have been painted in a forceful and dynamic style which quivers with vitality. Like Vincent van Gogh 20 years earlier, the artist has used heavily laden brushstrokes, applied in layered planes of contrasting, saturated hues. These are not the true colours of nature, but reflect the artist's own sensitivities and state of mind. The surging vibrancy and impassioned style of this painting, and the freedom of its execution, are characteristic of German Expressionism of which Schmidt-Rottluff was a leading exponent. During the Second World War Schmidt-Rottluff was severely persecuted by the Nazis who removed all of his paintings from German galleries and forbade him to paint. His work was reinstated in 1945, from which time the artist lived in East Germany.

☛ Van Gogh, Heckel, Kirchner, Nolde, Pechstein

416

Karl Schmidt-Rottluff. **b** Rottluff, 1884. **d** Berlin, 1976. **Flowering Trees**. 1909. Oil on canvas. **h**69 × **w**81 cm. **h**27¼ × **w**31¾ in. Private collection

Schnabel Julian Mele

The surface of this unusual and expressive portrait is made from bits of broken china, onto which the image has been painted. Schnabel was inspired by some walls in the Park Güell in Barcelona, designed by the Catalan architect Antoní Gaudí, which had been surfaced with a mosaic of ceramic fragments. He was also influenced by the Surrealists' experiments with 'automatic' drawing, a form of art which was supposed to come directly from the unconscious. Schnabel's 'plate paintings', such as this, enabled him to paint on a surface without seeing the immediate effect. The fragmented surface causes the image to recede in places, the china acting as a screen rather than a medium to project the image. Schnabel painted on other unconventional surfaces, including velvet and tarpaulin. In the 1980s he was considered the *enfant terrible* of American art.

☛ Motherwell, Rauschenberg, Schwitters, Twombly

Julian Schnabel. b New York, NY, 1951. **Mele**. 1987. Oil and china plates on wood. **h**152 × **w**122 cm. **h**60 × **w**48 in. Private collection

Schongauer Martin The Madonna of the Rose Garden

It is surprising that this Madonna and Child look away from each other. Each seems absorbed in a different world, even though the Virgin tenderly cradles the Christ child and he has his arms around her neck. Schongauer was a pioneer in printmaking and was much admired by Albrecht Dürer. He concentrated on images of the Virgin that were

very similar to the altarpiece shown here. This is Schongauer's only documented painting, yet his talents as a printmaker are evident even in paint. For example, the sharp folds of Mary's robe which are divided into planes of light and shadow parallel the manner in which an engraver would represent tones. Prints were cheap and easy to

transport. This would have facilitated the rapid dispersion of Schongauer's compositions, thereby making his reputation over a large area of Europe. Schongauer was much influenced by Flemish art, especially apparent in the exquisite details of the flowers and birds in this painting.

☞ Bouts, Campin, Dürer, Lochner, Van der Weyden

418

Martin Schongauer. b Augsburg, c1435. d Breisach, 1491. **The Madonna of the Rose Garden**. 1473. Oil on panel. **h**200 × **w**115 cm. **h**78¾ × **w**45¼ in. Saint Martin, Colmar

Schwitters Kurt

Picture of Spatial Growths – Picture with Two Small Dogs

An assortment of items – including a used envelope, a postcard, discarded packaging and bus tickets – have been attached to a piece of board. Combined with words picked at random from newspapers, and daubed with paint, they have been arranged without meaning to form a collage. The result is a balanced, abstract composition made from meaningless fragments: Schwitters has created art out of non-art. His random collection of objects undermines the traditional notion of art as something expressive, or meaningful. A talented poet as well as an artist, Schwitters was associated with the Dadaists, a group of writers and artists active from 1915 to 1922, who wanted to disrupt the public's complacency and acceptance of traditional values. Schwitters was refused membership to the Berlin Dada group and established his own branch in Hanover which he named 'Merz', a word derived from the proper noun 'Com*merz*bank'.

☛ Duchamp, Ernst, Gris, Hamilton, Man Ray, Schnabel

Van Scorel Jan Adam and Eve

The robust, statuesque figures of Adam and Eve, framed by lush trees and with a river landscape winding its way into the distance, dominate this scene from the Garden of Eden. Scorel was much travelled and his style of painting synthesizes the delicacy of his Netherlandish predecessors with the substantiality of form of Italian art. The bold nudity and the solid forms of the figures, contained within a firm, confident outline, are typical of Scorel's style of religious painting and reveal the influence of the Italian Renaissance artists Michelangelo and Raphael whom the artist knew when he lived in Rome. His northern roots enabled him to depict the landscape with great sensitivity and fill it with delightful details such as the small animals in the foreground. Scorel was so famous by the mid-sixteenth century that he was asked to restore the great Ghent altarpiece by Jan van Eyck.

☛ Dürer, Van Eyck, Van der Goes, Massys, Michelangelo

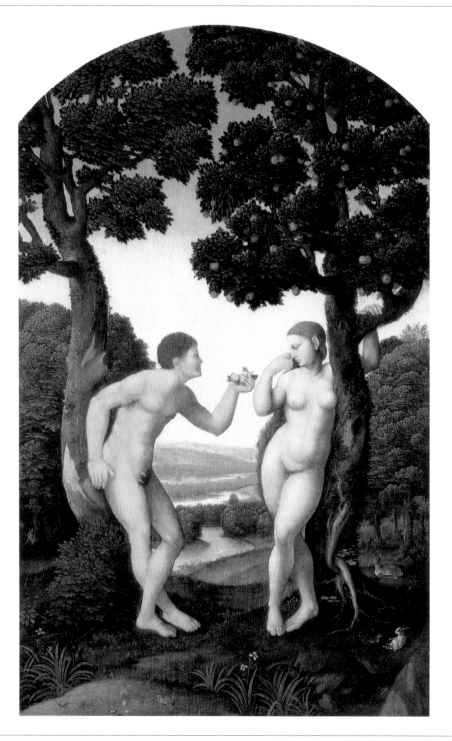

Jan van Scorel. **b** Scorel, 1495. **d** Utrecht, 1562. **Adam and Eve**. c1540. Oil on panel. **h**47.6 × **w**31.8 cm. **h**18¾ × **w**12½ in. Private collection

Sebastiano del Piombo · The Death of Adonis

Venus learns of the death of her lover Adonis who, having been slain by a boar, lies dead in the background. The asymmetrical composition with a concentration of figures on the right of the canvas, and the pointing fingers, outstretched arms and moving heads which create movement within the painting, are typical of Sebastiano's style which is free from the rigidity of earlier Renaissance paintings. The nudes and surrounding landscape are bathed in a delicate light characteristic of the art of Sebastiano's native Venice, in particular the work of Giorgione who was his friend and teacher. Sebastiano also worked in Rome where he came into contact with Raphael but he was more strongly influenced by Michelangelo who gave him sketches and cartoons to develop. The solid, muscular bodies in this painting reflect the artist's deep understanding of Michelangelo's nudes.

☛ Giorgione, Michelangelo, Palma Vecchio, Raphael, Titian

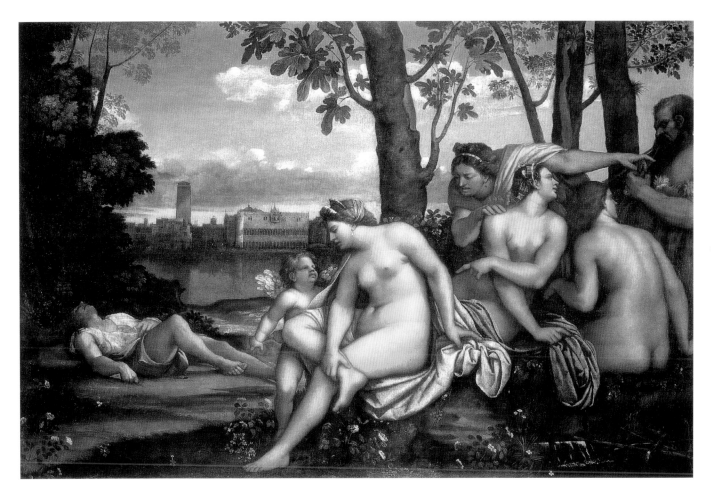

Sebastiano del Piombo. b Venice, c1485. **d** Rome, 1547. **The Death of Adonis.** c1511. Oil on canvas. **h**189 × **w**285 cm. **h**74½ × **w**112¼ in. Galleria degli Uffizi, Florence

Segal George

Bus Riders

Four ghost-like figures appear to have been frozen in time in the everyday activity of riding on a bus. Segal created plaster-casts of his friends and family and placed them in familiar settings to highlight the banal but necessary activities that are routinely performed by all of us. Although rough on the outside, inside each cast bears the imprint of every detail of the sitter's clothes and skin. Like real people on a bus these figures keep themselves to themselves. Segal's intention was to portray the anonymity of the mundane, daily actions that are imposed on us by the society in which we live, and to capture mankind's sense of alienation in the modern world. His plaster men and women sit in chairs, eat in diners and shave their legs. The portrayal of familiar activities which the spectator could relate to was typical of Pop Art, a movement which developed in America in the 1960s.

☛ Dine, Hamilton, Oldenburg, Rosenquist, Wesselmann

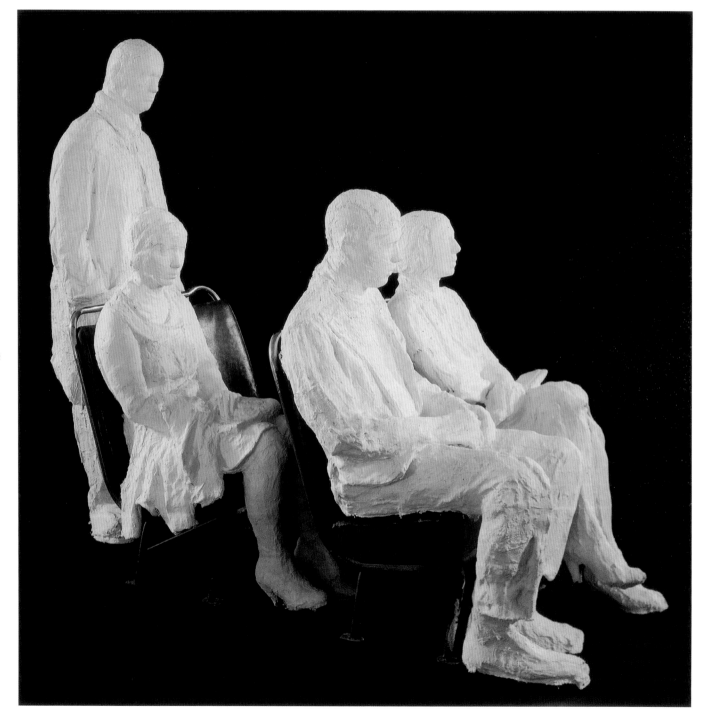

George Segal. b New York, NY, 1924. **d** North Brunswick, NJ, 2000. **Bus Riders**. 1964. Mixed media. **h**175.2 × **w**193 cm. **h**69 × **w**76 in. Hirshhorn Museum and Sculpture Garden, Washington, DC

Serra Richard

Clara, Clara

Two immense plates of steel curve towards each other as if drawn by an irresistible, resonating force. The sculpture dominates rather than decorates the public square in which it stands, its uncompromising presence aggressively stating the power of its structural might. Serra, who lives in New York, works in a variety of commonplace materials, including metal squares, firebricks, logs and rusted nails, and demonstrates in a Conceptual way a material's ability to express energy and develop tensions with the structures surrounding its newly created form. *Clara, Clara* is Minimalism taken to its paradoxical extreme – the most simple, unadorned message of purity of form amplified into a new dimension. Serra's work has kindled awe, despair and also much controversy. To some it offers a forlorn glimpse of a world free from mundane function. Serra insists that his works are illustrated in black and white.

☛ Andre, LeWitt, Noguchi, Smith

Richard Serra. b San Francisco, CA, 1939. **Clara, Clara**. 1983. Cor-Ten steel. **h**3.6 × **w**36.6 m. **h**12 × **w**120 ft. Originally in the Jardin des Tuileries, Place de la Concorde, Paris. Now in the Square de Choisy, Paris

Seurat Georges

Sunday Afternoon on the Island of the Grande Jatte

Seurat has painted a typical Sunday afternoon at the Grand Jatte, a popular site on an island in the River Seine to the north-west of Paris. He visited the Grand Jatte every day for six months to make preparatory drawings of the landscape and to sketch numerous figures, such as the woman with her fashionable bustle and the mother and child, before creating this carefully planned composition in his studio. When the painting was first shown it was received with great indignation by the majority of artists and critics. They strongly disapproved of Seurat's revolutionary new painting technique, known as 'Pointillisme'. The surface of the painting is broken up and the colour painted onto the canvas as dots of pure colour. When viewed at a distance the dots appear to fuse together, creating a mesmerizing haze of brilliant colour. Seurat died of a severe infection at the age of 32.

☛ Dufy, Monet, Pissarro, Signac, Vlaminck, Vuillard

424

Georges Seurat. b Paris, 1859. **d** Paris, 1891. **Sunday Afternoon on the Island of the Grande Jatte**. 1884–6. Oil on canvas. **h**202 × **w**300 cm. **h**81 × **w**120½ in. Art Institute of Chicago, Chicago, IL

Severini Gino

Pierrot the Musician

Pierrot the musician, dressed in an immaculate white costume which contrasts with his black mask of the *commedia dell'arte*, sits in a room with brightly patterned walls. In 1910 Severini joined the Futurist movement, a group of artists and writers who expressed the dynamism of the modern world by representing machines and figures in motion, and went on to create some masterpieces of Futurist art. He was much influenced by Georges Seurat, evident in his use of pure colour, and became friends with a number of Cubist artists, including Pablo Picasso. The calm composition of this painting and the precision and care with which Severini has executed the stiff folds of Pierrot's outfit, his rubbery hands and the guitar, marks the artist's movement away from the influence of Futurism and Cubism and towards a rekindling of the Neo-Classical spirit which dominated Severini's work until his death.

☛ Balla, Boccioni, Greuze, Picasso, Seurat, Terbrugghen

Gino Severini. b Cortona, 1883. **d** Paris, 1966. **Pierrot the Musician**. 1924. Oil on canvas. **h**130 × **w**89 cm. **h**51⅛ × **w**35 in. Museum Boymans-van Beuningen, Rotterdam

Sheeler Charles

Windows

Skyscrapers soar up into the Manhattan sky. The windows of these 36-storey buildings are not intended to give the spectator an insight into the people who live and work inside but to create an abstract pattern across the surface of the precisely painted picture. In 1920 Sheeler took a series of photographs of New York's skyscrapers which he used to make a film called *Mannahatta*. These images of a complex arrangement of buildings, shadows and windows inspired him to make his first 'Precisionist' paintings. Along with Stuart Davis, Georgia O'Keeffe and others, Sheeler reveals in his work a pristine, static, unpopulated approach to the North American environment, executed in styles ranging from photographic realism to pure abstraction. The reflections suggested in this painting have been influenced by Sheeler's use of superimposed images in his photography.

☛ Davis, Estes, O'Keeffe, Richter, Schad

Charles Sheeler. b Philadelphia, PA, 1883. d Dobbs Ferry, NY, 1965. **Windows**. 1951. Oil on canvas. h81.3 × w51.1 cm. h32 × w20⅛ in. Hirschl and Adler Galleries Inc., New York, NY

Sherman Cindy

Untitled No. 96

This photograph is reminiscent of Victorian art in its romantic portrayal of a meditative young woman. The symbolic motifs of the Pre-Raphaelites, however, are replaced with the brash surfaces of modernity; the young woman becomes a teenager; the 'letter' she holds is a section of the lonely hearts column; and the framing is cinematic. *Untitled*

No. 96 is one of an ongoing series of photographic tableaux which the New York artist Sherman stages, acts in and directs. Sherman is the 'star' of all her works where, heavily disguised, she acts out a series of narratives often drawn from cinema or the history of great art. Her increasingly baroque works of the late 1980s have moved into *grand guignol*. The

female body is dismembered or replaced with pornographic prosthetics in a violent evocation of the image as a corpse and woman as victim. But Sherman's disrespect for traditional values combines with grim humour to form a powerful and original artistic approach.

☞ Dine, Estes, Gilbert & George, Man Ray, Millais

Cindy Sherman. **b** Glen Ridge, NJ, 1954. **Untitled No. 96**. 1981. Colour photograph. **h**61 × **w**122 cm. **h**24 × **w**48 in. Saatchi Collection, London

Siberechts Jan A View of Longleat

Longleat is one of the largest and most impressive monuments of Elizabethan architecture. Siberechts, a Flemish landscape painter who lived in England from 1672, specialized in the depiction of noble country houses and was commissioned to record this masterpiece of the English Renaissance just as a photographer might record the erection of a modern building today. Siberechts has chosen a bird's-eye view of Longleat, but the strict symmetry and dispassionate style of the painting has made it rather stiff and, it could be said, more of a topographical record of the building than a work of high art. The few figures lingering in the grounds of the house give little indication of courtly life, but Siberechts has managed to imbue the scene with a certain restrained formality which would have appealed to the taste of the seventeenth-century English nobility.

☛ Canaletto, Guardi, Pannini, Piper

Jan Siberechts. b Antwerp, 1627. **d** London, 1703. **A View of Longleat**. 1675. Oil on canvas. **h**111.8 × **w**172.7 cm. **h**44 × **w**68 in. Private collection

Sickert Walter

Ennui

Time seems to stand still in this languid setting. A man puffs on his cigar and stares into the distance, while a young woman head in hand and stifled by boredom, gazes up at a painting on the wall which she must have looked at a hundred times before. Born in Germany of Danish and Irish descent, Sickert was trained in Paris, where he became friends with Edgar Degas and the French Impressionists. He was also the pupil of James McNeill Whistler in London. He specialized in painting landscapes, townscapes and portrayals of daily life. These reflected the same interests as his friends in Paris although he differs from them in his use of sombre colours and rough dark tones. Sickert was the most important British Impressionist although his work is not typical of Impressionist painting. His studio in Camden Town, London, became a meeting-place for the avant-garde artists and writers of his day.

☛ Degas, Gilman, Hammershøi, Orpen, Whistler

Walter Sickert. **b** Munich, 1860. **d** Bathampton, 1942. **Ennui**. c1914. Oil on canvas. **h**152.4 × **w**112.4 cm. **h**60 × **w**44 in. Tate Gallery, London

Signac Paul

The Papal Palace, Avignon

Small patches of pure colour are fused together optically to create an image of the Papal Palace at Avignon. On the left, picked out in hues of green, stands Avignon's famous bridge. A devotee of Georges Seurat's 'Pointillist' technique, Signac placed complementary colours next to each other without blending them together. The result is a series of dots that merge together when viewed from a distance. Signac exploited the Impressionists' discoveries about how colour changes under different light conditions. The purples and pinks that dominate this painting, for instance, are similar to the colouring of Claude Monet's famous visions of the cathedral at Rouen. Seurat himself was opposed to his ideas being over-verbalized, but his early death enabled Signac to expound theories on Neo-Impressionism and the use of colour. From around 1900 he abandoned the round dots of Pointillism and began to use square spots of primary colours.

☞ Boccioni, Monet, Pissarro, Seurat

Paul Signac. b Paris, 1863. **d** Paris, 1935. **The Papal Palace, Avignon.** 1900. Oil on canvas. **h**73.5 × **w**92.5 cm. **h**29 × **w**36¼ in. Musée d'Orsay, Paris

Signorelli Luca

The Flagellation of Christ

Christ, tied to the column at the centre of the composition, is being beaten at the behest of Pontius Pilate who does not believe that he is the Son of God. The sculptural reliefs in the background, the Corinthian capital of the column and the decorative frieze at the bottom of the painting reflect the Renaissance interest in motifs from classical Antiquity. Strong, oblique lighting, including the shadows cast on the ground, helps to define the three-dimensional space of the scene. The muscular calves of the figures and strong symmetrical composition are characteristic of Signorelli's style of painting which was greatly influenced by Piero della Francesca, his teacher, and the brothers Antonio and Piero Pollaiuolo. His beautiful black-chalk drawings of the body in motion were the most rigorous studies of the nude before Michelangelo.

☛ Perugino, Piero della Francesca, Pollaiuolo, Sassetta

Luca Signorelli. b Cortona, c1450. d Cortona, 1523. The Flagellation of Christ. c1490. Oil on panel. h85.5 × w62 cm. h33¼ × w24⅜ in. Pinacoteca di Brera, Milan

Siqueiros David Alfaro Death and Funeral of Cain

Crowds of people have congregated as if in anticipation of experiencing a miraculous religious vision – but instead a grotesque dead chicken lies slumped across the cliff-top in front of them. The crowd's inability to recognize the inanity of the object they are venerating emphasizes the futility of their mission. Siqueiros was one of the founders (with Diego Rivera and José Clemente Orozco) of the school of mural painting which developed in Mexico after the Revolution. The bold composition of this painting, its striking use of colour and free mixture of reality and fantasy, influenced by the Surrealists and Mexican folk art, is reminiscent of the artist's work in murals. A political activist and revolutionary, Siqueiros was imprisoned and exiled many times throughout his life. His impassioned style of painting has immense power and vitality and is ripe with dynamic and provocative suggestions and ideological meaning.

☛ Orozco, Rivera, Snyders, Tamayo

432

David Alfaro Siqueiros. b Chihuahua, 1896. d Mexico City, 1974. **Death and Funeral of Cain**. 1947. Acrylic on panel. **h**76 × **w**96 cm. **h**29⅞ × **w**37¾ in. Museo de Arte Alvar y Carmen T de Carillo, Mexico City

Sisley Alfred

Snow at Louveciennes

Subtle tones of white and grey form the colour-base of this almost monochromatic winter scene. The thickly and distinctly applied paint gives depth and heaviness to the snow as if it is accumulating on the ground, walls and trees. The sketchily painted small figure fixes the centre of the picture and our attention, and gives a sense of

purpose and scale to the landscape. Sisley's quest to capture colour and light led him to experiment in varying atmospheric conditions. He was greatly influenced by Claude Monet with whom he evolved an impressionistic style. Their search to translate visual perceptions into pure effects of luminosity and tones is the basis of

Impressionism, of which Sisley became a leading exponent. Sisley was almost exclusively a landscape painter. His predilection for roads and pathways leading into the painting, which opens fan-like in this snow-scene, reveals the influence of Camille Corot.

☞ Avercamp, Corot, Monet, Pissarro

Alfred Sisley. b Paris, 1839. d Moret-sur-Loing, 1899. **Snow at Louveciennes**. 1878. Oil on canvas. **h**61 × **w**50 cm. **h**24 × **w**19¾ in. Musée d'Orsay, Paris

Sittow Michiel Katherine of Aragon

Downcast eyes, hair parted in the middle, a close-fitting headdress and a halo heighten the mood of this demure, tranquil and pensive portrait. It is believed that the subject has been depicted as a saint in deference to her pious character. The alternating Ks and roses of her elaborate gold necklace and the shells which ring the bodice of her dress have led to the suggestion that the sitter is Katherine of Aragon. Sittow was an Estonian artist who trained in Bruges under Hans Memling and continued the Netherlandish tradition of detailed portraiture while living in Italy and Spain. His style is very smooth and realistic and it is unlikely that a photograph of this woman would be any more exact than the artist's precise likeness. Besides a few exquisite religious works painted in brilliant but subtle colours, only a small number of Sittow's beautiful and highly perceptive portraits have survived – including this fine example.

☞ Anguissola, Clouet, Holbein, Memling

Michiel Sittow. b Reval, 1468. **d** Reval, 1525/6. **Katherine of Aragon**. c1503/4. Oil on panel. **h**29 × **w**20.5 cm. **h**11½ × **w**8⅛ in. Kunsthistorisches Museum, Vienna

Sluter Claus

The Prophets Daniel and Isaiah

The realistic facial expressions, the detail of Isaiah's two-pronged beard, the decorative brocade on the edge of his garment and the intricacy of his loosely tied belt, are all elements hitherto unseen in north European sculpture. Rather than an archetypal image of a prophet, Sluter has created a thoughtful, intelligent man with an individual personality. In 1383 Philip the Bold, Duke of Burgundy, founded a Carthusian monastery at Champmol near Dijon in France. In the 1390s he commissioned the greatest craftsmen available to create a group of buildings and monuments for this site. One of these artisans was Sluter, a Dutch sculptor working in Haarlem, who produced a large well to stand by the entrance to the ducal chapel. Known as *The Well of Moses*, it comprised six life-size prophets carved in stone, surmounted by a wooden crucifix and five statues. These figures, which include the prophets Daniel and Isaiah, are seen as one of the most important influences on northern sculpture.

☛ Donatello, Ghiberti, Della Quercia, Van der Weyden

Claus Sluter. Active in Haarlem, c1380. **d** Dijon, 1405. **The Prophets Daniel and Isaiah**. 1404–5. Stone. **h**169 cm. **h**66½ in. Hôpital la Chartreuse, Dijon

Smith David

VB XVII

This agglomeration of industrial parts has become a series of unstable volumes that are ripe with dynamic energy. Smith, a former metal worker in a car factory, is considered one of the most influential American sculptors of the mid-twentieth century. Influenced by the welded Cubist constructions of Pablo Picasso he was the

first American sculptor to use welding for sculptural purposes. He later used 'found objects' for his sculptures and from the 1950s ordered industrial parts from manufacturers' catalogues which enabled him to make much larger sculptures more quickly and easily. His work reflects the power, movement, progress and destruction

of the industrial age which fascinated him. His dynamic compositions launched a new era in sculpture. Always a pioneer, Smith experimented in and was influenced by many styles yet he always evoked an expressive element within the form and structure of steel.

☛ Caro, Duchamp, Moholy-Nagy, Picasso, Tatlin

David Smith. b Decatur, IA, 1906. d Bennington, VT, 1965. **VB XVII**. 1962. Steel. **h**206.4 cm. **h**81¼ in. Collection of Candida and Rebecca Smith

Snyders Frans

A Game Stall

A man in a dandified costume holds a dead peacock amid a panoply of plumed poultry and game in this richly stocked market stall. His two dogs look on inquisitively, tempted by the tasty morsels on display. Snyders was concerned with the whole effect of colour, texture and feeling. No part of this canvas is left free of meticulous detail, creating a visual gourmet drama that is marvellously rendered in sumptuous colouring and with great craftsmanship. Snyders painted many vigorous hunting scenes and was the first painter to specialize in animal still lifes (large compositions featuring fruit, flowers, dead game and so on). His talent and luscious painting style were highly praised by his contemporaries, including Jacob Jordaens and his close friend Peter Paul Rubens with whom he collaborated to paint the still-life and animal parts of his exuberant hunting scenes.

☛ Fabritius, De Heem, Kalf, Rubens, De Troy

Frans Snyders. b Antwerp, 1579. d Antwerp, 1657. **A Game Stall**. 1620s. Oil on canvas. **h**170 × **w**254 cm. **h**67 × **w**100 in. York City Art Gallery, York

Sodoma

The Descent from the Cross

Billowing draperies of oranges, reds, greens and blues add vibrancy to this scene of Christ's body being taken down from the Cross. Sodoma's work is characterized by beautiful colours, subtle effects of light and a poetic feel for landscape. The background in this painting is believed to have been inspired by Flemish painters such as Jan van Eyck, although many Italian artists, including Leonardo da Vinci, also used landscape as a background feature. Renaissance paintings such as this were often made by a group of artists, or workshop, working under one master. The master was responsible for the composition and for painting key elements of the work, while his assistants would complete the background and secondary figures. Despite this team effort, the painting would still have been considered a product of the master's hand. Born in Lombardy, Sodoma worked in both Siena and Rome where he received many important commissions.

☞ Van Eyck, Leonardo, Memling, Signorelli, Van der Weyden

Sodoma (Giovanni Antonio Bazzi). **b** Vercelli, 1477. **d** Siena, 1549. **The Descent from the Cross**. c1505/10. Oil on panel. **h**414 × **w**264 cm. **h**163 × **w**104 in. Pinacoteca Nazionale, Siena

Soulages Pierre Painting 16

Strong broad strokes of black paint sweep down the canvas in a heavy, bold formation. The large black mass, intensified by the contrasting small white gleams of light, gives the painting a monumental and serene aspect. It is this skilful illumination, combined with the sculptural quality of the distinctive forms, which makes the picture so unique. The work's connection to the Art Informel movement is demonstrated by the constrained freedom of the brushstrokes which have been articulated to create a powerful abstract composition. Born in south-west France, Soulages settled in Paris in 1946 and started to work in an abstract style that is reminiscent of the prehistoric dolmens and Romanesque sculpture of his native Auvergne. Soulages' paintings often consisted of broad bands, usually as black and shiny as patent leather, intersecting one another to form latticed structures against bright colours. His recent work has developed into a more textured surface with obvious ridges of paint.

☛ Hartung, Kline, Riopelle, Da Silva, De Staël

Pierre Soulages. b Aveyron, 1919. **Painting 16**. 1965. Oil on canvas. **h**162 × **w**130 cm. **h**64 × **w**51 in. Private collection

Soutine Chaim

The Little Pastry Cook

Thick smears of paint animate the surface of this picture. The distorted forms and excited colouring give an air of disjointed vivacity to the cook. Soutine's turbulent style was influenced by the expressive and dynamic work of Vincent van Gogh, although he protested not to like the Dutchman's work. Indeed, Soutine claimed to despise the work of his contemporaries and was indifferent to the experiments of the Fauves and the Cubists. He preferred to paint in his own unique style and declared a close affinity with Old Masters such as Rembrandt. Born in Lithuania, Soutine moved to Paris in 1913. His usual subjects were still lifes, tempestuous landscapes – with dark clouds and moving trees – and psychologically revealing portraits of valets and bakers. The highly charged movement and impulsive brushstrokes in his paintings anticipate the free style of Willem de Kooning and embody the spirit known as Expressionism.

☞ Bacon, Van Gogh, De Kooning, Rembrandt, Schiele

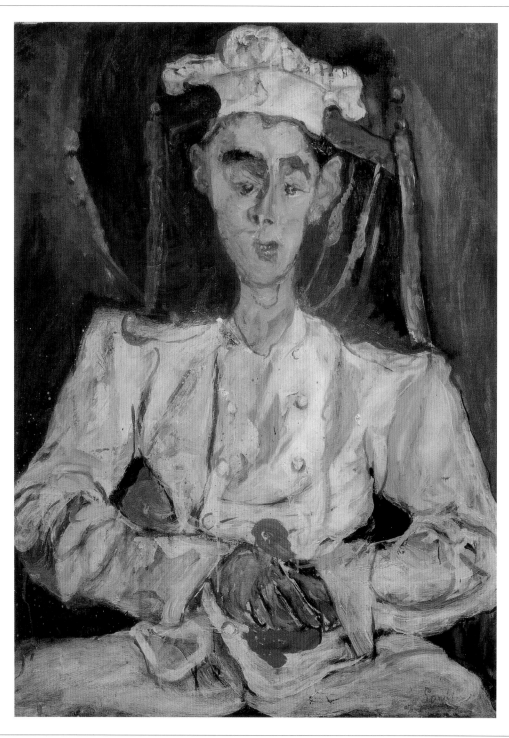

Chaim Soutine. **b** Smilovitchi, 1893. **d** Paris, 1943. **The Little Pastry Cook**. c1922. Oil on canvas. **h**72 × **w**54 cm. **h**28⅓ × **w**21¼ in. Musée de l'Orangerie, Paris

440

Spencer Sir Stanley Saint Francis and the Birds

A naive and enlarged figure of St Francis, his back towards us, gesticulates wildly with his arms outstretched as he looks up to the sky. Ducks, hens and birds on the roof gaze upon him as if in adoration. The large figure dominates the canvas; strangely, his hands have been reversed. The paint has been applied in broad, flat swathes giving the surface a tapestry-like pattern, while the figures are solid, almost cylindrical in form. This imaginative and lively painting was rejected by the Royal Academy, probably because its outrageous humour offended the arbiters of good taste. Spencer depicted Christianity as a living, everyday experience and drew most of his inspiration from the small village of Cookham in Berkshire. Francis is clad in green rather than his usual brown habit because Spencer used his father, who wore his dressing-gown and bedroom slippers, as the model for the saint.

☞ Botero, Gauguin, Rego, Rivera, H Rousseau, Sassetta

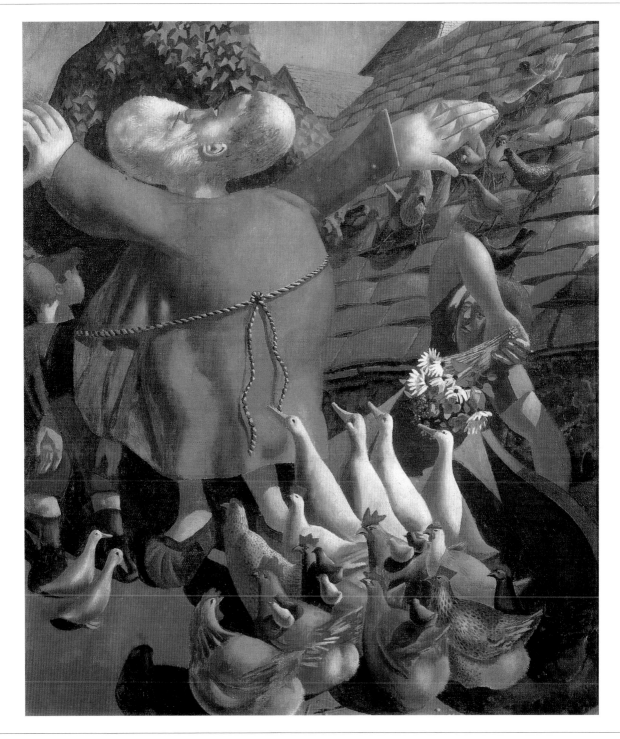

441

Sir Stanley Spencer. b Cookham, 1891. d Cookham, 1959. **Saint Francis and the Birds**. 1935. Oil on canvas. **h**71 × **w**61 cm. **h**28 × **w**24 in. Tate Gallery, London

Spilliaert Léon Moonlit Beach

At first glance the strong lines and broad bands of tone in this picture make it look like an abstract work of art. As the viewer's eye becomes accustomed to the painting, however, a beach scene becomes apparent; the sweeping, pale light of the moon highlights waves coming into the shore and dark breakwaters stretching into the sea.

Similarly, the colours – which at first seem limited – become richer as the eye begins to appreciate the subtle differences in tones and the searing white of the rising moon. The artist has concentrated on the effect of moonlight on a beach at night rather than a realistic depiction of the scene, and has thus captured effectively

the mood of this solitary place. Spilliaert is known for his economy of form in haunting landscapes that are devoid of human life. Most of these paintings were executed in and around his native Ostend.

☛ Grimshaw, Krøyer, Marin, Mucha

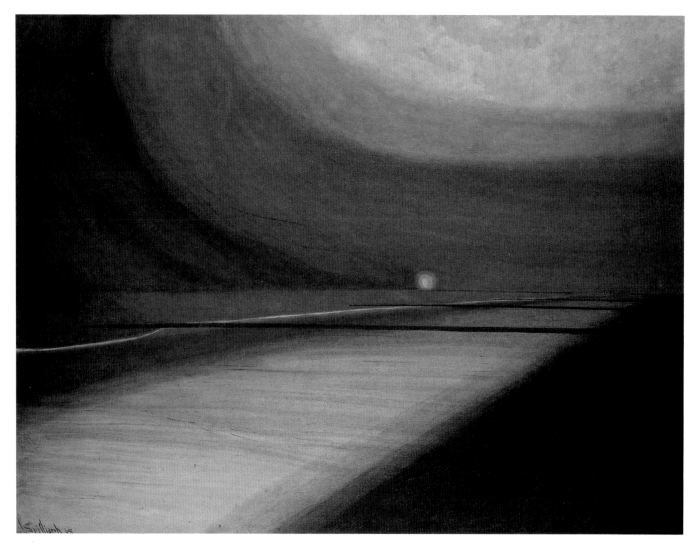

442

Léon Spilliaert. **b** Ostend, 1881. **d** Brussels, 1946. **Moonlit Beach**. 1908. Ink, watercolour and pencil on paper. **h**50 × **w**65 cm. **h**19²⁄₃ × **w**25½ in. Private collection

De Staël Nicolas

Red Bottles

The vibrant luxuriousness of the paint in this still life is used by De Staël to convey a calm beauty. The space around the bottles is almost as rich as the objects themselves which float in the creamy texture of the paint's surface, evoking a sense of timelessness. The painting's importance lies in its delicate balance of abstract and representational imagery, and its interplay between and control of powerful hues of exquisite colour and form. De Staël has eliminated background, ornament and outline, a feature which characterizes his lyrical style. He began his career as an abstract painter, and was much influenced by Georges Braque, but as he began to paint more freely his paintings became more figurative. His favourite themes from this period were musicians, athletes, nudes and still lifes. De Staël committed suicide shortly after this picture was painted.

☞ Braque, Morandi, Nicholson, Vieira da Silva

443

Nicolas de Staël. b St Petersburg, 1914. d Antibes, 1955. **Red Bottles**. 1955. Oil on canvas. **h**73 × **w**100 cm. **h**28¾ × **w**39⅜ in. Private collection

Steen Jan

The Christening Feast

A proud father holds his new-born child while friends and relations gather round to gossip, admire the baby and to partake of the christening feast being prepared by the three women on the right of the painting. This happy, bustling tableau accurately depicts a typical scene in a seventeenth-century Dutch household. In the foreground, however, the artist has painted broken eggs, a well-known symbol of mortality. This is to remind us of the death that waits for everyone, even at the celebration of a birth. Steen was one of the most popular of all Dutch genre painters. A pupil of Jan van Goyen, he initially painted landscapes but went on to depict scenes of middle-class life. The son of a brewer, he supplemented his artist's income from 1654 by becoming an inn-keeper. It is certain that this and many other paintings were influenced by the merrymaking he saw at that time.

☞ Dou, Van Goyen, Van Ostade, De Troy, Watteau

Jan Steen. b Leyden, c1626. d Leyden, 1679. **The Christening Feast**. 1664. Oil on canvas. **h**89 × **w**109 cm. **h**35 × **w**42¾ in. Wallace Collection, London

Stella Frank

Kastura

This massive wall-relief is constructed from sections of brightly painted aluminium which have been fixed to a rectangular base. Stella has skilfully balanced the monumental quality of the work with the apparent freedom of its support, offered by a discreet curved grille structure which permits the spectator to see through to the wall behind. The three-dimensional abstract cut-outs challenge the traditional confines of the picture plane as their freedom of construction permits no defined edges. The work shows a number of influences. One of these is Minimalism, demonstrated in the use of mass-made material and the industrial method of enlarging a maquette which was hand-made by the artist. Another is Abstract Expressionism, evident in the freely applied paint. Stella's wide range of work includes highly innovative prints, some of which are monumental in size.

☛ Caro, Hofmann, Johns, Kelly, Pollock, Ryman

Frank Stella. b Malden, MA, 1936. **Kastura**. 1979. Oil and epoxy on aluminium and wire mesh with metal tubing. **h**292.1 × **w**233.7 cm. **h**115 × **w**92 in. Museum of Modern Art, New York, NY

Still Clyfford

Painting, 1944

The black expanse of paint, applied with a palette knife, is interrupted by a jagged red line which cuts through it like lightning and is in turn sliced through with yellow and white streaks of fire. Typical of Still's style, this work was painted at a formative period when most of his contemporaries were working with archaic themes, literary subjects and mythical creatures. Still broke new ground with his thickly applied abstract areas of colour which appear like slabs of earth, and his diverse textural surfaces. His paintings were an early example of Abstract Expressionism which, reminiscent of the Surrealists and their 'automatic' painting, sought to release the creativity of the unconscious mind by emphasizing spontaneity. Like his fellow Abstract Expressionists Jackson Pollock, Barnett Newman and Mark Rothko, Still tended to work on a massive scale. From 1961 he lived in rural Maryland in virtual isolation from the New York art world which he scorned.

☛ Burri, Motherwell, Newman, Pollock, Rothko

Clyfford Still. **b** Grandin, ND, 1904. **d** New Windsor, MD, 1980. **Painting, 1944**. 1944. Oil on canvas. **h**264.5 × **w**221.4 cm. **h**104⅛ × **w**87¼ in. Museum of Modern Art, New York, NY

Stuart Gilbert

George Washington

Reflecting the ideals of the country over which he presided, this portrait of the first President of the United States is an honest representation executed without pomp. The muted colours sublimate the background in favour of the face, which is painted with great realism to reflect Washington's trustworthy and capable character.

At the beginning of the eighteenth century Stuart was the most celebrated American portraitist. He lived to paint all of the first five Presidents. During the American War of Independence he lived in London and studied with the history painter Benjamin West, a fellow countryman. He returned to North America with an understanding of the portraiture of the British artists Thomas Gainsborough and Joshua Reynolds, which he infused with a characteristically frank American approach. His portrait of Washington is used as the basis for the President's image on dollar bills.

☛ Gainsborough, Houdon, Lawrence, Reynolds, West

Gilbert Stuart. b North Kingstown, RI, 1755. d Boston, MA, 1828. **George Washington**. 1795. Oil on canvas. **h**76.8 × **w**64.1 cm. **h**30¼ × **w**25¼ in. Metropolitan Museum of Art, New York, NY

Stubbs George

Mares and Foals in a Landscape

With a deft and steady hand, Stubbs has faithfully and delicately reproduced the horses and the foliage above them. The minutely observed details, such as the tail hairs and hooves, the individual colouring of each horse and the delicately painted leaves of the oak tree, have been captured with remarkable accuracy. Stubbs earned an unrivalled reputation as a painter of horses, dogs and wild animals for noble patrons. Primarily an anatomist, his depictions of horses came from hours of observation and scientific study. To assist him in his work Stubbs drew detailed anatomical studies from every conceivable angle, thoroughly examining the bone and muscle structure of horses in order truly to understand how to portray the mechanics of movement. His paintings are more than mere scientific studies, however, and show a masterful understanding of design and composition.

☞ Agasse, Audubon, Bassano, Marc, Marini

448

Sutherland Graham Portrait of Somerset Maugham

William Somerset Maugham, the English novelist and playwright, sits against a vibrant yellow wall looking quietly dignified. His features are almost caricature-like, especially his jowls and jutting chin, which appears to push his head out of the picture, towards the viewer. Sutherland was one of the leading British artists of the twentieth century. He painted many landscapes and religious paintings and in his later years became a successful portrait painter of the famous. His semi-abstract style, balanced by a superb draughtsmanship, always followed the laws of realism but his use of amorphous-like forms and agonized imagery, which had a strong influence on the young Francis Bacon, created much controversy. When this painting first appeared it was criticized for making Maugham look like 'an old Chinese madam in a brothel in Shanghai' and his famous portrait of Winston Churchill was so loathed by Lady Churchill that she destroyed it following her husband's death.

☛ Auerbach, Bacon, Freud, Organ

Graham Sutherland. b London, 1903. d London, 1980. **Portrait of Somerset Maugham**. 1949. Oil on canvas. **h**137 × **w**64 cm. **h**54 × **w**25⅛ in. Tate Gallery, London

Tamayo Rufino Woman with Red Mask

Painted in glowing sensuous colours, a woman – wearing a red mask and with a mandolin on her knees – sits upright on a chair. The sense of mystery surrounding the figure is enhanced by the intentionally limited yet vibrant colour-range of the artist's palette. Tamayo was deeply influenced by Pablo Picasso and the Cubists. This is one of the first works executed by the artist incorporating angular outlines. It is very likely that it was painted straight onto the canvas without the use of a preparatory sketch. Like his fellow Mexican Diego Rivera, Tamayo combined Mexican folk themes with a diversity of European styles, chiefly Cubism, Surrealism and Expressionism, and consistently demonstrated the pictorial values of the Mexican people and their folklore. This was painted before Tamayo's first visit to Europe in 1950. He also worked for a long time in the USA.

☛ Jawlensky, Orozco, Picasso, Rivera, Severini

Rufino Tamayo. b Oaxaca, 1899. d Mexico City, 1991. **Woman with Red Mask**. 1940. Oil on canvas. **h**121 × **w**85 cm. **h**54⁷⁄₈ × **w**33¾ in. Private collection

Tanguy Yves

The Invisibles

Abstract, biomorphic shapes climb rapier-shaped objects and appear to float upwards against a menacing, clouded sky. Tanguy was much influenced by De Chirico and joined the Surrealist movement after meeting the Surrealist writer and guru André Breton in 1925. The title and theme of this painting refer to Breton's idea of the existence of invisible animals who have escaped man's sensory frame of reference by means of camouflage. The painting's visionary quality is a clear illustration of Surrealist imagery: Tanguy has allowed his subconscious to 'create' these beings, whose existence is uncertain yet impossible to disprove. This is a common theme in much of his Surrealist art, where amorphous creatures tend to inhabit barren, hallucinatory landscapes of the mind. Neatness and precision were deeply ingrained in his personality, and these qualities are also evident in his paintings.

☞ Bellmer, Brauner, De Chirico, Dalí, Matta, Miró

Yves Tanguy. b Paris, 1900. d Woodbury, CT, 1955. **The Invisibles**. 1951. Oil on canvas. **h**98.5 × **w**81 cm. **h**38⅞ × **w**31⅞ in. Tate Gallery, London

Tàpies Antoni

Grey Ochre

The thick surface of this painting has been incised and lacerated by the artist to evoke feelings of desolation and anger, and a sense of the ravages of time. It represents a physical, forbidding obstacle yet also conveys a certain beauty and elegance through its partial destruction. Tàpies experiments with different materials, combining oil paint with crushed marble, powdered pigment or latex, for example, to create huge desolate surfaces which he covers with creases, incisions and fossil-like imprints. A sense of elapsed time, intimated by the ravaged surface of the paint, apparently worn by a duration greater than that of the artist's hand, is one of the key elements that gives Tàpies' work its enduring power. Tàpies is widely considered the most important post-war Spanish artist and his work has achieved international acclaim. Recently he has produced heavy clay sculptures of everyday objects such as baths and chairs.

☛ Burri, Dubuffet, Fautrier, Hartung, Riopelle

452

Antoni Tàpies. b Barcelona, 1923. **Grey Ochre.** 1958. Oil and marble dust on canvas. **h**259.7 × **w**194.3 cm. **h**102¼ × **w**76½ in. Tate Gallery, London

Tatlin Vladimir

Monument to the Third International

Created in a moment of political enthusiasm, this leaning spiral was designed to be twice the height of the Empire State Building in New York and to have alternately rotating central sections. Space is ordered into fragmented compartments that are formally related to each other as in a mathematic equation. Tatlin was the founder of Constructivism, a Russian art movement that grew out of artistic experiments with abstraction but later turned to more utilitarian concerns. He advocated the idea of the 'artist engineer' and saw the primary role of Constructivism as fulfilling social needs. Tatlin also created a series of hanging relief constructions using a variety of materials such as wood, metal, glass and wire and employing exclusively geometric forms. This masterpiece, a symbol of Constructivist ideals combining the disciplines of sculpture and architecture, was never constructed. The piece illustrated is a modern replica of the original model.

☛ Gabo, Lipchitz, Malevich, Popova, Rodchenko, Sheeler

453

Vladimir Tatlin. b Kharkov, 1885. d Novodevichye, 1953. **Monument to the Third International**. 1919. Wood, iron and glass. **h**420 cm. **h**165⅓ in. Musée National d'Art Moderne, Paris

Teniers David

The Archduke Leopold's Gallery

A patchwork of paintings is on display in this gallery belonging to the Regent of the Spanish Netherlands, Leopold Wilhelm of Austria. There was a widespread growth in art collecting during the seventeenth century when aristocrats, noblemen and rich bankers accumulated vast numbers of works by contemporary artists and Renaissance masters. This room is crammed with recognizable paintings by Titian, Peter Paul Rubens, Raphael, Giorgione and Annibale Carracci, among others, many of which are now in the Kunsthistorisches Museum in Vienna. The large, bearded figure of the Archduke is being shown the paintings by Teniers himself who was appointed Court Painter to the Archduke and Keeper of his paintings. He made many copies of the pictures in the collection and produced over 2,000 paintings, of every kind of subject, during his long and prolific career.

☛ Bazille, Dou, Metsu, Vermeer, Zoffany

454

Ter Borch Gerard Dancing Couple

A stylish and rather mischievous-looking courtier in military uniform asks a demure-looking young lady dressed in a sumptuous white silk gown to dance. Light falls on the couple as he takes her hand; the rest of the sparsely furnished interior and the seated onlookers fall into shadow. Ter Borch, an early Dutch portraitist and painter of genteel genre paintings, achieved recognition for his intimate, homely scenes of well-to-do family life and for the expertise with which he captured fine fabrics such as silk and satin. The detail of his paintings and the curious doll-like charm of his figures appealed to the tastes of the Amsterdam and Haarlem middle classes.

Ter Borch travelled extensively throughout Europe and must have had first-hand knowledge of almost all the great seventeenth-century artists, including Rembrandt and Diego Velázquez, yet his style of painting bears no hint of their influence.

☛ Dou, Metsu, Rembrandt, Velázquez, Vermeer

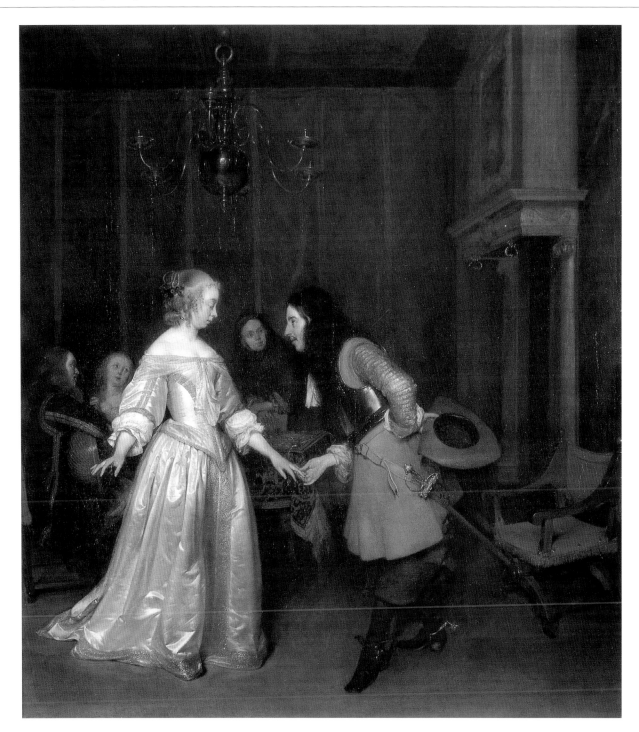

Gerard Ter Borch. **b** Zwolle, 1617. **d** Deventer, 1681. **Dancing Couple**. 1660. Oil on canvas. **h**76 × **w**66 cm. **h**30 × **w**26 in. Polesden Lacey, Dorking

Terbrugghen Hendrick The Flute Player

A young dandy dressed in a striped brocade shirt with baggy sleeves is playing a flute, his dark velvet hat setting his profile into relief. This painting appears to be free from all literary overtones – a pure evocation of a light, joyful subject. Dutch painting of this time generally held a wider symbolic meaning, however, and this picture may represent a personification of Music, or may illustrate Hearing, one of the five senses. The design of the picture is unusual: the boldly painted figure, outlined against a plain background, is viewed close-to and almost fills one-half of the picture space. This directness of composition, and the dramatic use of light and shade, show the influence of the early work of Caravaggio. Terbrugghen studied in Rome and together with Gerrit van Honthorst and other members of the so-called Utrecht School was instrumental in transporting Caravaggio's ideas to northern climes.

☛ Caravaggio, Greuze, Honthorst, Lotto

Hendrick Terbrugghen. **b** Deventer, 1588. **d** Utrecht, 1629. **The Flute Player**. 1621. Oil on canvas. **h**71.3 × **w**55.8 cm. **h**28⅛ × **w**21⅞ in. Staatliche Kunstsammlungen, Kassel

Thiebaud Wayne Various Cakes

A display of delicious cakes has been painted in bright, lurid colours – making them appear even more false and synthetic than they are in reality. Thiebaud's early work was devoted to the depiction of all-American foods, especially pies, which he executed in an impassive, realist style using thick, juicy pigment. He often repeated variations of a single object as though they were on display in a cafeteria, presenting them almost as ritualistic offerings to the spectator. The blatant rendition of the unmistakable consumer items, concentrating on their texture, colour and shape, makes the painting an important example of American Pop Art. Thiebaud worked as a freelance cartoonist and illustrator in New York before deciding to become an artist at the age of 29. He now lives and works in Sacramento and San Francisco and concentrates more on the landscapes and cityscapes of his immediate environment.

☛ Dine, Morandi, Oldenburg, Rosenquist, Wesselmann

Wayne Thiebaud. b Mesa, AZ, 1920. **Various Cakes**. 1981. Oil on canvas. **h**63.5 × **w**58.4 cm. **h**25 × **w**23 in. Private collection

Tiepolo Giovanni Battista The Finding of Moses

Pharaoh's daughter has discovered Moses floating down the River Nile in a basket. Standing in the centre of a group of male and female attendants she has entrusted the baby to a bare-footed nurse. The girl in blue on the left (to whom the nurse and old woman are pointing) is possibly Miriam who, unknown to the Egyptian Princess, is Moses' sister. Tiepolo is considered by many to be one of the greatest artists of the eighteenth century. He was a leading exponent of the Italian Rococo, a style characterized by its airy frivolity, joyous sense of colour and playful effects. His work is praised for its luminous tones and imaginative compositions. The last of the great Venetian decorators, some of his most impressive works were commissioned for church ceilings. The abundance of his work was partly thanks to a large workshop where he employed his two sons and daughter.

☛ Amigoni, Boucher, Canova, Fragonard

Giovanni Battista Tiepolo. b Venice, 1696. d Madrid, 1770. **The Finding of Moses**. c1730. Oil on canvas. **h**202 × **w**342 cm. **h**79 × **w**134 in. National Gallery of Scotland, Edinburgh

Tinguely Jean

Trophy of Chasse-Le-Golem

This ramshackle sculpture is created from a variety of incongruous objects that have been welded together. The addition of an electric motor enables the static object to be transformed into a living work of art. When the electric current is turned on the wheel slowly begins to revolve, clanking and groaning the assemblage into action. The motile quality of the sculpture connects it to the Kinetic Art movement, based on the idea that light and movement can create a work of art, while its use of manufactured items together with its exhibitionist nature make it a late example of New Realism. Throughout the late 1950s and 60s Tinguely created self-propelling, edible and musical machines. He is renowned for organizing a number of public events which involved the construction and rapid deterioration of machines, the most famous of which occurred at the Museum of Modern Art in New York in March 1960.

☛ Calder, Klein, Nauman, Viola

Jean Tinguely. b Fribourg, 1928. d Fribourg, 1991. **Trophy of Chasse-Le-Golem**. 1990. Iron, steel, rubber band, electric motor and hippopotamus jaw-bone. **h**177.8 cm. **h**70 in. Gimpel Fils, London

Tintoretto Jacopo The Annunciation

The Archangel Gabriel, accompanied by numerous cherubs, violently bursts in upon a startled Virgin. In contrast to contemporary scenes of the Annunciation, the Virgin is represented living in a house of decayed splendour and she is dressed in simple clothes. Outside, Joseph works on his carpentry, unaware of the dramatic events occurring within. Little is known of Tintoretto's early years but he claimed to be a pupil of Titian. He is the leading representative of the Italian Mannerist style and his work is marked by its outstanding sense of drama, achieved by the use of unexpected viewpoints and striking perspective, extreme contrasts of scale and brilliant effects of light and colour. Tintoretto became the embodiment of Venice's cultural energies; during his long and prolific career he left the city just once, for a brief visit to the city of Mantua.

☛ Fra Angelico, Bordone, Martini, Palma Vecchio, Titian

460

Jacopo Tintoretto. **b** Venice, 1518. **d** Venice, 1594. **The Annunciation**. 1583/7. Oil on canvas. **h**421.6 × **w**544.8 cm. **h**166 × **w**214½ in. Scuola Grande di San Rocco, Venice

Tissot James

Holiday (The Picnic)

Yellowing leaves of the chestnut tree shade a group of well-dressed men and women who are enjoying a picnic beside a pond. The canvas, painted in the backyard of Tissot's London house which was near Lord's Cricket Ground, sparkles with colour and exquisite detail. In his depiction of daily life in an outdoor setting, Tissot shares the realism of French artists such as Édouard Manet. His style is also akin to that of the Impressionists, who were working at exactly the same time as Tissot, but his paintings differ in their crystal-clear vision and elegant society subjects. Tissot often focused on finely dressed women, adorned in the latest fashions and casting a spell over their men. His paintings have recently enjoyed a well-deserved revival in popularity; for many years they were regarded as the epitome of late Victorian vacuous and decadent society.

☛ Dufy, Fragonard, Manet, Renoir, Sargent

James Tissot. **b** Nantes, 1836. **d** Buillon, 1902. **Holiday (The Picnic)**. c1876. Oil on canvas. **h**76.2 × **w**99.4 cm. **h**30 × **w**39⅛ in. Tate Gallery, London

Titian

Diana and Actaeon

Sumptuous colour, captivating movement and harmonious composition mark this as a masterpiece of Titian's work. The young prince Actaeon has stumbled upon Diana, the virgin huntress and symbol of chastity (identified by her crescent moon), who is bathing with her nymphs in a remote grotto in the forest. Diana is so incensed at Actaeon for having glimpsed her divine nudity that she transforms him into a stag, to be hunted to death by his own hounds. Titian's imaginative powers reached their zenith in the interpretations of ancient legends and Classical myths which he created during the 1550s at the instigation of Philip II of Spain, his principal patron. Titian was the greatest of Venetian painters. During his last years his style developed a very free handling which almost anticipated the work of the Impressionists in its rendering of colour and light and ease of form.

☛ Guercino, Lotto, Rubens, Veronese, Vouet

Titian (Tiziano Vecellio). b Pieve di Cadore, c1488/9. d Venice, 1576. **Diana and Actaeon.** 1556–9. Oil on canvas. **h**184 × **w**202 cm. **h**72½ × **w**79½ in. On loan to the National Gallery of Scotland, Edinburgh

Tobey Mark

White Journey

The surface of the paper swarms with minute abstract signs and scratches of paint creating an apparently chaotic pattern. The frenetic rhythm created by these intricate and delicate lines is typical of Tobey's style; it is this sophistication and dynamism that has made his work so popular with collectors. Although the composition is similar to paintings created by members of the Abstract Expressionist movement, notably Jackson Pollock, Tobey pursued a unique parallel development partly through the influence exerted on him by the Far East. He was deeply influenced by Chinese calligraphy and was one of the first American intellectuals to become interested in Zen Buddhism. Tobey achieved international recognition in the 1950s as one of America's foremost painters and enjoyed a strong reputation in Europe which was developed by his highly successful and influential Swiss dealer Ernst Beyeler.

☞ Kline, Pollock, Riopelle, Ryman

Mark Tobey. b Centreville, WI, 1890. d Basel, 1976. **White Journey**. 1956. Distemper on paper. **h**113.5 × **w**89.5 cm. **h**44⅝ × **w**35¼ in. Beyeler Collection, Basel

Toulouse-Lautrec Henri de Dance at the Moulin Rouge

The Moulin Rouge, a dance hall in Montmartre, Paris, still exists today. At the end of the nineteenth century it was a popular venue for middle-class gentlemen who, accompanied by women of dubious character, were entertained by lively spectacles and dancing. Toulouse-Lautrec, now one of the best known of all nineteenth-century French artists, frequently spent whole nights at the Moulin Rouge, drinking and sketching music-hall stars and members of royalty who wandered into this dark, somewhat seedy world. The rapid style and visible brushstrokes of this work show that Toulouse-Lautrec painted it as he sat in the dance hall. An aristocrat by birth who was severely disabled in childhood, Toulouse-Lautrec always felt isolated from society by his deformity. He preferred the company of the marginal classes and surrounded himself with the actresses, clowns, dancers and prostitutes who became the subjects of his paintings.

☞ Degas, Renoir, Laurencin, Seurat, Severini

464

Henri de Toulouse-Lautrec. b Albi, 1864. d Gironde, 1901. **Dance at the Moulin Rouge**. 1890. Oil on canvas. **h**115 × **w**150 cm. **h**45¼ × **w**59 in. Philadelphia Museum of Art, Philadelphia, PA

De Troy Jean-François The Oyster Lunch

Inside a sumptuously decorated Rococo palace, a group of wealthy nobles, dignitaries and aristocrats are enjoying a lavish feast of oysters and champagne. De Troy's rich use of colour, influenced by the work of Titian and Peter Paul Rubens, and the meticulous attention paid to details, such as the crusty bread on the table, the baskets of oysters in the foreground and the bottles left to cool in the ice-cabinet, give a sense of the extravagance of this event. The painting was commissioned by Louis XV for his private apartments at Versailles. De Troy enjoyed a great reputation in his day as a skilful decorator, portraitist and genre painter. He spent much time in Italy enjoying social as well as artistic activities and in 1738 he was appointed director of the Académie de France in Rome. There he is alleged to have died of grief upon receiving the terrible news that he was to return to France and leave behind the woman he loved.

☞ De Heem, Kalf, Lucas van Leyden, Rubens, Titian

Jean-François de Troy. b Paris, 1679. **d** Rome, 1752. **The Oyster Lunch**. 1735. Oil on canvas. **h**186 × **w**120 cm. **h**73¼ × **w**47¼ in. Musée Condé, Chantilly

Turner J M W

Snowstorm: Steamboat off a Harbour's Mouth

A small ship is caught in the heart of a storm and struggles to keep afloat. The sea, snow and smoke from the ship's engine have been sucked together in a swirling mass of lashing wind and spray which Turner has captured with all the unhesitating spontaneity of a modern abstract artist. Well ahead of his time, few people understood Turner's work during his lifetime but today he is regarded as the most masterly of British painters. His work in watercolours and oils captures the magical effects of light, colour and movement in pale glowing colours. Towards the end of his life Turner showed particular interest in the conflict between the elements.

In order to paint this picture and capture the true atmospheric effects of a storm, he is said to have had himself tied for four hours (at the age of 67) to the bridge of a steamboat, sailing from Harwich in bad weather.

☛ Church, Cozens, Friedrich, Martin, Monet, Pollock

J M W (Joseph Mallord William) Turner. b London, 1775. d London, 1850. **Snowstorm: Steamboat off a Harbour's Mouth**. 1842. Oil on canvas. **h**91 × **w**122 cm. **h**36 × **w**48 in. Tate Gallery, London

Twombly Cy

Bolsena

Random scrawls and scribbles animate the surface of this painting, recalling the freedom of expression of a child's drawing. The loose, unordered style allows forms and images to emerge and melt in the imagination. The system of lines has its own meaning, although to the observer this meaning may be unclear. The artist's paintings are deliberately meant to represent something unintelligible or inexplicable. Twombly is totally unhindered by traditional formulae and ideas of composition. Like the Abstract Expressionists, he favours a formless, prosaic response to the creative impulse. Lines, scribbles and lettering form the substance of his pictures, usually on a white or partially white background. Twombly shows some affinity with Jackson Pollock, although his works are more disjointed and deliberately provocative and lack Pollock's innate lyricism and harmony.

☛ Basquiat, De Kooning, Dubuffet, Pollock, Schwitters

Cy Twombly. b Lexington, VA, 1929. **Bolsena**. 1969. Oil, coloured chalk and pencil on canvas. **h**200 × **w**240 cm. **h**78¾ × **w**94½ in. Private collection

Uccello Paolo

The Battle of San Romano

This is one of three panels illustrating the Florentine victory over the Sienese at the Battle of San Romano in 1432 which were originally hung in the great hall of the Palazzo Medici in Florence. This image shows the leader of the Florentine troops, Niccolò da Tolentino, mounted on a white horse during battle. Uccello was fascinated with how to depict space and became absorbed in the art of perspective and foreshortening. This is particularly evident in the corpse dressed in battle armour and the broken lances which lie on the ground as if they have fallen on the receding lines of the picture's perspective. Uccello's genius, however, expresses itself here above all in the profusion of detail and curious forms and in the marvellously fanciful background. A painter, mosaicist, decorator and master of marquetry, Uccello was one of the most skilled and conscientious craftsmen of his time.

☛ Castagno, Gozzoli, Masaccio, Piero della Francesca

Paolo Uccello. b Florence, 1397. d Florence, 1475. **The Battle of San Romano**. c1450. Tempera on panel. **h**182 × **w**320 cm. **h**71½ × **w**126 in. National Gallery, London

Utamaro Kitagawa Lovers

Two lovers, their faces almost hidden, embrace in a room that opens out onto a garden terrace. Their naked bodies can be glimpsed through the delicate swathes of the patterned silk kimonos. The print is composed of flowing lyrical lines which gracefully delineate the forms and there is no shading or suggestion of depth. A master of the woodblock print, Utamaro was the first Japanese artist to become well known in the West. In contrast to the Western tradition, he was not concerned with creating natural poses and depth but flat shapes and patterns. His approach greatly influenced artists such as Edgar Degas in the nineteenth century, who were seeking a new mode of expression and a fresh way of viewing the world. This print comes from *The Poem of the Pillow*, probably the finest of Utamaro's erotic albums. Sumptuously produced with an astonishing collection of colour prints these books also depicted amusing scenes from Japanese legends.

☛ Cellini, Degas, Gauguin, Hokusai, Rodin, Whistler

469

Kitagawa Utamaro. **b** Tokyo, 1753. **d** Tokyo, 1806. **Lovers** (from *The Poem of the Pillow*). 1788. Woodblock print on paper. **h**24.8 × **w**37.4 cm. **h**9¾ × **w**14¾ in. Victoria and Albert Museum, London

Utrillo Maurice

Flag Over the Town Hall

An air of tranquillity dominates this simple view of a small town where a group of people are gathered outside the white wall of a garden. Only the French flag flying above the town hall is painted in bright colours, punctuating the otherwise earthy tones of the canvas. Utrillo was the illegitimate son of Suzanne Valadon, an artist and model of Auguste Renoir, Edgar Degas and Henri de Toulouse-Lautrec. She persuaded her son to start painting in 1902, following one of the many bouts of alcoholism and drug abuse which afflicted him throughout his life, and he revealed a remarkable talent. An intense feeling of atmosphere dominates many of Utrillo's paintings, enhanced by his unerring use of colour and tone. Utrillo produced mostly townscapes, including many street scenes of the area around Montmartre. These became so popular that they have spawned countless imitations and forgeries.

☛ Degas, Dufy, Foujita, Laurencin, Renoir

Maurice Utrillo. b Paris, 1883. **d** Dax, 1955. **Flag Over the Town Hall**. 1924. Oil on canvas. **h**98 × **w**130 cm. **h**38½ × **w**51⅛ in. Musée de l'Orangerie, Paris

Vallotton Félix

Landscape with Trees

The sinuous curves of the trunks and the clumped masses of leaves are the focal point of this study. The trees have been reduced to their simplest shapes and the pattern created by the trunks is silhouetted against the evening sky. Vallotton was a member of the Nabis, a group of late nineteenth-century French painters, including Pierre Bonnard, Édouard Vuillard and Maurice Denis, who were deeply influenced by Paul Gauguin's use of Symbolism and flat, pure colour. Like the Impressionists, Vallotton was interested in painting nature from life. He did not share their wish to capture the fleeting moment, however, preferring to focus on the tangible shapes and colours before him. The result is a meticulous and sometimes cruelly realistic style through which his landscapes often achieve great depth of feeling. After visiting an exhibition of Japanese prints in 1890, Vallotton became a prolific wood-engraver.

☛ Bonnard, Denis, Gauguin, Hiroshige, Pissarro, Vuillard

Félix Vallotton. b Lausanne, 1865. **d** Paris, 1925. **Landscape with Trees**. 1911. Oil on canvas. **h**100 × **w**73 cm. **h**39⅓ × **w**28¾ in. Musée des Beaux-Arts, Quimper

Vasarely Victor Pal-Ket

Purple, blue and green geometric shapes, arranged in a chessboard pattern, appear to float on and distort the canvas. Through using opposing systems of perspective and violently contrasting colours, Vasarely has deliberately created an optical illusion, giving an impression of movement to the painting. The shapes appear to shift under the eye. Vasarely was one of the pioneers of Optical art, known by the nickname Op Art, which developed alongside Pop Art in the 1960s. Op Art is based on the idea that the artist, whether painter or sculptor, can persuade the spectator to see visual illusions by creating optical effects. Vasarely was fascinated with the concept of perception and how real or ambiguous images can be created by using exact geometric principles. Hungarian by birth, Vasarely moved to Paris in 1930. His work in painting, sculpture, prints and drawings is always abstract in nature and relies on the manipulation of visual sensations for its effect.

☛ Albers, Flavin, Hayter, Riley, Vieira da Silva

Victor Vasarely. b Pecs, 1908. d Annet-sur-Marne, 1997. **Pal-Ket**. 1973–4. Acrylic on canvas. **h**151.2 × **w**150.8 cm. **h**59½ × **w**59⅜ in. Museo de Bellas Artes, Bilbao

Velázquez Diego de Silva y Las Meninas

The five-year-old daughter of King Philip IV of Spain, the Infanta Margareta-Teresa, stands in the centre of the canvas surrounded by her retinue of maids and dwarfs. Velázquez has depicted himself on the left of the canvas, painting a huge portrait of the King and Queen who can be seen reflected in the mirror directly behind the Infanta's head. Velázquez is one of the greatest portraitists of all time and this work is considered the masterpiece of his final years. He was little influenced by other artists although in 1623 he was appointed Court Painter in Madrid and became aware of Titian's work in the Spanish Royal Collection. He also met Peter Paul Rubens, who shared his studio for a short while and is believed to have inspired Velázquez to visit Italy. Velázquez had a deeply sensitive appreciation of character. His painting is characterized by freely painted harmonies of colour and tone and a unique blend of realism with atmosphere.

☛ Goya, El Greco, Kirchner, Rubens, Titian, Zurbarán

Diego de Silva y Velázquez. **b** Seville, 1590. **d** Madrid, 1660. **Las Meninas**. 1656. Oil on canvas. **h**318 × **w**276 cm. **h**127 × **w**108½ in. Museo del Prado, Madrid

Vermeer Jan

Lady Seated at a Virginal

In this deceptively simple painting of an interior a young girl sits at a virginal with a viola da gamba to her left and a painting on the wall behind her. A feeling of space dominates the canvas, creating a sense of timelessness and otherworldliness. We only gradually become aware of the picture's rich and meticulous colouring. Vermeer was one of the greatest of the seventeenth-century Dutch painters and he surpassed all others in his portrayal of domestic interiors. The poetry of his vision and the brilliant splendour of the light he captures evokes the work of his fellow countryman Jan van Eyck. Very little is known of Vermeer's life. His calm and peaceful paintings derive from his own meditation and analysis of the world around him. He died in debt at the age of 43, leaving a widow and 11 children. His paintings were almost completely forgotten until the mid-nineteenth century.

☛ Dou, Van Eyck, Hammershøi, De Hooch, Metsu

Jan Vermeer. b Delft, 1632. d Delft, 1675. **Lady Seated at a Virginal**. 1674–5. Oil on canvas. **h**51 × **w**46 cm. **h**20¼ × **w**18 in. National Gallery, London

Veronese

The Finding of Moses

The silk brocade of the dress worn by the principal figure is so crisp and delicately portrayed it is tempting to touch its luxurious folds. Venetian artists are often said to have been great colourists, but Veronese was arguably the greatest of them all. The deep blues, ochres and transparent greys of the dresses display his fondness for rich hues and bright tones. In this painting, a late work, his finesse with loose brushwork can also be admired. Veronese specialized in vast narrative paintings of biblical, allegorical or historical subjects in which he included crowds of elegantly dressed figures, accompanied by courtiers, musicians, soldiers, horses, dogs or monkeys, set within monumental architecture or against verdant landscapes. As his name implies, Veronese originally came from Verona, but he settled in Venice where he was particularly influenced by the work of Titian.

☛ Giorgione, Tiepolo, Tintoretto, Titian

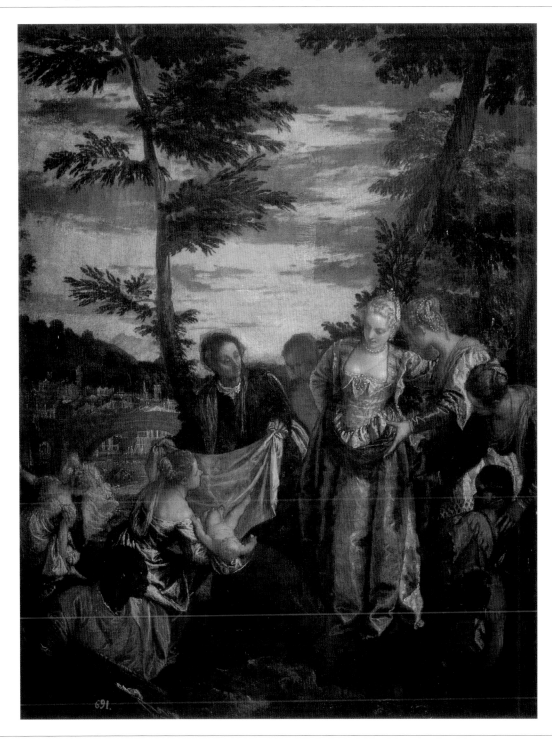

Veronese (Paolo Caliari). b Verona, 1528. d Venice, 1588. **The Finding of Moses**. c1580. Oil on canvas. **h**50 × **w**43 cm. **h**19¾ × **w**17 in. Museo del Prado, Madrid

Verrocchio Andrea del Bust of a Woman Holding a Nosegay

The crisply carved folds of this woman's dress have been created by the hand of a master sculptor. The head looks out and slightly upwards and the hands, which were the first to be shown in a portrait bust, are placed irregularly on the breast. Although Florentine artists of the Renaissance were proficient in most media and techniques,

Verrocchio's versatility was exceptional. Trained as a goldsmith, he was also a painter, a sculptor and one of the most accomplished draughtsmen of the Renaissance. He led an extremely active workshop in Florence which trained a number of artists to be goldsmiths, sculptors and painters. These included Perugino among others, but the

most famous product of Verrocchio's tutelage was Leonardo da Vinci. Leonardo's famous drawings and paintings are founded on his master's style and his hand can be recognized in some of Verrocchio's own paintings and sculpture.

☞ Algardi, Donatello, Ghirlandaio, Leonardo, Perugino

476

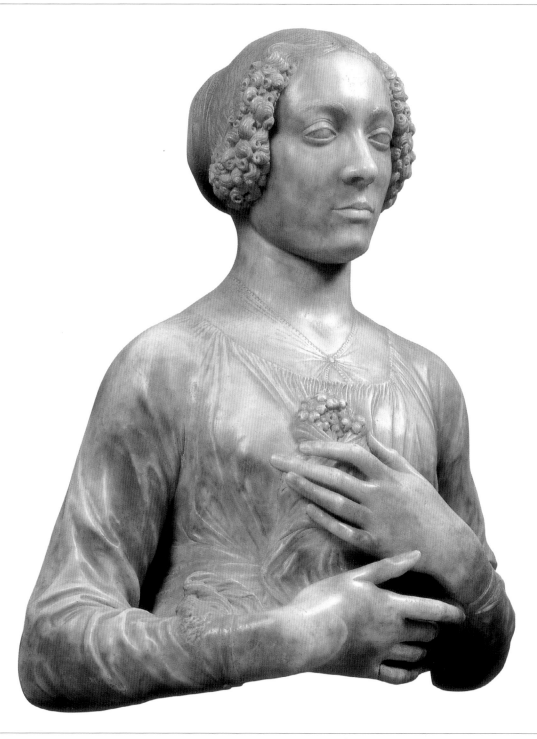

Andrea del Verrocchio. b Florence, 1435. **d** Venice, 1488. **Bust of a Woman Holding a Nosegay**. c1480. Marble. **h**60 cm. **h**23²⁄₃ in. Museo Nazionale del Bargello, Florence

Vieira da Silva Maria Elena Checkmate

Juxtaposed squares, rectangles and lozenges in soft muted colours and random diagonal formations have been woven together to form a net-like pattern. A system of perspective has been employed so that the central chessboard pattern slowly recedes into the distance. The surface of the canvas appears to twist and turn but the painting is not disturbing.

Instead, the use of gentle light and soft colours creates a peaceful and mysterious atmosphere. Vieira da Silva was a French painter of Portuguese origin. She initially worked as a sculptor with Émile Bourdelle and then, after moving to Paris, studied painting under Fernand Léger and engraving with Stanley William Hayter. During the 1930s she

developed into an abstract painter and produced a multitude of works which are characterized by a use of muted colour contrasts, often dominated by tones of greys and whites, and of linear structures placed against amorphous grounds.

☛ Bourdelle, Hayter, Léger, Poliakoff, Riopelle, Vasarely

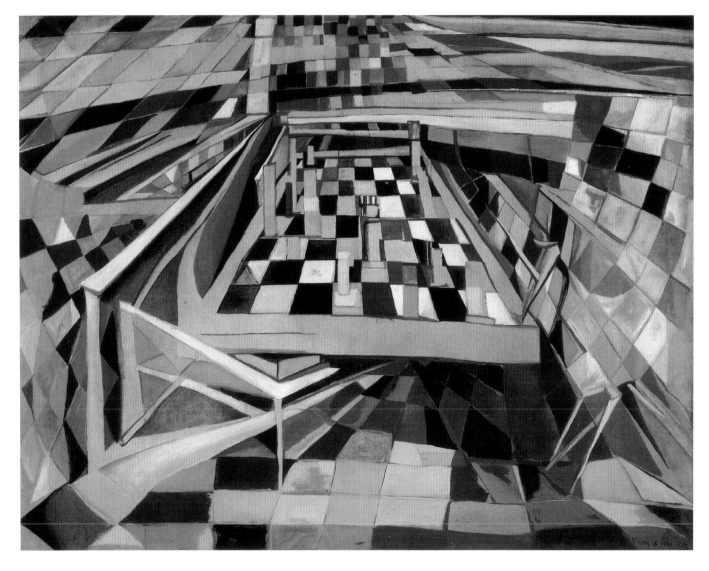

Maria Elena Vieira da Silva. b Lisbon, 1908. d Paris, 1992. **Checkmate**. 1949–50. Oil on canvas. **h**89 × **w**116 cm. **h**35 × **w**45⅝ in. Private collection

Vigée-Lebrun Marie-Louise-Élisabeth — Self-portrait

The artist sits holding a handful of paintbrushes and a palette, her right hand at work on one of the portraits which made her famous. Painted on a neutral ground, this self-portrait is brought to life by the artist's radiant features and the rich, triumphant red of the material around her waist, which is repeated on the tip of one of the brushes. Vigée-Lebrun was noted for her wit and beauty and a sense of her charming personality is evoked by her peaceful gaze and engaging smile. Although she was aged 35 at the time of this painting, she has painted a somewhat idealized image of herself in the full bloom of innocent youth. This soft, flattering style of portraiture made Vigée-Lebrun highly sought-after throughout Europe. She excelled in portraits of women and children; her reputation as an artist was confirmed when she executed a portrait of Queen Marie-Antoinette who she is said to have painted 25 times.

☞ Anguissola, Greuze, Mengs, Ramsay, Sherman

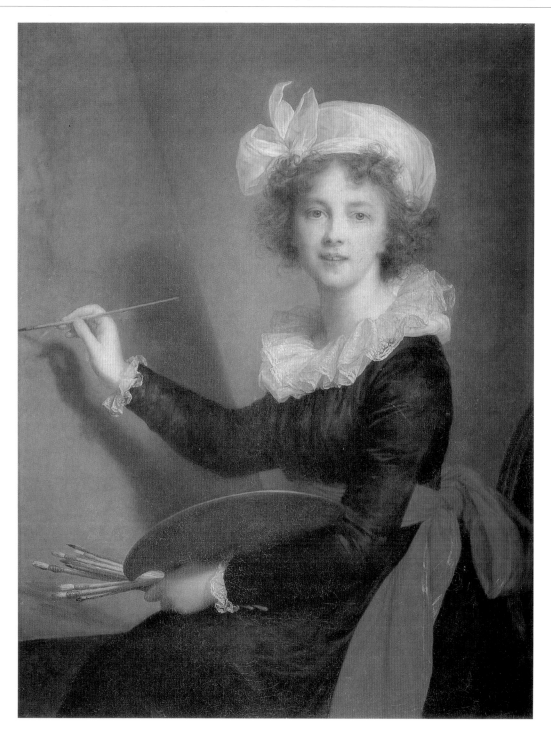

478

Viola Bill

To Pray Without Ceasing

The cycle of life – from the birth to the death of man, from the explosion of the universe to total darkness – is condensed into the space of a day in this video installation. A sequence of images flows across a TV screen in 12-hour cycles, computer programmed to repeat twice a day, seven days a week. A disembodied voice can also be heard reciting excerpts from Walt Whitman's poem *Song of Myself*. The images are strongest at night but washed out by daylight when only the voice can be discerned. Projecting itself like a glowing icon, the work's title further suggests that this is a devotional object: it is almost a contemporary Book of Hours, as each image relates to a specific time of day. Viola takes state-of-the-art video, audio and information technology into visionary realms, drawing on sources ranging from ancient mystic teachings to the LA riots in an exploration of the unconscious mind.

☛ Beauneveu, Flavin, Limbourg, Merz, Nauman

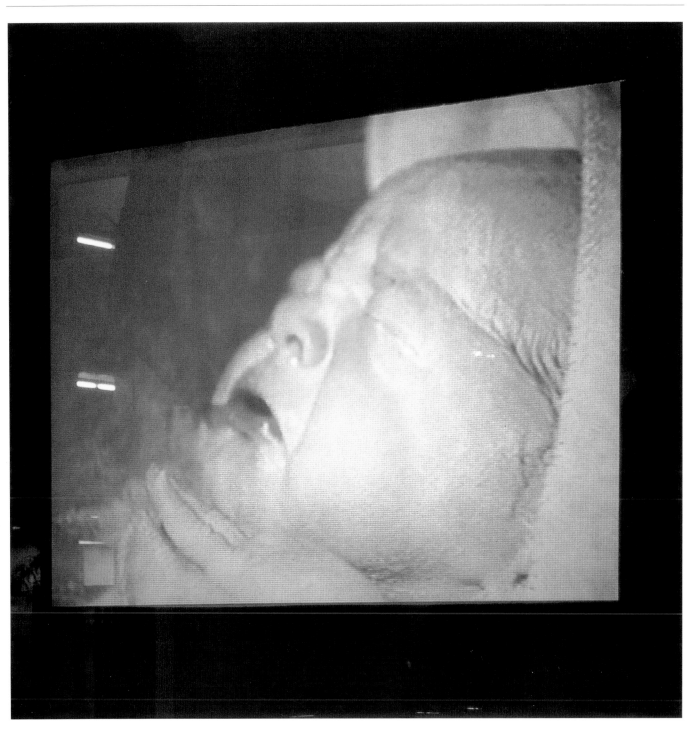

Bill Viola. **b** New York, NY, 1951. **To Pray Without Ceasing**. 1992. Video installation. Dimensions vary depending on size of screen. Private collection

Vlaminck Maurice de The Circus

Sweeping brushstrokes of blues, oranges and pinks have reduced the circus tent and the surrounding houses to their most basic shapes. The perspective has been distorted to create a highly expressive and turbulent scene. Largely self-taught, Vlaminck was a professional racing cyclist until he met the artist André Derain in 1900 and began to paint

seriously. In 1905 he became a member of the Fauve movement, a group of artists including Derain, Henri Matisse and Georges Rouault who exhibited together at the Paris Salon. With its distorted forms and flat patterns painted in violent colours, their work created such a furore that a critic dubbed them *les fauves* ('the wild beasts'). Some

of Vlaminck's best work dates from the Fauve period. Initially influenced by the expressive quality of Vincent van Gogh, from 1907 Vlaminck became interested in the work of Paul Cézanne and he rejected bright colours in favour of sombre tones and more traditional subjects.

☛ Derain, Van Gogh, Heckel, Kirchner, Peckstein

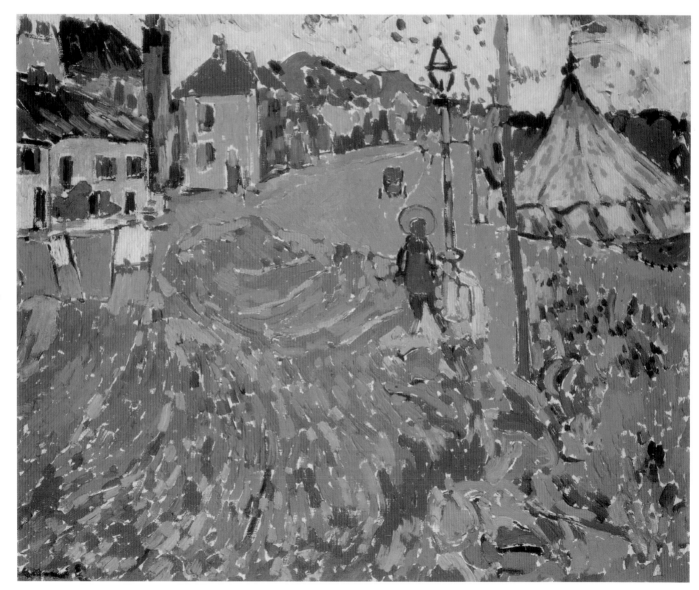

Maurice de Vlaminck. **b** Paris, 1876. **d** Rueil-de-Gadelière, 1958. **The Circus**. 1906. Oil on canvas. **h**60 × **w**73 cm. **h**23²⁄₃ × **w**28¾ in. Private collection

Vouet Simon

Time Overcome by Hope, Love and Beauty

Two young women with deadly looking weapons threaten an old man who desperately tries to protect himself. The scythe that lies beneath him and the hourglass that he holds in his left hand tell us that he is Time. The two women are personifications of Hope (on the left) and Beauty (on the right); together with Love (the cherub Cupid) they are seen triumphing over Old Man Time, suggesting that Youth, Beauty and Love are eternal and immutable values. The extravagant gestures of all three figures, and the billowing movement of the draperies as the figures push and pull against each other, are hallmarks of Vouet's classicized Baroque style of painting. His richly coloured and highly dramatic compositions, mostly of religious and allegorical works, set the artistic fashion in seventeenth-century Paris. He painted many large decorative paintings, most of which have unfortunately been destroyed.

☛ Bronzino, Caravaggio, Carracci, Domenichino, Poussin

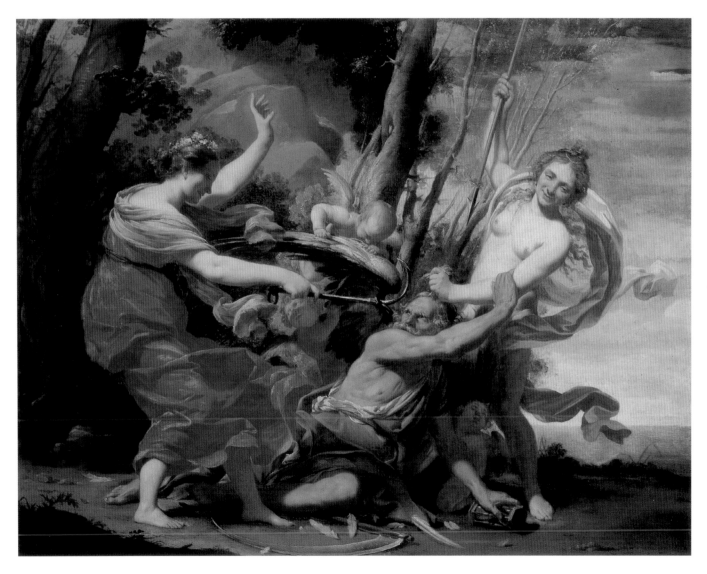

Simon Vouet. b Paris, 1590. d Paris, 1649. **Time Overcome by Hope, Love and Beauty**. 1627. Oil on canvas. **h**107 × **w**142 cm. **h**42$\frac{1}{8}$ × **w**55$\frac{7}{8}$ in. Museo del Prado, Madrid

Vuillard Édouard

Two Schoolboys

Two young boys play in a public garden which Vuillard has turned into a magical dream world. The mottled bands of chalky browns and greens create speckled harmonies of colour, giving a delicately vibrant effect to the surface. Vuillard was commissioned to paint a series of nine large panels for the dining-room of a smart Parisian town house. The panels were an amalgam of his impressions of the parks of Paris, where he sketched children playing and recorded the patterns of shadow and light. Vuillard was inspired by the shimmering techniques of Georges Seurat and Claude Monet and these panels in particular recall the paintings Monet executed of his garden at Giverny. Vuillard is renowned for his use of bold but sensual colour harmonies, a feeling for textures and patterned shapes, and for having the rare ability to evoke atmosphere and reveal the mysterious charm of everyday life.

☛ Bonnard, Denis, Homer, Monet, Seurat, Vallotton

482

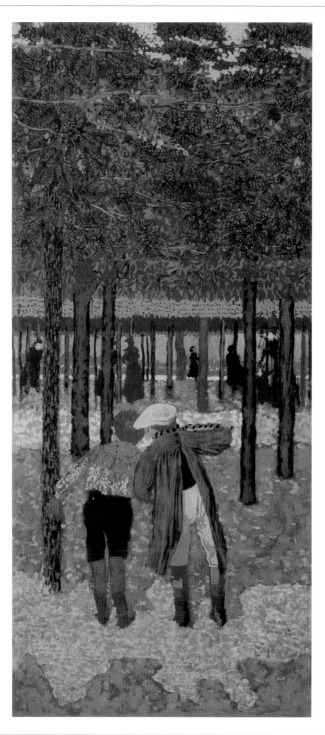

Édouard Vuillard. b Cuiseaux, 1868. d La Baule, 1940. Two Schoolboys. 1894. Distemper on canvas. h212 × w96 cm. h83½ × w37¾ in. Musées Royaux des Beaux-Arts de Belgique, Brussels

Wadsworth Edward The Beached Margin

Nautical objects are assembled in bold relief against a marine background of sea and sand. The painting displays Wadsworth's technical ability and meticulous draughtsmanship: the minutest details are depicted with startling detail and the difficult medium of egg tempera (which he mixed himself) is handled skilfully. The imaginative quality of these fantastic geometric creations gives an intellectual pleasure much greater than is offered by the usual still life. The painting comes close to Surrealism in its use of unexpected juxtapositions and in its hyper-real clarity. During the First World War, Wadsworth joined the Royal Navy and designed and painted camouflage for ships. This led to an overriding passion for the sea and ships, recurrent subjects in his work. As well as his paintings and engravings, Wadsworth also executed a number of mural decorations, notably for the liner *Queen Mary*.

☛ Carrà, De Chirico, Dalí, Lewis, Nash

Edward Wadsworth. b Cleckheaton, 1889. d London, 1949. **The Beached Margin**. 1937. Tempera on linen. **h**71.1 × **w**101.6 cm. **h**28 × **w**40 in. Tate Gallery, London

St Ives with Godrevy Lighthouse

A town with its harbour and lighthouse is depicted from a high vantage point. The work has a flat, naive quality, recalling images created by children; it is completely free from optical mannerisms such as perspective or a vanishing point. Much of the brown card has been left visible, forming the colour-base of the painting to which only pale blue, green, white and black have been added. Wallis worked as a fisherman all his life and only started to paint in his 60s. Discovered by Ben Nicholson, he became the most influential British 'primitive' artist through his effect on the St Ives painters in Cornwall. His paintings, mainly of ships, coasts and harbours, were not drawn from life but were spontaneous responses to remembered or imagined experiences. Wallis often worked on pieces of cardboard cut into irregular shapes, a technique that was later emulated by the more sophisticated St Ives painters.

☛ Gontcharova, Lowry, Nicholson, H Rousseau, Wadsworth

Alfred Wallis. b Devonport, 1855. d Madron, 1942. **St Ives with Godrevy Lighthouse**. c1935. Oil and pencil on card. **h**17 × **w**95 cm. **h**6⅔ × **w**37⅓ in. Private collection

Warhol Andy

Marilyn

Marilyn Monroe's face is presented as an impenetrable mask in bright luminous colours. Published in ten different colour combinations, using the impersonal screenprinting process, the multi-coloured surface portrays her image in a startlingly lurid manner. Monroe is probably Warhol's most famous subject. He used a publicity still as the basis for this and other pictures of her, presenting us with a frozen image that reinforces the universal power of the most tragic of all Hollywood's personae. The portrayal of Monroe as a product of mass culture, packaged for the public as if a consumer item, connects this work to the American Pop Art movement.

Warhol, a painter, graphic artist and film-maker, was a cult figure during the 1960s. He remained, however, an intensely private man, saying: 'If you want to know everything about me, just look at the surface of my paintings, it's all there, there's nothing more.'

☛ De Kooning, Lichtenstein, Oldenburg, Rosenquist, Wesselmann

Andy Warhol. **b** Pittsburgh, PA, 1928. **d** New York, NY, 1987. **Marilyn**. 1967. Screenprint on paper. **h**91.5 × **w**91.5 cm. **h**36 × **w**36 in. Museum of Modern Art, New York, NY

Waterhouse John William — The Lady of Shalott

The luminosity of this painting and its careful attention to detail heighten the emotion in this episode from Tennyson's poem. One can almost feel the cool of the day as the doomed girl begins her final journey, her haunting beauty dominating the scene. Apart from telling a tragic story, this work is an exercise in closely observed landscape painting – each rush and reed has been painstakingly depicted and the same attention has been paid to rendering the reflections on the water. Waterhouse was a follower of the Pre-Raphaelite artists and continued their interest in depicting scenes from poetry and mythology. He displayed an unerring feel for the dramatic moment, combined with a fine sense of composition and superb painting technique. Above all, though, it is the beauty of his wistful female models (in this instance believed to be the artist's wife) that has ensured the artist's lasting popularity.

☛ Alma-Tadema, Burne-Jones, Leighton, Martini, Millais

John William Waterhouse. b Rome, 1849. **d** London, 1917. **The Lady of Shalott**. 1888. Oil on canvas. **h**153 × **w**200 cm. **h**60½ × **w**78¾ in. Tate Gallery, London

Watteau Antoine The Embarkation for Cythera

Verdant trees, plump cherubs, amorous couples and sumptuous silks grace this vision of graceful gallantry. The festooned statue of Venus and Cupid emphasizes that this Arcadia is devoted to the pursuit of love. There is nothing overtly erotic about the painting, but it has an undeniable sensuousness. Like many of Watteau's paintings, its magical frivolity contains an undercurrent of melancholy – the wistful backward glance of the central figure seems to hint at the transitoriness of pleasure. Watteau championed this type of idyllic, festive landscape and brought the genre, which is typical of the Rococo style, to a height never reached before. He held a great admiration for the work of Peter Paul Rubens, who was the main influence on his work. Watteau's sophistication and elegance are inherently French and reflect the pomp and extravagance of the Court of Louis XIV at Versailles.

☛ Boucher, Fragonard, Giorgione, Lancret, Rubens

Antoine Watteau. **b** Valenciennes, 1684. **d** Nogent-sur-Marne, 1721. **The Embarkation for Cythera**. 1718. Oil on canvas. **h**130 × **w**192 cm. **h**51¼ × **w**75½ in. Schloss Charlottenburg, Berlin

Weight Carel

Daisy in the Garden

The mundane and depressing atmosphere of a typical urban back garden in south-west London on an overcast day has been effectively captured in this precisely painted work. Weight's open brushwork heightens the intensity of the scene; in a mysterious way the bleak and dingy surroundings appear to amplify the loneliness of the human figure as she walks through the garden towards us. The originality of the painting is demonstrated by Weight's instinctive feeling for the subject. An individualist who avoided the commercial art world, Weight painted personal visions of everyday life imbued with an uneasy feeling. His figures are painted in urban and rural environments and are often running or walking briskly towards the edge of the painting, as if escaping. His compositions sometimes include spirits, ghosts and witches. Most of his scenes are set in south London where he lived and worked.

☛ Freud, Rego, Sickert, Spencer

Carel Weight. b London, 1908. d London, 1997. **Daisy in the Garden**. c1962. Oil on canvas. **h**76.2 × **w**101.6 cm. **h**30 × **w**40 in. Private collection

Wesselmann Tom Great American Nude No. 27

The erotic image of the spread-legged nude, her features left blank to avoid any suggestion of a portrait, is juxtaposed with cut-out images of milkshakes and ice-creams. This was one of a series of works created by Wesselman in the early 1960s in which he combined nudes depicted in flat, clear colours with collage elements taken from brochures or posters. The painting's importance lies in its conspicuous demonstration of sexual freedom, painted at a time when nudity in the American media was still rare, and its inclusion of the direct imagery of the new consumer age. This manipulation of erotic symbols and the popular culture of a consumer society connects the painting to the American Pop Art movement. From 1983 Wesselman abandoned painting on canvas and turned to the construction of cut-out metal wall-pieces derived from felt-tip or ink drawings.

☛ Boucher, Jones, Hamilton, Polke, Rosenquist, Warhol

Tom Wesselmann. b Cincinnati, OH, 1931. **Great American Nude No. 27**. 1962. Enamel paint and collage on panel. **h**122 × **w**91.4 cm. **h**48 × **w**36 in. Mayor Gallery, London

West Benjamin William Penn's Treaty with the Indians

William Penn is depicted making peace with the Lenape Indians, a landmark in the creation of the Pennsylvania colony. This somewhat romanticized and inaccurate representation of a documented event, in which West has imposed a Classical composition on figures in contemporary dress, is typical of the historical paintings which earned West his international reputation. West was born in North America and studied in Italy before setting up as a portraitist in London in 1763. He had enormous flair and versatility and achieved great popularity. He was appointed Historical Painter to George III and later replaced Joshua Reynolds as President of the Royal Academy. West was an extremely influential figure in the development of American art. His studio in London was the training ground for some of the most important American artists of the period, including Gilbert Stuart.

☛ Cole, Hicks, Reynolds, Stuart

Benjamin West. **b** Swarthmore, PA, 1738. **d** London, 1820. **William Penn's Treaty with the Indians**. 1771/2. Oil on canvas. **h**192 × **w**273 cm. **h**75½ × **w**107¾ in. Pennsylvania Academy of the Fine Arts, Philadelphia, PA

Van der Weyden Rogier The Descent from the Cross

The sorrowful demeanour of these figures makes this one of the most moving paintings in the history of art and one of the masterpieces of fifteenth-century painting. Details such as the tears falling from Mary Magdalene's nose and the way the fabric of her dress pulls across her back as she clasps her hands in sorrow show that Van der Weyden was a keen observer of life. Yet the overall composition, with the figures crowded into the front of the picture frame as if they were standing in a shallow box, looks more like a tableau in a Christmas pageant than an accurate description of a real event. Van der Weyden's early work shows the influence of Jan van Eyck and Robert Campin. He achieved great success during his lifetime and his influence was extremely profound for a long time after his death, not only on painting in northern Europe but throughout the Continent.

☛ Bouts, Campin, Van Eyck, Grünewald, Memling

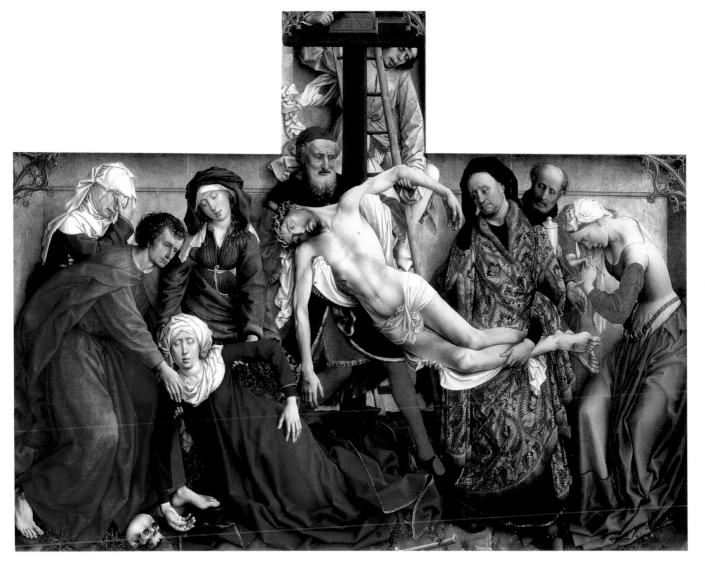

Rogier van der Weyden. b Tournai, c1399. d Brussels, 1464. **The Descent from the Cross**. c1435/8. Oil on panel. **h**220 × **w**262 cm. **h**86⅝ × **w**103⅛ in. Museo del Prado, Madrid

Whistler James Abbott McNeill Symphony in White No. 2: Little White Girl

This beautiful, sultry portrait of Whistler's mistress Joanna Hiffernan is a study in the arrangement of closely related shades of white. The asymmetrical composition with its off-centre, cropped figure, and the direct lighting which reduces the painting to a coloured pattern, clearly shows Whistler's interest in Japanese art. This influence, which was most marked in the 1860s when Japanese art was finding its way into Europe, is also alluded to in the depiction of the fan, the porcelain jar on the mantelpiece and the cherry blossom. The technique of silhouetting a figure against an almost blank ground remained Whistler's standard practice. In a reaction against the domination of subject matter in Victorian painting, Whistler emphasized the aesthetic nature of his work by calling his paintings 'nocturnes' and 'symphonies'. Whistler's growing fame as a wit and eccentric coincided with his decline as a painter.

☛ Chase, Degas, Goya, Hiroshige, Hokusai, Manet

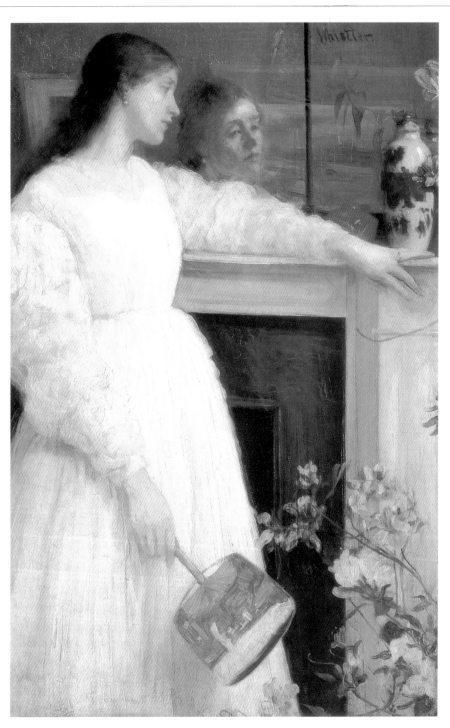

James Abbott McNeill Whistler. b Lowell, MA, 1834. d London, 1903. **Symphony in White No. 2: Little White Girl**. 1864. Oil on canvas. **h**76 × **w**51 cm. **h**30 × **w**20 in. Tate Gallery, London

Wilkie Sir David — The Letter of Introduction

A young man presents a letter of introduction to an elderly gentleman who regards him with suspicion, an attitude reflected also by his dog. This subtle painting appeals to our emotions by juxtaposing the lad's ruddy, innocent country candour with the old man's sidelong glance of sceptical distrust, redolent of a life spent in the corrupt city. Wilkie specialized in painting moralizing domestic scenes in the manner of seventeenth-century Dutch genre painters such as Adriaen van Ostade and Gerard Ter Borch. Much of Wilkie's art found its parallel in the poetry of Robert Burns and Sir Walter Scott. The son of a minister in Fife, Wilkie forms with Henry Raeburn and Allan Ramsay the great triumvirate of Scottish art. Perhaps the greatest eulogy given to him was when J M W Turner painted *Burial at Sea* to express his grief at learning about Wilkie's death while coming home from a trip to the Middle East.

☛ Lely, Van Ostade, Raeburn, Ramsay, Ter Borch, Turner

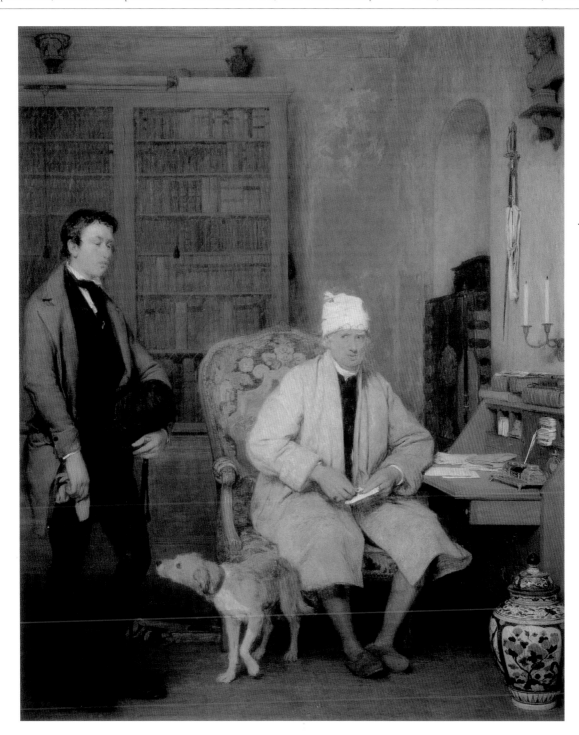

Sir David Wilkie. b Cults, Fife, 1785. d At sea (off Malta), 1841. **The Letter of Introduction**. 1813. Oil on panel. h61 × w50 cm. h24 × w19¾ in. National Gallery of Scotland, Edinburgh

Wilson Richard

View in Windsor Great Park

Bucolic hills inhabited by cattle and deer contribute to this pastoral scene. The horizon is so low the clouded sky has become as important to the picture as the land below. The rustic peasants are not here to tell a story but, like the livestock, are an integral part of the landscape. Wilson worked in London before travelling to Italy where he studied landscapes with imaginary Classical ruins and was greatly inspired by the Italian paintings of Claude Lorrain and Nicolas Poussin. Upon returning home, he continued to paint Italianate landscapes but used the scenery of England and Wales and views of country houses (he received many commissions) as the subjects of his paintings. These paralleled the grand schemes of the landscape designer Capability Brown. Wilson was one of the Founder-Members of the Royal Academy in London, but he never achieved commercial success in England and died in obscurity.

☞ Agasse, Claude, Pannini, Poussin, Zuccarelli

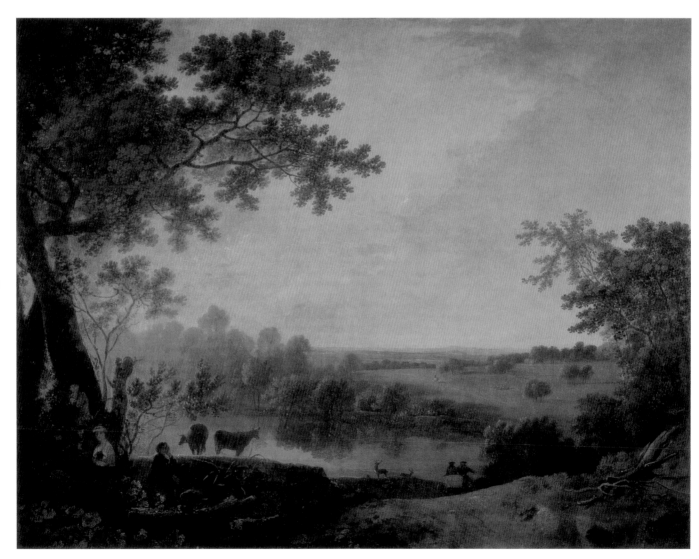

494

Richard Wilson. b Penegoes, 1713. d Mold, 1782. **View in Windsor Great Park**. c1765. Oil on canvas. **h**104 × **w**137 cm. **h**41 × **w**54 in. National Museum of Wales, Cardiff

Witz Konrad

The Miraculous Draught of Fishes

The rather ungainly but solid and meticulously depicted figures animate the sun-lit landscape of the shores around Lake Geneva. Close attention has been paid to the naturalistic detailing of the rocks and plants in the shallows (visible through the water) and the trees and houses in the background. The scene is striking for its clarity and is especially important in the history of art for containing one of the first attempts by a painter to record faithfully the landscape before him. Witz is considered to be one of the greatest of the pre-Renaissance German artists. Little is known of his life although his strongly realistic style suggests that he must have been familiar with the work of the Flemish painter Jan van Eyck. The luminous spaciousness of the hills which recede into the distance show that Witz was capable of rendering perspective, although this was not achieved by mathematical calculation.

☞ Van Eyck, Master of Moulins, Patenier, Schongauer

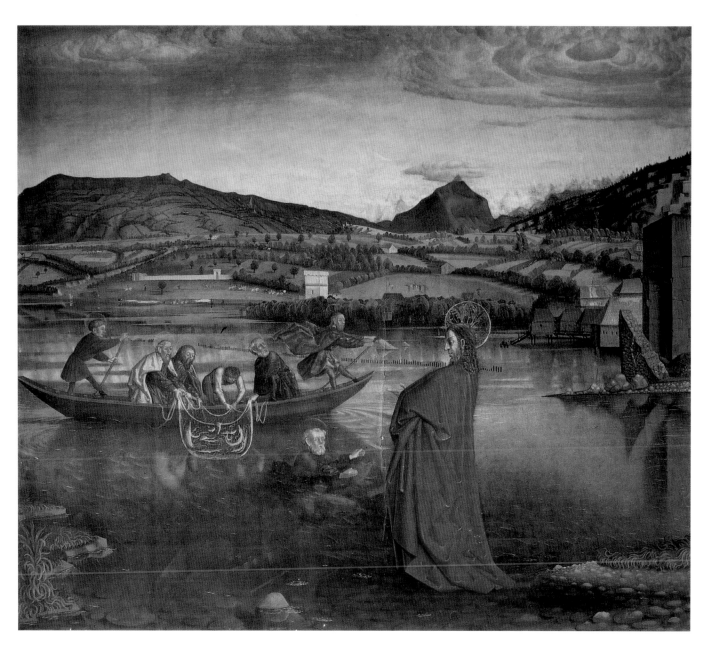

Konrad Witz. b Rottweil, c1410. **d** Basel, c1446. **The Miraculous Draught of Fishes**. 1444. Oil on panel. **h**132.1 × **w**153.7 cm. **h**52 × **w**60½ in. Musée d'Art et d'Histoire, Geneva

Wood Grant

American Gothic

Wood was captivated by a simple Gothic-style cottage he saw in a small town in southern Iowa and created this picture around the image that it evoked in his mind. He used his sister and his dentist as models for the couple standing in front of the plain white house. Wood was accused of satirizing Midwestern values, but he insisted

that he made the work as a homage to the down-to-earth, Puritan dignity found in small-town America. A lifelong resident of Iowa, Wood was one of the exponents of Regionalism, a form of realism common in North America during the 1930s and based on the desire that American artists should end their cultural dependence on Europe by

finding inspiration for their art in their local surroundings. His crisp, firmly delineated and precisely modelled style was derived from the Gothic and early Renaissance masters Wood had studied in Europe in the 1920s.

☞ Van Eyck, Hopper, Martini, Wyeth

Grant Wood. b Anamosa, IA, 1892. **d** Anamosa, IA, 1942. **American Gothic**. 1930. Oil on board. **h**74.3 × **w**62.4 cm. **h**29¼ × **w**24½ in. Art Institute of Chicago, Chicago, IL

Wright of Derby Joseph The Forge

A glowing ingot of iron provides the only illumination for this night scene. Its light catches the founder, his family and his workers in the middle of their evening routine. The enormous hammer which is used to beat the ingot was driven by a water-wheel outside the forge, thus easing the work of the founder (which perhaps has enabled his family to pay him a visit). Although the artist has attempted to make this scene as realistic as possible, even to the point of painting the smoke of the smouldering ingot, the scene is a contrived vision of manual labour depicted for a wealthy market. Wright specialized in lighting effects, usually derived from a single artificial light source articulated by strong *chiaroscuro*, the contrast between light and shade. In the town of Derby, Wright found admirers in some of the pioneers of science and industry, including the porcelain manufacturer Josiah Wedgwood.

☛ Brown, Caravaggio, Correggio, Honthorst

Joseph **Wright of Derby**. b Derby, 1734. d Derby, 1797. **The Forge**. 1772. Oil on canvas. **h**121.9 × **w**132.1 cm. **h**48 × **w**52 in. Collection of Lord and Lady Romsey, Broadlands, Romsey

Wyeth Andrew

Christina's World

A young girl, seen from behind, sits in a field and gazes up at a farmhouse on top of the hill. A sense of melancholy and desolation is emphasized by the vast space between the figure and the distant houses. The finely depicted surface, executed in subdued tones but with a warm glow of bright sunlight, is typical of Wyeth's style which is characterized by a minute, precise realism, undoubtedly influenced by photography in its exactness of detail and the use of unusual viewpoints. His usual subjects are deserted landscapes and scenes conveying the conflicts of solitude but Wyeth adds a disturbing element by depicting such emotional themes in a highly detailed manner reminiscent of magazine illustration. Wyeth works predominantly in the areas around Pennsylvania and Maine where he has lived for most of his life. His work has tremendous popular appeal.

☛ Estes, Hopper, Richter, Sheeler, Wood

Andrew Wyeth. b Chadds Ford, PA, 1917. **Christina's World**. 1948. Tempera and gesso on panel. **h**82 × **w**121 cm. **h**32¼ × **w**47¾ in. Museum of Modern Art, New York, NY

Yeats Jack Butler

The Basin in Which Pilate Washed his Hands

Slashing strokes of bright colour have been spontaneously applied in a loose, expressionistic manner. The passionate freedom of the artist's style and the bold approach to the subject are striking. The forms emerge and dissolve simultaneously from the indiscernible mass of the landscape background. Yeats was the son of a painter and the brother of the poet W B Yeats. He began his career as an illustrator and watercolour artist and did not begin painting in oils until 1915 at the age of 44. His style became increasingly free and more violent in its use of colour. Yeats was greatly influenced by the Irish Troubles which were reflected in the subject matter of his later work. He was admired by his friend Oskar Kokoschka and his Expressionistic work draws a close parallel with that of the Austrian-born painter. Yeats' subject matter, however, remains entirely Irish.

☛ Appel, Gorky, Kokoschka, De Kooning, Kossoff, Pollock

499

Jack Butler Yeats. b London, 1871. d Dublin, 1957. **The Basin in Which Pilate Washed his Hands**. 1951. Oil on canvas. **h**101.6 × **w**152.4 cm. **h**40 × **w**60 in. Waddington Galleries Ltd, London

Zoffany Johann

Charles Towneley's Library in Park Street

Marble athletes, nymphs, gods, goddesses and portrait busts are crammed into the library of this collector. Towneley, seated in the chair on the right, his faithful dog at his feet, is surrounded by fellow antiquaries and connoisseurs. The elegant library contains all the accoutrements of the cultured eighteenth-century gentleman with highly refined tastes. The bust of Clytie on the desk is said to have been such a favourite of Towneley's that he referred to it as his wife. German by birth, Zoffany travelled and studied extensively in Italy. He met Towneley in Florence and the two men became close friends. Zoffany arrived in London in 1760 and set up as a painter of portraits, interiors and theatrical scenes. He was commissioned by the actor David Garrick to paint a number of conversation pieces and attracted the attention of King George III. In 1783 he went to India where he made his fortune painting portraits.

☛ Gainsborough, Hogarth, Kauffmann, Teniers

500

Johann Zoffany. **b** Frankfurt, 1733. **d** London, 1810. **Charles Towneley's Library in Park Street**. 1783. Oil on canvas. **h**127 × **w**99 cm. **h**50 × **w**39 in. Towneley Hall Art Gallery, Burnley

Zorn Anders

Dagmar

Like a nymph watching her reflection in the rippled surface of a lake, this nude perches at the edge of the water absorbed in quiet thought. Her pink skin is echoed by the soft hues of the rocks and the greens of nature beyond. Although there is nothing overtly erotic about the figure, her voluptuous body beckons the viewer to look at the painting and there is something innocently sensuous about her pose. Zorn was also interested in printmaking; he made an etching of this composition and created prints of his paintings and sculpture. One of the most cosmopolitan Swedish artists of his time, he travelled extensively in Europe and North America.

Although his dancing brush and moving light and colour ally him to the Impressionists, his solid forms and the luminosity and natural feeling that can be seen in this work are characteristic of Scandinavian painting at the turn of the century.

☛ Boucher, Krøyer, Manet, Schiele

501

Anders Zorn. b Mora, 1860. **d** Mora, 1920. **Dagmar**. 1911. Oil on canvas. **h**88 × **w**63 cm. **h**34½ × **w**24¾ in. Private collection

Zuccarelli Francesco

Landscape with the Rape of Europa

A great softness and delicacy pervade this picturesque landscape animated with elegant female figures and playful putti. Zuccarelli has used the motifs of a Roman town and the story of the rape of Europa to evoke an Arcadian, pastoral landscape in the manner of the French landscape painter Claude Lorrain. Zeus, who has disguised himself as a bull, swims ashore to where Europa is playing. He entices her to climb onto his back and carries her away to Crete. This narrative scene has deliberately been relegated to the background and is almost incidental to the composition. Zuccarelli, a Florentine landscape painter, worked principally in Venice and London where he stayed for 17 years. His light and pleasing style of landscape painting inhabited by joyful peasantry was very popular in England. Zuccarelli was one of the Founder-Members of the Royal Academy in London.

☛ Allston, Claude, Piero di Cosimo, Wilson

Francesco Zuccarelli. b Pitigliano, 1702. **d** Florence, 1788. **Landscape with the Rape of Europa**. c1750. Oil on canvas. **h**131 × **w**168 cm. **h**51¼ × **w**66 in. Private collection

Zurbarán Francisco de Saint Francis of Assisi

The image of St Francis standing in his tomb comes from a thirteenth-century apocryphal tale. Visitors to the crypt of the church in Assisi are said to have observed St Francis standing erect in his grave long after his death. Zurbarán made the image of the saint even more startling through the use of strong lighting from the left which picks out his dark robe and ecstatic face and casts the right side of his body into dark shadow. This lighting is inspired by Caravaggio's use of *chiaroscuro*, but in contrast to the Italian's usual flamboyant compositions Zurbarán infuses his painting with an austere religiousness more common to the Spanish Baroque paintings of his contemporaries. Zurbarán found it difficult to adapt to the changing fashion in painting and was challenged in particular by the rise of the young Bartolomé Murillo. Unable to re-establish his once high reputation he died in great poverty in 1664.

☛ Caravaggio, Murillo, Sassetta, Spencer, Velázquez

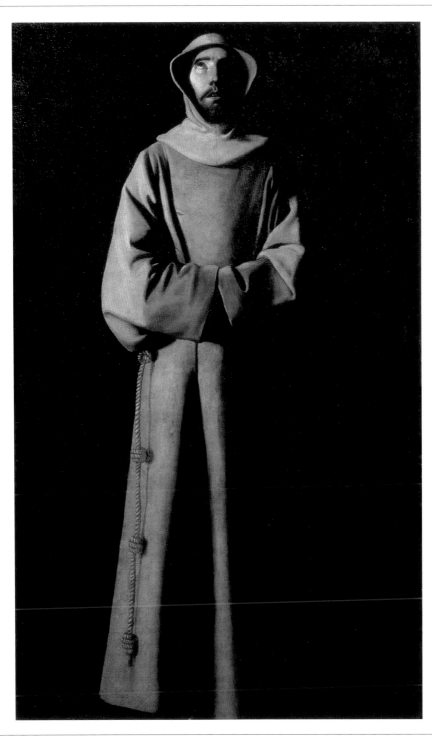

Francisco de Zurbarán. b Fuente de Cantos, 1598. **d** Madrid, 1664. **Saint Francis of Assisi.** c1650/60. Oil on canvas. **h**209 × **w**110 cm. **h**82 × **w**43 in. Museu Nacional d'Art de Catalunya, Barcelona

Glossary of technical terms

Abstract

A form of art which does not seek to represent the world around us. The term is applicable to any art that does not represent recognizable objects, but refers particularly to forms of twentieth-century art in which the idea of art as imitation of nature has been abandoned. Wassily Kandinsky, Piet Mondrian and Kasimir Malevich were among abstraction's early pioneers.

Acrylic

A synthetic paint, first used in the 1940s, combining some of the properties of oil and watercolour. It can be used to create a variety of effects from thin washes (see Morris Louis) to thick brushwork (see David Alfaro Siqueiros).

Antique, Classical

Terms referring to the civilizations of Ancient Greece and Rome, and their influence on the arts. Although often considered interchangeable, the terms have slightly different meanings. 'The Antique' generally refers to the physical remains of the Greek and Roman world, such as architecture and sculpture; this was a particularly popular theme in the eighteenth century (see Giovanni Paolo Pannini, Francesco Zuccarelli). 'Classical' suggests a continuation of style or approach which can be traced directly to the Ancient world (see Jacques-Louis David, Hiram Powers).

Chiaroscuro

Chiaroscuro means 'light-dark' in Italian and is used to describe the use of light and shade in a work of art, particularly when they are strongly contrasting. Caravaggio and Rembrandt are well known for their use of this technique, which they used for dramatic effect. The technique was particularly popular in the seventeenth century.

Classical *see* **Antique**

Collage, Photomontage

Collage, coming from the French world *coller* (meaning 'to stick'), is a technique in which pieces of paper, cloth and other miscellaneous objects are pasted onto a flat surface. The Cubists were the first to use collage as a serious artistic technique (see Juan Gris). Photomontage applies the same principles to the use of photographs; it was an important technique in Dadaism (see Raoul Hausmann) and Surrealism, and has also been used in Pop Art by artists such as Richard Hamilton.

Figurative

Art which depicts recognizable images of the world around us. These images may be acutely accurate (see Richard Estes) or heavily distorted (see Georges Braque). The term 'representational art' is used synonymously with figurative art.

Fresco

Meaning 'fresh' in Italian, fresco is a particular kind of wall painting in which pure pigment (colour) in powdered form is mixed with water and applied to a surface of wet, freshly laid lime plaster. This technique is known as *buon fresco*, or true fresco, to distinguish it from painting on dry plaster, known as *fresco secco*, which is far less durable as the pigment does not penetrate the substance of the plaster. Fresco painting is particularly appropriate to dry climates and was widely used in Italy from the late Middle Ages (see Giotto, Fra Angelico) up to the seventeenth century (see Pietro da Cortona).

Genre painting

Painting that depicts scenes of everyday life rather than idealized or religious subjects. Genre painting was particularly popular in Holland in the seventeenth century, and artists often specialized in subjects such as tavern scenes (see Jan Steen), musical parties or simple interiors (see Jan Vermeer). The style became more prevalent elsewhere in the eighteenth century with the work of Jean-Baptiste-Siméon Chardin in France, Pietro Longhi in Italy and William Hogarth in England.

Gouache

Opaque **watercolour**, also known as body colour. The pigments (particles of colour) are bound together with glue; lighter tones are achieved by adding white (see Wifredo Lam). Gouache thus differs from transparent watercolour, where tone can be lightened simply by adding water. The thick texture of gouache can produce the same effects as oil paint, but it has the disadvantage of producing a final tone which, when dry, is lighter than it appears during application.

Illumination

Refers to the colourful decoration of manuscripts which was particularly popular from Medieval times to the Renaissance. The term is derived from the Latin word *illuminare*, meaning 'to adorn'. The manuscripts, made from parchment or vellum (treated animal skin), were written by hand and colourfully painted with miniatures, ornate capital letters and borders (see André Beauneveu, Pol, Jean and Herman de Limbourg). With the invention of printing the illuminated manuscript gradually went out of fashion and by the early sixteenth century relatively few were produced.

Oil, Oilstick

Oil paint consists of pigment (colour) bound together with an oil medium, usually linseed oil. Its invention is usually credited to Jan van Eyck in the fifteenth century. Oil has the advantage over **tempera** of being slow to dry and therefore reworkable. It can be applied with a brush (see Anton Raphael Mengs) or a palette knife (see Jean-Paul Riopelle), generally onto canvas, though certain woods (particularly poplar) were used in earlier periods. Oilsticks are a more recent invention, combining some of the properties of oil paint with those of **pastel** crayons (see Jean Michel Basquiat). They come in various sizes and can either be gripped in the hand like a pencil and applied 'neat', or diluted with a suitable medium.

Pastel

A drawing material consisting of a stick of pigment (colour) bound together with resin or gum. It is generally used on paper and a variety of effects can be achieved, from sharply defined lines to soft shading. The powdery nature of pastel means that without careful handling the drawn image can quickly deteriorate. Pastel dates back to sixteenth-century Italy when colours were limited to black, white and terracotta red. Its heyday was in the eighteenth century when it became popular in portraiture; the medium underwent a revival in the nineteenth century with the work of the Impressionists (see Jean-Étienne Liotard, Edgar Degas).

Photomontage *see* **Collage**

Prints

A variety of techniques can be used to make prints, including woodblock, woodcut, engraving, etching, silkscreen, screenprint, and lithography. Woodblock and woodcut are known as 'relief methods' because the parts of the block which are to print black are left in relief while the rest is cut away (see Katsushika Hokusai). Engraving and etching are 'intaglio methods', in which the design is engraved on a metal plate, or in the case of etching bitten into the plate by means of acid (see Stanley William Hayter). In silkscreen and other forms of screen printing, a stencil is attached to a screen (traditionally made from silk) stretched on a frame, and colour is forced through the unmasked areas of the screen (see Andy Warhol). With lithography, the design is drawn with wax onto a slab of stone and through the opposition of grease and water, areas which receive and reject the printing ink are separated (see Alphonse Mucha).

Sfumato

From the Italian word *fumo*, meaning smoke, 'sfumato' describes the blending of tones or colours so subtly that they melt into one another to produce a 'misty' effect, as Leonardo da Vinci put it, 'without lines or borders, in the manner of smoke'. Leonardo was himself one of the greatest exponents of this method, as can be seen in the soft gradations between light and shade in the *Mona Lisa*.

Stucco

A light plaster, mixed with powdered marble and glue and sometimes reinforced with hair or wire, used for sculpture and architectural decoration. It was most widely used from the sixteenth to the eighteenth centuries and is particularly suited to the ornate decorations of the Baroque and Rococo styles (see Francesco Primaticcio). Workers in stucco could produce a material similar to marble by adding large quantities of glue and colour to the mixture. Good stucco is only distinguishable from marble in that it is warmer to the touch.

Tempera

A paint made from ground pigment (colour) bound together with egg-yolk and water. This was the most common technique for the production of easel paintings until the late fifteenth century (see Cimabue, Jean Fouquet). Tempera was generally painted on a white chalky substance called 'gesso' which had been applied in layers to a wooden support. The absorbent nature of gesso and the quick-drying qualities of tempera meant that the artist had to work quickly and accurately; reworking the image was virtually impossible. Despite the medium's decreased popularity in comparison to oil there have been twentieth-century practitioners: see Giacomo Balla and Edward Wadsworth.

Watercolour

Pigment (colour) bound by a water-soluble medium such as gum arabic. This is usually diluted with water to the point where it is translucent, and applied to paper in broad areas known as washes. White paper is often left exposed to create highlights and washes applied over one another to achieve gradations of tone (see Emil Nolde). Watercolour lends itself well to the creation of atmospheric effects and was particularly popular with English eighteenth- and nineteenth-century landscape painters such as John Robert Cozens and J M W Turner.

Waterpaint

A thick, water-based paint, similar to emulsion paint. It has the texture of oil paint when wet but dries without the sheen of oil. In this sense it is similar to **gouache**. Unlike gouache, however, it is crack-resistant, making it an ideal medium for large-scale work such as wall painting. A twentieth-century medium, it was commonly used by Lucio Fontana.

Glossary of artistic movements

Abstract Expressionism

A movement in American painting that developed in New York in the 1940s. Most Abstract Expressionists were energetic (or 'gestural') painters. They invariably used large canvases and applied paint rapidly and with force, sometimes using large brushes, sometimes dripping or even throwing paint directly onto the canvas. This expressive method of painting was often considered as important as the painting itself. Other Abstract Expressionist artists were concerned with adopting a peaceful and mystical approach to a purely abstract image. Not all the work from this movement was abstract (see Willem de Kooning and Philip Guston) or expressive (see Barnett Newman and Mark Rothko), but it was generally believed that the spontaneity of the artists' approach to their work would draw from and release the creativity of their unconscious minds.

☛ Francis, Frankenthaler, Guston, Hofmann, Kline, De Kooning, Motherwell, Newman, Pollock, Rothko, Still

Art Informel

The French word *informel* means 'without form' rather than 'informal'. In the 1950s Art Informel artists were looking for a new way to create images without adopting the recognizable forms used by their predecessors (see **Cubism** and **Expressionism**). Their aim was to abandon geometrical and figurative forms and to discover a new artistic language. They invented shapes and methods that came about by improvization. The work of Art Informel is extremely varied but they often used free brushstrokes and thick layering of paint. Like **Abstract Expressionism**, which developed simultaneously in the USA, Art Informel is a very broad label and includes figurative (see Jean Fautrier) and non-figurative (see Hans Hartung) painters. Although centred mainly on Paris, its influence reached other parts of Europe, notably Spain, Italy and Germany.

☛ Burri, Dubuffet, Fautrier, Hartung, Riopelle, Soulages, De Staël, Tàpies

Arte Povera *see* Conceptual Art

Bauhaus

The Bauhaus school was founded by the architect Walter Gropius at Weimar in 1919 and became the centre of modern design in Germany in the 1920s. Reflecting some of the socialist currents in Europe at the time, its philosophy was to bring art and design into the domain of daily life. Gropius believed that artists and architects should be considered as craftsmen and that their creations should be practical and affordable. Bauhaus students included artists, architects, potters, weavers, sculptors and designers who studied together in workshops as had the artists and artisans of the Renaissance. The characteristic Bauhaus style was simple, geometrical and highly refined. In 1933 the school was closed by the Nazi government claiming that it was a centre of communist intellectualism. Although the school was physically dissolved, its staff continued to teach its ideals as they left Germany and emigrated all over the world.

☛ Albers, Kandinsky, Klee, Moholy-Nagy

Barbizon School

In the early to mid-nineteenth century a number of French artists travelled to a small village 40 miles south-west of Paris. The village is called Barbizon and lies on the outskirts of the Forest of Fontainebleau. Far from the pressures of city life, these artists were able to take their easels into the countryside and paint from nature in the open air. They painted gentle landscapes and people at work in the fields, and studied the fleeting effects of light and atmospheric effects on the world around them. Many of the Barbizon artists have been virtually forgotten, and a number of their discoveries have been attributed to the Impressionists who later exploited their innovatory techniques.

☛ Corot, Courbet, Daubigny, Millet, T Rousseau

Baroque

The Baroque style flourished in Rome in the early 1600s and persisted in varying degrees throughout Europe until the eighteenth century. The name comes from the Italian word *barocco*, meaning bizarre or zany. Baroque art is generally typified by its dramatic exuberance and emotive appeal to the viewer. The archetypal Baroque religious picture might show the saints or the Madonna in a swirl of billowing draperies and fleecy clouds surrounded by cherubs. Themes such as subjects from Ancient mythology were also popular, and were treated in the same exaggerated manner. Not all art of the period was so luxuriant, however, and the sombre dramaticism of artists such as Caravaggio is equally termed Baroque.

☛ Bernini, Caravaggio, Cuyp, Gentileschi, Guercino, Kalf, Rembrandt, Reni, Rubens, Sánchez-Cotan, Velázquez, Zurbarán

The Camden Town Group

An English group of painters formed in 1911. The group often met in Walter Sickert's studio in north London. They took much of their subject matter from urban working-class life and were influenced by the strong forms and colours used by artists such as Vincent van Gogh and Paul Gauguin. In 1913 it amalgamated with other groups to become the London Group.

☛ Gilman, Sickert

Cobra

An international association of artists that existed in Europe from 1948 to 1951. The name Cobra was made up from the initials of the cities in which the original members of the association were living (Copenhagen, Brussels and Amsterdam). The aim of the Cobra artists was to promote free expression of the unconscious and they used thick free handling of paint and striking colours to give their work vitality and force. They put particular emphasis on the development of fantastical imagery derived from Nordic folklore, and from mystical symbols of the unconscious rather than purely abstract forms.

☛ Appel

Conceptual Art

In Conceptual Art it is the 'concept' behind the work, rather than the technical skill of the artist in making it, that is important. Conceptual Art became a major international phenomenon in the 1960s and its manifestations have been very diverse. The ideas or 'concepts' may be communicated using a variety of different media, including texts, maps, diagrams, film/video, photographs and performances, and displayed in a gallery or designed for a specific site. In some cases the landscape itself becomes an integral part of the artist's work, as in the 'land art' of Richard Long or the 'environmental sculptures' of Christo. The ideas expressed through Conceptual work have been drawn from philosophy, feminism, psychoanalysis, film studies and political activism. The notion of the Conceptual artist as a maker of ideas rather than objects undermines traditional ideas about the status of the artist and the art object. 'Arte Povera', a Conceptual tendency that established itself in Italy in the 1960s, developed this idea by using banal and worthless materials (see Josef Beuys, Mario Merz).

☛ Beuys, Buren, Christo, Long, Merz, Nauman, Viola

Constructivism

An abstract art movement founded in Russia in 1913. Constructivism swept away traditional notions about art, believing that it should imitate the forms and processes of modern technology. This was especially true of sculpture, which was 'constructed' out of component parts using industrial materials and techniques. In painting, the same principles were applied within a two-dimensional format; abstract forms were used to create structures reminiscent of machine technology and were suspended in space in almost architectural fashion. Although 'pure' Constructivism was current in Russia during the early years of the Revolution, its aims and ideals have been used by artists throughout the twentieth century.

☛ Gabo, Lissitzky, Moholy-Nagy, Popova, Rodchenko, Tatlin

Cubism

This revolutionary method of making a pictorial image was invented by Pablo Picasso and Georges Braque in the first decade of the twentieth century. Although it may appear abstract and geometrical, Cubist art does in fact depict real objects. These are 'flattened' onto the canvas so that different sides of each shape can be shown simultaneously from various angles. Instead of creating the illusion of an object in space, as artists had endeavoured to do since the Renaissance, Cubist art defines objects in the two-dimensional terms of the canvas. This innovation gave rise to an extraordinary reassessment of the interaction between form and space, changing the course of Western art forever.

☛ Archipenko, Braque, Gris, Léger, Picasso

Dada

The name Dada is deliberately meaningless and was given to an international 'anti-art' movement that flourished from 1915 to 1922. Its main centre of activity was the Cabaret Voltaire in Zurich, where like-minded poets, artists, writers and musicians would gather to participate in experimental activities such as nonsense poetry, 'noise music' and automatic drawing. Dada was a violent reaction to the snobbery and traditionalism of the art establishment: its members were ready to use any means within their imagination to cause outrage amongst the bourgeoisie. A typical Dada work of art was the 'ready-made', essentially an ordinary object taken from its original context and put on exhibit as 'art'. The Dada movement, with its cult of the irrational, was important in preparing the ground for the advent of **Surrealism** in the 1920s.

☛ Arp, Duchamp, Hausmann, Man Ray, Picabia, Schwitters

De Stijl

An artistic movement and magazine founded in Holland in 1917 by Theo van Doesburg and Piet Mondrian. These men

Glossary of artistic movements

believed that art should strive towards complete harmony, order and clarity in a constant process of refinement. The work of De Stijl was therefore austere and geometrical, using mainly square forms. It was composed of the simplest elements: straight lines and pure primary colours. The movement's aims were deeply philosophical and were rooted in the idea that art should in some way reflect the mystery and order of the universe. The movement came to an end in 1931 after Van Doesburg's death, but had a profound effect on architecture and the applied arts in Europe.

☛ Van Doesburg, Mondrian

Expressionism

An artistic force concentrated mainly in Germany from 1905 to 1930. Expressionist artists sought to develop pictorial forms which would express their innermost feelings rather than represent the external world. Expressionist painting is intense, passionate and highly personal, based on the concept of the painter's canvas as a vehicle for demonstrating emotions. Violent, unreal colour and dramatic brushwork make the typical Expressionist painting quiver with vitality. It is not surprising that Vincent van Gogh, with his frenzied painting technique and extraordinary use of colour, was the inspiration for many Expressionist painters.

☛ Beckman, Van Gogh, Heckel, Jawlensky, Kirchner, Kokoschka, Marc, Munch, Nolde, Pechstein, Rouault, Schiele, Schmidt-Rottluff, Soutine

Fauvism

In 1905 an exhibition was held in Paris which included a room full of paintings that blazed with pure, highly contrasting colours. They seemed to have been painted with great enthusiasm and passion. One critic dubbed the creators of these paintings 'les fauves' – French for 'wild beasts' – and the name stuck. This 'wildness' manifested itself mainly in the strong colours, dynamic brushwork and expressive depth of their pictures, which evoke a fantastical, joyous world of heightened emotion and colour.

☛ Derain, Van Dongen, Matisse, Vlaminck

Futurism

An avant-garde movement founded in Milan in 1909. Its members aimed to liberate Italy from the weight of its past and to glorify modernity. The Futurists were fascinated by modern machinery, transport and communications. In painting and sculpture, angular forms and powerful lines were used to convey a sense of dynamism. One of the main features of Futurist art was its attempt to capture movement and speed: this was usually achieved by depicting several images of the same object or figure in slightly differing positions at the same time, giving the impression of a flurry of movement.

☛ Balla, Boccioni

Gothic

Predominant in the Middle Ages (from around 1150 to 1500), this is the style of the great cathedrals of Europe. Altarpieces made during this time had elaborate crenellations which mimicked church architecture. Gothic paintings and sculptures are characterized by elongated figures which are highly patterned. In painting, there is often little attempt to depict three-dimensional space. The perspective that was employed is usually random and unconvincing. At the end of the

fourteenth century there was a move towards greater elegance and refinement, and an increased interest in natural themes. Minutely detailed depictions of plants and animals became a common feature in paintings. Because this later style was not confined to one country, it is often called International Gothic.

☛ Beauneveu, Cimabue, Duccio, Fouquet, Gaddi, Gentile da Fabriano, Limbourg, Lorenzetti, Lorenzo Monaco, Martini, Della Quercia

Impressionism

A movement in painting that originated in France in the 1860s. Impressionist painters celebrated the overwhelming vision of nature seen in the splendour of natural light – whether dawn, daylight or twilight. They were fascinated by the relationship between light and colour, painting in pure pigment using free brushstrokes. They were also radical in their choice of subject matter, avoiding traditional historical, religious or romantic themes to concentrate on landscapes and scenes of everyday life. The movement's name, initially coined in derision by a journalist, was inspired by one of Claude Monet's paintings entitled *Impression – Sunrise*.

☛ Caillebotte, Cassatt, Degas, Manet, Monet, Morisot, Pissarro, Renoir, Sisley

Kinetic Art

Term used to describe art incorporating real or apparent movement. The idea was first introduced in the 1920s but reached its height of popularity during the 1950s and 1960s. Kinetic art may be quite simple (such as Alexander Calder's wind-driven mobiles) or complex (such as Jean Tinguely's motor-operated sculptures). The term may also be applied to works of art that use light effects to give the viewer the illusion of movement.

☛ Calder, Tinguely

Mannerism

A development of the Renaissance style, Mannerism is generally seen as a reaction against the harmony, order and perfection of the fifteenth and early sixteenth centuries. The style was prevalent in Italy between 1520 and 1600. It is characterized by a use of bright, almost garish colours, elaborate compositions, exaggerated forms and dramatic movement. The term originates in the use of the word *maniera*, meaning 'stylishness' and signifying grace, poise and harmony. The word has developed a variety of meanings over the centuries; however, it is generally associated with art and artists who openly demonstrated excessive skill, virtuosity and caprice.

☛ Bronzino, Cellini, Giambologna, Giulio Romano, El Greco, Parmigianino, Pontormo, Rosso, Tintoretto

Minimalism

A trend in painting and sculpture that developed primarily in the USA during the 1960s and 70s. As the name implies, Minimalist Art is pared down to its essentials; it is purely abstract, objective and anonymous, free of surface decoration or expressive gesture. Minimalist painting and drawing is monochromatic and often draws on mathematically derived grids and linear matrices; yet it can also evoke a sensation of the sublime and of states of being. Sculptors used industrial processes and materials, such as steel, perspex, even flourescent tubes, to produce geometric forms, often made in series. This sculpture has no illusionistic properties,

relying instead on a bodily experience of the work by the spectator. Minimalism can be seen as a reaction against the emotionalism of **Abstract Expressionism**, which had dominated modern art through the 1950s.

☛ Andre, Flavin, Judd, Kelly, LeWitt, Mangold, Ryman, Serra, Stella

Nabis

A small group of French artists, active in the 1880s, who were inspired by Paul Gauguin's method of painting in pure colour. Their approach is epitomized by a statement by Maurice Denis, one of the group's members: 'Remember that a picture, before being a horse, a nude, or some kind of anecdote, is essentially a flat surface covered with colours.' Their pictures are characterized by broad surfaces of flat colour or patterns. As well as painting the group was interested in print-making, posters, book illustrations, textiles and theatre design.

☛ Bonnard, Denis, Maillol, Vallotton, Vuillard

Neo (-Classicism, -Expressionism, -Romanticism)

The prefix 'neo', meaning 'new', refers to a revival of previous trends or ideas. *Neo-Classicism*, for example, was a movement that developed in the latter half of the eighteenth century; its aims were a return to **Classical** values and a revival of the elegant styles of Ancient Greek and Roman art. In art and architecture it is characterized by a preference for line and symmetry, and by its frequent borrowing from Antique sources. *Neo-Expressionism* refers to the re-emergence of **Expressionist** characteristics in the work of particular artists in the USA and Europe, especially Germany, in the late 1970s. Neo-Expressionist works tend to be highly personal, often executed with violent fervour. *Neo-Romanticism* refers to a strongly theatrical form of twentieth-century painting which combines both **Romantic** and **Surrealist** elements.

☛ (Neo-Classicism) Alma-Tadema, Canova, J-L David, Ingres, Leighton, Mengs, Powers, Prud'hon; (Neo-Expressionism) Auerbach, Baselitz, Bomberg, Boyd, Clemente, Frink, Kiefer, Schnabel; (Neo-Romanticism) Nash, Piper

Op Art

A movement in abstract art that developed in the 1960s. Op Art (short for 'optical art') exploits the fallibility of the human eye. The artist plays games with the viewer by creating images which appear to shimmer and pulsate. Although the work of art itself is static, the forms and colours used cause an optical illusion of movement.

☛ Riley, Vasarely

Pittura Metafisica (Metaphysical Painting)

Metaphysical Painting was founded in Italy in 1917 by Giorgio de Chirico and Carlo Carrà. It is characterized by distorted perspectives, unnatural lighting and strange imagery, often using tailors' dummies and statues instead of the human body. By placing objects in unlikely contexts, the Metaphysical Painters aimed to create a dreamlike, magical atmosphere. In this respect the movement has much in common with Surrealism, but it differs from Surrealism in its concern with rigid compositional structure and architectural values.

☛ Carrà, De Chirico, Delvaux

Pop Art

A movement in the USA and Britain that emerged in the 1950s and took its inspiration from the imagery of consumer society and pop culture. Comic strips, advertising and mass-produced objects all played a part in this movement, which was characterized by one of its members, Richard Hamilton, as 'popular, transient, expendable, low cost, mass-produced, young, witty, sexy, gimmicky, glamorous and Big Business'. The brashness of subject matter is often emphasized by hard-edged photograph-like techniques in painting and minute attention to detail in sculpture. Photomontage, collage and assemblage are also common in Pop Art.

☛ P Blake, Dine, Hamilton, Hockney, Johns, Jones, Kitaj, Lichtenstein, Oldenburg, Rauschenberg, Rosenquist, Segal, Thiebaud, Warhol, Wesselmann

Pre-Raphaelite Brotherhood

An association of young English artists formed in 1848. Dismayed at what they saw as the decadent state of British painting, the Pre-Raphaelites sought to evoke the sincerity of early Italian art before the High Renaissance master Raphael, as exemplified by artists such as Sandro Botticelli and Filippo Lippi. Pre-Raphaelite pictures frequently depict literary, historical and religious scenes and often make moralizing comments on social behaviour and relationships. The artists painted richly textured and minutely detailed pictures which show particular interest in the decorative qualities of flowers and fabric.

☛ Brown, Burne-Jones, Hunt, Millais, Rossetti, Waterhouse

Renaissance

Throughout the Middle Ages man lived in fear of God and within the omnipresence of the Church. Art generally showed the heavens and saints, and bore little relation to what was happening on earth. From the fourteenth century, however, man began to realize his importance and effect on the world. This rebirth (or 'renaissance') was reflected in art: figures became more life-like, space became more real and the Christian story began to be told from a human point of view. As the decades continued artists were able to recreate the world on panels, frescos and altarpieces with increasing ease. Beginning with the stylized works of Giotto and Masaccio, the Renaissance culminated in the monumental creations of Leonardo da Vinci, Raphael and Michelangelo. Although generally associated with Italy, the Renaissance also developed independently north of the Alps in Germany and Flanders. While Italian Renaissance artists laid emphasis on perspective and the illusion of space, Flemish and German artists were more interested in a detailed, jewel-like depiction of the world around them.

☛ (Early Renaissance) Fra Angelico, Botticelli, Donatello, Ghiberti, Ghirlandaio, Giotto, Filippino Lippi, Mantegna, Masaccio, Perugino, Piero della Francesca, Pollaiuolo, Signorelli, Verrocchio; (High Renaissance) Andrea del Sarto, Fra Bartolommeo, Leonardo, Michelangelo, Raphael, Titian; (Northern Renaissance) Altdorfer, Dürer, Elsheimer, Grünewald, Mabuse, Massys, Van der Weyden

Rococo

A light, playful and decorative style that emerged in France around 1700 and was disseminated throughout Europe in the eighteenth century. The term comes from the French word *rocaille*, meaning the fancy shell and rockwork used to decorate fountains and grottoes. Predominantly a style of interior decoration, the Rococo is typified by charm, elegance and playfulness and a palette usually consisting of pastel colours. Its subject matter frequently dealt with the leisurely pastimes of the aristocracy, and risqué love themes.

☛ Amigoni, Boucher, Fragonard, Tiepolo, Watteau

Romanticism

A movement in the arts that flourished in northern Europe and the USA during the late eighteenth and early nineteenth centuries. Romanticism is so varied in its manifestations that a single definition is almost impossible. Romantic artists turned away from intellectual disciplines and placed importance on the imagination and individual expression. Their paintings often depict grand emotions such as fear, desolation, victory, and true love. The movement had officially died out by the mid-nineteenth century but romantic tendencies have survived into the twentieth century in artistic strains such as **Expressionism** and **Neo-Expressionism**.

☛ Allston, Bierstadt, Blake, Church, Cole, Constable, Cozens, Etty, Friedrich, Géricault, Goya, Martin, Turner

Surrealism

Surrealism originated in France in the 1920s. In the words of its main theorist, the writer André Breton, its aim was to 'resolve the previously contradictory conditions of dream and reality', and the ways in which this was achieved varied widely. Artists painted unnerving and illogical scenes with photographic precision, created strange creatures from collections of everyday objects, or developed techniques of painting which would allow the unconscious to express itself. Surrealist pictures, while figurative, represent an alien world, whose images range from dream-like serenity to nightmarish fantasy.

☛ Bellmer, Brauner, Dalí, Delvaux, Ernst, Kahlo, Gorky, Magritte, Matta, Miró, Tanguy, Wadsworth

Symbolism

A literary and artistic movement that flourished in France in the late nineteenth century. Symbolist artists rejected realism, believing that painting should convey ideas and states of mind rather than simply describe the visible world. Their styles varied from jewel-like richness to pale serenity but their common interest was in conveying a feeling of other-worldliness. Subjects of a religious or mythological flavour were popular, and eroticism, death and sin were common themes.

☛ Moreau, Redon

Vorticism

An English avant-garde movement founded by Wyndham Lewis in 1914. The name Vorticism came from the Italian Futurist Umberto Boccioni's remark that all creative art emanates from an emotional vortex. Like **Futurism**, Vorticism employed a harsh, angular and highly dynamic style in both painting and sculpture and aimed at capturing activity and movement. Although Vorticism did not survive the First World War it was significant as the first movement towards abstraction in English art.

☛ Bomberg, Lewis

Further Reading

Also available from Phaidon Press:

The Story of Art by E H Gombrich.
The eminent art historian's bestselling introduction to the history of art.

The Story of Modern Art by Norbert Lynton.
An accessible and up-to-date account of the art of the twentieth century.

Directory of museums and galleries

Austria

Kunsthistorisches Museum
Burgring 5
1010 Vienna
℃ (43 1) 525240

Giovanni Bellini, *Young Woman at her Toilet*
P Bruegel, *Peasant Wedding Feast*
Cellini, *Salt Cellar*
Van der Goes, *The Fall of Man*
Mabuse, *Saint Luke Painting the Virgin*
Sittow, *Katherine of Aragon*

Österreichische Galerie
Prinz Eugen-strasse 27
1037 Vienna
℃ (43 1) 79557134

Klimt, *The Kiss*

Belgium

Koninklijk Museum voor Schone Kunsten
Leopold de Waelplein
2000 Antwerp
℃ (32 3) 2387809

Ensor, *Skeletons Fighting for the Body of a Hanged Man*
Fouquet, *Virgin and Child*

Musées Royaux des Beaux-Arts de Belgique
9 rue du Musée
1000 Brussels
℃ (32 2) 5083211

J-L David, *The Death of Marat*
Vuillard, *Two Schoolboys*

Canada

Art Gallery of Ontario
317 Dundas Street West
Toronto, ON
M5T 1G4
℃ (1 416) 9770414

Oldenburg, *Giant Hamburger*

Czech Republic

Národní Galerie
Hradcanské nám 15
11904 Prague 1
℃ (42 2) 371775

Schiele, *Seated Woman with Bent Knee*

Denmark

Ny Carlsberg Glyptotek
Dantes Plads 7
1556 Copenhagen V
℃ (45) 33911065

Gauguin, *Woman with a Flower*

Skagens Museum
Eröndumsvej
9990 Skagen
℃ (45) 98446444

Krøyer, *Summer Evening on the Southern Beach*

France

Musée National Fernand Léger
Chemin du Val de Pome
06410 Biot
℃ (33) 93656361

Léger, *The Builders*

Musée Condé
Château de Chantilly
BP 243
60631 Chantilly
℃ (33) 44570800

Limbourg, *January*
De Troy, *The Oyster Lunch*

Musée d'Unterlinden
1 place d'Unterlinden
68000 Colmar
℃ (33) 89418923

Grünewald, *The Crucifixion*

Château de Fontainebleau
77300 Fontainebleau
℃ (33) 64222740

Primaticcio, *Danaë*

Musée Fabre
39 boulevard Bonne Nouvelle
34000 Montpellier
℃ (33) 67660634

Courbet, *Bonjour, Monsieur Courbet*

Musée des Beaux-Arts
10 rue Georges-Clémenceau
44000 Nantes
℃ (33) 40416565

Greuze, *The Guitarist*

Bibliothèque Nationale
58 rue de Richelieu
75084 Paris
℃ (33 1) 47038126

Beauneveu, *Saint Philip*

Musée Bourdelle
16 rue Antoine-Bourdelle
75015 Paris
℃ (33 1) 45484727

Bourdelle, *Herakles*

Musée d'Art Moderne de la Ville de Paris
11 ave du Président Wilson
75116 Paris
℃ (33 1) 47236127

Delaunay, *Homage to Blériot*

Musée de l'Orangerie
Place de la Concorde
75001 Paris
℃ (33 1) 42974816

Soutine, *The Little Pastry Cook*
Utrillo, *Flag Over the Town Hall*

Musée d'Orsay
1 rue de Bellechasse
75007 Paris
℃ (33 1) 40494814

Bazille, *The Artist's Studio on the rue de la Condamine*
Boudin, *The Beach at Trouville*
Cassatt, *Woman Sewing*
Manet, *Déjeuner sur l'herbe*
Millet, *The Gleaners*
Morisot, *The Cradle*
Orpen, *The Café Royal in London*
Pissarro, *Landscape at Chaponval*
Signac, *The Papal Palace, Avignon*
Sisley, *Snow at Louveciennes*

Musée du Louvre
Palais du Louvre
75001 Paris
℃ (33 1) 40205050/151

Arcimboldo, *Summer*
Boucher, *Odalisque*
Canova, *Cupid and Psyche*
Champaigne, *The Last Supper*
G David, *The Marriage Feast at Cana*
Géricault, *Officer of the Hussars*
De Heem, *Still Life of Dessert*
Honthorst, *The Concert*
Houdon, *Bust of Denis Diderot*
Ingres, *The Bather of Valpinçon*
Jordaens, *The Four Evangelists*
La Tour, *The Cheat with the Ace of Diamonds*
Leonardo da Vinci, *Mona Lisa*
Pisanello, *Ginevra d'Este*
Poussin, *The Arcadian Shepherds*
Prud'hon, *The Empress Josephine*

Musée National Auguste Rodin
77 rue de Varenne
75007 Paris
℃ (33 1) 47050134

Rodin, *The Kiss*

Musée National d'Art Moderne
Centre National d'Art et de Culture Georges-Pompidou
31 rue Saint-Merri
75191 Paris
℃ (33 1) 44781233

Dix, *Portrait of the Journalist Sylvia von Harden*
Tatlin, *Monument to the Third International*

Musée des Beaux-Arts
place Saint Corentin
29000 Quimper
℃ (33) 98954520

Vallotton, *Landscape with Trees*

Musée des Beaux-Arts
26 bis rue Thiers
76000 Rouen
℃ (33) 35712840

Daubigny, *The Lock at Optevoz*

Musée Départemental du Prieuré
2 bis rue Maurice Denis
78100 Saint-Germain-en-Laye
℃ (33 1) 39737787

Denis, *Portrait of Yvonne Lerolle*

Musée National du Château de Versailles
78000 Versailles
℃ (33 1) 30847400

Delacroix, *The Battle of Taillebourg*

Germany

Schloss Charlottenburg
Luisenplatz
1000 Berlin 19
℃ (49 30) 320911

Watteau, *The Embarkation for Cythera*

Ludwig Roselius Sammlung
Böttcherstrasse 4
2800 Bremen 1
℃ (49 421) 321911

Modersohn-Becker, *Old Poorhouse Woman with a Glass Bottle*

Wallraf-Richartz Museum
Bischofsgartenstrasse 1
5000 Cologne 1
℃ (49 221) 2212379

Lochner, *The Virgin and Child in a Rose Arbour*

Staatliche Kunstsammlungen Dresden
Georg-Treu-Platz 1
PSF 450
8012 Dresden
℃ (49 351) 4953056

Correggio, *The Nativity*
Liotard, *The Chocolate Pot*

Wilhelm-Lehmbruck-Museum
Düsseldorferstrasse 51
4100 Duisburg
℃ (49 203) 2832630

Heckel, *Windmill, Dangast*

Städelsches Kunstinstitut und Städtische Galerie
Schaumainkai 63
6000 Frankfurt 70
℃ (49 69) 6050980

Cranach, *Venus*

Hamburger Kunsthalle
Glockengiesserwall
2000 Hamburg 1
℃ (49 40) 24862612

Friedrich, *The Wreck of the Hope*
Kirchner, *Self-portrait with Model*
Overbeck, *The Adoration of the Magi*

Staatliche Kunstsammlungen Kassel
Schloss Wilhelmshöhe
3500 Kassel
℘ (49 561) 36011

Rembrandt, *Jacob Blessing*
Terbrugghen, *The Flute Player*

Alte Pinakothek
Barerstrasse 27
8000 Munich 40
Tel: (49 89) 23805216

Altdorfer, *Battle of Alexander at Issus*

Stiftung Schlösser und Gärten Potsdam-Sanssouci
Park Sanssouci
O-1500 Potsdam
℘ (49 331) 96940

Caravaggio, *Doubting Thomas*

Staatsgalerie Stuttgart
Konrad-Adenauer-Strasse 30–32
7000 Stuttgart
℘ (49 711) 2125050

Marc, *Little Yellow Horses*

Kunsthalle Tübingen
Philosophenweg 76
7400 Tübingen 1
℘ (49 7071) 61444

Hamilton, *Just What is it That Makes Today's Homes So Different, So Appealing?*

Italy

Pinacoteca Nazionale
Via Belle Arti 56
40100 Bologna
℘ (39 51) 243222

Perugino, *The Virgin and Child with Saints*

Palazzo Schifanoia
Via Scandiana 23
44100 Ferrara
℘ (39 532) 62038

Del Cossa, *May*

Galleria degli Uffizi
Piazzale degli Uffizi
50122 Florence
℘ (39 55) 218341

Botticelli, *Spring*
Catena, *The Supper at Emmaus*
Cimabue, *The Santa Trinità Madonna*
Clouet, *Portrait of François I on Horseback*
Duccio, *The Rucellai Madonna*
Gentile da Fabriano, *The Adoration of the Magi*
Gentileschi, *Judith and Holofernes*
Filippino Lippi, *Portrait of an Old Man*
Filippo Lippi, *The Coronation of the Virgin*
Lorenzo Monaco, *The Coronation of the Virgin*
Luini, *The Executioner Presents John the Baptist's Head to Herod*
Martini, *The Annunciation*

Michelangelo, *The Doni Tondo*
Orcagna, *Saint Matthew Surrounded by Scenes of his Life*
Palma Vecchio, *The Holy Family with Mary Magdalene and the Infant Saint John*
Parmigianino, *The Madonna with the Long Neck*
Piero di Cosimo, *Perseus Freeing Andromeda*
Rosso Fiorentino, *Moses and the Daughters of Jethro*
Salviati, *Charity*
Sebastiano del Piombo, *The Death of Adonis*
Vigée-Lebrun, *Self-portrait*

Museo Nazionale del Bargello
Via del Proconsolo 4
50122 Florence
℘ (39 55) 210801

Algardi, *Bust of Cardinal Paolo Emilio Zacchia*
Donatello, *David*
Della Robbia, *Madonna and Child between Two Angels*
Verrocchio, *Bust of a Woman Holding a Nosegay*

Palazzo Pitti
Piazza Pitti 1
50100 Florence
℘ (39 55) 210323/6673

Andrea del Sarto, *Assumption of the Virgin*
Fra Bartolommeo, *Resurrected Christ with Saints*

Pinacoteca di Brera
Via Brera 28
20121 Milan
℘ (39 2) 808387

Carrà, *The Metaphysical Muse*
Signorelli, *The Flagellation of Christ*

Galleria e Museo Estense
Piazza Sant Agostino 109
41100 Modena
℘ (39 59) 222145

Dossi, *Alfonso I d'Este*

Palazzo Barberini
Via Quattro Fontane 13
00184 Rome
℘ (39 6) 4814430/24184

Pietro da Cortona, *Glorification of the Rule of Urban VIII*

Palazzo del Vaticano
00120 Vatican City
Rome
℘ (39 6) 6983333

Raphael, *The School of Athens*

Palazzo Pubblico
Piazza del Campo
53100 Siena
℘ (39 577) 292111

Lorenzetti, *Allegory of Good Government*

Pinacoteca Nazionale di Siena
Via San Pietro 31
53100 Siena
℘ (39 577) 281161

Sodoma, *The Descent from the Cross*

Galleria dell'Accademia
Campo della Carità 1059A
30121 Venice
℘ (39 41) 22247

Gentile Bellini, *The Miracle of the True Cross near the San Lorenzo Bridge*
Bordone, *Presentation of the Ring to the Doge of Venice*
Giorgione, *The Tempest*

Galleria Internazionale d'Arte Moderna di Ca' Pesaro
Santa Croce 2076
30100 Venice
℘ (39 41) 5224127

Manzù, *The Cardinal*

Museo Correr
Piazza San Marco 52
30100 Venice
℘ (39 41) 5225625

Carpaccio, *Two Venetian Ladies on a Balcony*

Mexico

Museo de Arte Alvar y Carmen T de Carillo
Avenida Revolución 1608
01000 Mexico City, DF
℘ (52 5) 5503983

Siqueiros, *Death and Funeral of Cain*

The Netherlands

Stedelijk Museum
Paulus Potterstraat 13
1071 CX Amsterdam
℘ (31 20) 5732911

Malevich, *Suprematism*
Merz, *Unreal City*

Mauritshuis
Korte Vijverberg 8
2513 AB The Hague
℘ (31 70) 3469244

Fabritius, *The Goldfinch*

Rijksmuseum Kröller-Müller
Nationale Park de Hoge Veluwe
Houtkampweg 6
6731 AW Otterlo
℘ (31 8382) 1241

Redon, *The Cyclops*

Museum Boymans-van Beuningen
Museumpark 18-20
3015 CB Rotterdam
℘ (31 10) 4419400

Dou, *Maidservant at a Window*
Severini, *Pierrot the Musician*

Norway

Nasjonalgalleriet
Universitetsgaten 13
0033 Oslo 1
℘ (47 2) 200404

Munch, *The Madonna*

Portugal

Museu Nacional de Arte Antiga
Rua das Janelas Verdes
1293 Lisbon
℘ (351 1) 3976001/64151

Bosch, *The Tribulations of St Anthony*

Romania

Muzeul de Arta
Calea Unirii 15
1100 Craiova
℘ (40 41) 12342

Brancusi, *The Kiss*

Russia

Tretyakov Gallery
Lavrushensky Per 10
109017 Moscow
℘ (7 095) 2307788/82054

Ivanov, *The Appearance of Christ to the People*

Hermitage Museum
Dvortsovaya nab 34
St Petersburg
℘ (7 812) 3113465

Gros, *Napoleon Bonaparte on the Bridge at Arcole*
De Hooch, *Woman and a Maid with a Pail in a Courtyard*
Matisse, *The Dinner Table (Harmony in Red)*
Mengs, *Self-portrait*

Spain

Museu Nacional d'Art de Catalunya
Palacio National
Parc de Montjuic
08038 Barcelona
℘ (34 3) 3255635

Zurbarán, *Saint Francis of Assisi*

Museo de Bellas Artes
Plaza del Museo 2
48009 Bilbao
℘ (34 4) 4410154/9536

Vasarely, *Pal-Ket*

Capilla Real
Sacristia de la Capilla
Granada
℘ (34 58) 229239

Memling, *Descent from the Cross*

Fundación Colección Thyssen-Bornemisza
Paseo del Prado 8
28014 Madrid
℘ (34 1) 4203944

509

Constable, *The Lock*
Ghirlandaio, *Portrait of Giovanna Tornabuoni*
Schad, *Portrait of Doctor Haustein*

Museo Nacional del Prado
Paseo del Prado
28014 Madrid
℡ (34 1) 4202836

Baldung, *The Three Ages of Man and Death*
Bassano, *The Animals Entering the Ark*
Domenichino, *The Sacrifice of Isaac*
Dürer, *Self-portrait with Gloves*
Gaddi, *Saint Eligius in the Goldsmith's Shop*
Giordano, *The Dream of Solomon*
Murillo, *The Immaculate Conception of the Escorial*
Ribera, *Saint Paul the Hermit*
Velázquez, *Las Meninas*
Veronese, *The Finding of Moses*
Vouet, *Time Overcome by Hope, Love and Beauty*
Van der Weyden, *The Descent from the Cross*

Switzerland

Kunstmuseum Basel
St Alban-Graben 16
4010 Basel
℡ (41 61) 2710828

Böcklin, *Centaur's Combat*
Klee, *Senecio*

Musée d'Art et d'Histoire
2 rue Charles Galland
1211 Geneva 3
℡ (41 22) 3114340

Hodler, *Lake Thun*
Witz, *The Miraculous Draught of Fishes*

510

UK

Towneley Hall Art Gallery
Burnley
Lancashire BB11 3RQ
℡ (44 282) 424213

Zoffany, *Charles Towneley's Library in Park Street*

The Fitzwilliam Museum
Trumpington Street
Cambridge CB2 1RB
℡ (44 223) 332900

Rosselli, *The Virgin and Child Enthroned with Saints*

National Museum of Wales
Cathays Park
Cardiff CF1 3NP
℡ (44 222) 397951

Wilson, *View in Windsor Great Park*

National Gallery of Scotland
The Mound
Edinburgh EH2 2EL
℡ (44 31) 5568921

Bellotto, *View of the Ponte delle Navi, Verona*
Elsheimer, *The Stoning of Saint Stephen*

Massys, *Portrait of a Notary*
Raeburn, *The Reverend Robert Walker Skating on Duddingston Loch*
Ramsay, *Lady Robert Manners*
Tiepolo, *The Finding of Moses*
Titian, *Diana and Actaeon*
Wilkie, *The Letter of Introduction*

Scottish National Gallery of Modern Art
Belford Road
Edinburgh EH4 3DR
℡ (44 31) 5568921

Kitaj, *If Not, Not*
Kokoschka, *Portrait of a 'Degenerate Artist'*
Lichtenstein, *In the Car*

The Burrell Collection
Pollok Country Park
2060 Pollokshaws Road
Glasgow GA3 1AT
℡ (44 41) 6497151

Degas, *The Rehearsal*

Leeds City Art Gallery
The Headrow
Leeds LS1 3AA
℡ (44 532) 478248

Grimshaw, *Nightfall down the Thames*

British Museum
Great Russell Street
London WC1B 3DG
℡ (44 20) 76361555

Bonington, *Rouen from the Quais*
Hiroshige, *Moonlight, Nagakubo*
Hokusai, *Mount Fuji in Clear Weather*

Courtauld Institute Galleries
Somerset House
Strand
London WC2R 0RN
Tel: (44 20) 78732526

Modigliani, *Nude*

Imperial War Museum
Lambeth Road
London SE1 6HZ
℡ (44 20) 74165000

Lewis, *A Battery Shelled*

National Gallery
Trafalgar Square
London WC2N 5DN
℡ (44 20) 78393321

Antonello da Messina, *Saint Jerome in his Study*
Avercamp, *A Scene on the Ice Near a Town*
Beccafumi, *Tanaquil, Wife of Lucomo*
Bronzino, *An Allegory of Venus and Cupid*
Campin, *The Virgin and Child before a Fire-screen*
Canaletto, *The Bucintoro Preparing to Leave the Molo on Ascension Day*
Carracci, *Christ Appearing to Saint Peter on the Appian Way*
Chardin, *The Young Schoolmistress*

Cuyp, *Cattle with Horseman and Peasants*
Van Dyck, *Charles I on Horseback*
Van Eyck, *The Arnolfini Marriage*
Gainsborough, *Mr and Mrs Andrews*
Van Gogh, *Sunflowers*
Guardi, *An Architectural Caprice*
Hals, *Portrait of a Young Man with a Skull*
Hogarth, *Breakfast Scene, from Marriage à la Mode*
Holbein, *The Ambassadors*
Kalf, *Still Life with Lobster, Drinking Horn and Glasses*
Lancret, *A Lady and a Gentleman with Two Girls in a Garden*
Longhi, *Exhibition of a Rhinoceros at Venice*
Lotto, *A Lady as Lucretia*
Mantegna, *The Agony in the Garden*
Metsu, *The Music Lesson*
Monet, *Waterlily Pond*
Patenier, *Saint Jerome in a Rocky Landscape*
Piero della Francesca, *The Baptism of Christ*
Pollaiuolo, *Apollo and Daphne*
Rosa, *Self-portrait*
Rubens, *The Judgement of Paris*
Sassetta, *Saint Francis of Assisi Renouncing his Earthly Father*
Savery, *Orpheus*
Uccello, *The Battle of San Romano*
Vermeer, *Lady Seated at a Virginal*

National Portrait Gallery
2 Saint Martin's Place
London WC2H 0HE
℡ (44 20) 73060055

Organ, *Charles, Prince of Wales*

Saatchi Collection
98a Boundary Road
London NW8 0RH
℡ (44 20) 76248299

Rego, *The Family*
Sherman, *Untitled No. 96*

Tate Gallery
Millbank
London SW1P 4RG
℡ (44 20) 78878000

Albers, *Homage to the Square*
Bellmer, *The Spinning Top*
P Blake, *On the Balcony*
W Blake, *Pity*
Bomberg, *The Mud Bath*
Braque, *Clarinet and Bottle of Rum on a Mantelpiece*
Broodthaers, *Casserole and Closed Mussels*
Burne-Jones, *King Cophetua and the Beggar Maid*
De Chirico, *The Uncertainty of the Poet*
Copley, *The Death of Major Pierson*
Delvaux, *Venus Asleep*
Derain, *The Pool of London*
Dobson, *Endymion Porter*
Ernst, *The Forest*
Francis, *Around the Blues*
Freud, *Girl with a White Dog*
Gaudier-Brzeska, *Red Stone Dancer*
Gertler, *The Merry-Go-Round*
Gorky, *The Waterfall*

Hausmann, *The Art Critic*
Hockney, *A Bigger Splash*
Hunt, *The Awakening Conscience*
Jones, *Man Woman*
Kandinsky, *Cossacks*
Klein, *IKB 79*
Leighton, *The Bath of Psyche*
Lipchitz, *Half-standing Figure*
Louis, *Alpha Phi*
Martin, *The Great Day of His Wrath*
Miró, *Women, Bird by Moonlight*
Moore, *Recumbent Figure*
Nash, *Dead Sea*
Nicholson, *August 1956 (Val d'Orcia)*
Noland, *Gift*
Picasso, *Weeping Woman*
Rothko, *Untitled*
Schwitters, *Picture with Spatial Growths – Picture with Two Small Dogs*
Sickert, *Ennui*
Spencer, *Saint Francis and the Birds*
Stubbs, *Mares and Foals in a Landscape*
Sutherland, *Portrait of Somerset Maugham*
Tanguy, *The Invisibles*
Tàpies, *Grey Ochre*
Tissot, *Holiday (The Picnic)*
Turner, *Snowstorm: Steamboat off a Harbour's Mouth*
Wadsworth, *The Beached Margin*
Waterhouse, *The Lady of Shalott*
Whistler, *Symphony in White No. 2: Little White Girl*

Victoria and Albert Museum
Cromwell Road
South Kensington
London SW7 2RL
℡ (44 20) 79388500

J Bruegel, *The Garden of Eden*
Daumier, *The Print Collectors*
Hilliard, *Young Man Leaning Against a Tree*
Rossetti, *The Day-dream*
Utamaro, *Lovers*

Wallace Collection
Hertford House
Manchester Square
London W1M 6BM
℡ (44 20) 79350687

Fragonard, *The Swing*
Van Ostade, *Interior with Peasants*
Romney, *Mrs Mary Robinson, 'Perdita'*
T Rousseau, *The Forest of Fontainebleau, Morning*
Steen, *The Christening Feast*

Maidstone Museum and Art Gallery
Saint Faith's Street
Maidstone ME14 1LH
℡ (44 622) 756405

Pannini, *Roman Capriccio*

Manchester City Art Gallery
Corner of Mosley Street and Princess Street
Manchester M2 3JL
℡ (44 61) 2365244

Brown, *Work*

Laing Art Gallery
Higham Place
Newcastle upon Tyne NE1 8AG
℃ (44 91) 2327734

Landseer, *Wild Cattle at Chillingham*

Salford Museum and Art Gallery
Peel Park
Salford M5 4WU
℃ (44 61) 7362649

Lowry, *Coming from the Mill*

Sheffield City Art Galleries
The Graves Art Gallery
Surrey Street
Sheffield S1 1XZ
℃ (44 742) 735158

Gilman, *An Eating House*

The Royal Collection
The Royal Library
Windsor Castle
Berkshire SL4 1NJ
℃ (44 753) 868286

Agasse, *The Nubian Giraffe*

York City Art Gallery
Exhibition Square
York YO1 2EW
℃ (44 904) 623839

Snyders, *A Game Stall*

USA

Baltimore Museum of Art
Art Museum Drive
Baltimore
MD 21218
℃ (1 410) 3966300/7100

Andre, *Zinc Magnesium Plain*

Indiana University Art Museum
Bloomington
IN 47405
℃ (1 812) 8555445

Duchamp, *Fountain*

Museum of Fine Arts
465 Huntington Avenue
Boston
MA 02115
℃ (1 617) 2679300

Allston, *Landscape with a Lake*

Art Institute of Chicago
Michigan Avenue at Adams Street
Chicago
IL 60603
℃ (1 312) 4433600

Seurat, *Sunday Afternoon on the Island of the Grande Jatte*
Wood, *American Gothic*

Cleveland Museum of Art
11150 East Boulevard
Cleveland
OH 44106
℃ (1 216) 4217340

Church, *Twilight in the Wilderness*

Des Moines Art Center
4700 Grand Avenue
Des Moines
IA 50312
℃ (1 515) 2774405

Bacon, *Study after Velázquez's Portrait of Pope Innocent X*

Detroit Institute of Arts
5200 Woodward Avenue
Detroit
MI 48202
℃ (1 313) 8337900

Feininger, *Sailing Boats*
Reni, *Saint Jerome and the Angel*

Wadsworth Atheneum
600 Main Street
Hartford
CT 06103
℃ (1 203) 2782670

Cole, *Scene from Last of the Mohicans*

Los Angeles County Museum of Art
5905 Wilshire Boulevard
Los Angeles
CA 90036
℃ (1 213) 8576111

Magritte, *The Treachery of Images*

Barnes Foundation
300 North Latch's Lane
Merion
PA 19066
℃ (1 215) 6673067/0290

Cézanne, *Mont Sainte-Victoire*

Yale University Art Gallery
1111 Chapel Street at York Street
New Haven
CT 06520
℃ (1 203) 4320600

Powers, *The Greek Slave*

The Brooklyn Museum
200 Eastern Parkway
Brooklyn
NY 11238
℃ (1 718) 6385000

Sargent, *Paul Helleu Sketching with his Wife*

Solomon R Guggenheim Museum
1071 Fifth Avenue
New York
NY 10128
℃ (1 212) 3603500

Mondrian, *Composition*

Hispanic Society of America Museum
Broadway between 155 and 156 Streets
New York
NY 10032
℃ (1 212) 9262234

Goya, *Portrait of the Duchess of Alba*

Metropolitan Museum of Art
Fifth Avenue at 82nd Street
New York
NY 10028
℃ (1 212) 8795500

Bierstadt, *The Rocky Mountains*
Bingham, *Fur Traders Descending the Missouri*
Stuart, *George Washington*

Museum of Modern Art
11 West 53rd Street
New York
NY 10019
℃ (1 212) 7089400

Arp, *Leaves and Navels, I*
Balla, *Flight of the Swallows*
Beckmann, *Departure*
Calder, *Lobster Trap and Fish Tail*
Lam, *The Jungle*
Marini, *Horseman*
Noguchi, *Stone of Spiritual Understanding*
Pollock, *Number 1A, 1948*
Stella, *Kastura*
Still, *Painting, 1944*
Warhol, *Marilyn*
Wyeth, *Christina's World*

Whitney Museum of American Art
945 Madison Avenue
New York
NY 10021
℃ (1 212) 5703600/76

Johns, *Three Flags*

Pennsylvania Academy of the Fine Arts
118 North Broad Street
Philadelphia
PA 19102
℃ (1 215) 9727600

West, *William Penn's Treaty with the Indians*

Philadelphia Museum of Art
26th Street at Benjamin Franklin Parkway
Philadelphia
PA 19101
℃ (1 215) 7638100

Eakins, *Between Rounds*
Hicks, *The Peaceable Kingdom*
Masolino, *Saint Peter and Saint Paul*
H Rousseau, *The Monkeys*
Toulouse-Lautrec, *Dance at the Moulin Rouge*

Carnegie Museum of Art
4400 Forbes Avenue
Pittsburgh
PA 15213
℃ (1 412) 6223131

Catlin, *Ambush for Flamingoes*

Corcoran Gallery of Art
500 17th Sreet NW
Washington
DC 20006
℃ (1 202) 6383211

Bellows, *Forty-two Kids*

Hirshhorn Museum and Sculpture Garden
Independence Avenue at 7th Street SW
Washington
DC 20560
℃ (1 202) 3572700

Deacon, *Fish Out of Water*
Newman, *Covenant*
Segal, *Bus Riders*

National Gallery of Art
6th Street at Constitution Avenue NW
Washington
DC 20565
℃ (1 202) 7374215

Castagno, *The Young David*
Chase, *A Friendly Visit*
Corot, *Ville d'Avray*
Frankenthaler, *Mountains and Sea*
Homer, *Breezing Up*

National Museum of American Art
Eighth and G Streets NW
Washington
DC 20560
℃ (1 202) 3572700

Rauschenberg, *Reservoir*

Phillips Collection
1600 21st Street NW
Washington
DC 20009-1090
℃ (1 202) 3872151

Bonnard, *The Open Window*
Davis, *Egg Beater No. 4*
Dove, *Me and the Moon*
Marin, *Maine Islands*

Smithsonian Institution
1000 Jefferson Drive SW
Washington
DC 20560
℃ (1 202) 3572700

Hopper, *People in the Sun*

Acknowledgements

Contributors

Adam Butler, Claire Van Cleave, Susan Stirling

Photographic Acknowledgements

Art Gallery of Ontario, Toronto. Purchase, 1967
(Acc.No.66/29): 342; Paolo Baldacci Gallery, New York:
48; courtesy Marc Blondeau: 156; Bridgeman Art Library:
8, 9, 14, 16, 20, 24, 25, 30, 33, 35, 37, 41, 49, 54, 62, 65,
70, 71, 78, 83, 84, 88, 95, 96, 97, 98, 100, 109, 114, 116,
118, 131, 134, 135, 136, 137, 138, 141, 145, 146, 147, 155,
161, 162, 170, 171, 172, 174, 175, 177, 184, 185, 186, 187,
188, 193, 198, 199, 203, 212, 230, 232, 234, 236, 237, 239,
243, 245, 247, 254, 256, 260, 267, 268, 269, 274, 278, 284,
285, 286, 287, 289, 290, 294, 299, 300, 301, 311, 314, 319,
324, 327, 328, 332, 338, 343, 345, 348, 349, 350, 355, 358,
359, 361, 378, 386, 396, 397, 398, 399, 401, 402, 403, 405,
406, 407, 409, 415, 420, 421, 425, 428, 431, 434, 437, 447,
448, 460, 461, 467, 472, 475, 476, 478, 481, 492, 496, 500,
501, 502; courtesy Galerie Bruno Bischofberger, Zurich:
102; Galerie Jeanne Bucher, Paris: 443, 477; Leo Castelli
Gallery, New York/photo © 1989 Dorothy Zeidman: 158;
Christie's, New York: 92, 160, 450; The Cleveland Museum
of Art, Mr and Mrs William H Marlatt Fund: 98; courtesy
Paula Cooper Gallery, New York/photo © 1986 D James
Dee: 11; Patrick Derom Gallery, Brussels/photo Vincent
Everarts: 442; Anthony d'Offay Gallery, London: 28, 182,
221, 257, 282, 334, 365, 387, 408; courtesy Fischer Fine
Art, London: 63; Galleria Blu, Milan: 159; Gimpel Fils,
London: 214, 459; Giraudon/Bridgeman Art Library: 53,
58, 59, 80, 93, 103, 117, 119, 120, 124, 125, 140, 168, 176,
178, 196, 213, 228, 233, 265, 275, 276, 316, 326, 346, 370,
373, 393, 430, 440, 465, 470, 471; Marian Goodman
Gallery, New York/photo Michael Goodman: 50; Hirschl
& Adler Galleries Inc., New York: 426; Hirshhorn Museum
and Sculpture Garden, Smithsonian Institution, Gift of
Joseph H Hirshhorn, 1966/photo Lee Stalsworth: 422;
© David Hockney: 220; courtesy Leonard Hutton
Galleries, New York: 190, 416; courtesy Leonard Hutton
Galleries, New York/© Nolde-Stiftung Seebüll: 340;
Index/Bridgeman Art Library: 195, 390, 503; Indiana
University Art Museum, Partial Gift of Mrs William
Conroy: 142; courtesy Annely Juda Fine Art, London: 280,
320, 369, 392; K&B News Foto, Florence/Bridgeman Art
Library: 368; Crane Kalman Gallery Ltd, London: 223;
Galerie Karsten Greve, Cologne/photo Georges Poncet:
61; courtesy Knoedler & Company, New York: 436; Latin
American Masters, Beverly Hills, California: 309; Lauros-
Giraudon/ Bridgeman Art Library: 18, 329, 372; photo
© Carol Marc Lavrillier: 60; Margo Leavin Gallery, Los
Angeles/photo Douglas M Parker: 246; Lisson Gallery,
London: 113, 122, 244, 273, 297; Marlborough Fine Art
(London) Ltd: 21, 129, 249, 255, 380, 419; © Succession
H Matisse/DACS, 2000: 308; The Mayor Gallery, London:
489; courtesy McKee Gallery, New York: 204; courtesy
Robert Miller Gallery, New York: 29; Museum of Modern
Art, New York, acquired through the Mr and Mrs Victor
Ganz, Mr and Mrs Donald H Peters and Mr and Mrs
Charles Zadok Funds: 445; Museum of Modern Art, New
York, gift of the artist: 337; Museum of Modern Art, New
York, gift of Mr David Whitney: 485; Museum of Modern
Art, New York, Inter-American Fund: 261; The Museum
of Modern Art, New York, purchase: 19, 498; Museum
of Modern Art, New York, The Sidney and Harriet Janis
Collection: 446; courtesy of The Pace Gallery, New
York/photo © Ellen Page Wilson: 130, 240; Perls Galleries,
New York: 17; Archives Serge Poliakoff, Paris: 364; photo
© RMN, Paris: 296; Yseult Riopelle: 389; The Royal Collection
© 1994 Her Majesty The Queen: 4; courtesy Salvatore Ala
Gallery, New York: 313; courtesy Richard Serra/photo Dirk
Reinartz: 423; Sotheby's, London: 207; © Sotheby's Inc., New
York: 209, 293, 384; Allan Stone Gallery, New York: 151, 253,
457; photo Mirek Switalski: 432; Waddington Galleries Ltd: 82,
107, 206, 417, 499; courtesy John Weber Gallery, New York/©
Daniel Buren: 72; Yale University Art Gallery, New Haven,
Olive Louise Dann Fund: 371; Donald Young Gallery Ltd,
Seattle/photo Eduardo Calderon: 479.